R/US/1867/27/5- 216

D0301643

ASIAN MARKETING GROUP
LONDON

2 5 JAN 2006

RECEIVED

GARAVI GUJARAT GROUP
LIBRARY

OLD
MASTERS
and
young
geniuses

OLD MASTERS

and

young geniuses

The Two Life Cycles
of Artistic Creativity

David W. Galenson

PRINCETON UNIVERSITY PRESS
PRINCETON AND OXFORD

Copyright © 2006 by Princeton University Press
Published by Princeton University Press, 41 William Street,
Princeton, New Jersey 08540
In the United Kingdom: Princeton University Press,
3 Market Place, Woodstock, Oxfordshire OX20 1SY

All Rights Reserved

Library of Congress Cataloging-in-Publication Data

Galenson, David W.
Old masters and young geniuses : the two life cycles of artistic
creativity / David W. Galenson.
 p. cm.
Includes bibliographical references and index.
ISBN-13: 978-0-691-12109-3 (cl : alk. paper)
ISBN-10: 0-691-12109-5 (cl : alk. paper)
1. Creation (Literary, artistic, etc.) 2. Ability, Influence of age
on. 3. Arts, Modern—19th century. 4. Arts, Modern—20th
century. I. Title.

NX160.G36 2005
700′.1′9—dc22 2005046571

British Library Cataloging-in-Publication Data is available

This book has been composed in Onyx MtStd, Syntax LTStd, and Sabon

Printed on acid-free paper. ∞

pup.princeton.edu

Printed in the United States of America

1 3 5 7 9 10 8 6 4 2

TO | my mother

CONTENTS

ILLUSTRATIONS AND TABLES |

PREFACE

During my senior year in college I was very busy writing an honors thesis in economics. To give myself a break from that work, in the spring I took several courses in other departments, one of which was a survey of the history of modern art. The course was fascinating, for it focused on a series of important innovations that had dramatically changed fine art in barely more than a century. The course covered the development of modern art through the 1960s, and one of the things that struck me during the last few weeks of the semester was how young the leading painters of that decade had been: Jasper Johns, Frank Stella, Larry Poons, and a number of their friends were hardly beyond college age themselves when they made the paintings we studied.

The course greatly increased my enjoyment of contemporary art, and during the years that followed I had the opportunity to visit a number of museums that have excellent collections. One effect of these visits was to reinforce my observation about the youth of the major artists of the 1960s, for although the best museums concentrated on the late work of the Abstract Expressionists who dominated the 1940s and '50s, they also consistently gave pride of place to the early works of the Pop artists and the other leading members of the next generation of painters. The Museum of Modern Art in New York, for example, which may have the single best collection of recent American art, consistently displays paintings Robert Rauschenberg, Jasper Johns, Jim Dine, and Frank Stella made before they had reached the age of 30.

By 1997 I had spent nearly a decade working on a large and detailed study of the economic mobility of immigrants and their children in nineteenth-century American cities. To take a break from that research, I decided to devote part of the summer to a systematic examination of the careers of some of the American artists I had first studied in college, by looking at how the prices their paintings brought at auction were affected by the ages of the artists when the paintings were produced. When I first began to collect auction prices for the work of several dozen important American painters, I had no idea that this would eventually lead to a new understanding of the life cycles of human creativity; in fact, I didn't know then what the current theory of this was, or even that there was one. Yet what I would learn during the next seven years not only would make me aware of the pronounced differences in the methods and careers of experimental and conceptual innovators in the arts, but also would serve

as a vivid illustration of how radical and unexpected the results of the
gradual process of experimental research can be. During that time a series
of many small steps, each directly motivated by what I had learned in the
past few weeks or months, produced a cumulative effect that is as surpris-
ing to me as it may be to many readers.

My initial analysis of the auction prices for the American painters pro-
duced the puzzling result that the work of some artists (including Jackson
Pollock, Willem de Kooning, and Mark Rothko) increased in value as
their careers progressed, whereas other artists (including Jasper Johns,
Robert Rauschenberg, and Andy Warhol) produced their most valuable
work at very early ages. To understand why these age-price profiles dif-
fered so much, I began to look in more detail at the careers of individual
painters. I wasn't sure what I was looking for, but among the things I
considered were how the artists worked, what their goals were, what was
distinctive about their art, and when they made their most significant con-
tributions. This led to my initial recognition that the two different pat-
terns of prices over the artists' life cycles were indicators of very different
patterns of artistic creativity over the life cycle, which in turn were associ-
ated with very different artistic goals and very different methods of mak-
ing paintings. For the first time I began to understand that the young
artists of the 1960s produced works that differed so completely from
those of their predecessors because they used fundamentally different
methods in the pursuit of fundamentally different goals.

This was the beginning of an exciting period of discovery, as I progres-
sively expanded my study to larger numbers of important modern paint-
ers to see whether my initial generalizations would hold up. Much to my
surprise, they did, and a vast amount of detailed analysis and information
that art scholars had collected about great modern painters began to fall
into consistent patterns. The realization that my analysis afforded signifi-
cant new insights into the history of modern art eventually prompted me
to write a book, using the analysis of the two patterns of innovation to
inform a narrative of several central episodes in the development of mod-
ern painting.

After that book was completed, I continued to extend my analysis to
other groups of modern painters, and I continued to discover new implica-
tions of the analysis. During this time, however, I began to suspect that the
behaviors I had identified in modern painting, with the basic distinction
between experimental and conceptual approaches, were much more gen-
eral characteristics of most, if not all, intellectual activities. I was initially
reluctant to act on this suspicion, because I was enjoying being immersed
in the history of modern painting, but eventually my curiosity prompted
me to study another art. My research on painters had shown me the great
value of being able to consult high-quality critical literature, so I first

decided to study a sample of important modern poets. As I began to learn about the goals, methods, and achievements of these poets, I was delighted to see how well the experimental and conceptual categories could be translated to literature, and I was startled to discover how well the analysis could predict the patterns of poets' life cycles of creativity. After the pilot study of poets I studied a group of modern novelists, and I had the same shock of recognition as I learned about their strengths and weaknesses, and the development of their work through their lives, and I again saw how readily many of the facts collected by literary scholars about these writers could be organized into systematic patterns. And as was the case for painters, I saw the surprising benefits of applying this analysis to poets and novelists, as many previously puzzling aspects of their behavior and the development of their work could be explained as general characteristics of types of artists.

This book provides an overview of my research on the life cycles of artistic creativity. Beginning with painters, it shows how we categorize artists, and how we can measure their creativity over the course of their careers. It then considers some extensions of the analysis and discusses a number of implications for our understanding of modern painting. The book then applies the analysis to other groups of important artists, treating in turn painters before the modern era, modern sculptors, poets, novelists, and movie directors. The final chapter places the results in a broader perspective and considers not only how this research compares to artists' and psychologists' views of artistic life cycles, but also how it contributes to our understanding of human creativity in general, and how it might help us to increase our own creativity.

I hope this book will lead to both more and better research on individual creativity. This is a subject economists have not considered, and I hope my work will show them both the value of adding it to their research agenda and the rewards from analyzing individual life histories. Psychologists have studied the creative life cycles of exceptional individuals, but for reasons I explain in the last chapter I believe their work has been flawed, and I hope they will use my results to improve their research. Humanists typically view the life cycles of individual artists in isolation, and I hope my work will show them the value of systematic comparative research.

I hope this book will influence researchers in these disciplines, but I also hope it will find an audience of nonspecialists. One of the greatest satisfactions of this work for me has been the deeper understanding it has given me of the arts I have studied. I hope that others who enjoy these arts will recognize the rewards that follow from a more systematic approach to them, and will share my experience that it increases the pleasure they derive from looking at paintings or reading novels.

Many people have helped me with this research, in a variety of ways, but two have taught me the most, and I am greatly indebted to them. Early in this project I read an intriguing book on the origins of the market for modern art by Robert Jensen, a professor of art history at the University of Kentucky. When I got in touch with him, his enthusiasm for my research led to a remarkable series of conversations that continues today. In the course of these frequent discussions, with unfailing graciousness Rob has given me the benefit of his vast knowledge of art history. His patience, open-mindedness, and intellectual curiosity have made our discussions as enjoyable as they have been valuable. I would have done this research without Rob's help and encouragement, but it would have been more difficult, and it wouldn't have been nearly as much fun.

When I began to extend my research beyond painting, I had the good fortune to hire Joshua Kotin, a graduate student in English at the University of Chicago, as a research assistant. I soon discovered that Josh had a deep understanding of both modern poetry and fiction, and during the past two years, with admirable tact and efficiency, he has greatly increased my understanding of the development of modern literature. Josh's constructive criticism and broad knowledge have improved my work on poets and novelists, and have given me a greater appreciation for the accomplishments of these writers.

The outline of this book originated in a paper I presented at a conference titled "Measuring Art" at the American University of Paris in May 2003. I thank Gerardo della Paolera, the president of AUP, for his hospitality, and Martin Kemp and Camille Saint-Jacques for their comments on my work at the conference.

Clayne Pope always read my work in economic history and discussed it with me, and I appreciate that he has continued to do this in spite of my change of course. Morgan Kousser's enthusiasm for my research on painters, and his willingness to publish my early papers in *Historical Methods*, provided welcome encouragement.

Among my colleagues at the University of Chicago, I am grateful to Fernando Alvarez, Jim Heckman, Richard Hellie, Ali Hortacsu, Emmet Larkin, Bob Lucas, Derek Neal, Yona Rubinstein, Allen Sanderson, Josh Schonwald, Hugo Sonnenschein, and Lester Telser for suggestions and discussions. Among those elsewhere, I thank Andy Abel, John James, Julia Keller, Aaron Kozbelt, Gracie Mansion, Ralph Petty, Magda Salvesen, Colin Stewart, Bruce Weinberg, and Michael Zickar for useful discussions. I am also grateful to participants in seminars at the University of Chicago, New York University, the University of North Carolina, and the École des hautes études en sciences sociales, and in sessions at the annual meetings of the Southern Economic Association, the American Economic Association, and the National Art Education Association, for their com-

ments. Laura Demanski and Peter Northup performed excellent research assistance. A grant from the National Science Foundation provided financial support for much of this research.

At Princeton University Press, I thank Tim Sullivan for his interest in my work.

Shirley Ogrodowski learned firsthand the drawbacks of experimental research projects, as she typed what must have seemed like an endless series of revised chapters of this manuscript. As always, I am grateful for the efficiency and unfailing good cheer with which she did this.

OLD
MASTERS and
young
geniuses

introduction

In May 1902, already suffering acutely from the illness that would cause his death the following year, Paul Gauguin wrote from the Marquesas Islands to Georges-Daniel de Monfreid, his most loyal friend, "For two months I have been filled with one mortal fear: that I am not the Gauguin I used to be." Gauguin's fear was less for his life than for his art. Shortly before his death, he recorded in his notebook his faith that at any age "an artist is always an artist." Yet he was forced to continue by posing a question: "Isn't he better at some times, some moments, than at others? Never impeccable, since he is a living, human being?"[1]

Great artists whose lives are dominated by the desire to make the most important contributions they possibly can are inevitably drawn to thinking about the relationship between their stage of life and the quality of their work. Sometimes, as with Gauguin, the results are painful to read. In other cases they are amusing. So, for example, Gertrude Stein poked fun at the ambitious young Robert Delaunay. In *The Autobiography of Alice B. Toklas*, Stein wrote of Delaunay's frequent visits to her apartment in the rue de Fleurus, and his inspection of her remarkable art collection. She recalled, "He was always asking how old Picasso had been when he had painted a certain picture. When he was told he always said, oh I am not as old as that yet. I will do as much when I am that age."[2]

Whether their insights were poignant or comical, most artists have considered the relationship between age and the quality of work not in general, but within the specific context of their own careers, in anticipating their future greatness, looking back on the improvement over time in their skills, or worrying about the deterioration of their abilities. Although their awareness of the relationship underscores its importance, their assessments of it obviously cannot be taken to have any degree of generality. Leaving artists' judgments aside, we can pose very simply the question that I wish to consider: How, and why, does the quality of artists' work vary with age? The purpose of this book is to present my theory of creative artists' life cycles, demonstrate how this theory can be implemented empirically, and examine some of the consequences of this analysis.

IMPORTANCE IN ART

> Perhaps the importance that we must attach to the
> achievement of an artist or a group of artists may
> properly be measured by the answer to the following
> question: Have they so wrought that it will be im-
> possible henceforth, for those who follow, ever again
> to act as if they had not existed?
> *Walter Sickert, 1910*[3]

> Shall the painter then . . . decide upon painting? Shall
> *he* be the critic and sole authority? Aggressive as is this
> supposition, I fear that, in the length of time, his asser-
> tion alone has established what even the gentlemen
> of the quill accept as the canons of art, and recognize
> as the masterpieces of work.
> *James McNeill Whistler, 1892*[4]

There are many common misunderstandings of the history of art, but
perhaps none is more basic than the confusion over what determines the
quality of art. Although it is of course possible to consider separately the
quality of a number of different attributes of an artist's work, the overall
importance of art is a function of innovation. Important artists are inno-
vators whose work changes the practices of their successors; important
works of art are those that embody these innovations. Artists have made
innovations in many areas, including subject matter, composition, scale,
materials, and technique. But whatever the nature of an artist's innova-
tion, its importance ultimately depends on the extent of its influence on
other artists.

It should immediately be noted that the importance at issue here is not
the short-run interest that gains an artist immediate critical or commercial
success, but the long-run importance that eventually causes his work to
hang in major museums and makes his contribution the subject of study
by scholars of art. These two types of success have often coincided, but
in many cases they have not. The modern era contains prominent exam-
ples not only of great painters, like van Gogh and Gauguin, who were
largely neglected in their own time, but also of artists like William Adol-
phe Bouguereau (1825–1905) and Ernest Meissonier (1815–91), whose
work was critically acclaimed and highly priced during their own life-
times, but whose reputations have subsequently declined considerably. It
is not surprising that the correlation between short-run and long-run suc-
cess is imperfect, for recognition of significant innovation often involves

a lag, as time may be required for other artists to react to a new practice and adapt it to their own uses. Although these lags have tended to become shorter over the course of the modern era, as the costs of travel and communication have fallen, the time required for influences to appear nonetheless remains variable, because artistic innovations differ in subtlety and complexity. Thus whereas some important innovations have diffused rapidly, others have taken hold much more slowly.

During the modern era, the art world has also been an active breeding ground for conspiracy theories. There is a widespread belief, not only among the general public but even among many art scholars, that artistic success can be produced by persuasive critics, dealers, or curators. In the short run, there is little question that prominent critics and dealers can gain considerable attention for an artist's work. It is equally clear, however, that unless this attention is eventually transformed into influence on other artists, it cannot gain that artist an important place in art history in the long run. Thus Harold Rosenberg, who was himself a prominent critic, recognized in 1965 that "the sum of it is that no dealer, curator, buyer, or critic, or any existing combination of these, can be depended on to produce a reputation that is more than a momentary flurry." And Rosenberg furthermore declared that a painter who influenced his peers could not be ignored by the art world: "A painter with prestige among painters is bound to be discovered sooner or later."[5]

Recognizing that innovation is the source of genuine importance in art allows us to understand precisely what it is about the life cycle that concerned Paul Gauguin, Robert Delaunay, and many others who have sought to become great painters. For the question of how the quality of artists' work varies with age can be restated as the question of why different artists have innovated at different ages. Answering this question is the task for this study.

CHAPTER ONE

theory

EXPERIMENTAL AND CONCEPTUAL INNOVATORS

Does creation reside in the idea or in the action?
Alan Bowness, 1972[1]

There have been two very different types of artist in the modern era. These two types are distinguished not by their importance, for both are prominently represented among the greatest artists of the era. They are distinguished instead by the methods by which they arrive at their major contributions. In each case their method results from a specific conception of artistic goals, and each method is associated with specific practices in creating art. I call one of these methods aesthetically motivated experimentation, and the other conceptual execution.

Artists who have produced experimental innovations have been motivated by aesthetic criteria: they have aimed at presenting visual perceptions. Their goals are imprecise, so their procedure is tentative and incremental. The imprecision of their goals means that these artists rarely feel they have succeeded, and their careers are consequently often dominated by the pursuit of a single objective. These artists repeat themselves, painting the same subject many times, and gradually changing its treatment in an experimental process of trial and error. Each work leads to the next, and none is generally privileged over others, so experimental painters rarely make specific preparatory sketches or plans for a painting. They consider the production of a painting as a process of searching, in which they aim to discover the image in the course of making it; they typically believe that learning is a more important goal than making finished paintings. Experimental artists build their skills gradually over the course of their careers, improving their work slowly over long periods. These artists are perfectionists and are typically plagued by frustration at their inability to achieve their goals.

In contrast, artists who have made conceptual innovations have been motivated by the desire to communicate specific ideas or emotions. Their goals for a particular work can usually be stated precisely, before its production, either as a desired image or as a desired process for the work's

execution. Conceptual artists consequently often make detailed prepara-
tory sketches or plans for their paintings. Their execution of their paint-
ings is often systematic, since they may think of it as primarily making a
preconceived image, and often simply a process of transferring an image
they have already created from one surface to another. Conceptual inno-
vations appear suddenly, as a new idea immediately produces a result
quite different not only from other artists' work, but also from the artist's
own previous work. Because it is the idea that is the contribution, concep-
tual innovations can usually be implemented immediately and completely,
and therefore are often embodied in individual breakthrough works that
become recognized as the first statement of the innovation.

The precision of their goals allows conceptual artists to be satisfied that
they have produced one or more works that achieve a particular purpose.
Unlike experimental artists, whose inability to achieve their vague goals
can tie them to a single problem for a whole career, the conceptual artist's
ability to consider a problem solved can free him to pursue new goals.
The careers of some important conceptual artists have consequently been
marked by a series of innovations, each very different from the others.
Thus whereas over time an experimental artist typically produces many
paintings that are closely related to each other, the career of the concep-
tual innovator is often distinguished by discontinuity.

ARCHETYPES

I seek in painting.
Paul Cézanne[2]

I don't seek; I find.
Pablo Picasso[3]

Two of the greatest modern artists epitomize the two types of innovator.
In September 1906, just a month before his death, sixty-seven-year-old
Paul Cézanne wrote to a younger friend, the painter Émile Bernard:

Now it seems to me that I see better and that I think more correctly
about the direction of my studies. Will I ever attain the end for which
I have striven so much and so long? I hope so, but as long as it is not
attained a vague state of uneasiness persists which will not disappear
until I have reached port, that is until I have realized something which
develops better than in the past, and can thereby prove the theories—
which in themselves are always easy; it is giving proof of what one
thinks that raises serious obstacles. So I continue to study.

But I have just re-read your letter and I see that I always answer off the mark. Be good enough to forgive me; it is, as I told you, this constant preoccupation with the aim I want to reach, which is the cause of it.

I am always studying after nature, and it seems to me that I make slow progress. I should have liked you near me, for solitude always weighs me down a bit. But I am old, ill, and I have sworn to myself to die painting. . . .

If I have the pleasure of being with you one day, we shall be better able to discuss all this in person. You must forgive me for continually coming back to the same thing; but I believe in the logical development of everything we see and feel through the study of nature and turn my attention to technical questions later; for technical questions are for us only the simple means of making the public feel what we feel ourselves and of making ourselves understood. The great masters whom we admire must have done just that.[4]

This passage expresses nearly all the characteristics of the experimental innovator: the visual objectives, the view of his enterprise as research, the need for accumulation of knowledge, with the requirement that technique must emerge only from careful study, the distrust of theoretical propositions as facile and unsubstantiated, the incremental nature and slow pace of his progress, the total absorption in the pursuit of an ambitious, vague, and elusive goal, the frustration with his perceived lack of success in achieving that goal of "realization," and the fear that he would not live long enough to attain it. The irony of Cézanne's frustrations and fears at the end of his life stems from the fact that it was his most recent work, the paintings of his last few years, that would come to be considered his greatest contribution and would directly influence every important artistic development of the next generation.

The critic Roger Fry recognized the incremental and persistent nature of Cézanne's approach: "For him as I understand his work, the ultimate synthesis of a design was never revealed in a flash; rather he approached it with infinite precautions, stalking it, as it were, now from one point of view, now from another. . . . For him the synthesis was an asymptote toward which he was for ever approaching without ever quite reaching it; it was a reality, incapable of complete realization."[5] The historian Alan Bowness stressed Cézanne's inductive visual approach and avoidance of preconception: "His procedure is always empirical, not dogmatic—Cézanne is not following a set of rules, but trying, with every new picture, to record his sensations before nature."[6] Émile Bernard spent a month in Aix in 1904 and recalled that Cézanne spent the whole month working on a single still life: "The colors and shapes in this painting changed al-

most every day, and each day when I arrived at his studio, it could have been taken from the easel and considered a finished work of art." Bernard reported that Cézanne "never placed one stroke of paint without thinking about it carefully," and concluded that his method of working was "a meditation with a brush in his hand."[7] Art scholars have often been puzzled by Cézanne's casual disregard for his own paintings, but his lack of concern appears understandable as a consequence of his experimental method. Thus the critic Clive Bell explained that Cézanne's real goal was not making paintings, but making progress toward his goal: "The whole of his later life was a climbing towards an ideal. For him every picture was a means, a step, a stick, a hold, a stepping-stone—something he was ready to discard as soon as it had served his purpose. He had no use for his own pictures. To him they were experiments. He tossed them into bushes, or left them in the open fields."[8]

As Cézanne grew older, his paintings could increasingly be understood as visual representations of the uncertainty of perception, for the more he worked, the more acutely he became aware of the difficulty and complexity of his chosen task. Thus in 1904 he wrote to Bernard: "I progress very slowly, for nature reveals herself to me in very complex ways; and the progress needed is endless. One must look at the model and feel very exactly; and also express oneself distinctly and with force. . . . The real and immense study to be undertaken is the manifold picture of nature."[9] Cézanne's comments suggest that his uncertainty had a number of sources. He told his friend Joachim Gasquet: "Everything we look at disperses and vanishes, doesn't it? Nature is always the same, and yet its appearance is always changing. It is our business as artists to convey the thrill of nature's permanence along with the elements and the appearance of all its changes."[10] The critic David Sylvester explained that because they alternate between looking at the model and at the canvas, painters do not actually copy what they see: "In fact, one never copies anything but the vision that remains of it at each moment. . . . Working from life is working from memory: the artist can only put down what remains in his head after looking." For a painter as committed as Cézanne to visual accuracy, this gap between perception and execution becomes a source of anxiety and despair: "The model can go on standing still for ever, but the work will nonetheless be the product of an accumulation of memories none of which is quite the same as any other."[11] Cézanne worked to develop techniques that would represent this process of sequential representation. Thus Meyer Schapiro noted that in his later work "we see the object in the painting as formed by strokes, each of which corresponds to a distinct perception and operation. . . . The form is in constant making."[12]

Another major source of uncertainty involved contours. A celebrated statement of Cézanne's is that "There is no line; . . . there are only contrasts."[13] As he explained in a letter of 1905 to Bernard,

> the sensations of color, which give the light, are for me the reason for the abstractions which do not allow me to cover my canvas entirely nor to pursue the delimitation of the objects where their points of contact are fine and delicate; from which it results that my image or picture is incomplete. On the other hand the planes fall one on top of the other, from whence neo-impressionism emerged, which circumscribes the contours with a black line, a fault which must be fought at all costs.[14]

Cézanne struggled with the fact that the contour of an object is not a line, but rather the edge of a surface that is foreshortened because it is seen by the viewer at a sharp angle: "The contour [of an apple] is the ideal limit toward which the sides of the apple recede in depth."[15] To represent this edge by a single outline not only sacrifices an illusion of depth, but violates the artist's knowledge of the existence of the foreshortened surface. Roger Fry observed that "the contours of objects became almost an obsession to Cézanne." Cézanne's treatment of objects reflected his anxiety over the problem: "He almost always repeats the contour with several parallel strokes as though to avoid any one too definite and arresting statement, to suggest that at this point there is a sequence of more and more foreshortened planes. . . . The contour is continually being lost and then recovered again."[16] Examined close up, the many small hatched strokes that serve to define objects in Cézanne's late paintings create a sense of change: "It is as if there is no independent, closed, pre-existing object, given once and for all to the painter's eye for representation, but only a multiplicity of successively probed sensations."[17] The painting becomes a representation not of something seen, but rather of the process of seeing, and of Cézanne's recognition of the inevitable incompleteness of that representation. Thus Meyer Schapiro declared that Cézanne was "able to make his sensing, probing, doubting, finding activity a visible part of the painting."[18]

In 1923 Pablo Picasso gave a rare interview to a friend, the artist and critic Marius de Zayas, in which he emphasized that art should communicate discoveries rather than serving as a record of the artist's development:

> I can hardly understand the importance given to the word *research* in connection with modern painting. In my opinion to search means nothing in painting. To find, is the thing. . . .
>
> When I paint my object is to show what I have found, not what I am looking for. . . .

The several manners I have used in my art must not be considered as an evolution or as steps toward an unknown ideal of painting. . . .

I have never made trials or experiments. Whenever I had something to say, I have said it in the manner in which I have felt it ought to be said. Different motives inevitably require different methods of expression.[19]

Picasso's rejection of the description of his art as an evolution has been confirmed by generations of critics and scholars. As early as 1920, with Picasso not yet forty years old, Clive Bell described his career as "a series of discoveries, each of which he has rapidly developed," and commented on the abruptness and frequency of his stylistic changes, a theme that would later be echoed by dozens of biographers.[20] Thus decades later the critic John Berger wrote of Picasso's "sudden inexplicable transformations" and observed that "in the life work of no other artist is each group of works so independent of those which have just gone before, or so irrelevant to those which are to follow."[21] Historian Pierre Cabanne made this point by comparing Picasso with Cézanne: "There was not one Picasso, but ten, twenty, always different, unpredictably changing, and in this he was the opposite of a Cézanne, whose work . . . followed that logical, reasonable course to fruition."[22]

Picasso often planned his paintings carefully in advance. During the winter of 1906–7, he filled a series of sketchbooks with preparatory studies for Les Demoiselles d'Avignon, the large painting that would become his most famous single work.[23] Historian William Rubin estimated that Picasso made more than four hundred studies for the Demoiselles, "a quantity of preparatory work . . . without parallel, for a single picture, in the entire history of art."[24] The painting was a brutal departure from the lyrical works of the rose period that immediately preceded it, and its arrival jolted Paris's advanced art world. Henri Matisse angrily denounced the painting as an attempt to ridicule the modern movement, and even Georges Braque, who would later realize that he and Picasso "were both headed in the same general direction," initially reacted to the painting by comparing Picasso to a fairground fire-eater who drank kerosene to spit flames.[25] The importance of the Demoiselles stems from its announcement of the beginning of the Cubist revolution, which Picasso and Braque would develop in the next few years. As historian John Golding has observed, Cubism was a radical conceptual innovation, based not on vision but on thought: "Even in the initial stages of the movement, when the painters still relied to a large extent on visual models, their paintings are not so much records of the sensory appearance of their subjects, as expressions in pictorial terms of their idea or knowledge of them. 'I paint objects as I think them, not as I see them,' Picasso said."[26]

Picasso's certainty about his art contrasted sharply with Cézanne's doubt. Thus in 1946, when he was sixty-five, Picasso told his companion Françoise Gilot that his work was so often interrupted by visitors that he frequently did not push his works "to their ultimate end," but he knew that he could do this when he wished: "In some of my paintings I can say with certainty that the effort has been brought to its full weight and conclusion."[27] He explained to a biographer that his certainty came from the clarity of his conception: " 'The key to everything that happens is here,' he said one day, pointing to his forehead. 'Before it comes out of the pen or brush, the key is to have it at one's fingertips, entirely, without losing any of it.' "[28]

In an essay written in 1985, Meyer Schapiro puzzled over the fact that in the early 1920s Picasso had been able to work simultaneously in two very different styles: "In the morning he made Cubist paintings; in the afternoon he made Neoclassical paintings." For Schapiro, Picasso's lack of commitment to one style at a time did no less than call into question the integrity of his enterprise: "There exists in his practice a radical change with respect to the very concept of working, of production. Working involves, at least within our tradition, the commitment to a necessary way of working. If you can work in any other way you please, then no one way has a necessity; there is an element of caprice or arbitrariness of choice."[29] The German artist Oskar Schlemmer had also commented in 1921 on both Picasso's extraordinary ability to change styles and his lack of commitment, as he wrote to a friend that after reading a new book that surveyed Picasso's career, "I was amazed at the versatility of the man. An actor, the comic genius among artists? For everything is there: he could easily assume the role of any artist of the past or of any modern painter."[30] Interestingly, however, also in 1921 the artist and critic Amédée Ozenfant had explained Picasso's unusual practice: "Can . . . people not understand that Cubism and figurative painting are two different languages, and that a painter is free to choose either of them as he may judge it better suited to what he has to say?" Ozenfant recognized that Picasso's alternation of styles was simply a consequence of the conceptual nature of his art: "When he paints a picture, he knows what he wants to say and what kind of picture will in fact say it; his forms and colors are judiciously chosen to achieve the desired end, and he uses them like the words of a vocabulary."[31] Picasso's ability to choose styles to fit his ideas could not have differed more from Cézanne's lifelong quest to create a style that would allow him to achieve a single goal. Picasso's alternation of styles, like his many rapid changes of style over the course of his career, reflected the origin of his art in ideas that could be formulated and expressed quickly, whereas Cézanne's steadfast commitment to a single style, that could only

evolve gradually over time, was a product of the visual nature of his art, and the impossibility of fully achieving his elusive goal.

PLANNING, WORKING, AND STOPPING

> For any given artist, what does his work signify? A
> passion? A pleasure? A means, or an end? For some,
> it dominates life; for others, it is a part of it.
> According to their natures, some will pass easily from
> one work to another, tear up or sell, and go on to
> something quite different; others, on the contrary,
> become obsessed, involved in endless revision, cannot
> give up the game, turn their backs on their gains
> and losses: like gamblers, they keep doubling the
> stakes of patience and determination.
> *Paul Valéry, 1936*[32]

The distinction between experimental and conceptual artists can be sharpened by considering their procedures in making paintings. For this purpose, we can divide the process into three stages: planning—all the artist does before beginning a particular painting; working—all the artist does while in the process of putting paint on the canvas; and stopping—the decision to cease working.[33]

For experimental artists, planning a painting is unimportant. The subject selected might be simply a convenient object of study, and frequently the artist returns to work on a motif he has used in the past. Some experimental painters begin without a specific subject in mind, preferring instead to let the subject emerge as they work. Experimental painters rarely make elaborate preparatory sketches. Their most important decisions are made during the working stage. The artist typically alternates between applying paint and examining the emerging image; at each point, how he develops the image depends on his reaction to what he sees. Lacking a clear goal for the work, the artist is looking for things he finds interesting or attractive. If he finds them, he may continue working; if he does not, he may scrape off the image or paint over it. The decision to stop is also based on inspection and judgment of the work: the painter stops when he cannot see how to continue the work. Sometimes this is because he likes the painting and considers it finished, but often he remains dissatisfied, yet can not see how to improve the work. In either case, experimental painters are inclined to consider the decision to stop as provisional, and often return to work on paintings they earlier abandoned or considered finished, even after long intervals.

For the conceptual artist, planning is the most important stage. Before he begins working, the conceptual artist wants to have a clear vision either of the completed work or of the process that will produce it. Conceptual artists consequently often make detailed preparatory sketches or other plans for a painting. With the difficult decisions already made in the planning stage, working and stopping are straightforward. The artist executes the plan and stops when he has completed it.

The history of modern art contains a series of important artists who considered the essence of art to be in the planning stage, rendering the execution of the work perfunctory. Prominent examples come readily to mind. When visitors to his studio praised his great painting of the island of the Grande Jatte, Georges Seurat remarked to a friend, "They see poetry in what I have done. No, I apply my method and that is all there is to it."[34] In 1885 Paul Gauguin advised his friend Émile Schuffenecker, "Above all, don't sweat over a painting; a great sentiment can be rendered immediately."[35] In 1888 Vincent van Gogh wrote to his brother, "I am in the midst of a complicated calculation which results in a quick succession of canvases quickly executed but calculated long *beforehand*."[36] Marcel Duchamp explained that his artistic goal was "to get away from the physical aspect of painting."[37] Charles Sheeler recalled that in 1929 he began "a period that followed for a good many years of planning a picture very completely before starting to work on the final canvas, having a blueprint of it and knowing just exactly what it was going to be."[38] Ad Reinhardt wrote in 1953 that a technical rule for painting should be that "everything, where to begin and where to end, should be worked out in the mind beforehand."[39] Andy Warhol declared in 1963 that "the reason I'm painting this way is that I want to be a machine."[40] A few years later Sol LeWitt stated that in his art "all of the planning and decisions are made beforehand and the execution is a perfunctory affair."[41] Chuck Close explained that creating his images of faces from photographs is done methodically: "I have a system for how the head is going to fit into the rectangle. The head is going to be so big, it is going to come so close to the top edge, and it is going to be centered left to right."[42] Robert Smithson told an interviewer in 1969, "An object to me is the product of a thought."[43] Robert Mangold wrote in 1988, "I want to approach the final painting with a clear idea of what must happen."[44] Gerhard Richter wrote that when he painted, he "simply copied the photographs in paint and aimed for the greatest possible likeness to photography"; a consequence of this procedure was that "conscious thinking is eliminated."[45] Audrey Flack recalled the moment when she arrived at her practice of painting over projections of color slides: "It was late at night and I suddenly had the idea of projecting an image onto the canvas. . . . I owned no projector but was so excited by the idea that I called a friend who immediately re-

sponded to the urgency of my request. . . . This was the beginning. It opened up a new way of seeing and working."[46] Ed Ruscha was equally pleased to find his method: "It was an enormous freedom to be premeditated about my art. . . . I was more interested in the end result than I was in the means to an end."[47] Bridget Riley recently explained, "My goal was to make the image perfect, not mechanical . . . but perfect in the sense of being exactly as I intended it."[48]

Just as readily, we can find important modern artists who believed that the principal source of their achievement lay in events that occurred during the process of painting. Frustrated by the changing weather that slowed his progress on his paintings of Rouen Cathedral in 1893, Claude Monet wrote to his wife that "the essential thing is to avoid the urge to do it all too quickly, try, try again, and get it right."[49] Auguste Renoir explained that his paintings took time to develop: "At the start I see my subject in a sort of haze. I know perfectly well that what I shall see in it later is there all the time, but it only becomes apparent after a while."[50] Wassily Kandinsky wrote, "Every form I ever used constituted itself 'of its own accord,' " with a form frequently "constituting itself actually in the course of work, often to my own surprise."[51] In 1909 Paul Klee wrote in his diary that "in order to be successful, it is necessary never to work toward a conception of the picture completely thought out in advance. Instead, one must give oneself completely to the developing portion of the area to be painted."[52] When a young artist visited the New York studio of the aging Piet Mondrian and asked him whether he was not losing good pictures by continually revising the same canvases, Mondrian replied, "I don't want pictures, I just want to find things out."[53] Joan Miró told an interviewer in 1948, "Forms take reality for me as I work. In other words, rather than setting out to paint something, I begin painting and as I paint the picture begins to assert itself, or suggest itself under my brush."[54] Alberto Giacometti told a critic, "I don't know if I work in order to do something or in order to know why I can't do what I want to do."[55] Mark Rothko declared, "I think of my paintings as dramas. . . . Neither the action nor the actors can be anticipated."[56] Jackson Pollock explained in 1947, "I have no fears about making changes, destroying the image, etc., because the painting has a life of its own. I try to let it come through."[57] Hans Hofmann told an interviewer, "At the time of making a picture, I want not to know what I'm doing; a picture should be made with feelings, not with knowing."[58] William Baziotes wrote, "What happens on the canvas is unpredictable and surprising to me."[59] Robert Motherwell recorded his realization "that each brush stroke is a decision."[60] Howard Hodgkin told a critic, "My pictures really finish themselves."[61] Balthus wrote that "a painting's different stages betray the painter's endless trial and error as he tries to arrive at what he feels is the definitive, final, completed

state."[62] Pierre Alechinsky explained, "I apply myself to seeking out im-
ages that I do not know. . . . Indeed, it would be sad to know in advance
that which is to come, for the simple reason that it deprives one of the
sense of discovery."[63] Francis Bacon told an interviewer that "in my own
work the best things just happen—images that I hadn't anticipated."[64]
Pierre Soulages described the process of making a painting as "a kind of
dialogue between what I think is being born on the canvas, and what I
feel, and step by step, I advance and it transforms itself and develops."[65]
Richard Diebenkorn confessed, "I find that I can *never* conceive a painting
idea, put it on canvas, and accept it, not that I haven't often tried."[66]
Helen Frankenthaler recalled how she learned to compose her paintings:
"When one made a move toward the canvas surface, there was a dialectic
and the surface gave an answer back, and you gave it an answer back."[67]
Joan Mitchell facetiously placed her style within the context of 1960s art:
"Pop art, op art, flop art, and slop art. I fall into the last two categories."[68]
Susan Rothenberg said of her paintings that "the results are a way of
discovering what I know and what I don't."[69]

The contrast between the two types of artist is as great if we consider
differences in practice in the final stage of making a painting. Considering
the two archetypal cases discussed here, Cézanne rarely considered his
paintings finished. His friend and dealer Ambroise Vollard observed that
"when Cézanne laid a canvas aside, it was almost always with the inten-
tion of taking it up again, in the hope of bringing it to perfection."[70] One
consequence of this was that Cézanne rarely signed his works: fewer than
10 percent of the paintings in John Rewald's recent catalogue raisonné
are signed.[71] In contrast, Picasso always signed his works and often dated
them not only with the customary year but also the month and day—and
occasionally even the time of day—of their execution.[72] He told Françoise
Gilot, "I paint the way some people write their autobiography. The paint-
ings, finished or not, are the pages of my journal, and as such they are
valid. The future will choose the pages it prefers. It's not up to me to make
the choice."[73]

Innovation and Age: Old Masters and Young Geniuses

> When a situation requires a new way of looking at
> things, the acquisition of new techniques, or even new
> vocabularies, the old seem stereotyped and rigid. . . . But
> when a situation requires a store of past knowledge then
> the old find their advantage over the young.
> *Harvey Lehman, 1953*[74]

Picasso was a rare prodigy. Cézanne was not a prodigy,
his art was a hard-earned skill that took a lot of time.
David Hockney, 1997[75]

Recognizing the differences between the experimental and conceptual approaches provides the basis for systematic predictions concerning the relationship between age and artistic innovation. The long periods of trial and error often required for important experimental innovations means that they will tend to occur late in an artist's career. Because conceptual innovations are made more quickly, it might be thought that they should be equally likely to occur at any age. Yet the achievement of radical conceptual innovations depends on the ability to perceive and appreciate the value of extreme deviations from existing conventions and traditional methods, and this ability will tend to decline with experience, as habits of thought become more firmly established. The most important conceptual innovations should therefore tend to occur early in an artist's career. As noted earlier, some conceptual artists will make a series of unrelated contributions over the course of their careers, but this analysis predicts that the most important of these will generally be the earliest.

Cézanne did not even formulate the central problem of his career, of making Impressionism a more timeless and solid art, until he was in his midthirties. He then worked steadily at developing his solution to that problem—"searching for a technique"—for more than three decades and arrived at his most important contribution at the end of his life.[76] In contrast, Picasso conceived his most important idea while in his midtwenties, when he painted the *Demoiselles*, and he and Braque developed that idea into the several forms of Cubism, his most important contribution, within less than a decade. By 1914 Picasso had thus concluded "the most complete and radical artistic revolution since the Renaissance."[77] He was then just thirty-three, the same age at which Cézanne had traveled to Pontoise to learn from Pissarro the techniques of Impressionism, which became the starting point for the quest that would culminate in his greatest achievement more than thirty years later. Cézanne's slow production and elaboration of his creative ideas led to a very late peak in the quality of his work, whereas Picasso's rapid production and development of his new ideas led to a very early peak.

ARTISTS, SCHOLARS, AND ART SCHOLARS

I think an artist is seldom jealous of another man's
income. We are jealous of the quality of his work.
Walter Sickert, 1910[78]

> Invention in the arts and in thought is part of the
> invention of life, and . . . this invention is essentially a
> single process.
> *Brewster Ghiselin, 1952*[79]

> Today it is again apparent that the artist is an artisan,
> that he belongs to a distinct human grouping as
> *homo faber*, whose calling is to evoke a perpetual
> renewal of form in matter, and that scientists and
> artists are more like one another as artisans than
> they are like anyone else.
> *George Kubler, 1962*[80]

> Why do people think artists are special?
> It's just another job.
> *Andy Warhol, 1975*[81]

> Few people depend as much as artists and intellectuals
> do for their self-image upon the image others, and partic-
> ularly other writers and artists, have of them. "There
> are," writes Jean-Paul Sartre, "qualities that we acquire
> only through the judgments of others." This is especially
> so for the quality of a writer, artist, or scientist, which is
> so difficult to define because it exists only in, and
> through, co-optation, understood as the circular
> relations of reciprocal recognition among peers.
> *Pierre Bourdieu, 1993*[82]

> The more I've read of mathematicians and physicists,
> the more engrossed I've become. They really seem
> like artists to me.
> *David Hockney, 1988*[83]

The next important step in this presentation is to consider how the theo-
retical predictions made here can be tested empirically. Before doing this,
however, it is useful briefly to indicate how this analysis relates to some
earlier treatments in art history.

Perhaps the most generally acclaimed recent examination of the context
within which artists make paintings is Michael Baxandall's *Patterns of
Intention*. To understand how objects come to be made, Baxandall begins
the book with a description of the construction of a bridge in Scotland in
the nineteenth century. A company formed by four railroads decided
where they wished to have a bridge, then hired an engineer to design and

build it. Baxandall then uses this framework to consider the production of paintings, with the artist in the role of the engineer.

Curiously, Baxandall's first application of this framework is not, as might be expected, to a case in which a Renaissance prince or cardinal hired a painter to execute a commission, but rather to Picasso in 1910.[84] Since Picasso was not hired by Daniel-Henry Kahnweiler to paint his portrait, much less given a set of criteria for the work, Baxandall must begin by making a series of adjustments to his framework to apply it to this situation. My object here is not to argue with Baxandall's conclusions, nor is it to understand his motivation in proceeding in such a roundabout way. My point is simply that in approaching the issue of modern artists' motivations it would appear more pragmatic to begin with a model that is closer to the situation of the modern artist. And we do not have far to look for such a model, for there are strong parallels between the situation of the modern artist and that of the research scholar.

Like the scholar, the modern artist's goal is to innovate—to create new methods and results that change the work of other practitioners. Most often, this involves not only solving problems, but also formulating them. Most great modern art, like most great scholarship, is unlike the case of the bridge, in which someone hires an agent to solve a recognized problem. In most cases important scholarly and artistic innovations come from perceiving a previously unrecognized problem, or formulating a previously recognized problem in a novel way, before creating a solution to it. And since in both scholarship and art questions are usually more durable than answers, the principal contribution often lies more in the recognition and formulation of the problem than in the specific solution offered.

This parallel between artists and scholars is not novel, for it has been drawn by several art scholars. In a lecture first given in 1948 the historian Meyer Schapiro compared modern artists to scientists in their commitment to "endless invention and growth" in their respective disciplines.[85] And in his 1962 book, *The Shape of Time*, the historian George Kubler regretted our "inherited habit of separating art from science," for he observed that "the value of any rapprochement between the history of art and the history of science is to display the common traits of invention, change, and obsolescence that the material works of artists and scientists both share in time."[86] Yet these analyses of Schapiro and Kubler have been largely ignored by art historians, perhaps because they conflict with the romanticized view of the artist's enterprise that serves as the implicit foundation for much of art history.[87]

It is unfortunate that the parallel between artists and scholars has not been more widely recognized, for it might have served as a corrective to some of the less compelling analyses of artists' motivations, by social

scientists as well as humanists. We understand, for example, that in the first instance nearly all important scholarship is produced for an audience of other scholars. Scholars may do this out of pure intellectual curiosity, but even if their goals are more self-serving, they recognize that influence within their discipline will often help them achieve fame and fortune. Great artists appear to be no different. They may work from a variety of motives, but their first goal is generally to influence their fellow artists. They understand that if they are successful in this, public acclaim and lucrative sales will generally follow.[88]

The careers of successful scholars and artists also have a common structure. At the graduate level, most important scholars have worked with a teacher who is himself an important contributor to the discipline. The same is true for artists. Few important modern painters have been self-taught, for at a formative stage of their careers most have studied, formally or informally, with successful older artists, who not only provided them with technical instruction and advice, but also inspired and encouraged them. Similarly, just as at an early stage of their careers most successful scholars have studied and worked closely with other promising scholars of their own generation, virtually all successful modern artists have initially developed their art in the company of other talented young artists. In some celebrated cases, including those of the Impressionists and the Cubists, these relationships involved collaborating to solve a problem of common interest, but even when the artists' goals differed considerably, these alliances provided moral support as well as challenges to the young artists involved. Thus, for example, Robert Rauschenberg recalled that at a time when he and Jasper Johns were developing their art with little understanding or encouragement from the art world at large, the support they gave each other gave them "permission to do what we wanted."[89] The complexity of these early collaborations is suggested by Gerhard Richter's comments on his relationship with two fellow art students, Sigmar Polke and Konrad Lueg, in the early 1960s. At the time, in 1964, he wrote: "Contact with like-minded painters—a group means a great deal to me: nothing comes in isolation. We have worked out our ideas largely by talking them through. Shutting myself away in the country, for instance, would do nothing for me. One depends on one's surroundings. And so the exchange with other artists—and especially the collaboration with Lueg and Polke—matters a lot to me: it is part of the input that I need." Nearly thirty years later, when an interviewer asked him about his earlier collaboration with Polke and Lueg, Richter stressed a different aspect of it: "There were rare and exceptional moments when we were doing a thing together and forming a kind of impromptu community; the rest of the time we were competing with each other."[90] All these early collaborations probably contain elements of both cooperation and com-

petition, and both are probably critical to the early development of ambitious artists. The importance of these collaborations is sometimes overlooked, for they usually dissolve as artists age and their interests diverge, but it is important to notice how often the contributions even of apparently isolated artists are in fact the product of working out solutions to problems that were formulated earlier in groups.

The distinction I have drawn between the two types of artistic innovator is equally not a new one, for the difference in artists' approaches has been noted by several art scholars. In his survey of the history of modern art Alan Bowness observed that the difference between what he called realist and symbolist artists "may depend on certain basic temperamental differences among artists—on, for example, the degree to which the painter or sculptor can envisage the finished work of art before he starts to make it."[91] The critic David Sylvester made a similar observation in comparing two generations of American painters, as he noted that "some artists like to think that they are working in the dark, others that they are firmly in control"; whereas the Abstract Expressionists "subscribed to the idea that making art meant feeling one's way through unknown territory," the work of the leading artists of the 1960s was "carefully planned, tightly organized, precise in execution."[92]

Although both Bowness and Sylvester clearly recognized the distinction I have described here, neither pursued it, and, most important, neither appears to have perceived its most startling implication—the difference in the creative life cycles of the two groups of innovators. I have found only one case in which an art scholar does appear to have identified essentially this difference in life cycles. Roger Fry devoted his inaugural lecture as professor of fine art at Cambridge University in 1933 to outlining a more systematic approach to the study of art. In the course of this attempt, Fry observed that an artist's experiences must inform his work, and that "the mere length of time that an artist has lived has then inevitably an influence on the work of art." Fry then continued:

> When we look at the late works of Titian or Rembrandt we cannot help feeling the pressure of a massive and rich experience which leaks out, as it were, through the ostensible image presented to us, whatever it may be. There are artists, and perhaps Titian and Rembrandt are good examples, who seem to require a very long period of activity before this unconscious element finds its way completely through into the work of art. In other cases, particularly in artists whose gift lies in a lyrical direction, the exaltation and passion of youth transmits itself directly into everything they touch, and then sometimes, when this flame dies down, their work becomes relatively cold and uninspired.

After making this statement, Fry immediately acknowledged the casual nature of his comments, conceding apologetically, "I fear a great deal of this must appear to you to be rather wildly speculative and hazardous."[93] Although it is not known whether Fry intended to pursue this particular observation, his death the following year prevented any effort on his part to document the hypothesis, and although many decades have passed since Fry spoke, no art historian has taken up the challenge to do this. Yet today, seventy years later, I believe that my research provides a firm evidentiary basis for Fry's remarkable generalization.

CHAPTER TWO

measurement

QUANTIFYING ARTISTIC SUCCESS

The modern professional humanist is an academic
person who pretends to despise measurement because of
its "scientific" nature. He regards his mandate as the
explanation of human expressions in the language of
normal discourse. Yet to explain something and to
measure it are similar operations. Both are translations.
George Kubler, 1962[1]

There is no single direct and obvious way to measure the quality of an
artist's work over the course of his career. Instead, there is a variety of
indirect ways. Each is based on a different kind of evidence, and each of
these types of evidence was produced by a different group of judges. None
of these groups of people were engaged in the activity that is my concern,
of measuring individual artists' creative life cycles. Yet as will be seen,
each of the groups' actions has the effect of generating evidence that can
be used for just this purpose. The independence of the processes that gen-
erated the bodies of evidence means that comparison of the various results
can serve to test the robustness of any conclusions. If the results obtained
from the different measures agree, the degree of confidence in the collec-
tive results will obviously be greater than that associated with the results
obtained from any single measure.

PRICES

Each stylistic portion of an artist's total time span consti-
tutes a separate sum of artifacts, and this is recognized
by the art market in the values it places upon certain
"periods" of an artist's work in contrast to others.
Harold Rosenberg, 1983[2]

Each year, the outcomes of auctions of fine art held throughout the world
are collected by a publisher in Lausanne, Switzerland, and issued in bulky

volumes titled *Le Guide Mayer*. These volumes provide the evidence for my econometric analysis of the prices of paintings. My analysis is based on the proposition that variation in the sale prices of a particular painter's work, in all auctions held during the years 1970–97, can be systematically accounted for in part by the values of a set of associated variables for which evidence is given in *Le Guide Mayer*: specifically, these are the artist's age when a given work was executed, the work's support (paper or canvas), its size, and the date of its sale at auction.

The estimates obtained for the multiple regression equation for a given artist allow us to isolate the effect of an artist's age at the time a painting was produced on the sale price of the painting, separating this effect from the impact on that price of the work's support, size, and sale date. The estimates can therefore be used to trace out the relationship between age and price for an artist as illustrated in figures 2.1 and 2.2, which show the estimated age-price profiles for Cézanne and Picasso, respectively. Each of these figures represents the hypothetical auction values of a series of paintings of identical size, support, and sale date, done throughout the artist's career.[3]

The auction market clearly values Cézanne's late work most highly. Figure 2.1 shows that the estimated peak of his age-price profile is at age 67; a painting done in that year is worth approximately 15 times that of a work the same size he painted at age 26. In contrast, Picasso's age-price profile reaches a peak at age 26—in 1907, the year he painted *Les Demoiselles d'Avignon*. A painting he did in that year would be worth more than four times as much as one the same size he produced when he was 67.

Before proceeding to consider other measures and other artists, it is useful to consider the impact of a potential bias involved in using auction data to estimate the relative value of an artist's work over the life cycle. The issue in question involves famous artists, like Cézanne and Picasso, whose work is eagerly sought by museums. Although museums sometimes sell paintings, in general they are believed to be less likely to sell than are private collectors. How does the absence from the auction market of museum holdings of great artists' work bias estimates like those of figures 2.1 and 2.2?

This question has never been systematically examined, but evidence for Cézanne can be drawn from John Rewald's catalogue raisonné of his work, which includes information on the ownership of each painting at the time the book was published in 1996. Considering the oil paintings, the probability that a painting was owned by a museum was considerably greater for late than for early paintings.[4] This in itself does

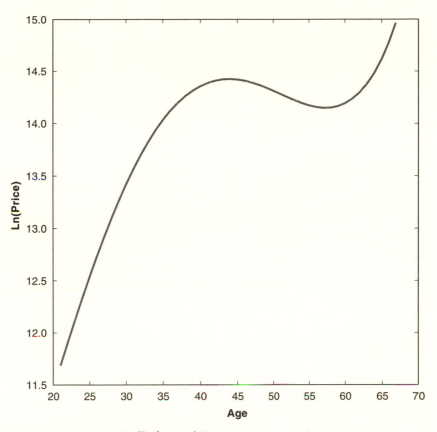

Figure 2.1 Age-Price Profile for Paul Cézanne

not bias the age-price profile of figure 2.1, but would merely tend to reduce the amount of auction evidence on the value of late paintings from which to estimate that relationship. Yet what can bias the profile of figure 2.1 is that museums do not tend to take paintings randomly from a given period of an artist's career, but rather pursue most avidly the best works. We do not have direct measures of quality for Cézanne's paintings, but the catalogue raisonné does contain evidence on their sizes. This serves as a proxy for quality, for larger paintings are typically considered more important than smaller ones.[5] Analysis of the evidence of the catalogue raisonné strongly confirms that the works by Cézanne owned by museums are on average considerably larger than those in private collections.[6]

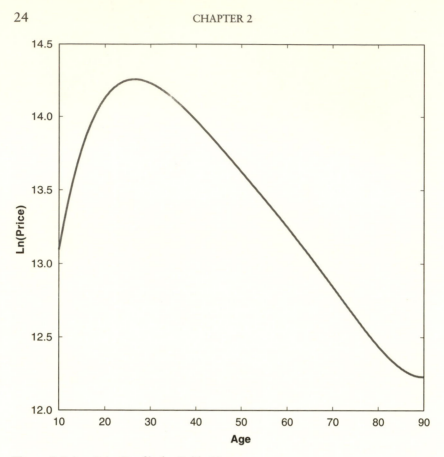

Figure 2.2 Age-Price Profile for Pablo Picasso

The catalogue raisonné therefore shows that it is not just late works by Cézanne that are disproportionately removed from the auction market, but that it is the best of the late works that are most disproportionately absent. If none of Cézanne's works were owned by museums, the average quality of his late paintings coming to auction would likely rise relative to the average quality of the early works sold, and the profile of figure 2.1 would consequently rise even more steeply with the artist's age than it does. Thus for Cézanne the impact of museum purchases is actually to reduce the estimated value of the works from the period the auction market considers his best—the late works—relative to the rest of his paintings. This reinforces the conclusion from figure 2.1 that his latest works are the most valuable.[7]

Textbook Illustrations

Quality in art can be neither ascertained nor proved
by logic or discourse. Experience alone rules in this
area. . . . Yet, quality in art is not just a matter of
private experience. There is a *consensus* of taste. The
best taste is that of the people who, in each genera-
tion, spend the most time and trouble on art, and this
best taste has always turned out to be unanimous,
within certain limits.
Clement Greenberg, 1961[8]

Few art historians or critics have been important art collectors, so al-
though the judgments of art historians may play an important indirect
role in determining the prices of paintings, through their influence on
collectors, the art market does not directly measure the opinions of art
scholars. This is not true, however, of textbooks, in which art scholars
systematically set down their views.

Published surveys of art history nearly always contain photographs that
reproduce the work of leading artists. These reproductions are chosen to
illustrate each artist's most important contribution or contributions. No
single book can be considered definitive, because no single scholar's judg-
ments can be assumed to be superior to those of his peers, but pooling
the evidence of the many available books can effectively provide a survey
of art scholars' opinions on what constitutes a given artist's best period.
The scores of authors and editors of textbooks of art history published in
recent decades include many distinguished academics, among them
George Heard Hamilton of Yale and Martin Kemp of Oxford, and such
prominent critics as Robert Hughes of *Time* and John Canaday of the
New York Times. But although the eminence of the authors varies, all the
authors are likely to be among those who, in Clement Greenberg's words,
"spend the most time and trouble on art," for they have made the consid-
erable effort to communicate their views on the history of art in a system-
atic way. And for the modern period, the number of textbooks available
is sufficiently large that no important result will be significantly influenced
by the opinions of any single author or any one book.

Tabulating illustrations in textbooks is obviously analogous to a cita-
tion study, in which the relative importance of scholarly publications is
judged by the number of citations they receive. Yet using illustrations as
the unit of analysis has considerable advantages over citation counts, for
illustrations are substantially more costly than written references. In addi-
tion to the greater space taken up by the illustration and the greater cost

TABLE 2.1
Illustrations by Age, Cézanne and Picasso, from Books Published in English

Age	Cézanne		Picasso	
	n	%	n	%
10–19	0	0	3	1
20–29	3	2	127	38
30–39	21	16	85	25
40–49	30	22	64	19
50–59	33	24	46	14
60–69	49	36	5	2
70–79	—	—	3	1
80–89	—	—	0	0
90–92	—	—	0	0
Total	136	100	333	100
Age with most illustrations	67		26	

Source: Tabulated from books listed in Galenson, "Quantifying Artistic Success," 17n1.

of printing, authors must obtain and pay for copyright permission to reproduce each painting, and must buy or rent a suitable photograph. This substantial cost in time and money implies that authors will be more selective in their use of illustrations, and that these may consequently give a more accurate indication than written references of what an author considers genuinely important.

Table 2.1 demonstrates the use of this evidence for Cézanne and Picasso. It presents the distribution of all the illustrations of their work, tabulated by the artist's age at the date of the work's execution, contained in 33 textbooks published in English since 1968. The contrast in the two distributions is striking. Whereas Cézanne's illustrations rise steadily with age, with more than a third of his total representing works done in just the last eight years of his life, nearly two-fifths of Picasso's illustrations are of works he painted in his 20s, with a sharp drop thereafter. And for both artists the single year represented by the largest number of illustrations is precisely the same as the year estimated to be that of the artist's peak in value—age 67 for Cézanne, and 26 for Picasso.

Table 2.2 presents the comparable evidence for the same artists obtained from a survey of 31 textbooks published in French since 1963. The

TABLE 2.2
Illustrations by Age, Cézanne and Picasso, from Books Published in French

	Cézanne		Picasso	
	n	%	n	%
10–19	0	0	0	0
20–29	7	6	77	38
30–39	15	13	44	22
40–49	29	25	27	13
50–59	30	26	34	17
60–69	34	30	8	4
70–79	—	—	7	3
80–89	—	—	5	2
90–92	—	—	0	0
Total	115	100	203	100
Age with most illustrations	67		26	

Source: Tabulated from books listed in Galenson, "Measuring Masters and Master-pieces," pp. 83–85, appendix.

results are almost identical to those of table 2.1. French scholars clearly agree that Cézanne's final decade was his greatest, and that Picasso was at his peak during his 20s. They equally consider Cézanne's best single year to have been at age 67, and Picasso's 26.

EXAMPLES: TEN IMPORTANT MODERN PAINTERS

I have never had either a first or a second or a third or
a fourth manner; I have always done what I wanted
to do, standing loftily apart from the gossip and
legends created about me by envious and interested
people. . . . If you think of all my exhibitions from
1918 until today you will see continual progress,
a regular and persistent march towards those summits
of mastery which were achieved by a few consum-
mate artists of the past.
Giorgio de Chirico, 1962[9]

TABLE 2.3
Peak Ages, Ten Early Modern Artists

Artist	Age at Peak Value	Age at Peak Illustrations	
		American texts	French texts
Experimental			
Camille Pissarro (1830–1903)	45	43	47
Edgar Degas (1834–1917)	46	42	43
Wassily Kandinsky (1866–1944)	52	47	—
Georgia O'Keeffe (1887–1986)	48	39	—
Jean Dubuffet (1901–1985)	46	53	46, 59, 83
Conceptual			
Edvard Munch (1863–1944)	34	30	—
André Derain (1880–1954)	24	25, 26	26
Georges Braque (1882–1963)	28	29	31
Juan Gris (1887–1927)	28	28	25
Giorgio de Chirico (1888–1978)	26	26	—

Sources: Age at peak value: Galenson, *Painting outside the Lines*, tables 2.1, 2.2. For artists who do not appear in those tables, prices were estimated as described there.

Age at peak illustrations: Galenson, "Quantifying Artistic Success," table 5; Galenson, "Measuring Masters and Masterpieces," table 5; Galenson, "The New York School vs. the School of Paris: p. 146; Galenson, "Toward Abstraction"; Galenson, "Before Abstract Expressionism."

Note: The entry given is the artist's age in the single year from which the textbooks reproduce the largest number of the artist's paintings.

The use of the two measures of artists' life cycles just described can be illustrated more generally with some additional examples. Evidence for the two measures for ten important modern painters is given in table 2.3.

The evidence of both prices and illustrations places Camille Pissarro's best period in his mid-40s. Pissarro was one of the core group of landscape painters—together with Monet, Renoir, and Sisley—who pioneered the development of Impressionism. The greatest achievements of this group are widely recognized as having come in the 1870s, when Pissarro was in his mid-40s. During that decade the impact of the group's discoveries was so great that nearly all of Paris's advanced artists, including painters as disparate as Manet, Cézanne, Gauguin, and van Gogh, were lured into experiments with their methods. Impressionism was quintessentially a visual innovation, aimed at capturing "fugitive impressions of nature," and both Pissarro's goals and his methods identify him as experimental.[10] His art was visual, and he needed attractive views. Looking for a new home

in 1883, he complained of the ugliness of one town: "Can a painter live here? I should have constantly to go off on trips. Imagine! No! I require a spot that has beauty!"[11] Pissarro struggled with finishing his paintings, as, for example, in 1895 he wrote to his son that he had nearly completed a series of large paintings but confessed, "I am letting them lie around the studio until I find, at some moment, the final sensation that will give life to the whole. Alas! while I have not found this last moment I can't do anything further with them."[12]

Both types of evidence in table 2.3 similarly place Edgar Degas's best period in his mid-40s. Degas often expressed his belief in repetition, saying, "One must redo ten times, a hundred times the same subject," because of his perennial dissatisfaction with his achievements.[13] His dealer Ambroise Vollard observed that "the public accused him of repeating himself. But his passion for perfection was responsible for his continual research."[14] A friend, the poet Paul Valéry, wrote, "I am convinced that [Degas] felt a work could never be called *finished*, and that he could not conceive how an artist could look at one of his pictures after a time and not feel the need to retouch it."[15] Degas's studies of ballet dancers are an example of a large body of work in which his experimental innovations in the representation of space emerged gradually, so although the series is famous as a whole, it lacks any one or two particularly famous landmark works. As Degas's friend, the critic George Moore, observed, "He has done so many dancers and so often repeated himself that it is difficult to specify any particular one."[16]

The quantitative measures of table 2.3 place Wassily Kandinsky's best work around the age of 50, during the late 1910s, when he was pioneering an abstract art. In spite of Kandinsky's writings on metaphysics, the inspiration for his art was visual, and his development of it experimental. He himself described the visual origins of his recognition of the potentialities of nonrepresentational painting, recalling an evening in 1910 when he returned to his studio around dusk and was startled to see "an indescribably beautiful picture, pervaded by an inner glow." On approaching the mysterious painting he discovered that it was one he had done earlier, standing on its side. This experience prompted him to set out on a search for forms that could be expressive even though unrelated to real objects. As he emphasized, however, he did not achieve this goal quickly, for "only after many years of patient toil and strenuous thought, numerous painstaking attempts, and my constantly developing ability to conceive of pictorial forms in purely abstract terms, engrossing myself more and more in these measureless depths, did I arrive at the pictorial forms I use today, on which I am working today and which, as I hope and desire, will themselves develop much further."[17] In considering the three great pioneers of abstract art, John Golding contrasted the progression of the experimental artists

Kandinsky and Mondrian with that of the conceptual Malevich: "It might be fair to say that Malevich's abstraction sprang, Athena-like, ready formed from the brow of its creator; this distinguishes Malevich's approach very sharply from that of both Mondrian and Kandinsky, who had sensed and inched their way into abstraction over a period of many years."[18]

The difference of nine years between the two measures of Georgia O'Keeffe's best work in table 2.3, while not extreme, is indicative of the absence of specific breakthrough years that resulted from her experimental approach. From the beginning of her career O'Keeffe often painted particular subjects in series. She explained, "I work on an idea for a long time. It's like getting acquainted with a person, and I don't get acquainted easily."[19] The series generally involved a progression: "Sometimes I start in very realistic fashion, and as I go from one painting to another of the same thing, it becomes simplified till it can be nothing but abstract."[20] But her persistence was nonetheless a product of dissatisfaction. Over a period of 15 years, she painted a door of her house in New Mexico more than 20 times. She explained, "I never quite get it. It's a curse—the way I feel I must continually go on with that door."[21] Her experimental attitude toward art led her to distrust the idea of the individual masterpiece: "Success doesn't come with painting one picture. It results from taking a certain definite line of action and staying with it." Not surprisingly, this led her to believe that artists must mature slowly: "Great artists don't just happen. . . . They have to be trained, and in the hard school of experience."[22]

The quantitative measures of table 2.3 for Jean Dubuffet agree only that he did his best work after the age of 45. Dubuffet's art was visual, as his goal was to draw on a variety of types of art by the self-taught or untrained to break with traditional concepts of artistic beauty and create an art that represented the viewpoint of the common man. He devoted considerable effort to devising new technical procedures to achieve this, including the use of accidental effects. During the 1950s, for example, he produced works he called assemblages by cutting up and reassembling painted surfaces. He explained that this technique, "so rich in unexpected effects, and with the possibilities it offers . . . of making numerous experiments, seemed to me an incomparable laboratory and an efficacious means of invention."[23] Describing him in the late 1950s, a critic observed that "the level of [Dubuffet's] work to date was uncommonly even," and this assessment can clearly be extended much further. There are no individual celebrated master works or pronounced peaks in Dubuffet's remarkably long career, but instead an outpouring of a large body of work that evolved over time but that was nonetheless unified by a distinctive philosophy and approach.[24]

Turning to the conceptual artists in table 2.3 shifts our attention to a different type of career, in which artists' major contributions appear precipitously, and generally at an earlier age. The quantitative measures for Edvard Munch both point to a peak period early in his 30s, during which he was systematically using insights he had gained from the work of Gauguin and other Symbolists during a recent trip to Paris, to express his own states of mind. Munch's most famous single work, and one of the most celebrated paintings of the late nineteenth century, was developed from a series of sketchbook drawings, and then was worked out in pastel, before being painted in oils. That painting, *The Scream*, uses distortions of perspective and of shapes to create a visual image of extreme anxiety. As Munch recorded the experience that inspired the painting, it occurred as he walked one day at sunset: "Suddenly the sky became a bloody red. . . . I stood there, trembling with fright. And I felt a loud, unending scream piercing nature."[25] Both Munch's goal of expressing emotions and his routine use of preparatory studies mark him clearly as a conceptual innovator. Although he lived past the age of 80, he never again produced work as powerful, or influential, as that of his youth.

The auction market and the textbooks, both English and French, agree that André Derain produced his most important work in his mid-20s. This was done during a short span of time, 1904–6, when Derain joined Matisse, Vlaminck, and several other young artists in the invention and practice of Fauvism. The movement extended Symbolism, which had developed during the late nineteenth century, to a logical extreme through the use of bright, exaggerated color, flattened images, and visible brushwork. Recognizing the conceptual basis of the art, Derain later admitted, "We painted with theories, ideas."[26] Fauvism was among the most short-lived of major movements in modern art, as Derain and his friends largely abandoned it within little more than three years. Derain thereafter began to work in a derivative Cubist style before painting for many decades in a more conservative manner that led him to be "displaced from the center of the progressive effort." Historian George Heard Hamilton concludes that "the tragedy of André Derain, if such it was, lay in the discrepancy between his early promise and his later ambitions"; this may be an epitaph not only for Derain, but for a number of conceptual innovators who have become prominent by making a dramatic early contribution but have been unable to follow it with comparable later innovations.[27]

Georges Braque was a minor member of the Fauve movement, but the measures of table 2.3 show that his greatest work came a few years later, when he was in his late 20s. This was of course when he joined Picasso in developing Cubism, as from 1909 until Braque joined the French army in 1914 the two worked together "like two mountaineers roped together."[28] As noted earlier, Cubism was a conceptual innovation in which

the artists expressed their full knowledge of objects, without being bound by the constraint of painting what they could see of an object from a single location. Thus Braque ridiculed the single viewpoint of Renaissance perspective, saying, "It is as if someone spent his life drawing profiles and believed that man was one-eyed."[29] Although he was wounded in World War I, Braque painted for many years afterward, but he never again worked with Picasso. His later work is more highly regarded than that of Derain, but it produced no further major innovations, as up to the age of 80 and beyond Braque continued to work within a Cubist style that he had largely worked out by the age of 30.

Picasso admitted one other young painter, Juan Gris, into his and Braque's inner circle of Cubism in 1911. Gris contributed to the development of the later, Synthetic phase of Cubism, and all the evidence of table 2.3 places his best work during his late 20s, in the short span of time just after he began working with Picasso and Braque. The critic Guillaume Apollinaire called Gris a "demon of logic" for his effort to make Cubism a more systematic and rigorous form. Instead of beginning with fragments of objects and building compositions, like Picasso and Braque, in Gris's "deductive method" abstract compositions were plotted out in advance, with shapes and positions often calculated mathematically or constructed with a compass, and objects were then fitted into this framework.[30] Historian Christopher Green observed that Gris's planning for his paintings was followed by "an immaculacy of oil technique that masked utterly the trace of process," while John Golding described Gris's *papier collés* as having a look of "tailor-made precision," equally a consequence of Gris's meticulous preparation.[31] Gris's goals also revealed his conceptual attitude, as in 1919 he wrote to his dealer and friend Daniel-Henry Kahnweiler, "I hope to be able to express an imagined reality with great precision using the pure elements of the mind."[32] Although Gris died prematurely, at the age of just 40, his most innovative work was already more than a decade in the past.

Giorgio de Chirico arrived in Paris in 1911, at the age of 23, and during the next six years produced a series of strikingly original paintings in which he sought to present imagined scenes that would give art the clarity "of the dream and of the child mind." He called these works metaphysical, and the poet André Breton, the founder and leader of the Surrealist movement, considered them the most important twentieth-century inspiration for Surrealist painting.[33] After serving in the Italian army in World War I, de Chirico remained in Italy and changed his style dramatically under the influence of his study of the work of a number of old masters. Historian James Thrall Soby observed that de Chirico's adoption of a neoclassical, academic style led abruptly to his "collapse . . . as an original, creative artist."[34] The change also led to a falling-out with the Surreal-

ists. Breton continued to praise de Chirico's early work but denounced the paintings he did after World War I. The Surrealists tried to induce de Chirico to return to his earlier style, but he resisted; Soby argues that his inspiration had disappeared, as "the hallucinatory intensity of his early art was spent."[35] De Chirico's curious reaction against the Surrealists' continued attacks on him led him not only vehemently to denounce modern art, but to produce numerous exact copies of the great early paintings that had established his reputation. By falsely dating these copies, de Chirico became a forger of his own early work. Whether motivated by spite or financial gain, de Chirico was never able to convince the art world of the superiority of his late over his early work. Although he continued to paint until his death at 90, as the measures of table 2.3 suggest, de Chirico's reputation rests almost entirely on the paintings he produced in his mid-20s, which influenced almost every important Surrealist painter.

This brief examination of the careers of ten important modern artists serves to illustrate the value of measuring systematically, and in several ways, the timing of artists' major contributions. Although many more artists could be considered, these cases demonstrate that the auction market and textbook treatments tend to agree quite closely on when painters produced their best work. Table 2.3 also shows how sharply the careers of experimental artists can differ from those of conceptual innovators, as for the artists included all the measures indicate that the experimental painters produced their best work beyond the age of 40, whereas the conceptual artists had generally reached their peaks by the age of 30.

Retrospective Exhibitions

"Jasper Johns: A Retrospective" is the most significant
survey of this artist's work ever organized, a full and
clear mapping of his four decades of exploration, traced
in paintings, drawings, prints, and sculptures.
Geoffrey C. Bible, 1996[36]

Unlike textbook illustrations, which are most often chosen to represent the author's judgment of an artist's most important work, systematic critical evaluations of the relative quality of artists' work over the course of their entire careers are implicit in the composition of retrospective exhibitions. Museum curators who organize retrospective exhibitions tacitly reveal their judgments of the importance of an artist's work at different ages through their decisions on how many paintings to include from each phase of the artist's career. The distribution by age at execution of an artist's works that are included in these exhibitions can consequently

TABLE 2.4
Distribution by Artist's Age of Paintings Included in Retrospective Exhibitions,
Cézanne and Picasso

	Cézanne		Picasso	
	n	%	*n*	%
10–19	0	0	25	3
20–29	13	6	212	28
30–39	42	18	134	18
40–49	61	27	78	10
50–59	56	24	149	20
60–69	57	25	64	9
70–79	—	—	56	7
80–89	—	—	35	5
90–92	—	—	3	0
Total	229	100	756	100
Age with most illustrations	67		26	

Source: Cachin, Cahn, Feilchenfeldt, Loyrette, and Rishel, *Cézanne*; Rubin, *Pablo Picasso*.

serve as a third quantitative measure of the quality of work over the course of artists' careers.

Retrospectives are often organized by a single curator, and it might consequently be objected that their composition is an unreliable guide to an artist's career because it is subject to idiosyncratic preferences or simply ignorance. Yet organizers of major retrospectives normally work with many other art historians, both within and outside their own institutions. The composition of a retrospective therefore typically represents the collective judgment of a group of scholars. In general, it also appears that the larger the museum arranging the retrospective, the greater the number of scholars who work to assemble and analyze it. Retrospectives presented by major museums may consequently be least subject to this criticism. Important artists are usually given retrospectives by wealthy museums, so for the painters considered here retrospectives can generally be assumed to represent careful and considered reviews of their careers.

Table 2.4 presents the age distributions of the works included in the most recent full retrospective exhibitions for Cézanne and Picasso. These closely resemble the age distributions of textbook illustrations of the two

artists' work shown in tables 2.1 and 2.2. For both artists the retrospectives' age distributions are slightly less skewed toward the peak ages; this is to be expected, since one obvious purpose of these exhibitions is to illustrate the artist's work at all stages of his career. But it is nonetheless clear that the Cézanne respective gave its greatest emphasis to his final decades, and that the Picasso exhibition gave the greatest weight to his early years. The single years most heavily represented in the retrospectives—age 67 for Cézanne, and age 26 for Picasso—were precisely the same as the estimated ages at peak value for both artists, and were therefore also the same ages most heavily represented in both the American and French textbooks.

Retrospectives may less often be useful for earlier modern artists than for more recent artists. The paintings of earlier great modern artists, like Cézanne and Picasso, have become so valuable, and are in many cases so important in attracting visitors to museums' permanent collections, that full retrospective exhibitions of their work are rarely held. Thus although parts of these artists' careers are frequently featured in special exhibitions, comprehensive retrospectives are rarely mounted. The Cézanne exhibition used for table 2.4 was held in 1996, but it was the first full survey of his work since 1936, and the Picasso retrospective used for table 2.4 was held more than 20 years ago, in 1980. This is less true, however, for important artists of the more recent past. Thus, for example, just within the past 10 years comprehensive retrospectives have been held for such important artists of the post–World War II era as Jasper Johns, Willem de Kooning, Roy Lichtenstein, Jackson Pollock, Robert Rauschenberg, and Mark Rothko. Retrospective exhibitions can consequently be a particularly valuable source for studying the careers of recent modern artists.

EXAMPLES: TEN IMPORTANT AMERICAN PAINTERS

We believe that we can find the end, and that a painting
can be finished. The Abstract Expressionists always felt
the painting's being finished was very problematical.
We'd more readily say that our paintings were finished
and say, well, it's either a failure or it's not, instead of
saying, well, maybe it's not really finished.
Frank Stella, 1966[37]

The effect of adding the evidence of retrospective exhibitions to the two measures used earlier can be demonstrated by considering the careers of ten prominent members of the two generations of American painters who dominated modern art after World War II. The first of these generations

TABLE 2.5
Peak Ages, Ten American Painters

Artist	Age at Peak Value	Age at Peak Textbook Illustrations	Peak Age for Works in Retrospective
Experimental			
Mark Rothko (1903–70)	54	54	46
Arshile Gorky (1904–48)	41	40	43
Willem de Kooning (1904–97)	43	48	45
Barnett Newman (1905–70)	40	46	44
Jackson Pollock (1912–56)	38	38	36
Conceptual			
Roy Lichtenstein (1923–97)	35	40	39
Robert Rauschenberg (1925–)	31	34	35
Andy Warhol (1928–87)	33	34	34
Jasper Johns (1930–)	27	25	28, 29, 32
Frank Stella (1936–)	24	23	25

Sources: Age at peak value: Galenson, Painting outside the Lines, table 2.2.

Age at peak textbook illustrations: Galenson, "Was Jackson Pollock the Greatest Modern American Painter?" table 5.

Age at peak number of works in retrospective: tabulated from retrospective catalogues listed in Galenson, Painting outside the Lines, table B.1.

was dominated by experimental innovators, and the second by conceptual innovators.

The first five artists listed in table 2.5 are the leading members of the Abstract Expressionists. This was a group united not by a style, but by a desire to draw on the subconscious to create images, and all the members of the group used an experimental approach. The absence of preconceived outcomes was a celebrated feature of Abstract Expressionism. Jackson Pollock's signature drip method of applying paint, with the inevitable puddling and spattering that could not be completely controlled by the artist, became the trademark symbol of this lack of preconception, reinforced by his statement, "When I am in my painting, I'm not aware of what I'm doing."[38] Mark Rothko wrote that his paintings surprised him: "Ideas and plans that existed in the mind at the start were simply the doorway through which one left the world in which they occur."[39] Barnett Newman expressed the same idea less dramatically: "I am an intuitive painter. . . . I have never worked from sketches, never planned a painting,

never 'thought out' a painting before."[40] Arshile Gorky's widow recalled that he "did not always know what he intended and was as surprised as a stranger at what the drawing became. . . . It seemed to suggest itself to him constantly."[41] Willem de Kooning told a critic, "I find sometimes a terrific picture . . . but I couldn't set out to do that, you know."[42]

The Abstract Expressionists developed their art by a process of trial and error. In 1945 Rothko wrote to Newman that his recent work had been exhilarating but difficult: "Unfortunately one can't think these things out with finality, but must endure a series of stumblings toward a clearer issue."[43] This description applied equally to the production of individual paintings. Elaine de Kooning recalled that her husband repeatedly painted over his canvases: "So many absolutely terrific paintings simply vanished because he changed them and painted them away."[44] Newman declared, "My work is something that has happened to me as much as something that has happened to the surface of the canvas."[45] An assistant who worked for Rothko in the 1950s remembered how he "would sit and look for long periods, sometimes for hours, sometimes for days, considering the next color, considering expanding an area"; a biographer observed that the extent of these periods of study was such that "since the late 1940s Rothko, building up his canvases with thin glazes of quickly applied paint, had spent more time considering his evolving works than he had in the physical act of producing them."[46] Like the other Abstract Expressionists, Rothko believed that progress came slowly, in small increments. He made his trademark image of stacked rectangles the basis for hundreds of paintings over the course of two decades, declaring, "If a thing is worth doing once, it is worth doing over and over again—exploring it, probing it."[47]

The Abstract Expressionists wanted to create new visual representations of their emotions and states of mind. Rothko declared his aim of "finding a pictorial equivalent for man's new knowledge and consciousness of his more complex inner self."[48] Pollock told an interviewer, "The unconscious is a very important side of modern art. . . . The modern artist, it seems to me, is working and expressing an inner world."[49] Their aspirations for what their work might accomplish were considerable. Newman believed that his work's rejection of aesthetic systems made it an "assertion of freedom"; when a critic challenged him to explain what one of his paintings could mean to the world, he replied that "if he and others could read it properly it would mean the end of all state capitalism and totalitarianism."[50]

With enormously ambitious but extremely vague goals, the Abstract Expressionists were continually uncertain not only whether their paintings were successful, but even whether individual works were finished. Newman declared simply, "I think the idea of a 'finished' picture is a

fiction."[51] De Kooning recalled that he considered his series of paintings of *Women*—now generally considered his most important achievement—a failure, but that had not fazed him: "In the end I failed. But that didn't bother me. . . . I didn't work on it with the idea of perfection, but to see how far one could go—but not with the idea of really doing it."[52] Pollock's widow, Lee Krasner, recalled that during the early 1950s, even after he had been recognized as a leader of the Abstract Expressionists, one day "in front of a very good painting . . . he asked me, 'Is this a painting?' Not is this a good painting, or a bad one, but a *painting*! The degree of doubt was unbelievable at times."[53]

The Abstract Expressionists came to dominate American art during the 1950s, and many younger artists directly followed their methods and goals. Yet some aspiring artists found the art and attitudes of the Abstract Expressionists oppressive. Reacting against what they considered the excessive and pretentious emotional and philosophical claims of Abstract Expressionism, these younger artists created a variety of new forms of art. Although these new approaches did not belong to any single movement or style, they shared a desire to replace the complexity of Abstract Expressionist gestures and symbols with simpler images and ideas. In the process, during the late 1950s and the '60s, they succeeded in replacing the experimental methods of the Abstract Expressionists with a conceptual approach.

These younger artists planned their work carefully in advance. Frank Stella explained that "the painting never changes once I've started to work on it. I work things out beforehand in the sketches."[54] Roy Lichtenstein prepared for his paintings by making drawings from original cartoons, then projecting the drawings onto canvas and tracing these projected images to create the outlines for the figures in his paintings. Although Lichtenstein's cartoon paintings were very different from Stella's geometric patterns, in 1969 Lichtenstein specifically compared the central concern of his work to Stella's: "I think that is what's interesting people these days: that before you start painting the painting, you know exactly what it's going to look like."[55] Andy Warhol's goal was to make his images so clear and simple that he did not have to participate in executing his paintings: "I think somebody should be able to do all my paintings for me."[56]

All these artists wanted the images in their work to be clear and straightforward. Stella emphasized that "all I want anyone to get out of my paintings . . . is the fact that you can see the whole idea without any confusion."[57] Jasper Johns explained that he chose to paint flags, targets, maps, and numerals because "they seemed to me preformed, conventional, depersonalized, factual, exterior elements."[58] Some of the artists produced their paintings, or had them produced, mechanically. Warhol

used silk screens manufactured by commercial printers from photographs he selected from magazines or newspapers because "hand painting would take much too long and anyway that's not the age we're living in. Mechanical means are today."[59] Lichtenstein mimicked mechanical production: "I want my painting to look as if it had been programmed. I want to hide the record of my hand." He stressed the contrast with his predecessors: "Abstract Expressionism was very human looking. My work is the opposite."[60]

These younger artists emphatically rejected the emotional and psychological symbolism that the Abstract Expressionists had considered central to their art. Stella told an interviewer: "I always get into arguments with people who want to retain the old values in painting—the humanistic values they always find on the canvas. If you pin them down, they always end up asserting that there is something there besides the paint on the canvas. My painting is based on the fact that only what can be seen there *is* there."[61] Similarly, when asked if he was antiexperimental, Lichtenstein replied, "I think so, and anti-contemplative, anti-nuance, anti-movement-and-light, anti-mystery, anti-paint-quality, anti-Zen, and anti all those brilliant ideas of preceding movements which everyone understands so thoroughly."[62]

A generation dominated by experimental artists was thus followed by one dominated by conceptual artists. Many implications of this shift have been discussed by art critics and historians, yet art scholars have not given systematic attention to the consequences of the shift for artists' life cycles. The three measures introduced earlier are presented in table 2.5 for the leading members of each of the two generations.[63]

A comparison of the three measures shows that they agree quite closely on when each individual artist produced his best work. The age at which an artist did his work of peak auction value never differs by more than eight years from either the age of most textbook illustrations or the age most heavily represented in the artist's retrospective exhibition, and for eight of the ten artists this difference is five years or less.

Table 2.5 also shows that the generational shift from experimental to conceptual innovators was accompanied by a sharp drop in the ages at which artists produced their best work. All three measures agree that Pollock's best period was in his late 30s, and that the other Abstract Expressionists' peaks all came after the age of 40. In contrast, of the next generation the three measures place Lichtenstein's peak in his late 30s, and those of the other four artists from their mid-20s to their early 30s. Thus the dramatic change in philosophy that occurred when Abstract Expressionism was replaced by Pop art was accompanied by a dramatic shift in the careers of the leading members of the two groups.

MUSEUM COLLECTIONS

> Artists of genius are few in number. . . . [T]he museum
> collection aspires to show a chronological sequence of
> the work of such artists, carrying forward an argument
> which forms the material of any history of modern art.
> *Alan Bowness, 1989*[64]

The decisions of museums, even apart from their assembly of retrospective exhibitions, provide another source of information on artists' major contributions. Museums wish to present the best work of the most important artists, and they consequently reveal their judgments of what this best work is in a number of ways. One is through their decisions on what to display. Most museums have the space to exhibit only a small fraction of all the paintings they own. Curators' decisions regarding which paintings to display therefore indicate what they consider the most important among the works available to them. These selections are of course constrained by the contents of the museums' collections. But the greatest museums, with the largest and best collections of the work of major artists, will be the least constrained in this way. The paintings these museums choose to hang will consequently tend to be good indications of their curators' judgments about when artists produced their best work.

A related source of information on curators' judgments is even more readily accessible. Nearly all major museums now publish illustrated books presenting their collections to the public. These books vary in size but often serve as highly selective surveys to what the museums judge to be their best works. An example of how these books can be used is afforded by *An Invitation to See*, the revised edition of which was published in 1992 by New York's Museum of Modern Art, and which contains photographs and brief discussions of 150 works selected from the museum's collection.[65] For the same 20 artists included in tables 2.3 and 2.5, tables 2.6 and 2.7 present the ages of the artists when they executed those of their works included in *Invitation to See*.

In table 2.6, the median age of Degas, Kandinsky, O'Keeffe, and Dubuffet—the four experimental artists from table 2.3 included in *Invitation to See*—when they executed the eight paintings reproduced in the book was 48 years, whereas the median age of the conceptual innovators Derain, Braque, Gris, and de Chirico when they produced the six of their paintings treated in the book was just 29.5 years. Table 2.7 shows that the six paintings of the Abstract Expressionists reproduced in *Invitation to See* were made by the artists at a median age of 44.5, whereas the six reproduced works by the five conceptual painters of the next generation were

TABLE 2.6
Ages at Which Artists Included in Table 2.3 Executed Paintings
Reproduced in *An Invitation to See*

Artist	Age at Execution of MoMA Paintings	Age at Peak Value
Experimental		
Pissarro	—	45
Degas	48	46
Kandinsky	48, 48, 48, 48	52
O'Keeffe	42	48
Dubuffet	50, 60	46
Conceptual		
Munch	—	34
Derain	27	24
Braque	30, 31, 55	28
Gris	27	28
de Chirico	29	26

Sources: Age at execution of MoMA paintings: Franc, *Invitation to See.*
Age at peak value: see table 2.3.

made at a median age of just 30.5. In addition, *Invitation to See* includes three paintings by Cézanne, executed at a median age of 59, and seven paintings by Picasso, done at a median age of 33. Analysis of the Museum of Modern Art's own selection of works from its collection therefore demonstrates that the museum's curators strongly agree that the experimental artists considered here produced their most important work considerably later in their careers than did the conceptual innovators.

The Museum of Modern Art is known for the great strength of its collection of American paintings of the post–World War II era.[66] In view of this, it is striking to note how closely the museum's selection of works by the artists in table 2.7 agrees with the auction market. Of the 12 paintings illustrated in *Invitation to See* by these ten American artists, none was made more than seven years from the respective artist's estimated age at peak value, 10 of the 12 were made within five years of that age, and fully half were made within just two years of the age at peak value.

Interestingly, in a very different context an official of the Museum of Modern Art recently explained precisely why the museum's decisions about what to acquire and exhibit so closely track the key times in artists' careers. When he was asked in 2003 why the museum has shown little

TABLE 2.7
Ages at Which Artists Included in Table 2.5 Executed Paintings
Reproduced in *An Invitation to See*

Artist	Age at Execution of MoMA Paintings	Age at Peak Value
Experimental		
Rothko	55	54
Gorky	43	41
de Kooning	48	43
Newman	46	40
Pollock	31, 38	38
Conceptual		
Lichtenstein	40	35
Rauschenberg	30	31
Warhol	34	33
Johns	25, 31	27
Stella	29	24

Sources: Age at execution of MoMA paintings: Franc, *Invitation to See.*
Age at peak value: see table 2.5.

interest in the recent work of Frank Stella, who is now in his 60s, John Elderfield, the museum's chief curator of the Department of Painting and Sculpture, told a reporter for the *New York Times*, "The moment in Frank's career which is of particular interest to MOMA is what happened in the 60's, because that was the moment when he entered and transformed painting." Elderfield then gave a general explanation that is clearly consistent with the position taken in this book: "MOMA is a museum interested in telling the story of successive innovations rather than a museum interested in the longevity of individual careers."[67]

MUSEUM EXHIBITION

This sounds like tall talk, but you can take nearly any
picture or sculpture in this exhibition and if it were
in another show with other works like it, it would
be considered one of the best.
*Peter Marzio, director of the Houston Museum of
Fine Arts, on "The Heroic Century"*[68]

An unusual opportunity to observe the judgments of art experts as to the most important works in the Museum of Modern Art's collection was a product of the recent closing of the museum's Manhattan building for renovations. With the museum temporarily relocated to much less spacious quarters in Queens, Houston's Museum of Fine Arts seized the opportunity to exhibit a selection from the Museum of Modern Art's permanent collection that had been placed in storage. Titled "The Heroic Century," the exhibition ran in Houston from September 2003 to January 2004. Given what a news account described as "nearly carte blanche access" to the permanent collection of the Museum of Modern Art, a Houston curator expressed his excitement: "A show like this . . . is once in a lifetime." The director of the Houston museum declared the show to be the most important with which he had been involved in a career of more than 35 years. Interestingly, he added, "This may be the most expensive show ever organized in terms of value."[69]

The selection of the paintings in the exhibition was done jointly by the staffs of the two museums. Thus the chief curator of the Museum of Modern Art emphasized that a "large percentage" of the 200 works presented in the show will be placed on permanent display when the museum returns to its Manhattan building.[70]

"The Heroic Century" included three paintings by Cézanne, executed at a median age of 60, and 11 paintings by Picasso, done at a median age of 32. The exhibition also included works by seven of the ten artists considered above in table 2.3, and by all ten of the artists listed in table 2.5. Tables 2.8 and 2.9 present the distributions of these paintings by the artists' ages when they were made.

The median age at which the two experimental artists in table 2.8 made the paintings exhibited was 48, whereas the comparable median age for the five conceptual artists was just 26. In table 2.9, the median age at which the experimental artists made the paintings exhibited was 44, compared with 32 for the conceptual artists. None of the 16 paintings listed in table 2.8 was made more than six years from the respective artist's estimated age at peak value, and none of the 21 works listed in table 2.9 was made more than seven years from the respective artist's age at peak value.

"The Heroic Century" was justifiably described as "a 'greatest hits' compilation of modern art."[71] This careful selection of outstanding paintings from one of the world's greatest collections of modern art clearly reveals the judgment of art experts that experimental painters produce their greatest work considerably later in their careers than their conceptual counterparts. It also demonstrates that their judgment in this matter is virtually the same as that of the collectors who buy modern art at auction.

TABLE 2.8
Ages at Which Artists Included in Table 2.3 Executed Paintings
Exhibited in "The Heroic Century"

Artist	Age at Execution of Exhibited Paintings	Age at Peak Value
Experimental		
Kandinsky	48, 48, 48, 48	52
O'Keeffe	42	48
Conceptual		
Munch	30	34
Derain	26	24
Braque	25, 26, 30, 31	28
Gris	25	28
de Chirico	26, 26, 26, 27	26

Sources: Age at execution of exhibited paintings: Elderfield, Visions of Modern Art. Age at peak value: see table 2.3.

MEASURING CAREERS

There is, it seems, a graph of creativity which can
be plotted through an artist's career.
Alan Bowness, 1989[72]

Systematic measurement of the quality of artists' work over the course of their careers is a recent development, so it is perhaps not surprising that art historians are not widely aware of how, and how well, it can be done. It is clear, however, that art historians had not anticipated that such measurements were possible, and unfortunately, it is also clear that many continued to deny the possibility of these measurements even after they had begun to appear. Thus for example as recently as 1998, a curator at New York's Museum of Modern Art declared that an artist's success "is completely unquantifiable."[73] This chapter's survey of methods of measurement and its illustrations of their use demonstrate decisively that this curator was wrong, and that artistic success can be measured, not only with evidence drawn from the auction market and from textbooks of art history, but even from decisions made by curators, including those of his own museum. The consistency of the evidence from this remarkably wide range of sources on the hypothesis examined here constitutes powerful evidence not only that conceptual artists arrive at their major contribu-

TABLE 2.9
Ages at Which Artists Included in Table 2.5 Executed Paintings
Exhibited in "The Heroic Century"

Artist	Age at Execution of Exhibited Paintings	Age at Peak Value
Experimental		
Rothko	47, 58	54
Gorky	43	41
de Kooning	44, 48	43
Newman	44, 44, 45	40
Pollock	32, 36, 39	38
Conceptual		
Lichtenstein	38, 40	35
Rauschenberg	27, 36	31
Warhol	33, 34	33
Johns	25, 27, 31	27
Stella	23	24

Sources: Age at execution of exhibited paintings: Elderfield, *Visions of Modern Art*.
Age at peak value: see table 2.5.

tions at younger ages than their experimental counterparts, but also that, as Clement Greenberg asserted, there is a strong consensus among those in the art world on what is important in art.

The variety of methods by which artists' careers can be quantified is valuable, as noted previously, for checking and reinforcing the validity of any single measurement. It is also valuable, however, for cases in which some sources of evidence are unavailable for an artist of interest. Marcel Duchamp produced very few works of art during his career, and only nine of his paintings came to auction during 1970–97, a number much too small to support meaningful statistical analysis. Yet Duchamp's work plays an important role in the development of modern art, and consequently has been examined intensively by textbooks and museums. The timing of his principal innovation emerges clearly from these sources. The surveys of both the American and French textbooks described earlier identify 1912, when Duchamp was 25 years old, as the most important year of his career, represented by the most illustrations.[74] *An Invitation to See* reproduces two works by Duchamp, executed in 1912 and 1918, when Duchamp was 25 and 31 years old, respectively. Since Duchamp lived past the age of 80, this concentration on his early work strongly suggests

that his principal innovation was conceptual. The text of an *Invitation to See* immediately confirms this. The first sentence of the book's discussion of *The Passage from Virgin to Bride* (1912) reads: "While still in his twenties, Duchamp determined to get away from the physical aspect of painting in order to create ideas rather than mere 'visual products.' " To emphasize that Duchamp's goal was a conceptual one conceived at an early age, the first sentence of the same book's discussion of his *To Be Looked at (From the Other Side of the Glass) with One Eye, Close To, for Almost an Hour* (1918) again made this point: "While still in his twenties, Duchamp determined to get away from the physicality of painting and 'put painting once again at the service of the mind' by creating works that would appeal to the intellect rather than to the retina."[75] These sources thus leave little doubt that art scholars judge Duchamp to have been a conceptual young genius rather than an experimental old master.

CHAPTER THREE

extensions

The theory presented here has a variety of implications that can add significantly to our understanding of the history of modern art, and a number of these will be considered later, in chapter 4. Before proceeding to those applications, however, it is useful to examine three important questions that arise in the course of using the theory to explain artists' careers. One of these involves the level of simplification used by the theory, and how the two categories I have described in fact stand for a continuous range of variation in practice. The second concerns whether artists can change categories during their careers. And the third considers whether some important cases that appear anomalous are in fact contradictions of the theory. Discussing these three questions can clarify the use of the theory and avoid some possible misconceptions about its predictions.

THE SPECTRUM OF APPROACHES

> If the artist carries through his idea and makes it into
> visible form, then all the steps in the process are of
> importance. . . . All intervening steps—scribbles,
> sketches, drawings, failed works, models, studies,
> thoughts, conversations—are of interest. Those that
> show the thought process of the artist are some-
> times more interesting than the final product.
> *Sol LeWitt, 1967*[1]

To this point, the distinction between conceptual and experimental approaches has been treated as binary. Yet as in virtually all scientific analysis, the true distinction between these concepts is not qualitative but quantitative. This does not mean the binary distinction is not valid or useful; as the preceding empirical measurements have illustrated, the distinction is valuable in understanding artists' careers. The usefulness of the distinction is analogous to the value of the distinction made by economists between theorists and empiricists. Although we recognize that much, if not most, research is based on both theory and evidence, the balance between the two is normally very unequal, and it is rarely difficult to identify in which area any particular work makes its real contribution.

Economists often speak informally of highbrow and lowbrow theorists, to refer to differences in the degree of abstraction the scholar typically uses. In similar fashion, we can ask not only how to distinguish conceptual from experimental artists, but how to understand systematic differences in the practices of artists within both groups. Doing this may help us to gain a better understanding of artists' life cycles, and it is likely to give us a deeper appreciation for the problems modern artists have confronted, and how they have solved them.

For present purposes, I propose to distinguish between two types of practitioner—extreme and moderate—within both the conceptual and experimental approaches. One dimension along which many artists can be arrayed with some confidence is the degree to which they make decisions about a work of art before as opposed to during the execution of the final work. This is the dimension I will consider here.

Taking first conceptual artists, it might seem that extreme practitioners are most readily described and identified: they are artists who make all the decisions for a work before beginning it. It is unclear, however, if this practice is literally possible. There are artists who came close to it, and perhaps achieved it, during the 1960s, by making plans for their work and having these plans executed by others. The artists often did this not simply by describing a desired image, but by specifying the process by which the work was to be made. Yet even in these cases the artists often supervised the execution, and in most cases retained the right of approval of the final work—thus continuing to make decisions, or at least retaining the option of making decisions, after the planning stage. Andy Warhol approached the extreme of complete preconception in the silk-screened paintings based on photographs that he began to do with his assistant Gerard Malanga in 1963. Warhol would begin by selecting a photograph from a magazine or newspaper. He then sent this to a silk-screen manufacturer with instructions about the size of the screens and the number of colors he wished to use. The printers would deliver the screens to Warhol's studio, which he appropriately called the Factory.[2] An assistant would then press a variety of inks through these screens to create the image on canvas. Warhol sometimes helped; Gerard Malanga explained, "When the screens were very large, we worked together; otherwise, I was pretty much left to my devices." Warhol's intent was apparently to accept all the paintings produced in this way. Thus Malanga recalled: "Each painting took about four minutes, and we worked as mechanically as we could, trying to get each image right, but we never got it right. By becoming machines we made the most imperfect works. Andy embraced his mistakes. We never rejected anything. Andy would say, 'It's part of the art.' "[3] Malanga's account suggests that no decisions were made by Warhol after the initial selection of the photographs and paints, though his use of the

first-person plural might raise the question of whether Warhol also auto-matically accepted works made by Malanga working in Warhol's absence.

Another approach to the extreme of complete preconception was de-scribed in Sol LeWitt's rules of 1971 for the execution of his wall draw-ings. LeWitt stipulated that the artist planned the drawing, which was then realized, and interpreted, by a draftsman. LeWitt recognized that "the draftsman may make errors in following the plan. All wall drawings contain errors, they are part of the work." Yet LeWitt left open the ques-tion of whether the artist was to play any role after the planning stage when he declared, "The wall drawing is the artist's art, as long as the plan is not violated."[4] Since LeWitt did not explain who would determine whether the plan was violated, or according to what criteria, his qualifi-cation left the possibility of a role for the artist after the planning stage.

Leaving aside these relatively minor questions about the practices of Warhol and LeWitt, it is clear that they should be classified as extreme conceptual artists. Yet for most of the modern era, having a painting exe-cuted entirely by someone other than the artist was not an option. Any artist making a painting obviously makes innumerable decisions in the process, as to what materials to use, where and when to work, and so on. Yet the real issue here does not concern these routine procedural deci-sions, but rather the major decisions that have the greatest impact on the appearance of the finished work. In this regard it is possible to define an extreme conceptual painter as one who makes extensive preparations in order to arrive at a precisely formulated desired image before beginning the execution of the final work.

Clear examples of modern artists who created these precise preparatory images can be cited. Georges Seurat's preparations for his early master-piece, *Sunday Afternoon on the Island of the Grande Jatte*, involved mak-ing more than 50 studies, including drawings, painted wood panels, and canvases.[5] The painting was considerably more complicated than his ear-lier major work, *Une Baignade à Asnières*: "The greater complexity of the subject he planned to offset by completer documentation."[6] Seurat's preparations led to a painting approximately one-tenth the size of the final work that has been titled "Definitive Study for 'La Grande Jatte.' "[7] By the time he executed the final canvas, he therefore knew precisely what he wanted to do:

> Standing on his ladder, he patiently covered his canvas with those tiny multi-colored strokes. . . . At his task, Seurat always concen-trated on a single section of the canvas, having previously determined each stroke and color to be applied. Thus he was able to paint stead-ily without having to step back from the canvas in order to judge the effect obtained. . . . His extreme mental concentration also enabled

him to keep on working late into the night, despite the treacherous character of artificial lighting. But the type of light in which he painted was unimportant, since his purpose was completely formulated before he took his brush and carefully ordered palette in hand.[8]

Henri Matisse's preparations for *Luxe, calme, et volupté*, the large Divisionist painting he produced in 1905, occupied the entire preceding winter. He not only made a series of drawings and smaller oil paintings, but at the end of these studies he drew a full-scale cartoon, or charcoal drawing on paper, of the work. He then had his wife and daughter transfer this drawing to canvas using the traditional technique of pouncing.[9] The use of this mechanical procedure clearly points to Matisse's wish to begin his painting from an unaltered replica of his final preparatory drawing.

The extensive preparations for these two major paintings, involving a large number of studies made over a considerable period of time, culminated in both cases in elaborate preparatory works that appear to signal that each artist had succeeded in making all the major decisions for his painting before he began to work on the final canvas. This identifies Seurat and Matisse as extreme conceptual painters.

To identify the opposite end of the spectrum being examined here, we can consider extreme experimental artists. Their description appears equally straightforward: these should be artists who make no decisions for a painting before beginning to create what will become the final work. This extreme is of course not literally possible. The artist must obviously make some preparations for a painting, by buying materials, having a place to work, and the like. But as previously we can put aside these routine problems and consider only those decisions that significantly affect the specific appearance of the finished work.

We can readily find examples of modern artists whose goal it was to begin their works entirely without conscious preconception. A number of Surrealist painters began their paintings with what they called automatic drawing. André Masson, for example, would begin a work by allowing his brush to move freely over the canvas. "Only after the drawing was well under way did Masson permit himself to 'step back' to consider the results."[10] The shapes he saw on the canvas would then suggest forms to him, and he would develop these into a finished image. Under the influence of the Surrealists, a number of the Abstract Expressionists also adopted automatism as a device to begin their paintings. The most celebrated of these was Jackson Pollock. He explained in 1948 that he would tack an unstretched length of canvas on the floor, then begin to work by dripping paint on it from all four sides: "It is only after a sort of 'get acquainted' period that I see what I have been about."[11] Like Masson, Pollock would then examine the pattern on the canvas and work toward

developing this into a coherent composition. Pollock's avoidance of pre-conception was such that often it was not until he was in the final stages of working that he would decide how large the final painting would be, and how it would be oriented.[12]

Identifying the extremes of both approaches is thus relatively easy; the more difficult problem is to separate the moderate conceptual from the moderate experimental artists. Artists in both of these groups make some preparatory studies for their paintings, but these are not as extensive as the meticulous preparations of the extreme conceptual artists. Where do we then draw the line between conceptual and experimental?

One resolution of this problem could be to consider other dimensions of the artists' work, including whether their goals are visual or ideational. This is obviously something we should do before making definite assignments of artists for whom there is any uncertainty regarding whether they preconceive their works. Yet it is worth working a bit more on the latter dimension before proceeding to other criteria. The test I would propose for separating moderate practitioners of the two types is whether their preliminary works suggest that they have in fact made the major decisions about the appearance of the images in their paintings before beginning to execute them.

Examples are obviously necessary to clarify this criterion. In 1860, Edouard Manet made a preparatory drawing for a painting of his parents that he squared up for transfer to the canvas. The drawing's exact resemblance to the finished work and the squaring-up together indicate that Manet had precisely preconceived the double portrait.[13] On these grounds, we might identify Manet as a conceptual painter. Yet this painting dates from a period before Manet had made a major contribution, and he did not often make similar full compositional studies in later years. During 1862–63, however, Manet made a small number of drawings of reclining nudes that several scholars believe to have been explicitly related to his celebrated *Olympia* of 1863. Theodore Reff discusses four such drawings and concludes that "none corresponds to the painting, whereas the final study, executed in watercolor over a swift pencil sketch, is virtually identical."[14] Reff's judgment is consistent with the observation of Manet's friend, the critic Théodore Duret, that "in his early years, his favorite method was to use watercolor for the preliminary studies for his pictures, in order to establish the proper color-scheme and composition."[15] The combination of a limited body of preparatory works with a single small study that closely resembles the finished painting, which itself ranks as one of his major achievements, situates Manet as a moderate conceptual innovator in this scheme.

Claude Monet serves as an example of a moderate experimental artist. In his study of Monet's technique, John House observed that Monet did

make sketches and drawings to record possible compositions for his paint-
ings, but argued that "they were not preparatory studies for individual
paintings, but rather preliminary notations of possible viewpoints, a sort
of repertory of potential subjects, which Monet might use in deciding
which motifs to paint and how to frame a particular scene." The use of
the sketches to identify a motif before beginning the final work means
that Monet was not an extreme experimental artist: unlike Masson and
Pollock, he had a clear idea from the outset of what his subject was to
be. Once Monet had selected a motif, however, the drawings played no
additional role in the production of the final work: "Once he fixed on the
viewpoint for a painting, the drawings would have no further use." House
describes precisely why Monet's practice identifies him as an experimental
artist according to the definition used here: "His search for a promising
subject completed, whether with or without the assistance of drawings,
the moment of precise formulation came when Monet first confronted his
bare canvas. The essential forms of a picture were generally established
in the early stages of its execution, in an initial mapping out which often
included elements of considerable complexity."[16] Thus the specific formu-
lation of the images in Monet's paintings was not determined before he
began a painting, but during its execution.

Monet's goals often required him to make significant changes in his
paintings during the working stage. House observed that "the execution
of the canvas was not one continuous progression from the discovery of
an interesting effect to its final pictorial realization. Difficulties might arise
at any stage, and the variety of things that might go wrong helps to high-
light the particular points in Monet's working process where decisions
had to be taken." Monet's working method also evolved over time: "The
frequency and extent of the pentimenti to be found in his paintings in-
crease during the 1880s and 1890s—a further indication of the growing
complexity of his methods during these years."[17]

Many of the changes in Monet's paintings were caused by his insistence
on "painting directly in front of nature," as his scenes might change more
quickly than he could capture them. This was sometimes caused by
human agency, as when boats were moved on the beach at Etretat in
stormy weather, but it was often due to natural causes: "Water levels may
be raised or lowered; the state of wind or waves may change; snow may
be added or erased; the angle or quality of lighting may be transformed;
and the seasons themselves may be altered."[18] Evidence of Monet's will-
ingness to change his paintings in the course of their execution has been
provided by recent X-ray examination of some of his works. So, for exam-
ple, in *On the Seine at Bennecourt*, executed in 1868, X-rays show that
the figure of a child was painted out of an earlier version and replaced by
a dog. Similarly, X-ray analysis of his *Bathers at La Grenouillère* (1869)

revealed a number of revisions in the composition made during its execu-
tion and led a group of scholars from England's National Gallery to de-
scribe its production as "impulsive and experimental."[19] The evidence of
these changes testifies to the sincerity of Monet's advice that "one ought
. . . never be afraid . . . of doing over the work with which one is not
satisfied, even if it means ruining it."[20]

Much more work remains to be done, in studying the practices of many
more painters, before the scheme proposed here can be considered fully
developed. Yet these examples suggest that it may be useful to consider
the experimental-conceptual distinction not simply as a binary categoriza-
tion, but rather as a quantitative difference. In this view there is a contin-
uum, with extreme practitioners of either type at the far ends, and moder-
ate practitioners of the two categories arrayed along the intermediate
positions of the scale. The greatest difficulties in categorizing painters will
obviously arise among the moderates of both groups, who may appear to
be quite similar in their practices. Yet close examination may often allow
them to be separated and classed clearly as experimental or conceptual,
according to whether, in Reff's terms, any single preparatory work is "vir-
tually identical" to the finished work, or whether, in House's language,
the "essential forms" of their pictures were established only during their
execution.

The need for careful study of artists' methods in making these distinc-
tions is occasioned by the fact that subtle differences in practices can be
associated with major differences in artistic goals. At the start of his career
as a painter, Paul Gauguin studied informally with Camille Pissarro. A
recent monograph argued that Gauguin's temperament would not have
attracted him to the direct approach of Monet, Renoir, or Sisley, but
would have led him to prefer Pissarro's "careful preparation of the com-
position of a painting."[21] Consistent with this position, a recent analysis
of Pissarro's method produced the conclusion that among the leading Im-
pressionists, Pissarro was apparently "least comfortable with the direct
rendering and informal compositions that characterized Impressionism in
the early 1870s."[22] Neither Pissarro nor Gauguin can be placed at either of
the extreme positions on the spectrum described here. Yet the significant
question is whether both should be placed at the same intermediate posi-
tion: Did they share a moderate experimental or moderate conceptual
approach? In fact, the answer appears to be that they did not; a difference
appears between the practices of teacher and student that places them at
different positions within the middle range of the spectrum considered
here, on opposite sides of the divide between experimental and concep-
tual. In 1886, Gauguin began to square up preparatory figure drawings
for transfer to the canvas, and thereafter, during the years in which he

produced his most important work, he regularly followed this process in preparing to paint the major figures in his paintings.[23] In contrast, although Pissarro accumulated scores of drawings of individual figures that he could place in his paintings as he desired, he rarely if ever transferred these drawings to the canvas by a mechanical process like squaring-up. Thus the authors of a study of Pissarro's drawings concluded that they were rarely made for any specific projected painting, and that his preparatory process was "as experimental as the manner of painting itself."[24] Gauguin's desire to preconceive central elements in his paintings, and Pissarro's avoidance of doing so, appear symptomatic of the substantial difference that arose in their artistic goals and caused a rift between the two friends. Thus Gauguin emerged as a leading Symbolist painter in the late 1880s, having arrived at the belief that artists should not copy nature too closely, since "art is an abstraction."[25] In contrast, Pissarro remained steadfastly committed to the visual goal of "capturing the so random and so admirable effects of nature."[26] The contrast in their goals confirms the categorization, initially based on consideration of their preparation for their paintings, of Pissarro as a moderate experimental painter, and Gauguin as a moderate conceptual one.

An interesting issue related to the placement of artists on the experimental-conceptual spectrum concerns possible differences between their desired and actual practices. A variety of constraints, including existing technology as well as artists' abilities, may prevent artists from achieving the degree of preconception of their work that they would like. An apparent example has been revealed by recent research. Thomas Eakins was a quintessential extreme conceptual artist. He planned his paintings meticulously, regularly making preparatory drawings of individual figures, elaborate perspective studies, and eventually full compositional studies for his paintings, which he then transferred to canvas through the use of a grid. Eakins was so committed to achieving representational accuracy that when possible he would borrow from boatbuilders the plans they had used to build the boats he painted.[27] A great deal of attention has recently been given to the discovery by two conservators that Eakins began a number of paintings by projecting photographic images onto his canvases, which he then traced to establish the contours for figures and objects.[28] Much less attention has been devoted to another finding of the conservators, however. In examining Eakins's paintings, they found an element for which his procedures contrasted sharply with the careful preconception of his compositions. Thus they observed that Eakins "often followed an indirect course of successive approximations toward a harmonious arrangement and ordering of color." Color frustrated Eakins, for it posed complicated problems that he could not solve to his satisfaction in advance. Early in his career he complained of his inability to use color with-

out the need to "change & bother, paint in & out." Color presented problems that were extremely complicated: "There is the sun & gay colors & a hundred things you never see in a studio light & ever so many botherations that no one out of the trade could ever guess at." Lacking a satisfactory way of determining color relationships before he began a painting, Eakins followed a systematic process in which he applied layers of paint, working incrementally from brighter to darker colors in the course of executing a painting. Eakins clearly considered this working by stages to be the lesser of two evils. Thus he was appalled at Delacroix's attempts "to seek the tones throughout his painting at the same time"; he found the results "abominable" and attributed this to the fact that Delacroix worked intuitively, and thus "didn't have any process" to find the proper color relationships.[29]

Eakins's response to the problem of color is intriguing and suggestive. It demonstrates that even extreme conceptual artists may be unable to plan their works as completely as they would like. Eakins's solution was to design a process that advanced systematically, and thus minimized the impact of any single decision that had to be made during the process of execution. This example appears to open up a wider research agenda, of examining how other conceptual artists have coped with obstacles that prevented them from preconceiving their works as thoroughly as they would have liked.

More work remains to be done before the continuum described here can be used with confidence. A key question in determining the value of this work will involve the implications of the analysis for understanding artists' life cycles. As demonstrated earlier, there is very strong evidence that artists' creativity over the life cycle is systematically related to their approach, when the approach is simply measured qualitatively, as conceptual or experimental. Will the finer categorization discussed in this section add even greater explanatory power to the study of life cycles? There is currently not sufficient evidence to begin to answer this question. One conjecture might be made, however. Specifically, it might be hypothesized that extreme conceptual artists will tend to achieve their major contributions earlier in their careers than any other type of innovator. The basis of this hypothesis is that in many cases these artists' innovations may often be both the most radical and the least complex. The former effect is a product of lack of experience, and consequent freedom from restrictions on extreme departures due to fixed habits of thought, while the latter means that the innovations can often be realized with only minimal requirements for acquired skills. But until more research is done to classify many more artists with precision, this must be considered no more than an untested conjecture.

CAN ARTISTS CHANGE?

Seurat has something new to contribute. . . . I am person-
ally convinced of the progressive character of his art and
certain that in time it will yield extraordinary results.
Camille Pissarro, 1886[30]

Seurat, who did indeed have talent and instinct, . . .
destroyed his spontaneity with his cold and dull theory.
Camille Pissarro, 1895[31]

As is the case for practitioners of other intellectual disciplines, it appears
that the typical pattern is for artists to find the approach that best suits
them in the course of arriving at their mature style. The approach they
settle on may not be the one in which they were originally trained. Thus
throughout the modern era, many artists who have studied in academies
have been taught to make careful preparatory studies for their paintings,
but after leaving their schools have discovered that they preferred to work
without fully preconceived images. So, for example, John Rewald ob-
served of Cézanne that "he hardly ever did preliminary sketches, since his
canvases are not the product of a long, abstract reflection but the result
of direct observation which did not allow such preparations."[32] This of
course applies to the mature artist. Cézanne in fact made four sketches, a
watercolor, and two compositional studies for *The Abduction* of 1867,
two preparatory drawings for his *Portrait of Achille Emperaire* of 1870,
and at least six preparatory drawings and a compositional study for *The
Feast* of 1872.[33] Yet these paintings were made before Cézanne traveled
to Pontoise later in 1872, where under Pissarro's guidance he began to
paint directly from nature and ceased to make preparatory drawings for
his paintings. This practice suited him, and he followed it with very few
exceptions thereafter.

Some artists have also changed in the opposite direction in the course
of arriving at their mature styles. So, for example, Paul Signac worked
under the influence of Impressionism early in his career. It was only after
he met Georges Seurat that he quickly discovered that he preferred a con-
ceptual approach and began to plan his paintings carefully in advance,
the practice he followed for the rest of his life.[34]

But artists' changes in practice in the course of arriving at their mature
styles, whenever that occurs, are not at issue here. The significant question
about the possibility of changes in approach is whether artists can make
mature, important contributions in both experimental and conceptual ap-
proaches at different stages of their careers.

This question has never been posed directly before, so no systematic research has been aimed specifically at producing evidence that bears on it. Surveying many available detailed analyses of the careers of individual artists suggests that there have been few who have consciously attempted to change their approach after arriving at a mature style. Yet some artists' careers do show indications that they may have made a genuine change over time from one approach to the other, and in at least one well-documented case an important artist specifically tried and failed to change approaches. A few examples can be considered here.

Edouard Manet was classified in the preceding section as a moderate conceptual artist, on the basis of the preparatory studies he did for paintings of the 1860s, including his famous *Olympia* of 1863. This was evidently not an uncommon practice for Manet around this time.[35] Yet as is well known, Manet's art changed considerably during the 1870s; one element of this was that "from 1870 on, Manet seldom felt the need to elaborate a preliminary composition in drawing form."[36] Nonetheless, there are specific drawings from the 1870s that are "reproduced practically unchanged in design and detail, in the medium of oils."[37] Yet X-ray analysis of Manet's last great work, *A Bar at the Folies-Bergère*, completed in 1882, reveals that he twice shifted the position of the reflection of the barmaid who is the painting's central subject. These changes made in the course of executing the painting appear to be a prime source of the visual contradiction between the placement of the barmaid and the mirrored reflection of her encounter with a customer that has made the painting the subject of a vast amount of scholarly inquiry and debate. Thus an oil study Manet had made in preparation for the painting, which appears to have served as his point of departure for the final version, presents much less exaggerated distortions from a realistic portrayal of the scene.[38] It is possible that the important modifications Manet made in the course of working on his final masterpiece serve as evidence that during the 1870s he had in fact evolved from his early moderate conceptual approach to a moderate experimental one, as in this time his "solution to composition became increasingly bound to the act of seeing or experiencing a motif or a scene directly."[39]

Together with his friends Claude Monet, Auguste Renoir, and Alfred Sisley, Camille Pissarro was a member of the core group of Impressionists who developed new ways of portraying nature and influenced virtually every advanced artist in Paris during the 1870s. Like his friends, however, Pissarro suffered acutely from the uncertainty that is typical of experimental artists, and during the early 1880s he appears to have become increasingly dissatisfied with his art. Thus in 1883 he confessed to his son Lucien, "I am much disturbed by my unpolished and rough execution; I should

like to develop a smoother technique."[40] In 1885 Pissarro, then 55 years old, met Georges Seurat, who was just 26. Pissarro was quickly converted to Seurat's conceptual ideas and techniques, and began to use them himself. During the next few years, Pissarro's attempts to follow Seurat apparently involved not only using smaller brushstrokes and pure contrasting colors that were intended to achieve more luminous effects, but also greater planning of his paintings. Thus a number of his landscape drawings from this period appear to have served as compositional studies for paintings.[41] In a letter of 1886 to his dealer Paul Durand-Ruel, Pissarro explained that the Neo-Impressionist art developed by Seurat was based on planning and preconception: "As far as execution is concerned, we regard it as of little importance: art, as we see it, does not reside in the execution: originality depends only on the character of the drawing and the vision peculiar to each artist."[42]

Pissarro's decision to join the Neo-Impressionists was a brave departure. Although his work had not yet gained great commercial success, he was an established figure in Paris's advanced art world, and his defection from Impressionism to join the much younger Neo-Impressionists came at considerable personal costs in broken friendships with Monet and others, as well as warnings from Durand-Ruel that his abrupt change in style would slow the growth of demand for his work. That he persisted in spite of these costs attests to the sincerity of Pissarro's rhetoric in expressing his conviction that the conceptual approach of Neo-Impressionism represented a real advance over the unsystematic, experimental approach of Impressionism. In spite of the strength of his commitment, however, Pissarro soon found the conceptual approach of Neo-Impressionism unduly confining. In 1888 he wrote to Lucien of his frustration with Seurat's small touches of pure color: "How can one combine the purity and simplicity of the dot with the fullness, liberty, spontaneity and freshness of sensation postulated by an impressionist art?"[43] Similarly, the next year he complained to the critic Felix Fénéon of his problems with a "technique which ties me down and prevents me from producing with spontaneity of sensation."[44] In 1891, when he reported to Lucien his sadness at Seurat's premature death, Pissarro wrote, "I believe you are right, pointillism is finished."[45] Several years later, with his customary honesty Pissarro wrote to a friend and former fellow Neo-Impressionist to explain his decision to give up the method:

> I believe that it is my duty to write you frankly and tell you how I now regard the attempt I made to be a systematic divisionist, following our friend Seurat. Having tried this theory for four years and having now abandoned it, not without painful and obstinate struggles to regain what I had lost and not to lose what I had learned,

I can no longer consider myself one of the neo-impressionists who abandon movement and life for a diametrically opposed aesthetic which, perhaps, is the right thing for the man with the right temperament but is not right for me, anxious as I am to avoid all narrow, so called scientific theories. Having found after many attempts (I speak for myself), having found that it was impossible to be true to my sensations and consequently to render life and movement, impossible to be faithful to the so random and so admirable effects of nature, impossible to give an individual character to my drawing, I had to give up. And none too soon![46]

Pissarro's account shows a clear awareness that an artist's ability to use a conceptual approach was not simply a matter of choice, but instead stemmed from basic traits of personality that he did not possess. Plagued as he was by self-doubt throughout his career, Pissarro must have envied the young Seurat, who dealt in "clear certainties," who "went his own way, sure of himself, trusting in the fertility and richness of his own esthetic sense," and who believed he could accomplish "the mission of releasing art from the tentative, the vague, the hesitant, and the imprecise."[47] In 1886, Pissarro must have hoped that he himself would acquire these attitudes if he adopted Seurat's artistic philosophy and practices. Within just a few years, however, he discovered that his lack of self-confidence was as immutable a feature of his personality as his need for spontaneity in painting. Thus, true to his experimental nature, in 1889 he confided to Lucien that his only certainty in abandoning his attempt to follow Seurat was that he had to continue searching: "I am at this moment looking for some substitute for the dot; so far I have not found what I want, the actual execution does not seem to me to be rapid enough and does not follow sensation with enough inevitability; but it would be best not to speak of this. The fact is I would be hard put to express my meaning clearly, although I am completely aware of what I lack."[48]

Pablo Picasso's artistic output was so vast that it is dangerous to generalize about his career without extended study, but it appears likely that as he grew older he tended to make fewer preparatory drawings for individual paintings, and that he also tended more often to produce paintings without any preparatory drawings.[49] It might be supposed that this implies that as he aged he evolved from a conceptual to an experimental approach. This is not necessarily the case, however, for particularly for an experienced artist, preparatory drawings may be unnecessary for preconception of a painting. A few accounts of Picasso's practices suggest this.

Françoise Gilot recalled that when she first went to live with Picasso in 1946, when he was 65, he tried to draw her, but was not satisfied with

the results. He then asked her to pose for him in the nude. When she had undressed, Picasso had her stand with her arms at her sides:

> Pablo stood off, three or four yards from me, looking tense and remote. His eyes didn't leave me for a second. He didn't touch his drawing pad; he wasn't even holding a pencil. It seemed a very long time.
>
> Finally he said, "I see what I need to do. You can dress now. You won't have to pose again." When I went to get my clothes I saw that I had been standing there just over an hour.

The next day Picasso began, from memory, a series of works of Gilot in that pose, including a well-known portrait of her titled *La Femme-Fleur*.[50] Another account of Picasso's ability to preconceive a work without the use of sketches was given by his friend and dealer, Daniel-Henry Kahnweiler, to the photographer Brassaï in 1962. It involved Picasso's production of a linocut with multiple colors, in an unusual way. Instead of the normal procedure of cutting a separate linoleum plate for each color, Picasso used only one: after printing one color, he would recut the plate and print another color. Kahnweiler observed that by repeating this process Picasso produced very complex prints, with as many as a dozen colors. Whereas the traditional approach permitted adjustments during the printing process, by allowing changes to any of the plates at the time of printing to make the separate images of the individual plates fit together with each other, Picasso's method provided no such margin for error, since the image for each color was irreversibly destroyed when the unique plate was recut to print the next color. Kahnweiler marveled at Picasso's ability to use this uncompromising process: "He must see in advance the effect of each color, because there's no pentimento possible! . . . [I]t's a kind of clairvoyance. I would call it 'pictorial premonition.' I was at his home a few days ago and saw him working. When he attacks the lino, he makes out or sees in advance the final result."[51] Although this issue has not been systematically studied, these anecdotes about Picasso's practice suggest that it is possible that experienced conceptual painters, like chess masters, can preconceive their works without having to fix their preparatory images on paper.

The lack of systematic study of the careers of individual painters aimed at answering the question posed in this section makes it premature to offer any general conclusions about whether painters can change from one approach to the other. Yet as in the preceding section I can offer a conjecture, to be tested in the future. This is that whereas it may be possible for conceptual artists to evolve gradually into experimental ones, it is not likely that experimental artists can change into conceptual ones. The logic of this conjecture is that accumulation of experience and knowledge over time may allow an early deductive way of thinking to develop into

a more nuanced inductive one, but that it is much less likely that the uncertainty and complexity of an artist who initially follows an inductive approach can ever be changed successfully into the simplicity and certainty of the deductive thinker.

ANOMALIES

> The life of an artist is rightly a unit of study in any
> biographical series. But to make it the main unit of study
> in the history of art is like discussing the railroads of a
> country in terms of the experiences of a single traveler
> on several of them. To describe railroads accurately, we
> are obliged to disregard persons and states, for the
> railroads themselves are the elements of continuity, and
> not the travelers or the functionaries thereon.
> *George Kubler, 1962*[52]

Like other behavioral relationships in the social sciences, the predicted relationships between the categories of analysis used here and artists' life cycles are not laws, but tendencies. It is particularly important to remember this when using quantitative evidence to examine artists' careers, because of a significant departure of the analyses presented here from the normal practice of empirical economics. Economists often carry out econometric estimation of relationships involving the human life cycle, but they invariably do this with data that represent the experiences of large numbers of people. The resulting estimates summarize the average behavior of members of the relevant groups. The behavior of many of the people included in the data sets may differ sharply from that of the average, but the measurements of population averages can nonetheless remain powerful as long as these divergent cases are relatively uncommon. In the present case, however, the estimates of artists' life cycles given above are for *individual artists*. The visibility of any deviation from the typical relationship is obviously enormously magnified by this microscopic procedure, and consequently the possibility of unusual or anomalous cases should be kept in mind.

Yet although anomalies exist, some cases that initially appear anomalous can in fact be understood through relatively straightforward extensions of the analysis used here. These extensions typically involve placing the case at issue within a broader context—either seeing the career of the artist in relation to those of others or situating the innovation within the specific experiences of the artist. Several examples involving important modern artists provide illustrations.

As discussed earlier in this chapter, Claude Monet was an experimental innovator. Monet believed that progress in art was possible only with total commitment to the study of nature and long hours of work. As late as 1890, at the age of 50, he wrote a friend that he was "profoundly disgusted with painting. It really is a continual torture! Don't expect to see anything new, the little I did manage to do has been destroyed, scraped off or torn up." Monet's goals were famously visual: "The further I get, the more I see that a lot of work has to be done in order to render what I'm looking for: 'instantaneity,' the 'envelope' above all, the same light spread over everything, and more than ever I'm disgusted by easy things that come in one go."[53] Although Monet was a great experimental artist, his major contribution was made at a very early age. The peak of his age-price profile occurs for work he did at age 29, and the five-year period from which the largest number of his paintings are illustrated in both the American and French textbooks is 1869–73, when he was 29–33.

These dates are hardly surprising, for they precisely locate the period when Monet was making his breakthrough innovations in Impressionism, which proved to be one of the most influential artistic achievements of the nineteenth century. During the summer of 1869, when Monet was 29, he painted with Renoir at a riverside café near Paris. Kenneth Clark called that café, La Grenouillère, the birthplace of Impressionism, as the two artists' novel treatment of the reflection of light on the waters of the Seine produced a new technique so powerful that it not only directly affected sympathetic artists like Pissarro and Sisley, but induced a wide variety of artists whose interests were less obviously related, including Manet, Cézanne, Gauguin, and van Gogh, to experiment with Impressionist methods.[54] That this seminal experimental discovery was made by Monet before the age of 30 appears to be a powerful violation of the prediction that important experimental innovations require lengthy periods of development.[55]

The resolution of this apparent contradiction follows from the recognition that the development of innovations need not be made entirely by individual artists. Monet's early breakthrough appears to have resulted from his ability to take advantage of a research agenda that several older artists had begun. Art historians have long repeated Monet's account of how, early in his career, he had initially rejected the advice of the older artist Eugène Boudin to paint from nature, but how he had then learned valuable lessons from Boudin and his friend Johan Jongkind after he had understood their methods and goals. Thus in an interview in 1900, Monet recalled that "Boudin, with untiring kindness, undertook my education," teaching him to study nature, and that Jongkind later "completed the teachings that I had already received from Boudin." Monet never hid his debt to his informal teachers, acknowledging in the 1900 interview that

after he met Jongkind in 1862, "from that time on he was my real master," while in 1920 he wrote to a friend, "I've said it before and can only repeat that I owe everything to Boudin." Monet explained that he came to be fascinated by Boudin's studies, "the products of what I call instantaneity."[56] But after learning the results of the research of the two older landscape painters, Monet formulated goals more ambitious than theirs, and it was only after several years of further experimentation that he discovered "the principle of the subdivision of colors" that allowed him to achieve the novel "effects of light and color" that transformed Paris's advanced art world.[57]

Monet's career illustrates George Kubler's warning that "biographies . . . are only way stations where it is easy to overlook the continuous nature of artistic traditions."[58] The innovation of Impressionism provides an example of a substantial difference between the overall duration of a research project and the work on that project by a key member. Monet's leadership in the discoveries of Impressionism appears to have been a consequence of his ability to build on the extended studies of the older artists: his relationship with Boudin and Jongkind was equivalent to joining a research project already in progress, and allowed him to formulate the goals and develop the techniques of Impressionism much sooner, and at a much younger age, than if he had had to work without the benefit of their lessons.

It is interesting to note that the pattern of Monet's career reflects his experimental approach in spite of his early great achievement. Unlike many conceptual innovators who made important early discoveries and simply declined thereafter, Monet made several significant contributions later in his life. Table 3.1 presents the distributions by age of the illustrations of Monet's paintings in the collections of textbooks in both English and French described earlier. Although both groups of scholars give clear precedence to the work of Monet's late 20s and 30s, both distributions also include large numbers of illustrations from Monet's 50s and for the work he did after the age of 60. The paintings presented from Monet's 50s are from the series he executed during the 1890s, including the grain stacks, the poplars, and the views of Rouen Cathedral, while the illustrations of works he produced after age 60 give primary emphasis to the many paintings of water lilies he made at Giverny. Both of these later bodies of work made innovations that built on, and added to, the earlier discoveries in Impressionism. Thus during the twentieth century many artists would adopt the practice of painting in series. This would often stem from a belief about the value of seriality that Monet articulated in 1891, when he said of the grain stacks that the individual canvases would "only acquire their value by the comparison and succession of the entire series."[59] And during the 1950s, a number of critics and artists pointed

TABLE 3.1
Illustrations by Age, Monet, from Books Published in English and in French

| | English | | French | |
Age	n	%	n	%
20–29	28	22	25	24
30–39	42	34	43	41
40–49	6	5	2	2
50–59	27	22	18	17
60–69	5	4	6	6
70–79	4	3	10	10
80–86	13	10	0	0
Total	125	100	104	100

Source: See table 2.1 and 2.2.

to Monet's late paintings of water lilies as a forerunner of Abstract Expressionism, in their size, composition, and use of color.[60] Because of his experimental approach, however, Monet did not arrive at these later innovations suddenly, but, as John House observed, "this transformation . . . was the result of a protracted process of evolution."[61] Throughout his life Monet remained committed to a visual art, as just months before his death he declared that "the only merit I have is to have painted directly from nature with the aim of conveying my impressions in front of the most fugitive effects."[62]

Vincent van Gogh's career appears to present an anomaly of an opposite type. Van Gogh was a conceptual innovator, hailed in 1890 by the critic Albert Aurier as a great Symbolist painter who "considers this enchanting pigment only as a kind of marvelous language destined to express the Idea."[63] Yet van Gogh produced his most valuable work not in his 20s, but at the age of 36. Although van Gogh became a painter relatively late, after working as an art dealer and pastor, his greatest achievements were nonetheless made in the final few years of his life, when he had been a full-time artist for nearly a decade. Yet van Gogh's career illustrates the necessity of a knowledge of advanced art in allowing an artist to make new contributions.

Van Gogh was largely a self-taught artist. He spent the first five years of his career as a painter in his native Holland and Belgium, where he could not see the most recent developments in modern art. Before he went to Paris, his brother Theo had told him of Impressionism, but Vincent did not know what it was. When Vincent decided to join his brother in Paris

in 1886, he quickly realized that, as he wrote to a fellow artist who had remained in Antwerp, "There is but one Paris. . . . What is to be gained is *progress* and what the deuce that is, it is to be found here."[64] In Paris, under the guidance of Camille Pissarro, with astonishing speed van Gogh gained a knowledge of the methods and goals not only of Impressionism but also of Neo-Impressionism, and he became acquainted with Paul Gauguin, Émile Bernard, and a number of other young artists who were developing a new Symbolist art. Exhausted by two years of intense work in Paris, in 1888 van Gogh left for Arles, where he developed the personal form of Symbolist painting that became his distinctive contribution to modern art. Van Gogh recognized that the Impressionists would find fault with his new style, "because instead of trying to reproduce exactly what I have before my eyes, I use color more arbitrarily, in order to express myself forcibly." His exaggerations of color and form were intended to communicate the intensity of his ideas and emotions, which he could not do within the constraints of Impressionism: "If you make the color exact or the drawing exact, it won't give you sensations like that."[65]

Clement Greenberg emphasized that "the ambitious artist . . . has to assimilate the best new art of the moment, or the moments, just before his own."[66] Vincent van Gogh did not begin to assimilate the best new art of his time until 1886, when he arrived in Paris. It was only then that he learned the techniques and motivations of the art that he would have to build on, and depart from, in order to make a significant contribution to advanced art. He did this remarkably quickly, as the landmark works of his career began to appear in 1888, just two years after he began his real education as an advanced artist, and continued from then through the remaining two years of his life. The art of these final years became a central influence on Fauvism and Expressionism. That van Gogh could make such a great contribution in such a short period is a clear consequence of his conceptual approach to art.

Roy Lichtenstein's career provides another example of the effect of a conceptual artist's delayed exposure to advanced art. Tables 2.5 and 2.7 show that Lichtenstein was the oldest of the leading conceptual artists of his era when he made his greatest contribution. Early in his career, Lichtenstein lived in the Midwest and upstate New York. In 1960 he took a teaching job at Rutgers University, where his colleagues included Allan Kaprow and Claes Oldenburg, who were experimenting with Happenings and using a variety of objects as props in their performances and sculptures. Although Lichtenstein told an interviewer that at the time he had not been aware of being influenced by his colleagues, he later realized, "Of course, I was influenced by it all."[67] His art began to change almost immediately, as during 1961 he first inserted cartoon characters into his paintings, and soon thereafter he began to make entire paintings that cop-

ied comic strips. In 1963 he arrived at the technique that he would routinely use thereafter, as he began by making a small drawing that he then projected onto a larger canvas to allow him to trace the outlines for the images in his paintings.[68] Lichtenstein made most of his best-known works in 1963, including *Whaam!*, which is the single painting by any American artist of his generation that is most often reproduced in textbooks.[69] Thus although Lichtenstein did not produce his breakthrough work until he was 40 years old, he arrived at the images that embodied his major conceptual innovation within three years after his first exposure to New York's advanced art world.

The social sciences do not produce deterministic laws from which there are no deviations, so inevitably there will be experimental artists who make major contributions early in their careers, and conceptual artists who make major contributions late in theirs. Yet what the examples considered here suggest is that we should not immediately assume that these occurrences are anomalous. Monet's life cycle appears as an anomaly only if we consider his career in isolation. When we place it in context, it serves as a reminder that artistic innovations are not made by isolated geniuses, but are usually based on the lessons of teachers and the collaboration of colleagues. Unlike many other instances in which young artists have reacted against the art of their teachers, Monet embraced the goals and methods of Boudin and Jongkind and used their work as a point of departure for the development of even more ambitious techniques and intentions. The careers of van Gogh and Lichtenstein demonstrate that innovative artists must understand the advanced art of their time before they can make new contributions. What appears to be necessary for radical conceptual innovation is not youth, but an absence of acquired habits of thought that inhibit sudden departures from existing conventions. When van Gogh learned the methods and goals of Impressionism, he could see almost immediately that it was not an art that was suited to his temperament, but his own subsequent discoveries were then aided by his relationships with other young artists who were also reacting against Impressionism out of similar motives. Even less consciously, Lichtenstein responded just as quickly to the conceptual innovations that were changing advanced American art in the early 1960s.

implications

MASTERS AND MASTERPIECES

In order to be noticed at the exhibition, one has to paint
rather large pictures that demand very conscientious
preparatory studies and thus occasion a good deal of
expense; otherwise one has to spend ten years until
people notice you, which is rather discouraging.
Frédéric Bazille, 1866[1]

This analysis of artists' life cycles has implications for many significant issues in the history of modern art. Some of these have long been of interest to art historians, but others have actually not been noticed by historians. One of the latter is posed by tables 4.1 and 4.2. These list the individual paintings, by artists who lived and worked in France during the late nineteenth and early twentieth centuries, that are most often reproduced in the 33 American and 31 French textbooks surveyed earlier in chapter 2. Both lists rank the top 10 paintings by number of illustrations; because of ties, this yields a total of 11 paintings in table 4.1, and 12 in table 4.2. The paintings listed in tables 4.1 and 4.2 are all classic works of modern art, their images immediately familiar to students of art. Their importance is the subject of little disagreement among scholars of different nations; eight paintings appear in both tables, and no painting ranked among the top five works in either table fails to appear in the other table. It might therefore be concluded that these lists hold no surprises.

Yet tables 4.1 and 4.2 do hold a major surprise. Some of the very greatest painters of this era, including Cézanne, Degas, Pissarro, and Renoir, fail to appear on either list. At the same time, a number of artists, including not only Picasso and Manet, but also Courbet and Duchamp, have multiple entries on the lists. The puzzle is considerable: Why does Cézanne, one of the very most important painters of the modern era, have no painting among those works identified by a consensus of art scholars as the most important, while Courbet and Duchamp, who are not generally considered nearly as important, both have more than one painting ranked among the most important individual works by both American and French scholars?

TABLE 4.1

Ranking of Paintings by French Artists, by Total Illustrations in American Textbooks

Rank	Illustrations	Artist, Title	Date	Location
1	30	Picasso, *Les Demoiselles d'Avignon*	1907	New York
2	25	Picasso, *Guernica*	1937	Madrid
3	24	Seurat, *Sunday Afternoon on the Island of the Grande Jatte*	1886	Chicago
4(t)	21	Duchamp, *Nude Descending a Staircase, No. 2*	1912	Philadelphia
4(t)	21	Manet, *Le Déjeuner sur l'herbe*	1863	Paris
6	20	Manet, *A Bar at the Folies-Bergère*	1882	London
7	16	Duchamp, *The Bride Stripped Bare by Her Bachelors, Even*	1923	Philadelphia
8(t)	15	Courbet, *L'Atelier*	1855	Paris
8(t)	15	Gauguin, *The Vision after the Sermon*	1888	Edinburgh
8(t)	15	Manet, *Olympia*	1863	Paris
8(t)	15	Matisse, *The Joy of Life*	1906	Merion

Source: Galenson, "Quantifying Artistic Success," table 3, p. 8.

A hint as to the resolution of this puzzle is suggested by an examination of tables 4.1 and 4.2 in light of the two categories of artist defined by this study. The two tables include a total of 15 paintings. Of these, all but one were executed by conceptual artists. Monet's *Impression, Sunrise*, which ranks seventh in table 4.2, is the only painting in either table produced by an experimental artist. The other 14 paintings, which fill 22 of the 23 places in the two tables, were all made by conceptual painters.

The puzzle is resolved by combining this recognition of the conceptual origin of nearly all these modern masterpieces with an understanding of the institutions of the art market in France during this period. Throughout the first three-quarters of the nineteenth century, French artists understood that the government's official Salon was the sole means of having their work presented to the public in a setting that would assure critics and collectors of its worth: the Salon had an effective monopoly of the legitimate presentation of new art to the public. Yet the enormous size of these annual or biennial exhibitions, which typically had thousands of entries, produced a considerable danger that even if an artist succeeded in having his work selected by the Salon's jury, it would be ignored because it was hung in a bad location. Historian George Heard Hamilton observed

TABLE 4.2

Ranking of Paintings by French Artists, by Total Illustrations in French Textbooks

Rank	Illustrations	Artist, Title	Date	Location
1	25	Picasso, *Les Demoiselles d'Avignon*	1907	New York
2(t)	18	Manet, *Olympia*	1863	Paris
2(t)	18	Picasso, *Guernica*	1937	Madrid
4	17	Seurat, *Sunday Afternoon on the Island of the Grande Jatte*	1886	Chicago
5	16	Manet, *Le Déjeuner sur l'herbe*	1863	Paris
6	14	Duchamp, *Nude Descending a Staircase, No. 2*	1912	Philadelphia
7	13	Monet, *Impression, Sunrise*	1872	Paris
8(t)	12	Courbet, *Burial at Ornans*	1850	Paris
8(t)	12	Duchamp, *The Bride Stripped Bare by Her Bachelors, Even*	1923	Philadelphia
10(t)	11	Courbet, *Young Women on the Banks of the Seine*	1856	Paris
10(t)	11	Gauguin, *The Vision after the Sermon*	1888	Edinburgh
10(t)	11	Rousseau, *The Snake Charmer*	1907	Paris

Source: Galenson, "Measuring Masters and Masterpieces," table 3, p. 54.

that "one way for an artist to avoid such a calamity was to paint a picture so large it could not possibly be overlooked. Such huge 'machines,' by reason of their size alone, attracted critical and popular attention quite out of proportion to their merit."[2]

Conceptual painters had a decisive advantage in producing large and complex works that, in Bazille's words, "demand very conscientious preparatory studies." Six of the paintings in tables 4.1 and 4.2—three each by Courbet and Manet—were initially submitted to the official Salon. Producing these large works was a regular part of these artists' annual routines. So, for example, late in 1854, Courbet wrote to a friend that "I have managed to sketch my painting, and at the moment it is entirely transferred to the canvas, which is twenty feet wide and twelve feet high. This will be the most surprising painting imaginable: there are thirty life-size figures." He noted, "I have two and a half months to carry it out . . . so that all told I have two days for each figure."[3] This schedule was dictated by the deadline for submitting works to the Salon of 1855, and Courbet met it. His confidence that he would be able to do this resulted

from his knowledge that once he had made a full compositional drawing of a painting, the execution of the work would follow without unforeseen difficulties: "Works of art are conceived all at once, and the composition, once it is well established and firmly outlined in the mind in all its details, casts it into its frame on paper or on canvas in such a way that there is no need to modify it in the course of execution."[4]

The importance of the official Salon declined considerably during the final quarter of the nineteenth century, but the importance of great individual works nonetheless persisted. In large part, this was because for the remainder of the century other large-scale group exhibitions continued to be the necessary venues for the legitimate presentation of new art to the public.[5] Thus many painters, including Matisse and Seurat, persisted in the practice of regularly planning large, ambitious paintings for display in group exhibitions. But even after exhibiting at group shows ceased to be necessary, the large, complex masterwork continued to be the chief token of success in Paris's advanced art world. Although Picasso was the first major modern artist who established himself without participating in group exhibitions, his greatest single work was nonetheless prompted by the tradition of the Salon masterwork. Early in his Paris career, the ambitious young Picasso recognized Matisse as his rival for the informal leadership of the advanced art world, and he envied the attention Matisse gained from showing his *Joy of Life* (listed in table 4.1) at the 1906 Salon des Indépendants. Challenged by Matisse's painting's "success within the terms of traditional Salon canvases," Picasso methodically and deliberately set out to produce a "large salon-type painting" that would be recognized as a masterpiece by the artists, critics, and collectors who made up Paris's advanced art world.[6] He succeeded in producing the work that many art historians consider the most important painting of the twentieth century, as the *Demoiselles d'Avignon* dominates both tables 4.1 and 4.2.

The importance of group exhibitions in the French art world of the nineteenth century thus profoundly influenced artists' practices. Ambitious painters devoted disproportionate effort to making large and complicated individual paintings as a means of establishing and advancing their reputations. And this type of competition afforded a great advantage to conceptual artists, whose practices better enabled them to plan and carry out large and complex individual paintings. Ambitious experimental painters struggled under the burden of trying to do this. Recognizing this leads to another important implication of the present analysis for our understanding of the history of modern art.

THE IMPRESSIONISTS' CHALLENGE TO THE SALON

I shan't send anything more to the jury. It is far too
ridiculous . . . to be exposed to these administrative
whims. . . . What I say here, a dozen young people of
talent think along with me. We have therefore decided
to rent each year a large studio where we'll exhibit
as many of our works as we wish.
Frédéric Bazille, 1867[7]

The Impressionists have killed many things, among
others the exhibition picture and the exhibition picture
system. The directness of their method and the clearness
of their thought enabled them to say what they had to
say on a small surface. . . . They introduced the group
system into exhibition rooms, showing that one picture
by an artist, though a detachable unit, also forms a
link in a chain of thought and intention that runs
through his whole oeuvre.
Walter Sickert, 1910[8]

The Impressionists' decision to secede from the official Salon and hold
their own independent group exhibitions is among the most celebrated
episodes in the history of modern art. Yet in spite of the vast amount of
scholarly attention that has been devoted to describing these exhibitions
and their consequences, one basic question that has been surprisingly ne-
glected is why it was Monet and a few of his friends, rather than any
others among the great number of other neglected painters in mid-nine-
teenth-century Paris, who actually undertook to devise an institutional
alternative to the Salon. Understanding the differing working methods of
conceptual and experimental artists provides a key element of the answer
to this question.

A major motivation for the Impressionists' desire to hold their own
exhibitions appears to have been their recognition that, as experimental
painters, their procedures were not well suited to fighting for acceptance
on the Salon's terms. The two friends Bazille and Monet first formulated
the idea of holding independent group exhibitions in 1867. For Monet,
this came at a point when he had failed at two time-consuming attempts
to produce major individual paintings for the Salon. During 1865 and
early 1866, he had spent months working on a large painting, 15 by 20
feet, that would be his *Déjeuner sur l'herbe*. He made a number of figure
drawings for the painting, a large charcoal sketch of the composition,

and an oil sketch of the whole composition before beginning the final canvas. Unable to complete the painting on time, Monet missed the submission deadline for the 1866 Salon. He ultimately abandoned the enormous unfinished work, which he later described as "incomplete and mutilated."[9] Later in 1866, he set out to make a smaller but still ambitious painting, 8 by 7 feet in size, titled *Women in the Garden*. This painting, made without preparatory sketches or studies, was rejected by the Salon jury in 1867.[10] These two unsatisfactory attempts appear to have convinced Monet that it was a mistake for him to try to follow his friends Courbet and Manet in producing large individual paintings for the Salon. Bazille's account of the two friends' original plans for a group exhibition in 1867 described a show "where we'll exhibit as many of our works as we wish," a format more appropriate for an experimental approach that naturally produced groups of smaller paintings rather than impressive individual works.

Manet's persistent refusal to stop exhibiting at the official Salon and join his friends at their independent shows is similarly illuminated by the fact that unlike Monet, Degas, Pissarro, Renoir, and Sisley, Manet was a conceptual artist. Despite a number of snubs by the Salon's jury, including the rejection of his *Déjeuner sur l'herbe* in 1863, Manet held to the position that "the Salon is the true field of battle—it is there that one must measure oneself."[11] Although his style often created conflict with the Salon's jury, Manet's conceptual approach allowed him regularly to create the large and complex individual paintings that were well suited to compete for attention at the great official exhibitions. In contrast, Monet and his Impressionist colleagues appear to have realized that they could create large paintings for the Salon only by sacrificing quality in their art.

Table 4.3 demonstrates the extent to which the Impressionists adapted their independent exhibitions to their experimental approach, listing the number of paintings by the leading members of the group included in each of the eight shows. Monet exhibited 9 paintings at the first show and at least twice that number in each of the four later shows in which he participated. Five artists—Degas, Monet, Pissarro, Renoir, and Sisley—each displayed 20 or more works in at least one of the exhibitions, and three of them did so more than once. These large numbers of paintings, which were much greater than the artists could ever have hoped to enter in the official Salon, could almost serve effectively to give the leaders of the movement one-man shows in the midst of their group exhibitions. In light of the analysis presented here, the Impressionists' group exhibitions can thus be seen as the response of a group of ambitious young experimental painters to an official institution that they recognized to be better suited in format to conceptual artists.

TABLE 4.3
Number of Entries by Selected Artists at Impressionist Exhibitions

	Year							
Artist	1874	1876	1877	1879	1880	1881	1882	1886
Cassatt	—	—	—	11	16	11	—	7
Cézanne	3	—	16	—	—	—	—	—
Degas	5	5	25	25	12	8	—	15
Monet	9	18	30	29	—	—	35	—
Morisot	9	17	12	—	15	7	9	14
Pissarro	5	12	22	38	16	28	36	19
Renoir	3	18	21	—	—	—	17	—
Sisley	5	8	17	—	—	—	27	—

Source: Moffett, *New Painting.*

MASTERPIECES WITHOUT MASTERS

*A work of art is a vehicle for the transmission of
information concerning the mental, or physical,
activity of an artist.*
Richard Hamilton, 1971[12]

An intriguing phenomenon in modern art is the existence of a number of extremely important individual works that were made by artists who are not themselves considered important. These works, which are often featured more prominently in the canon of modern art than any individual works by much more celebrated artists, dominate our perceptions of the careers of the artists who produced them. Although art historians are aware of each of these masterless masterpieces, they have not recognized a connection among them, for they treat them as isolated anomalies. The analysis presented here implies that this is not the case. Rather, these major works by minor artists appear to form a class, comprising dramatic examples of conceptual innovations, often made quickly and suddenly by very young artists.

Paul Sérusier (1863–1927) is known today as a minor Symbolist painter. A study of 31 French textbooks of modern art published since 1963 confirms Sérusier's minor status, as table 4.4 shows that these books contain a total of just 14 illustrations of his work, or less than one-fifth as many as they contain of the work of some great masters of the late nineteenth century also listed in the table. Remarkably, however, 11 of

TABLE 4.4
Ranking of Selected Nineteenth-Century Painters by
Total Illustrations in 31 French Textbooks

Artist	Illustrations
Cézanne	120
van Gogh	101
Renoir	75
Degas	74
Sérusier	14

Source: Galenson, "Measuring Masters and Masterpieces," pp. 53, 77.

the 14 illustrations of Sérusier's work are of a single painting, and table 4.5 shows that this places that painting above any single work by Cézanne, van Gogh, Renoir, or Degas in frequency of illustration in the French books. How is this possible?

Late in the summer of 1888, in the Breton artists' colony of Pont Aven, the 25-year-old art student Paul Sérusier introduced himself to Paul Gauguin, who was then generally recognized as the leading Symbolist painter, and spent a single morning painting with the master at the edge of a small forest. Gauguin told Sérusier not to hesitate to use pure colors to express the intensity of his feelings for the landscape: " 'How do you see this tree,' Gauguin had said. . . . 'Is it really green? Use green then, the most beautiful green on your palette. And that shadow, rather blue? Don't be afraid to paint it as blue as possible.' " Upon Sérusier's return to Paris, the small painting of the Bois d'Amour that he had made under Gauguin's supervision electrified a group of his fellow students, including Pierre Bonnard, Maurice Denis, and Édouard Vuillard. The students renamed Sérusier's little painting *The Talisman* in recognition of its inspiration for their art, gave themselves the collective name of the Nabis, from the Hebrew word for "prophet," and began to meet regularly to discuss Gauguin's Symbolist ideas as transmitted by Sérusier. The Nabis developed Gauguin's advice on expressive imagery into the doctrine that the artist's impressions could best be expressed by exaggeration, with distortions of line and simplification of color serving the painter just as exaggerations of language served the poet in creating metaphors. Thus the work of just a few hours, embodied in a painting less than 90 square inches in size, gave rise to one of the leading movements of advanced art of the 1890s.[13] This was possible because Gauguin's lesson was not visual, but conceptual. As Denis later recorded in a eulogy for Gauguin, Sérusier's painting provided the

TABLE 4.5
Most Frequently Illustrated Paintings by Artists in table 4.4

Artist, Painting	Illustrations
Sérusier, *Le Bois d'Amour (The Talisman)*, 1888	11
Cézanne, *The Large Bathers*, 1905	9
Renoir, *Moulin de la Galette*, 1876	9
van Gogh, *Père Tanguy*, 1887	7
Degas, *L'Absinthe*, 1876	5

Source: Galenson, "Measuring Masters and Masterpieces," pp. 54, 77.

group of young painters with a liberating new idea, for it "introduced to us for the first time, in a paradoxical and unforgettable form, the fertile concept of the 'plane surface covered with colors assembled in a certain order.' Thus we learned that every work of art was a transposition, a caricature, the passionate equivalent of a sensation received."[14]

The *Talisman* was thus credited with a causal role in Denis's early and far-reaching statement of formalist art theory declaring the visual autonomy of the work of art, and which would eventually be used to justify the abandonment of representation in painting.[15] The fame of *The Talisman* and the lack of fame of its maker thus forcefully illustrate a consequence of the nature of conceptual innovation: *The Talisman* was important because it communicated Gauguin's revolutionary conceptual aesthetic to Denis and the other Nabis, but Sérusier's unimportance resulted from the fact that he was little more than the scribe who recorded it.

Meret Oppenheim (1913–85) was born in Germany, raised in Switzerland, and went to Paris to study art at the age of 19. She worked informally under the guidance of a number of Surrealist artists she met there, including the sculptor Alberto Giacometti. Oppenheim painted and sculpted forms that were implied by ideas: "Every idea is born with its form. I carry out ideas the way they enter my head. Where inspiration comes from is anybody's guess but it comes with its form; it comes dressed, like Athena who sprang from the head of Zeus in helmet and breastplate."[16]

To support herself Oppenheim began designing jewelry, using the same conceptual approach as in her other artistic activities. One day in 1936 she was sitting in the Café de Flore with her friends Dora Maar and Pablo Picasso when Picasso became intrigued with a bracelet Oppenheim had made by covering metal tubing with fur. Picasso mused that one could cover anything with fur, and Oppenheim replied, "Even this cup and saucer." Shortly thereafter, when André Breton invited her to contribute to a

TABLE 4.6
Ranking of Selected Twentieth-Century Sculptors by
Total Illustrations in 25 Textbooks

Sculptor	Illustrations
Alberto Giacometti	39
Claes Oldenburg	36
Henry Moore	34
Alexander Calder	32
Meret Oppenheim	7

Source: Adams, *History of Western Art*; Arnason and Wheeler, *History of Modern Art*; Bell, *Modern Art*; Bocola, *Art of Modernism*; Britsch and Britsch, *Arts in Western Culture*; Britt, *Modern Art*; Cornell, *Art*; de la Croix, Tansey, and Kirkpatrick, *Gardner's Art through the Ages*; Dempsey, *Art in the Modern Era*; Feldman, *Thinking about Art*; Fleming, *Arts and Ideas*; Freeman, *Art*; Gilbert, *Living with Art*; Hartt, *History of Painting, Sculpture, Architecture*; Honour and Fleming, *Visual Arts*; Hughes, *Shock of the New*; Hunter and Jacobus, *Modern Art*; Kemp, *Oxford History of Western Art*; Sporre, *Arts*; Sproccati, *Guide to Art*; Stokstad and Grayson, *Art History*; Strickland and Boswell, *Annotated Mona Lisa*; Varnedoe, *Fine Disregard*; Wilkins, Schultz, and Linduff, *Art Past, Art Present*; Wood Cole, and Gealt, *Art of the Western World*.

Surrealist exhibition, Oppenheim bought a large cup and saucer with a spoon, and covered the three objects with the fur of a Chinese gazelle. Breton named the work *Déjeuner en fourrure* (*Luncheon in Fur*).[17]

Meret Oppenheim continued to make art past the age of 70, but she never became a famous artist. Table 4.6 shows that her work receives a total of only seven illustrations in 25 textbooks of art history, placing her far below some important sculptors of the twentieth century. Yet because all seven illustrations are of *Déjeuner en fourrure*, table 4.7 shows that it ranks ahead of any single sculpture by such modern masters as Alexander Calder, Henry Moore, Claes Oldenburg, and Oppenheim's friend Alberto Giacometti in frequency of reproduction in the 25 texts. Thus an object made by a 23-year-old artist as a result of a chance conversation in a Paris café became an emblem of Surrealism, and one of the most famous sculptures of the twentieth century.

The contemporary artist Jenny Holzer emphasized the conceptual nature of *Déjeuner en fourrure*: "Although it is wonderful to see, you can carry it in your mind without actually looking at it."[18] Oppenheim's sculpture was a striking embodiment of two central aspects of Surrealist art, for it was an object with symbolic meaning, lacking in aesthetic quality and craftsmanship, and its symbolism placed it squarely in a line of Surrealist works that represented sexual freedom.[19] Thus whereas Holzer rec-

TABLE 4.7
Most Frequently Illustrated Sculptures by Sculptors in Table 4.6

Sculptor, Sculpture	Illustrations
Oppenheim, *Le Déjeuner en fourrure*, 1936	7
Calder, *Lobster Trap and Fish Tail*, 1939	5
Moore, *Reclining Figure*, 1939	5
Giacometti, *Man Pointing*, 1947	4
Giacometti, *City Square*, 1948	4
Oldenburg, *Clothespin*, 1976	4

Source: See table 4.6.

ognized that its "nonart materials are appropriate" for the concerns of *Déjeuner,* Robert Hughes described the work as "the most intense and abrupt image of lesbian sex in the history of art."[20] The fame of the work and the lack of fame of its young maker both stem from the fact that *Déjeuner en fourrure* dramatically and fully embodied an innovative idea.

In London in the early 1950s, Richard Hamilton (1922–) was a member of the Independent Group, a number of young artists who met informally to discuss their interest in mass culture. They shared a fascination with American advertising and graphic design, and wanted to create an art that would have the same kind of popular appeal. They also wanted this art to bridge the growing gap between the humanities and modern science and technology.[21] In 1956 the Independent Group organized a joint exhibition, "This Is Tomorrow," which was designed to examine the interrelationships between art and architecture. Hamilton agreed to create an image that could be used as a poster for the show. The result was a small collage titled *Just what is it that makes today's homes so different, so appealing?*

Hamilton began the work by making a list of categories that included Man, Woman, Food, Newspapers, Cinema, TV, Telephone, Comics, and Cars. Hamilton, his wife, and another artist then searched through piles of magazines, many of which had been brought back from the United States by a fellow Independent Group member, cutting out illustrations of objects that could represent the categories on Hamilton's list. Hamilton then selected an image for each category, according to how they would fit into the fictitious living space he was constructing. Among its images, *Just what is it?* contains a male bodybuilder, a female pinup, a comic book cover, an insignia for Ford automobiles, and even the word "Pop" on a large Tootsie pop held up by the bodybuilder. The work's title was itself the caption from a discarded photograph.[22]

TABLE 4.8
Ranking of Selected Artists of 1950s and 1960s by
Total Illustrations in 36 Textbooks

Artist	Illustrations
Warhol	68
Rauschenberg	67
Johns	63
Lichtenstein	54
Hamilton	26

Source: Galenson, "One-Hit Wonders," table 11.

Richard Hamilton has had a long career as a painter, conceptual artist, and art teacher; he has been honored by no less than three retrospective exhibitions at London's Tate Gallery; and he is considered a leading figure in British Pop Art.[23] Yet he has never achieved nearly the same level of fame or critical attention as a number of American artists of his cohort. Thus table 4.8 shows that in a survey of 36 textbooks Hamilton's work was illustrated less than half as often as that of the leading American artists of the late 1950s and the '60s. Yet, remarkably, table 4.9 shows that 21 of the 26 illustrations of Hamilton's work were of *Just what is it?*, placing it far ahead of any individual work by Jasper Johns, Roy Lichtenstein, Robert Rauschenberg, or Andy Warhol in frequency of illustration in the 36 textbooks.

Just what is it? has been described as "an icon of early Pop.[24] In 1956, several years before Warhol or Lichtenstein had begun to reproduce photographic images or to mimic comic books, a 34-year-old English artist had combined these techniques in a single synthetic work, making it "an extraordinary prophecy of the iconography of Pop."[25] And appropriately for a prototype for a movement that would celebrate commercial culture, *Just what is it?* was not only made from advertisements, but was itself made to be an advertisement. *Just what is it?* differed considerably not only from the work Hamilton did before it, but also from that he would do later, for it was an isolated conceptual innovation. The rise of Pop Art did not make Hamilton a famous artist, but it did give *Just what is it?* a place in the canon of contemporary art for its role as a forerunner of the dominant art movement of the early 1960s.

These three instances of masterpieces without masters are not alone in the history of modern art, and the phenomenon is likely to become more common in the current era of conceptual art. A notable recent example

TABLE 4.9
Most Frequently Illustrated Works by Artists in Table 4.8

Artist, Work	Illustrations
Hamilton, *Just what is it that makes today's homes so different, so appealing?* 1956	21
Rauschenberg, *Monogram*, 1959	13
Lichtenstein, *Whaam!* 1963	12
Warhol, *Marilyn Diptych*, 1962	11
Johns, *Flag*, 1955	10

Source: Galenson, "One-Hit Wonders," table 12.

was identified by a survey of 40 textbooks of art history, which found that two works were tied for the distinction of being reproduced more often than any other others made by American artists during the 1980s.[26] One of these was *Tilted Arc*, executed in 1981 by the sculptor Richard Serra, who is widely recognized as one of the most important living American artists. The other was the Vietnam Veterans Memorial, dedicated in 1982, which had been designed by Maya Lin at the age of 21, during her senior year in college.

Lin originally made her design for the memorial as an assignment in an architecture seminar she took at Yale. She wanted to see the site, so she and a few friends traveled to Washington, D.C. She later recalled that "it was at the site that the idea for the design took shape": "I had a simple impulse to cut into the earth. I imagined taking a knife and cutting into the earth, opening it up, an initial violence and pain that in time would heal."[27]

Lin's plan was to have two long walls of polished black granite, arranged in a V shape, placed in the ground to form an embankment. One of the walls was to point to the Lincoln Memorial, the other to the Washington Monument: "I wanted to create a unity between the country's past and present." Lin soon realized that the strength of her design lay in its simplicity: "On our return to Yale, I quickly sketched the idea up, and it almost seemed too simple, too little. I toyed with adding some large flat slabs that would appear to lead into the memorial, but they didn't belong. The image was so simple that anything added to it began to detract from it."[28]

Lin's design was a radical departure from earlier memorial architecture, for the memorial was influenced much more by Minimalist sculpture than by traditional memorials. Her use of abstract forms initially shocked veterans and others who had expected a realistic portrayal of soldiers in combat. Yet when the memorial was completed, it quickly came to be

recognized as a moving tribute to the soldiers who had died in Vietnam. Today it not only is the most visited memorial in the capital, but is widely considered to have established a new level of excellence for memorial architecture. So, for example, when the Lower Manhattan Development Corporation held a competition for a memorial to the victims of the 2001 attack on the World Trade Center, Maya Lin was appointed to the five-member jury. When the eight final designs were presented to the public, the architecture critic for the *New Yorker* remarked that although all of these were intelligent, they received a lukewarm reaction from critics and the public because "in the post-Vietnam-memorial age, we may have come to expect too much of a memorial." The problem was that Lin had set a new standard: "Lin's Vietnam memorial set the bar very high."[29]

In the two decades since she designed the Vietnam Veterans Memorial, Lin has pursued a career as an architect and sculptor. A recent profile observed, "Now a beneficiary of a stream of commissions, this still-young master is riding her good fortune, turning out institutional and private projects while also making the individual sculptures to which she attaches such importance."[30] Yet whereas the Vietnam Veterans Memorial was illustrated in 16 of the 40 textbooks examined for the study cited here, no other work by Lin was reproduced in even a single book. Thus from the vantage point of art scholars, Lin's contribution consists of a single work, which one scholar described as "one of the most compelling monuments in the United States."[31] That a 21-year-old artist could conceive an innovation that would be fully expressed in a single enormously successful project, and that would be followed by no others deemed significant by art scholars, is a phenomenon unique to conceptual art, and in this Lin's career resembles those of Sérusier, Oppenheim, and Hamilton. Although their common features have gone unnoticed by art historians, their masterpieces were all achieved quickly, as the result of sudden insights, by young artists. All are prime examples of conceptual innovations.

CONTRASTING CAREERS

The young master is a new phenomenon
in American art.
Harold Rosenberg, 1970[32]

The dramatic innovations that many conceptual artists have made early in their careers have often allowed them to gain attention at much younger ages than their experimental counterparts. There were instances of this in the nineteenth century, as Manet became the focal point for controversy in Paris's advanced art world at the age of 31, when his *Dé-*

jeuner sur l'herbe was shown at the Salon des Refusés in 1863, and Georges Seurat similarly gained widespread attention at the age of 27, when his *Sunday Afternoon on the Island of the Grande Jatte* was exhibited in the final Impressionist exhibition in 1886. But this would become much more common in the twentieth century, as critics, dealers, and collectors became more aware of the fact that the paintings that introduced radical innovations often rose sharply in value within as little as a decade after their appearance.

One consequence of this recognition was that many art dealers became more willing to give exhibitions to young and unproven painters. This can be seen in a shift that occurred in New York during the late 1950s and early '60s, as the experimental Abstract Expressionists gave way to the conceptual artists of the next generation. Table 4.10 shows that the median age at which 11 leading Abstract Expressionist had their first one-man shows in New York was 34, but that this age fell to just 27.5 for a dozen leading members of the next generation. Only two of the 11 Abstract Expressionists had their first shows before the age of 30, compared with 10 of the 12 artists of the following cohort. Three major Abstract Expressionists—de Kooning, Still, and Newman—did not debut in New York until after age 40, whereas all the leaders of the next generation had their first shows in the city well before they reached 40.

When Frank Stella was given a retrospective exhibition at New York's Museum of Modern Art in 1970 at the age of 33, the critic Harold Rosenberg, who was a prominent supporter of the Abstract Expressionists, was indignant. He observed acidly that "the indispensable qualification of the creators of American art has been longevity." Nor was this unique to American art, for Rosenberg declared, "It is inconceivable that Cézanne, Matisse, or Miró could have qualified for a retrospective in a leading museum after their first dozen years of painting; certainly Gorky, Hofmann, Pollock, and de Kooning did not." Rosenberg argued that major artistic contributions required long gestation periods: "Self-discovery has been the life principle of avant-garde art . . . and no project can, of course, be more time-consuming than self-discovery. Every step is bound to be tentative; indeed, it is hard to see how self-discovery can take less than the individual's entire lifetime." In closing his scathing review of Stella's exhibition, Rosenberg protested, "For a coherent body of significant paintings to spring directly out of an artist's early thoughts, a new intellectual order had to be instituted in American art."[33] Although Rosenberg deplored this situation, his analysis of it was correct. As the experimental methods of the Abstract Expressionists were replaced by a variety of conceptual approaches, the artistic value of experience declined sharply, and the new intellectual order in advanced art gave rise to a new career pattern in which artists would routinely gain fame, and often fortune, at an early age.[34]

TABLE 4.10
Ages of American Artists at the Time of Their First
One-Man New York Gallery Exhibitions

Artist	Year of Birth	Year of Show	Artist's Age
Experimental			
Adolph Gottlieb	1903	1930	27
Mark Rothko	1903	1933	30
Arshile Gorky	1904	1938	34
Willem de Kooning	1904	1948	44
Clyfford Still	1904	1946	42
Barnett Newman	1905	1950	45
Franz Kline	1910	1950	40
William Baziotes	1912	1944	32
Jackson Pollock	1912	1943	31
Philip Guston	1913	1945	32
Robert Motherwell	1915	1944	29
Conceptual			
Roy Lichtenstein	1923	1951	28
Larry Rivers	1923	1951	28
Robert Rauschenberg	1925	1951	26
Sol LeWitt	1928	1965	37
Cy Twombly	1928	1955	27
Andy Warhol	1928	1962	34
Jasper Johns	1930	1958	28
James Rosenquist	1933	1962	29
Jim Dine	1935	1960	25
Frank Stella	1936	1960	24
David Hockney	1937	1964	27
Robert Mangold	1937	1964	27

Source: Galenson, Painting outside the Lines, appendix C.

CONFLICTS

We worked for years to get rid of all that.
*Mark Rothko, on Jasper Johns's first one-man
show, 1958*[35]

I'm neither a teacher nor an author of manifestos. I don't
think along the same lines as the Abstract Expressionists,
who took those sorts of things all too seriously.
Jasper Johns, 1969[36]

The difference in the timing of the careers of experimental and conceptual artists has been capable of causing considerable resentment, as experimental artists who have spent years struggling, often in poverty and obscurity, to make contributions to art have been jealous of younger conceptual artists' quick commercial success. Yet conflicts between the two types of artist have often arisen from a deeper source than mere jealousy. For although it need not always be manifest, there is a powerful potential for hostility and distrust between artists of the two groups as a result of differences in their philosophies of art, and associated differences in their practices and products.

There is a persistent tendency for conceptual artists to regard experimental painters as mere artisans, lacking in intelligence. The conceptual innovator Marcel Duchamp complained that modern art had been addressed not to the mind, but to the eye: "I was interested in ideas—not merely in visual products. I wanted to put painting once again at the service of the mind."[37] Duchamp explained that his art was a reaction against what he considered an excessive emphasis on appearance: "In French there is an old expression, *la patte*, meaning the artist's touch, his personal style, his 'paw.' I wanted to get away from *la patte* and all that retinal painting." The one modern artist he exempted from his criticism was his fellow conceptual artist Seurat: "He didn't let his hand interfere with his mind."[38] Duchamp had little regard, however, for those he called retinal painters: " 'Bête comme un peintre' was the saying in France all through the last half of the nineteenth century, and it was true, too. The kind of painter who just puts down what he sees *is* stupid."[39] Duchamp's disdain for "*la patte* and all that retinal painting" was echoed by a number of conceptual artists during the 1960s. So, for example, Frank Stella explained, "I do think that a good pictorial idea is worth more than a lot of manual dexterity."[40]

Conversely, experimental painters often consider conceptual artists to be intellectual tricksters, lacking in artistic ability and integrity. So, for example, in 1887 when his former protégé Paul Gauguin began to gain recognition for his conceptual contributions to Symbolism, Camille Pissarro could only conclude that Gauguin was not seriously committed to art: "At bottom his character is anti-artistic, he is a maker of odds and ends." With bitter irony, Pissarro wrote to his son that Gauguin had gained "a group of young disciples, who hung on the words of the master. . . . At any rate it must be admitted that he has finally acquired great influence. This comes of course from years of hard and meritorious work—as a sectarian!" Several years later, when a journalist praised Gauguin for his innovations, Pissarro again complained of the younger artist's insincerity: "When one does not lack talent and is young into the bargain how wrong it is to give oneself over to impostures! How empty of conviction are this

representation, this décor, this painting!" In what may have been the last meeting between the two former friends, Pissarro attended an exhibition of Gauguin's paintings at Durand-Ruel's gallery on the occasion of the younger artist's return from his first stay in Tahiti in 1893. Pissarro found the work to be dishonest and told his former pupil as much:

> I saw Gauguin; he told me his theories about art and assured me that the young would find salvation by replenishing themselves at remote and savage sources. I told him that this art did not belong to him, that he was a civilized man and hence it was his function to show us harmonious things. We parted, each unconvinced. Gauguin is certainly not without talent, but how difficult it is for him to find his own way! He is always poaching on someone's ground; now he is pillaging the savages of Oceania.

Pissarro noted that his Impressionist friends agreed: "Monet and Renoir find all this simply bad."[41] Gauguin's remarks to Pissarro at the gallery were prophetic, for his work would in fact influence many of the leading painters of the next generation, including Picasso and Matisse. Yet although these later conceptual artists could find inspiration in Gauguin's Symbolism and his imaginative use of primitive art, Pissarro and his fellow Impressionists, whose lives were devoted to the painstaking experimental development of a visual art, could see in his work only insincerity, opportunism, and plagiarism.[42]

The Impressionists' reaction to their conceptual successors was later echoed by the Abstract Expressionists' rejection of the conceptual artists who followed them in New York. Thus when Robert Motherwell first saw Frank Stella's early paintings of black stripes, he remarked, "It's very interesting, but it's not painting."[43] And in 1962, Motherwell explained that the new art was not in the true line of descent of fine art: "Immediately contemporary painting seems to be developing in the direction of pop art. Coca-Cola! There will be a tremendous excitement about what, in effect, will be the 'folk art' of industrial civilization and thus different from preceding art: i.e., the reference will not be to high art, but to certain effects of industrial society. The pop artists couldn't care less about Picasso or Rembrandt." With irony, Motherwell added, "I am all in favor of pop art. . . . I'm glad to see young painters enjoying themselves."[44]

Admirers of conceptual art typically praise its brilliance, clarity, and structure; detractors often criticize it as cold, calculated, and superficial. Experimental artists are often praised for their touch, and for the depth of expression that comes with experience; they are often criticized for their lack of discipline, and for their mysticism.

During the era of modern art, experimental painters have been recognized as leaders during relatively brief periods, while conceptual artists

have dominated for longer intervals. Thus the experimental art of Impressionism was the central form of advanced modern art for little more than a decade, during the 1870s, then was quickly succeeded by a variety of conceptual approaches, including Neo-Impressionism and Symbolism, which were in turn followed by the conceptual approaches of Fauvism and Cubism. Most of the major movements that followed Cubism were conceptual, though Surrealism included both conceptual and experimental painters among its diverse followers. Some of the experimental Surrealists were an early influence on Abstract Expressionism, which became the dominant movement in the advanced painting of the early 1950s. Yet this experimental art was quickly displaced by a variety of conceptual approaches in the late 1950s and beyond, as Pop, Minimalism, and a number of other innovations captured the attention of the art world. Although it does not appear that there is any necessary pattern or cycle in this alternation between approaches, several factors do appear to exert systematic influences. One is that the perceived excesses of either approach can create an interest in reacting against it, not only on the part of young artists, but also among critics, dealers, and others in the art world who can encourage and help these young artists. Thus, for example, a common theme in the recollections of many of the conceptual innovators of the 1960s is that when they were beginning their careers they found the art and attitudes of the Abstract Expressionists oppressive. These younger artists used humor and irony to combat what they considered the pretentious emotional and philosophical claims of the Abstract Expressionists, and they substituted impersonal execution for what they perceived to be the excessively personal styles of their predecessors.

Reactions against a dominant approach can of course occur in either direction, as experimental artists can equally seek to overthrow dominant conceptual paradigms. Today's art world, with its frequent complaints against the current extremes of conceptual art, may be ripe for an experimental revolution. Yet considering this possibility points to a different influence that may be a key factor in understanding why the predominantly conceptual phases of the modern era have been longer than the experimental ones. This is simply that because radical conceptual innovations can be made much more quickly than experimental ones, conceptual artists will tend to have an advantage in any situation in which there is a strong demand for innovation. Arthur Danto recently observed, "In many ways, the Paris art world of the 1880s was like the New York art world of the 1980s—competitive, aggressive, swept by the demand that artists come up with something new or perish."[45] The artists who thrive in these situations tend to be the young geniuses who can innovate deliberately and systematically, before giving way to the next cohort of young geniuses; thus the young Seurat emerged as a leader in Paris's advanced art

world in the 1880s, just as young conceptual artists like Julian Schnabel and Jean-Michel Basquiat emerged in the New York art world of the 1980s. In contrast, experimental painters were largely eclipsed in both these eras, perhaps overwhelmed by the urgent demand quickly to produce dramatic new results. So, for example, one of the greatest experimental painters of the nineteenth century largely retreated from Paris during the contentious 1880s, as after 1882 Cézanne lived in relative seclusion in Provence, seeking not only the inspiration of the southern landscape he loved, but also the peace and solitude he felt he needed for the slow and painstaking development of his art. His letters refer to his mistrust of the conceptual debates that were raging in Paris's cafes, as when he explained in 1889, "I had resolved to work in silence until the day when I should feel myself able to defend theoretically the result of my attempts."[46] We may not yet know the identity of today's important experimental artists if they are similarly developing their art out of the limelight, away from New York and the other hectic central battlegrounds of the art world where artists feel that "there is this pressure now to be surer, quicker, more confident."[47]

When the early conceptual innovations of a young artist are recognized quickly, the reassurance—and income—they provide the artist can be of great value in affording him the freedom to experiment further. It was in recognition of this that Picasso described the critical success of his early blue and rose periods as "screens that shielded me. . . . It was from within the shelter of my success that I could do what I liked, anything I liked."[48] His subsequent radical departure into Cubism may have been a product of this shelter. Yet although they are more likely to gain early acclaim, the greatest danger to conceptual artists may be the dry spells that occur when they run out of ideas.[49] Although many experimental painters suffer from chronic uncertainty about the quality of their work, they appear to be less likely to stop working altogether in crises of confidence, for their trial-and-error approach usually presents many possible avenues for further research. And experimental artists can draw some comfort from the realization that their work is more likely to improve over time than that of their aging conceptual counterparts.

THE GLOBALIZATION OF MODERN ART

It was for me the greatest revelation. I understood
instantly the mechanics of the new painting.
Raoul Dufy, on seeing Matisse's Luxe,
calme, et volupté, *1905*[50]

Just as conceptual innovations can often be created immediately, as the expression of new ideas, so can they often be communicated immediately. Experimental art, with more complex methods and imprecise goals, usually requires direct contact between teacher and student for instruction that leads to real understanding and mastery, but conceptual art, with its less complex methods and clearer goals, can often be transmitted without direct contact between artists, merely through seeing reproductions of works of art, or even simply reading written texts.

This difference in the ease and speed of transmission of the two types of art has had important implications for the changing geographic locus of the production of advanced art during the modern era. Artists who wanted to learn the techniques and philosophy of Impressionism had to spend time talking and working with members of the core group. Pissarro was the most welcoming of them, and Cézanne and Gauguin both spent time working in Pontoise under his guidance during the 1870s and '80s. In addition, Pissarro appears to have spent time explaining Impressionism to van Gogh in Paris during 1886–87, and to Matisse in the late 1890s.[51] Mary Cassatt similarly served an informal apprenticeship with Degas.[52] In all these cases, the instruction occurred gradually, for studying Impressionism involved not only learning a variety of techniques, but also understanding a diffuse set of visual goals that were more easily demonstrated than expressed verbally. Artists who wanted to use the methods of Impressionism, or to learn them so they could make them a foundation for new departures, simply had to go to Paris.

Even in the late nineteenth century, the communication of conceptual innovations apparently began to be made more quickly, with considerably less contact. A celebrated instance was discussed earlier in this chapter. Thus Paul Sérusier spent just a few hours working with Paul Gauguin, and during that time produced a painting that inspired not only a new art movement, but a new theoretical formulation of art theory. That Sérusier could accomplish this in so short a time was a direct consequence of the conceptual nature of the art in question: *The Talisman* was not important for its craftsmanship or its observation of the visual nature of its subject, but because it recorded an idea in a simple form that could be recognized directly by its viewers. When it was seen by a receptive audience of young art students, together with a few sentences of Gauguin's instructions as reported by Sérusier, its impact on them was immediate.

The first major artistic movements of the twentieth century originated in Paris, as Fauvism and Cubism were both products of collaborations among young painters in the city. Most of the movements that in turn built on Fauvism and Cubism also took their mature form only after their leading members had seen that work at first hand in Paris and had encountered some of the artists who had worked in those earlier movements.

Thus before the outbreak of World War I not only the most important French painters of the next generation, but also such major figures from elsewhere in Europe as Wassily Kandinsky, Franz Marc, Umberto Boccioni, Gino Severini, and Piet Mondrian were among the scores of young artists who spent time in Paris working and studying the accomplishments of Picasso, Matisse, and their collaborators.

A major departure from this pattern occurred, however, as Kazimir Malevich made a radical breakthrough to abstract painting in Moscow in 1915 without ever having visited Paris. Malevich's Suprematism was based on Cubism as well as other western European conceptual advances, but Malevich was able to learn about these without leaving Moscow. Malevich had moved to Moscow from his native Ukraine in 1907. There he met a group of talented young artists, including Mikhail Larionov and Natalia Goncharova, with whom he worked and exhibited. In Moscow, Malevich saw the results of recent developments in advanced art in several settings. In 1908 a major public group exhibition organized by Russian artists included a survey of French art from Cézanne to Picasso. For a number of years Malevich was able to see the most recent work of Matisse, Picasso, Braque, and others in the private collection of Sergei Shchukin, a wealthy Russian merchant who was one of the first important collectors of the young French artists. Malevich followed the development of Fernand Léger's work through photographs carried from Paris to Moscow by a Russian painter, Alexandra Exter, a pupil of Léger's who divided her time between France and Russia. He learned of the conceptual breakthroughs of Italian Futurism by reading the manifestos and pamphlets published by Boccioni and his colleagues. As John Golding observed in considering the impact of these published articles on Malevich and other young artists, these manifestos "were almost invariably blueprints for art that was about to be produced, . . . and this explains why the influence of Italian Futurism was to be . . . entirely disproportionate to that of its artistic and intellectual achievements: it provided artists all over the world with instant aesthetic do-it-yourself kits."[53]

Malevich's paintings from the years leading up to his 1915 departure into abstraction clearly reveal the direct influence of the most recent innovations of many advanced French and Italian conceptual painters, including Matisse, Picasso, Braque, Léger, Duchamp, and the Italian Futurists, in spite of the fact that he had never worked with, or even met, any of these artists. Even Malevich's radical leap of 1915, in which he launched the Suprematist movement with an exhibition that included his painting *Black Square*, demonstrated his understanding of the process of conceptual innovation, as it had developed in western Europe. Thus not only did the flat geometric shapes of his abstract paintings reflect his analysis of

the Synthetic Cubist collages of Picasso and Braque, but the paintings were accompanied by the *Suprematist Manifesto*, which presented an ambitious intellectual rationale for the artworks, reflecting lessons Malevich had learned from the Futurists about the value of published theoretical declarations for new conceptual art movements.[54]

Later in the twentieth century major geographic shifts occurred in the production of advanced art. The transmission of experimental art, however, initially continued to require direct extended contact between the artists, or groups of artists, involved. The development of Abstract Expressionism benefited decisively from the presence in New York of a number of European artists who came to the United States to escape Fascism. Hans Hofmann, who founded an art school in New York in 1933, had lived in Paris and Munich, and brought with him a deep understanding not only of the art of the School of Paris but also of German Expressionism, which he communicated through his lectures as well as his paintings. The young Chilean Surrealist painter Roberta Matta came to New York from Paris in 1941 and introduced Robert Motherwell, William Baziotes, and Jackson Pollock to the Surrealists' theory of automatism.[55] Even earlier, in 1936 the Mexican muralist David Siqueiros started a workshop in New York to experiment with new techniques and technologies, with the goal of producing large-scale works more quickly and efficiently than could be done with brushes. There Pollock and other young artists sprayed, poured, and spattered new synthetic paints onto canvases in the service of Siqueiros's desire to use "controlled accidents" in making art.[56] Pollock's experiences with these new methods of applying paint to large surfaces must have contributed to the development of his signature drip method of painting a decade later. Some of the Abstract Expressionists served informal apprenticeships with older American painters. Milton Avery attracted a group of young followers, including Adolph Gottlieb, Barnett Newman, and Mark Rothko, who met for weekly sketching classes in Avery's apartment. Avery's simplified forms, flat areas of expressive color, and quiet atmospheric effects influenced these younger painters, and even Rothko's use of thinned paint in his later work may have resulted from his early studies with Avery. Rothko stressed the importance of this direct contact for his education as an artist in his eulogy for Avery in 1965: "The instruction, the example, the nearness in the flesh of this marvelous man—all this was a significant fact—one which I shall never forget."[57] Whoever their teachers, and whatever the form their lessons took, the Abstract Expressionists' educations were heavily based on long sessions spent working together in studios, and arguing in cafeterias and bars, for their achievements were based on gradual development rather than sudden breakthroughs.

The same would not be true for the conceptual innovators of the next generation, whose achievements arrived quickly and early. Frank Stella first saw Jasper Johns's paintings, at Johns's first one-man show, at Leo Castelli's gallery in 1958. Stella later recalled his reactions to Johns's targets and flags: "The thing that struck me most was the way he stuck to the motif . . . the idea of stripes—the rhythm and interval—the idea of repetition. I began to think a lot about repetition." Stella was then a senior in college. He did not meet Johns, and his teachers at Princeton were hardly sympathetic to his new interest in Johns's art. (One of them, the artist Stephen Greene, was so amused by one of Stella's paintings that resembled a flag that he wrote "God Bless America" across the canvas.)[58] Yet Stella persisted, and just a year later, during 1959, he painted most of the Black Series, which, as shown earlier in table 2.5, remains the most often reproduced body of work of his celebrated career.[59] In 1960, Stella exhibited these paintings at his own first one-man show, also at Leo Castelli's gallery.

Soon significant instances of borrowing conceptual innovations would occur that did not involve even direct sight of the original art. As a student in Düsseldorf in the early 1960s, Sigmar Polke saw reproductions of early examples of American Pop Art. Polke quickly adapted to his own purposes Warhol's use of enlarged newspaper photographs and Lichtenstein's painted imitations of printed Ben Day dots. When Polke showed the resulting paintings in Düsseldorf in 1963, in an exhibition that he and two fellow students presented in the condemned premises of a vacant furniture store, his German version of Pop Art quickly established him, at the age of 22, as a leader of his generation of German artists.[60] Polke and his friends had no desire to hide the foreign source of their techniques, as they proudly declared their relationship to the Anglo-American Pop movement, stating in a press release that theirs was "the first exhibition of 'German Pop Art.' "[61]

Rapid borrowing and utilization of new artistic devices, across ever wider geographic areas, has become increasingly common in recent decades, in which conceptual approaches to art have predominated. One indication of this progressive globalization of modern art is that art historians are finding that they are no longer able to divide their subject as neatly along geographic lines as in the past. There are many published histories of French, or European, modern art from the mid–nineteenth century to World War I or to the mid–twentieth century, and there are many histories of American art from World War II through the 1960s. For more recent periods, however, art historians are finding these geographic restrictions to be more problematic in producing their narratives, not only because it is less clear that there is a single dominant locus of the advanced

art of the past half century, but also because artistic influence has spread more rapidly and freely over a wider area in recent times.[62]

Conceptual innovations can often be borrowed more readily than experimental ones because they are typically less complex, and because they are less tied to specific artistic goals. Thus during recent decades many artists have used earlier conceptual techniques in ironic ways, without concern for their original intent. If the art world continues to be dominated by conceptual approaches, we should expect that the major innovators of the future will not only continue to emerge at very young ages, but that they will also be spread more widely across countries and continents. So, for example, in 1965 the German art historian Werner Haftmann closed his survey *Painting in the Twentieth Century* with a prediction: "It is quite possible that the fundamental point of view expressed in this book reflects a historical situation that has already begun to change. I have written it as a European historian, about modern Western art. In a few decades such an undertaking may be inconceivable and it may only be possible to write as a world historian about world painting."[63]

In 1969, a leading New York dealer in conceptual art named Seth Siegelaub specifically described, and celebrated, the connection analyzed here between globalization and the conceptual nature of contemporary art:

> I like the idea of things, information, people, ideas moving back and forth. And now that has much to do with a quality of the art too. It can travel very easily, and it can be seen on a primary level, not just photographs of something but the something itself. The idea of primary information as opposed to secondary or tertiary information. Or hearsay. It's happening very, very quickly. And it makes communications even quicker. Just send a letter in the mail and you know what it's about. You don't have to wait for a painting to arrive, like someone in Europe wouldn't see a Pollock until the late fifties or early sixties, whenever the show took one over. Those days are over. And the idea that people can make art wherever they live, that they don't have to necessarily come to New York and be part of the scene, I like that too.[64]

To date there has been no systematic study of the changing composition by nationality of leading contemporary artists, but there are a number of indications that Siegelaub was correct, and that the globalization of fine art was already progressing rapidly during the 1960s. One source of evidence is published surveys of recent developments in art. So, for example, table 4.11 is based on an analysis of a textbook published in 2002 titled *Art since 1960*, written by an English scholar named Michael Archer. The analysis of the book for table 4.11 was done by identifying the country

TABLE 4.11
Number of Different Countries of Origin of Artists Mentioned in
Art since 1960, by Birth Cohort of Artists

Decade of Artist's Birth	Number of Countries
1890–99	6
1900–1909	5
1910–19	8
1920–29	18
1930–39	27
1940–49	22
1950–59	26
1960–69	23

Source: Michael Archer, *Art since 1960.*

of birth of every artist mentioned in the text. The table summarizes the number of different countries of origin of these artists, according to the decades in which the artists were born. The evidence shows a sharp increase in the number of countries represented over time, with approximately a tripling from the birth cohort of the 1910s to those of the 1930s and beyond. Thus, for example, the artists considered in the book who were aged 41–50 in 1960, the book's starting point, came from a total of just eight different countries, whereas those aged 21–30 in 1960 represented fully 27 different countries. Detailed examination of the evidence reveals that a number of Asian and African countries, including China, India, Iran, Korea, Morocco, and Tunisia, are represented for the first time in Archer's book by artists born during the 1930s, who were in their 20s and 30s during the 1960s, when conceptual approaches to fine art began to dominate.

Although the evidence of table 4.11 is drawn from a single source, there is little doubt that its substance could be replicated from many others: that there has been a widening of the geographic locus of contributors to fine art in recent decades has become a commonplace among observers of the art world. Thus recent surveys of modern art routinely close their narratives with chapters titled "Global Crosscurrents" or "Issue-Based Art and Globalization."[65] The nature of this globalization is in greater question, as, for example, Michael Archer observes in the final chapter of *Art since 1960* that whether there has been "an expansion to accommodate different, often conflicting, attitudes to art, its market and the manner in which it functions socially, or whether it is more properly identifi-

able as an expansion of a Western model of art into new market areas, is debatable."[66] Yet regardless of the answer to Archer's question, the dominance of conceptual approaches to fine art in the recent past has clearly served to accelerate the spread of new artistic ideas, and therefore the process of globalization of the production of art in our time.

before modern art

Painting and Sculpture, labor and good faith, have
been my ruin and I go continually from bad to
worse. Better it would have been for me if I set myself
to making matches in my youth! I should not be in
such distress of mind.
Michelangelo, 1542[1]

It is true that few of his mature works were ever com-
pleted and that those entirely finished were produc-
tions of his youth. . . . Michelangelo often said that, if
he were compelled to satisfy himself, he should
show little or nothing.
Giorgio Vasari, 1568[2]

Recent research has begun to demonstrate that the differences in artistic
goals and practices that separate experimental and conceptual artists are
not exclusively a phenomenon of the modern era, but that the two types
can clearly be identified much earlier. Although the process of categorizing
old masters has just started, it is already apparent that the same distinc-
tion can provide a coherent and unified framework for many of the fea-
tures of the art of the great painters of the past that have previously been
regarded as either unrelated or idiosyncratic.

An example is afforded by considering a number of facts established
by recent analyses of Rembrandt's art. Although hundreds of drawings
by Rembrandt survive, very few can be identified as preparatory works
for paintings. After the early stages of his career, Rembrandt made prepa-
ratory drawings for his paintings only under unusual circumstances. In
some cases, sketches that were previously thought to be studies for paint-
ings have proved to be copies of Rembrandt's paintings drawn by other
artists in his workshop. In other cases, drawings by Rembrandt that are
related to specific paintings did not precede those paintings, but were
made when Rembrandt was changing the composition of a painting al-
ready in progress and tried out a possible new solution in a sketch.[3] X-rays
of Rembrandt's paintings reveal that he often made significant changes in
the composition of his works in progress, and that the frequency and

extent of these changes increased over the course of his career.[4] Svetlana Alpers concluded that Rembrandt's "habit was not to work out his inventions in advance through drawings, but rather to invent paintings in the course of their execution."[5] Ernst van de Wetering explained that the frequency with which Rembrandt made changes in his works in progress meant that "perhaps more than those of any other seventeenth-century painter, Rembrandt's paintings have to be understood as a process."[6]

Rembrandt has long been known for the thick application of the paint in many of his works, as he often used heavy impasto to add emphasis to the focal points of his paintings. Applying paint in a series of layers, he sometimes worked it roughly with a palette knife, or even his fingers, instead of a brush, to produce an uneven surface that would alternately reflect light and cast shadows, much as would the real objects he was portraying. Alpers observed that Rembrandt's laborious working of the paint "called attention to invention as a process."[7] Van de Wetering has stressed that while early in his career Rembrandt began with a relatively fine technique, his use of the rough style became more pronounced as he grew older, increasing the force of his work over time.[8]

The many layers of paint in his works help to explain why Rembrandt was known to be slow to complete his paintings. He was not a decisive painter, and his uncertainty did not diminish, but increased, as he grew older. Contemporaries often complained that even the works that Rembrandt considered completed were in fact not finished. In large part this perception was a consequence of Rembrandt's rough style, which appeared unfinished in comparison with the meticulous, smooth surfaces that were produced by many other contemporary Dutch artists.[9] Arnold Houbraken, a painter who knew several artists who had worked with Rembrandt, remarked that he had seen paintings by Rembrandt "in which some parts were worked up in great detail, while the remainder was smeared as if by a coarse tarbrush, without consideration to the drawing." Yet, Houbraken continued, "he was not to be dissuaded from this practice, saying in justification that a work is finished when the master has achieved his intention in it."[10]

More than 50 younger artists are known to have worked in Rembrandt's studio at various times, as apprentices or associates.[11] Yet Alpers emphasized the individualism of Rembrandt's studio in contrast to the practice of a contemporary of his, Peter Paul Rubens. Thus Alpers observed that Rubens "promoted a division of labor. He developed a painting factory: assistants specialized in certain skills—landscapes, animals, and so on—and the master devised a mode of invention employing a clever combination of oil sketches and drawings. These permitted his inventions to be executed by others, sometimes with final touches to hands or faces by the master himself." Unlike this system of collective produc-

tion, however, in Rembrandt's studio the master and his students worked independently, and each artist produced paintings on his own for sale. Unlike Rubens, Rembrandt almost never collaborated with assistants. The practice of Rubens was common among his contemporaries, and Alpers concluded that "Rembrandt's idiosyncrasy was that he . . . treated the painting of a picture as a definitively individual enterprise. He demonstrated that there is no necessary contradiction between running a business and claiming individual pictorial authority."[12]

Rembrandt's relations with patrons were often strained. He required very long hours from his sitters, he was sometimes very tardy in finishing commissioned works, and he often ultimately delivered works that patrons considered unacceptable. Unlike Vermeer and a number of other contemporary Dutch artists, Rembrandt does not appear to have wanted to have a single wealthy patron who bought a large proportion of his works. Alpers noted that Rembrandt's working methods would have made such a relationship problematic, because his open-ended approach meant that the amount of labor he devoted to a painting was unpredictable, as was the work's final appearance. "Rembrandt's characteristic working and reworking of the paint meant that the amount of time he spent was incalculable and the achievement of completion impossible to judge." Rembrandt's difficulties with patrons therefore ultimately stemmed from his refusal to compromise stylistically: "He was . . . unwilling to produce works that could be paid for, and hence valued, in the accustomed ways."[13]

Rembrandt was interested in the art of the Italian Renaissance. So, for example, the inventory of his possessions made in 1656 when he declared bankruptcy included books of prints made after the paintings of Michelangelo, Raphael, Titian, and several dozen other artists.[14] Yet unlike Rubens and many other contemporary painters, Rembrandt rarely copied earlier works; among hundreds of his surviving drawings, barely more than a dozen are copies after canonical images, and his paintings rarely appear to have been based on earlier art. Alpers observed that Rembrandt worked from live models in every medium he used—painting, drawing, and even etching—and that this evidently provided his inspiration: "In Rembrandt's practice representation of models posing in the studio took the place of borrowing from the art of the past."[15]

Interestingly, the gradual process of creating images that undermined Rembrandt's ability to satisfy patrons for his paintings had an opposite effect on the commercial success of a different part of his artistic enterprise. Rembrandt's European reputation during his lifetime was largely a product of the sale and distribution of his etchings. His method of making prints was related to his practice in painting: thus a recent study observed that "Rembrandt made no less than 300 etchings, and most were created

directly on the copper plates without recourse to preliminary drawings."[16] And like his paintings, his etchings were subject to frequent changes; many were printed in three or four different versions, and some are known to exist in as many as eight states. In this domain, however, his practice of repeatedly reworking his plates was transformed into a source of profit, for impressions of each of a number of different states of a print could be sold as independent works. Thus Houbraken reported, "Thanks to his method of putting in slight changes or small additions so that his prints could be sold as new . . . no true connoisseur could be without the *Juno* . . . with or without the crown—or *Joseph* with his head in the light and with his head in shadow."[17]

Art historians have documented and discussed each of these features of Rembrandt's practice but have offered no unifying analysis for them and generally have not attempted to consider whether they might be characteristic of more than this single artist. Yet his failure to make preparatory drawings for his paintings, his frequent changes of his work in progress, his reluctance to finish his paintings, his progressive development of a style that revealed in the final product the process by which a painting had been made, his insistence on executing his own works entirely by himself, with images that were entirely his own, and the presentation of a series of different states of a single print for purchase are all consistent with the proposition that Rembrandt was an experimental artist, who worked by trial and error toward vague but ambitious visual goals.[18] Also consistent with this view is the widespread consensus among art scholars that Rembrandt's art was magnificent in his old age. Rembrandt died in 1669, at the age of 63. Jakob Rosenberg and Seymour Slive offered this judgment of his late work: "During the last years no basic change occurs in Rembrandt's style. . . . His expressive power, however, grows until the very end. The boldness and freedom of his brushwork are at a peak in the great works of the later sixties. Very few artists—one thinks of Michelangelo, Titian, Goya—offer the same spectacle of an ever-increasing power of expression which culminated at the end of their lives."[19]

The art historian Robert Jensen has recently demonstrated the value of examining the work and careers of some of the greatest old masters in light of the analytical framework that has been presented earlier in this study with reference to modern painters. Guided by Jensen's work, it is possible to indicate how the analysis helps us to gain a new perspective on the life cycles of some of the key figures in Western painting from the fifteenth through the seventeenth centuries.[20]

Masaccio (1401–29?) was perhaps the first of the young geniuses who have radically changed the development of Western painting. In a series of works probably painted shortly before his premature death at about the age of 28, Masaccio created a synthesis of three major elements to

achieve a dramatic new representational illusionism. Two of these were borrowed from earlier innovators. From his Florentine predecessor Giotto, Masaccio took the shading of light and dark, foreshortening of forms, and overlapping of figures that had begun to replace the flat images of medieval art with scenes that appeared three-dimensional. Second, from his friend the architect Brunelleschi, Masaccio borrowed the system of linear perspective that made it possible to represent distance in paintings in a scientifically measurable way, adding a new order and rationality to the depiction of the visible world. And to these borrowed techniques, Masaccio added an original element of his own, by using a single consistent source of light in his paintings. Later named chiaroscuro, the spotlight effect created by this device produced greater drama than the less highly focused illumination of Giotto, and also served to create greater unity within the composition, through the consistency of the shadows cast by the figures.

Masaccio's synthesis of these three elements produced a revolutionary breakthrough in the ability of painting to make convincing and powerful representations of figures in an illusionistic space that could be perceived as an extension of the viewer's own world. This synthesis was a great conceptual achievement, based not only on careful study of earlier artists' practices, but also on extensive mathematical calculation.[21] We have no contemporary descriptions of Masaccio's working methods, and there are no known surviving drawings by him. Inspection of one of his major works, however, has revealed that he "painted the head of the Virgin in the *Trinity* in Sta. Maria Novella, Florence, over an incised grid, which presupposes that he was working from a careful, squared study for this subtly foreshortened head." Squaring preparatory drawings to transfer them accurately to the support for the final work would become a common practice by the end of the fifteenth century, but it was not standard early in the century, and Masaccio may have been among the earliest artists to employ this method of using "a formal, precise drawing as a guide to painting."[22] Writing more than a century later, Giorgio Vasari accurately observed that Masaccio's discoveries had made Florence's Brancacci Chapel, the location of Masaccio's greatest work, "a school of art for the most celebrated sculptors and painters, who have constantly gone there to study"; among these students was Leonardo da Vinci, who himself paid tribute to the revolutionary role of Masaccio's "perfect works."[23]

Leonardo (1452–1519) brought a strong experimental orientation to many of his varied pursuits, for he had a firm belief that "those sciences are vain and full of error which are not born of experience."[24] Many art scholars have been intrigued by Leonardo's drawing style. David Rosand stressed the experimental and visual quality of Leonardo's drawing: "Only by drawing did he truly come to understand, was his vision clari-

fied."[25] E. H. Gombrich emphasized the contingent nature of his drawing: "Leonardo works like a sculptor modelling in clay who never accepts any form as final but goes on creating, even at the risk of obscuring his original intentions."[26] Martin Kemp credited Leonardo with "a revolution in drawing style," which he called a " 'brain storm' of dynamic sketching": "Never before had any artist worked out his compositions in such a welter of alternate lines. . . . Such flexibility of preparatory sketching became the norm for later centuries; it was introduced almost single-handedly by Leonardo." Leonardo made preliminary sketches for his paintings, but these did not typically yield a precise image for the final work. Kemp's inspection of a series of studies Leonardo made for a painting he executed in 1481 led him to conclude that "the painting's format never settled in his mind into a fixed pattern which could be systematically realized in a series of orderly steps. . . . The flow of his thought cascaded onwards in a rough and tumble of ideas, sometimes splashing off in unexpected directions—unexpected, we may suspect, even to Leonardo himself."[27]

Leonardo sternly warned other artists against the common practice of rigidly following precise preparatory drawings in executing their paintings:

> You who compose subject pictures, do not articulate the individual parts of those pictures with determinate outlines, or else there will happen to you what usually happens to many and different painters who want every, even the slightest trace of charcoal to remain valid; this sort of person may well earn a fortune but no praise with his art, for it frequently happens that the creature represented fails to move its limbs in accordance with the movements of the mind; and once such a painter has given a beautiful and graceful finish to the articulated limbs he will think it damaging to shift these limbs higher or lower or forward or backward.[28]

Leonardo tried to make meticulous plans for *The Last Supper*, the large fresco that would become his most reproduced work in historians' surveys of art. Yet Kemp notes that Leonardo failed to solve several problems in his preparatory drawings, and that consequently the painting not only presents the viewer with several visual paradoxes, such as the fact that the fresco's table is not large enough to seat all the disciples, but also that Leonardo deviated from his plans in the course of painting the work. Thus the image of Christ that is the fresco's central point of visual interest is not located where a careful plan would have placed it: "The focus of the perspective and the center of the grid are slightly but unquestionably out of conjunction." Kemp's proposed explanation for this is that Leonardo moved the focal point of the fresco's perspective away from the center of the work's grid for visual reasons, and thus that he made "intuitive

adjustments . . . for the sake of required effects—even if these adjustments were incompatible with the rules of scientific naturalism."[29]

Leonardo's style evolved as he aged. Kemp attributes the enigmatic quality of Leonardo's most popular painting, the *Mona Lisa*, to the artist's refusal late in his career to delineate definite contours; he argues that the painting's true originality lies in Leonardo's creation in painting of "the equivalent of a mobile face, in which the physiognomic signs do not constitute a single, fixed, definitive image." Instead of definite lines, the face of the *Mona Lisa* presents the viewer with "a series of tonal transitions which denote changes of contours," and "not even these rounded contours are definite." The elusive image is a product of a series of superimposed glazes, a technique characteristic of Leonardo's late work. Kemp believes that *Mona Lisa* was developed gradually over a number of years and may not have been completed until Leonardo had passed the age of 60.[30]

The richness of Leonardo's late work is consistent with the flexibility of his methods of execution in identifying him as an experimental artist. One of his greatest contributions to the development of painting was in fact his rebellion against the rigidity of traditional procedures that emphasized the use of careful and thorough preparatory studies for paintings, and his invention of working methods that instead allowed the artist the freedom to develop his ideas as he worked. As much as any artist in Western history, Leonardo stands for the enormous possibilities inherent in the artistic process, for as Gombrich observed, "ultimately it is the act of creation itself that matters to him."[31]

In 1508, Pope Julius II summoned Michelangelo (1475–1564) to Rome to decorate the ceiling of the Vatican's Sistine Chapel. Michelangelo considered himself primarily a sculptor and disliked large projects; an early biographer reported that he "made every effort to get out of it . . . pleading that this was not his art, and that he would not succeed."[32] The pope was adamant, however, and over the course of the next four years Michelangelo produced the enormous fresco that has become perhaps the single most celebrated work in the history of Western art.

Michelangelo's early intentions for the ceiling were relatively modest, but he soon decided that the painting he had planned would be too "poor," and the pope allowed him to "make what I wanted, whatever would please me." Michelangelo dramatically expanded the project, creating a complex work that summarized a series of biblical episodes. Yet although Michelangelo planned the images of individual figures and groups for the fresco, he does not appear to have made any drawings that planned the composition as a whole. The work is unified by the relationship of the figures to the architecture, but S. J. Freedberg observed that "it is not always quite clear what the various thematic motifs mean, or how

they relate precisely to each other." Michelangelo's style changed greatly in the process of executing the work, as an "increase of energy, freedom, and variety . . . is visible in each successive step."[33] A variety of evidence attests to the fact that Michelangelo's projects, not only in fresco but also in sculpture and architecture, normally evolved considerably during the course of their production.[34]

Michelangelo was a visual artist, and in both painting and sculpture he was willing to sacrifice such scientific considerations as correct bodily proportion to the overall visual impact of his work, so that his figures are often oversized, with improbable musculature, and portrayed in dramatic but unlikely contortions. Even as an architect, Michelangelo worked visually and experimentally; James Ackerman observed that in contrast to his contemporaries Michelangelo "rarely indicated measurements or scale on his drawings, never worked to a module, and avoided the ruler and compass until the design was finally determined." His architectural drawings instead considered such visual effects as the appearance of the type of stone to be used, and even "the most tentative preliminary sketches are likely to contain indications of light and shadow." The guiding concern was visual: "The observer is there before the building is designed."[35]

Michelangelo's frequent changes of his works in progress and his visual approach to all of his artistic endeavors clearly identify him as an experimental artist. So, too, does his growing inability over the course of his career to finish his works. Rudolf Wittkower has argued that the unfinished works of both Leonardo and Michelangelo represent a new phenomenon in the history of Western art. Wittkower rejects the view that Michelangelo failed to complete his works simply because of interruptions and disturbances occasioned by his powerful patrons, but contends that instead they remained incomplete because of the artist's dissatisfaction with his achievement:

> We have to face the fact that first with Leonardo (who never finished anything) and then with Michelangelo the *non finito* enters an unknown phase. We can be absolutely certain that medieval works, if unfinished, remained incomplete for external reasons. But when we come to Leonardo and Michelangelo, internal as well as external causes may have prevented completion.
>
> So far as we can see, never before had a tension existed between the conception and the execution of a work. But now doubt in the validity of worldly art, self-criticism, dissatisfaction with the imperfect realization of the inner image, the gulf between mind and matter and—in Michelangelo's case—between the purity of the Platonic idea and the baseness of its material realization prevented these masters from finishing their works.[36]

If Wittkower is correct, these two great Renaissance artists may offer the first cases in Western art in which the experimental perception that the perfect is the enemy of the good resulted in an artist's inability to produce finished works.

Raphael (1483–1520) was widely recognized by contemporaries as a young genius: Vasari introduced his biography by proclaiming that "Heaven sometimes showers infinite riches on one sole favorite," and remarked that men like Raphael were "mortal gods who leave such fame on earth that they may hope for sure rewards in heaven hereafter."[37] Raphael has long been known for the facility with which he assimilated the art of his predecessors; a recent study observed that "Raphael's receptivity was astonishing: the speed with which he took up a design procedure pioneered by Leonardo da Vinci, or a novel technique for representing form learned from Michelangelo's drawings, for example, is an indicator of the fertile vigor of his responsiveness to the challenge of new artistic problems."[38]

Both Raphael's finished works and his method of making them came to stand for order and rationality in art. Francis Ames-Lewis explained that "from the very start of Raphael's career he seems to have brought the activity of drawing to bear on the pictorial problems at hand in a much more concentrated way than had any earlier painter. Raphael seems to have perceived more clearly than earlier artists the benefit to the final design of a logical and increasingly elaborate preparatory drawing procedure." He worked systematically and purposefully, as "throughout the preparatory process he kept fully in mind the character and purpose of the final work."[39] Raphael's meticulous preparatory process led to works that are considered marvels of resolution. David Rosand observed that Raphael's method was "a system that assigns a precise practical function to the clear contour; it is also the basis for an aesthetic that appreciates such clarity. The search for compositional solution . . . is relegated to drawing. The finished panel boasts a decisiveness and perfection belying whatever creative sweat went into it: the art that hides art."[40]

In view of the fact that Raphael is celebrated for the fastidiousness of his preparatory process and the precision of his finished work, it is hardly surprising that his paintings are highly conceptual. The inspiration for his paintings came not from nature or daily life, but from antiquity or the work of other artists. His ambition was not to portray realistic figures or scenes, but to create perfect forms arranged in harmonious compositions. He did not need real models: lacking a sufficiently beautiful woman to pose as Galatea, he reported, "I made use of a certain ideal that is in my mind."[41] Gombrich described his images as "ideas come to life."[42] Hans Belting explained the enormous fame Raphael's *Sistine Madonna* acquired in Germany in the nineteenth century: "People were fascinated by

the concrete presence of a *work* in which an *idea* of art had crystallized with such clarity."[43] Vasari suggested that Raphael himself recognized that he could not match the great experimental artists Leonardo and Michelangelo in the visual power of their images, but that he understood that his own conceptual art had other strengths: "He saw that he who could express a thought clearly and compose without confusion may also be reputed an able master."[44]

Raphael's tribute to human reason, *The School of Athens* in the Vatican's Stanza della Segnatura, is often considered his greatest achievement. This enormous fresco, in which Plato and Aristotle are surrounded by 50 other philosophers and scientists of ancient Greece, was completed by Raphael when he was 28. Raphael's remarkable composition achieved a high degree of unity in spite of the enormous challenge posed by the large number of individual figures arrayed in a wide variety of poses, producing a representation of what Kenneth Clark called "society in perfect equilibrium."[45] A limited number of individual figure drawings for the fresco survive, but many more were probably made, for John Pope-Hennessy argued that "every single figure in the *School of Athens* must have been preceded by thoughtful, closely cogitated studies."[46] The complexity of the composition was so great that Raphael made a huge preparatory cartoon for the final work that included 51 of the 52 figures in the fresco.[47] In his greatest work the synthesizer Raphael appears to have paid tribute to two of the artists from whom he had learned the most, for the figure of Plato may be a portrait of Leonardo, and Heraclitus, the final figure added during the execution of the fresco, may be a portrait of Michelangelo.

Vasari reported an interesting difference between the practices of Michelangelo and Raphael. In Vasari's account, when Michelangelo had completed his initial drawings for the ceiling of the Sistine Chapel, the scale of the project was such that he needed assistance, so he sent to Florence for six artists who had experience in painting frescoes. When they had begun, however, their work was so far below Michelangelo's expectations that he locked them out of the chapel and refused to see them, whereupon they returned to Florence in shame. Michelangelo destroyed the work they had done and proceeded to paint the entire ceiling himself.[48] In contrast, Vasari reported that when Raphael became successful he employed a large number of assistants and "was never seen at court without some fifty painters."[49] Pope-Hennessy observed that after 1515, in a practice that may have anticipated the later procedures of LeWitt and Warhol discussed in chapter 3, "Raphael over a large part of his work became an ideator instead of an executant," as he made preparatory drawings or cartoons for works that would then be painted by assistants.[50] As would be true of the executive artists of the 1960s,

Raphael's willingness to have his works executed by others may have been a function of his conceptual approach to art, whereas Michelangelo's desire to produce his most ambitious project with his own hand might have reflected his experimental attitude.

Titian (1488/90–1576) appears rarely to have made preparatory studies for his paintings. A seventeenth-century historian of art recorded a description of Titian's method of painting as recounted by a student of the master:

> He used to sketch in his pictures with a great mass of colors, which served, as one might say, as a bed or base for the compositions which he then had to construct. . . . Having constructed these precious foundations he used to turn his pictures to the wall and leave them there without looking at them, sometimes for several months. When he wanted to apply his brush again he would examine them with the utmost rigor, as if they were his mortal enemies, to see if he could find any faults; and if he discovered anything that did not fully conform to his intentions he would treat his picture like a good surgeon would his patient. . . . In this way, working on the figures and revising them, he brought them to the most perfect symmetry. . . . Thus he gradually covered those quintessential forms with living flesh, bringing them by many stages to a state in which they lacked only the breath of life. . . . [T]he final stage of his last retouching involved his moderating here and there the brightest highlights by rubbing them with his fingers, reducing the contrast . . . and harmonizing one tone with another.[51]

Recent technical analysis using X-ray and infrared photography has confirmed that Titian worked directly on the canvas and proceeded experimentally: "From the start Titian used very little underdrawing in his works, except in difficult passages. . . . He built his compositions up directly from the primed ground using his paintbrush. . . . He tended to build up many layers of paint of variable thicknesses. . . . Titian is equally notable for the radical changes he made in the composition, viewpoint, and narrative moment he chose to depict."[52]

One of Titian's distinctive contributions was the creation of new spatial relationships, as the figures in his paintings would not uniformly face a single position in front of the canvas, but would instead be arranged with different orientations and at different depths in the illusionistic picture space. This had the effect of changing viewers' perceptions of the work as they changed their position in front of it, making them feel that they were active participants in the scene represented. X-rays of Titian's most reproduced painting, the *Pesaro Family Altarpiece*, in which this innovation appears in dramatic form, reveals that Titian arrived at the composi-

tion of the work experimentally, as several earlier versions of the scene lie beneath the final arrangement.[53]

X-rays of Titian's paintings have also documented a process he used that allowed him effectively to work in series, with an image from a finished painting serving as a point of departure for a later one. Thus, for example, an X-ray of *Danaë* (1544–46) revealed the outline of an image from an earlier painting beneath the surface: "As would become fairly standard later in his career, Titian evidently blocked out a replica of the *Venus of Urbino* [ca. 1538] before it left his studio; this assured that a compositional invention of obvious appeal was preserved for future development—and, of course, Titian would indeed develop a series of variations on that basic theme of the reclining Venus."[54]

Titian's style evolved throughout his long life, as the clarity and precision of his early work gave way to a style that emphasized the texture of the material surface of the painting. Vasari remarked on the change, noting that "the early works are executed with a certain delicacy and a diligence that are incredible, and they can be viewed from both up near and from a distance, and these last works, on the other hand, are executed in bold strokes and dashed off with a broad and even coarse sweep of the brush, insomuch that from near little can be seen, but from a distance they appear perfect." Vasari warned that many painters who tried to emulate Titian's late style "have painted clumsy pictures; and this happens because many believe they are done without effort, in truth it is not so, and they deceive themselves, for it is known that they are painted over and over again, and that he returned to them with his colors may times." This style required judgment born of experience: "This method so used is judicious, beautiful and astonishing, because it makes pictures appear alive."[55]

The vitality of Titian's late style became an inspiration to many later painters to work more freely and spontaneously. For centuries the great European academies taught the rigid absolute standards of aesthetic perfection personified by Raphael. For those painters who chafed under the restriction of this approach, however, Titian and his late style presented an alternative model, of the autonomous artist who discovers his own form of expression through the act of painting. Thus, for example, Ernst van de Wetering has argued that the "painting with splotches" of Titian's late style, and the description of Titian's method given by Vasari (and translated into Dutch in 1604), became a direct inspiration for Rembrandt's own great late style, as in a series of practices—the rough style that produced coherent images only when viewed from a distance, the production of works that were widely considered to be unfinished, the frequent alterations of works in progress that were an almost inevitable product of working directly on the canvas without preliminary studies, and the building up of images through the application of many layers

of paint—Rembrandt followed what had already become the legendary example of Titian.[56] Their visual approach to painting and the glorious development of their art over decades of study made both Titian and Rembrandt archetypal experimental innovators, and it is perhaps fitting that Roger Fry identified these two masters as the prime examples of artists "who seem to require a very long period of activity before this unconscious element finds its way completely through into the work of art."[57]

Frans Hals (1580/85–1666) was known by contemporaries for the vitality and spontaneity of his portraits, which were a product of his animated brushwork, his ability to capture fleeting expressions and momentary poses of his sitters, and his innovative use of highlights to create brilliant and impressionistic images. The eighteenth-century English portraitist Sir Joshua Reynolds acknowledged that Hals's ability to capture the character of the individuals he painted was unrivaled, but he thought that Hals lacked "a patience in finishing what he so correctly planned."[58] Hals's planning was informal, however, as Jakob Rosenberg and Seymour Slive report that not a single preparatory drawing can be attributed to Hals with certainty. Hals worked only with a model in front of him: "Purely imaginary subjects did not interest him. Thrown upon the resources of his own imagination he must have been lost and unable to proceed."[59]

Hals's style evolved markedly over the course of his career, away from the complex compositions and often boisterous scenes he had painted as a young man, toward greater simplicity and the use of more subdued, often monochromatic, color schemes. His late portraits are often austere and even tragic in mood. Although somber, however, his late works are his most powerful, as Rosenberg and Slive comment that "portraits of the last years have some of the psychological penetration and restraint which characterizes the majestic works of Rembrandt's mature phase."[60] Hals was destitute late in his life, and in 1662 he was forced to seek financial assistance from the authorities of his home city of Haarlem. His most illustrated painting, a group portrait of the regentesses of Haarlem's old men's home, was painted in 1664, when Hals was probably past the age of 80. The painting portrays the grim faces of the governors as they might have appeared to a candidate being interviewed for admission to the home. Hals's remarkable visual insight into the personalities of these cheerless women and the chilling atmosphere of their institution may have been heightened by his own financial troubles, for it may not have been difficult for him to imagine how it would look and feel to come before the regentesses in their official capacity. The consistently visual nature of Hals's work throughout his life and his greatness in old age clearly identify him as an experimental innovator.

There is a long history of comparisons of the work of Diego de Veláz-quez (1599–1660) to that of Titian, and there is little doubt that the meth-ods of Velázquez were influenced by those of Titian and his followers. Only a handful of drawings are attributed to Velázquez, and technical examination of his paintings reveals that he habitually made revisions of his works directly on the canvas as he painted.[61] In a recent study Carmen Garrido concluded that "Velázquez does not seem to have started with a fixed idea for a composition but rather preferred to see what happened as he worked, making adjustments as he painted."[62]

Throughout his adult years, Velázquez's style evolved progressively to-ward what one recent study called "dematerialization of form," as the firm outlines and thick paint of his early works gradually gave way to later works in which indefinite contours were created with thin glazes of paint.[63] Garrido observed that during this process "Velázquez's technique evolved towards greater simplification and rapidity of execution," and she remarked that his late technique, "which becomes increasingly sche-matic without sacrificing realistic effects, is the result of a long process of intellectual maturation."[64] The philosopher José Ortega y Gasset ex-plained that in basing his art on visuality, Velázquez had discovered that defining figures precisely was not realistic, for "*in his reality*, bodies . . . are imprecise." Ortega rejected claims that the imprecision of his late works was a result of Velázquez's concern with atmosphere, and instead insisted that he simply painted figures as he saw them: "The airy effect of his figures is owed simply to this daring indecision of profile and surface in which he leaves them. . . . He had made the most unpopular of discover-ies: that reality differs from myth in that it is never completed."[65]

Velázquez painted his most celebrated work, *Las Meninas*, at the age of 57. The painting's central point of interest, the face of the young Princess Margarita, "which seems slightly out of focus, fades at its edges into the ground color."[66] Jonathan Brown and Carmen Garrido reflect that "*Las Meninas* can be thought of as the largest oil sketch ever painted. All during his mature years Velázquez had sought to make the world come alive by suggesting the appearance of visual data through strategies of indefinite-ness. Trying to capture fugitive, changing circumstances in permanent form is the name of his game, and into *Las Meninas* Velázquez decanted the experiences of a lifetime in pursuit of this ambition."[67] In view of Velázquez's experimental commitment to a visual art, it is not surprising that he executed one of the most celebrated paintings in the history of Western art near the end of his long career.

Johannes Vermeer (1632–75) is famed for the clarity, simplicity, and elegance of his images, for the coherence and subtlety of his compositions, and for the meticulous attention to detail that helps to make his paintings compelling depictions of the transitory moments they represent. Technical

analysis of Vermeer's paintings has shown that he achieved these effects
through painstaking planning and working methods that relied on sys-
tematic construction of his images.

Vermeer's known oeuvre consists of fewer than 40 paintings. A recent
study of 26 of these with the use of a microscope revealed that in 15
the point on the canvas that coincides with the vanishing point of the
perspective lines of the composition is marked in some way. In most of
these cases there is a small hole in the canvas, indicating that Vermeer
followed the common practice of inserting a pin into the canvas at the
vanishing point, then using a string attached to it to trace correct orthogo-
nals, the straight lines of perspective that meet at the central vanishing
point.[68] Vermeer furthermore began some of his paintings by making de-
tailed underdrawings on the canvas. This was also a common practice,
but Vermeer used it in what was probably an uncommon way, for instead
of using the sketch simply as a guide to the composition of a scene, Ver-
meer also used it to establish the effects of light, with indications of high-
lights, shadows, and reflections. The importance of the underdrawing to
Vermeer is further witnessed by the care with which he followed its guid-
ance in carrying out his painting: "Some artists used the sketch as a gen-
eral starting point, freely modifying the forms in the final image. But
whenever Vermeer's design lines could be observed, it was clear that his
final painting layers conformed very closely to the sketch."[69]

When Vermeer began to draw on his canvas, he had therefore precon-
ceived not only the design of his final work, but also the subtleties of
how light would fall on its figures. And while it is known that Vermeer
frequently used the mechanical means detailed here to establish accurate
perspective in making his initial drawings, many scholars believe that he
also used an optical device called a camera obscura to help him capture
the remarkable visual effects that are featured in his paintings. The high
degree of preconception of the images in his works, and his willingness
to use mechanical devices to help his own eye and hand to produce them,
clearly distinguish Vermeer as a conceptual artist.

Masaccio and Raphael are among the most celebrated examples of
young geniuses in the history of Western art, and they and Vermeer have
also long been famed for the perfection and technical excellence of their
paintings. Leonardo, Michelangelo, Titian, Hals, Velázquez, and Rem-
brandt are in contrast among the painters who have long been recognized
for the expressive power of their late work. Yet in the absence of system-
atic comparative analysis, art scholars have failed to recognize the com-
mon patterns identified here. For both the clarity of conception and the
early greatness of Masaccio, Raphael, and Vermeer are characteristic of
conceptual innovators, whereas the absence of preconception and the

TABLE 5.1
Ages of Selected Old Masters When They Executed Their Single
Most Frequently Reproduced Painting

Artist, Painting	Date	Age
Masaccio, *Tribute Money*	c. 1427	c. 26
Leonardo da Vinci, *Last Supper*	1498	46
Raphael, *School of Athens*	1511	28
Michelangelo, *Sistine Chapel Ceiling*	1512	37
Titian, *Pesaro Family Altarpiece*	1526	36/38
(t) Rembrandt, *Anatomy Lesson of Dr. Tulp*	1632	26
(t) Rembrandt, *Night Watch*	1642	36
Vermeer, *View of Delft*	c. 1661	c. 29
Frans Hals, *Regentesses of the Old Men's Home*	c. 1664	79/84
Velázquez, *Las Meninas*	1656	57

Source: Robert Jensen, "Anticipating Artistic Behavior," table 2, p. 144.

greatness in old age of Leonardo, Michelangelo, Titian, Hals, Velázquez, and Rembrandt are marks of experimental innovators.

Robert Jensen analyzed the illustrations of paintings by these artists contained in 28 textbooks of art history. Based on his study, table 5.1 shows that the three conceptual artists considered here all executed their single most frequently reproduced painting before the age of 30, whereas the six experimental painters produced their major works at ages ranging from a minimum of 26 to a maximum of at least 79. The median age of the three conceptual artists when they made these greatest works was 28, whereas the median age of the six experimental artists was 42. The contributions of the conceptual painters were also more highly concentrated in time. Thus table 5.2 shows that at least half of the total illustrations of the paintings of Masaccio, Raphael, and Vermeer represent works done within a period of less than 10 years, whereas all but one of the comparable spans for the experimental painters are greater than ten years, with three intervals of 20 years or more, and a remarkable 30 years for Michelangelo. A survey of textbooks therefore clearly demonstrates that art historians consider the conceptual painters typically to have made their major contributions earlier in their careers, and within shorter periods of time, than the experimental old masters.

The contrasts between the careers of conceptual and experimental innovators that are observed even in this brief survey of a small number of old masters are dramatic. An illustration begins with the comments of Jakob

TABLE 5.2
Shortest Periods That Include at Least Half an Artist's Total Illustrations

Artist	No. Years	Ages
Masaccio	1	27
Vermeer	6	28–33
Leonardo	8	46–53
Raphael	9	22–30
Hals	14	35–48
Velázquez	18	40–57
Rembrandt	20	44–63
Titian	21	28–48
Michelangelo	30	37–66

Source: Jensen, "Anticipating Artistic Behavior," table 3, p. 144.

Rosenberg and Seymour Slive on the early work of Frans Hals: "Students of Dutch art, who have assiduously searched for Hals' juvenilia, have found virtually nothing. What one of the most talented artists who ever lived did before he was about twenty-five or thirty years old . . . remains an unsolved riddle. . . . [P]erhaps . . . he was a slow starter."[70] Although the work Hals did prior to the age of 30 can thus be casually dismissed as juvenilia, the same is emphatically not true of that of Tommaso di Ser Giovanno. Better known as Masaccio, Tommaso died before he reached the age of 30, but not before he had created a new visual representation of space that would dominate Western painting for nearly five centuries. That domination would end only in the twentieth century, when another painter who was himself not yet 30 years old would replace Masaccio's conception of space with a different conceptual principle. When that later young genius had in turn completed his remarkable career, past the age of 90, a biographer who was also an old friend was saddened by the poverty of his late work that was revealed by a posthumous exhibition: "All the same, a sad end. Of course it would have been more dignified if the great man had died in the odor of artistic sanctity, like Titian or Rembrandt or Cézanne. But, let us face it, Picasso's vision had reached its apogee in his thirties."[71]

CHAPTER SIX

beyond painting

The analysis of the two life cycles of creativity that has been presented in this book was initially developed by studying modern painters. The preceding chapter, however, showed that it can profitably be extended to the careers of premodern painters. Recent research has in fact established that the analysis can be applied much more broadly, to other intellectual activities. The value of doing this will be demonstrated in this chapter, through reference to selected important practitioners of four other arts. In each case, although the number of artists considered will not be large, the purpose is to illustrate how the analysis can be applied to important features of the methods and products of major figures in each activity, and can be used to gain a systematic understanding of the nature and timing of their major contributions.

SCULPTORS

The only principle in art is to copy what you see.
Auguste Rodin, 1906[1]

An object to me is the product of a thought.
Robert Smithson, 1969[2]

Tables 6.1 and 6.2 are based on a survey of all the illustrations of sculptures made by seven selected modern sculptors that are contained in 25 textbooks of art history. Table 6.1 ranks the seven sculptors by the total number of illustrations of their work that appear in all the books. Four sculptors (Auguste Rodin, Constantin Brancusi, Alberto Giacometti, and David Smith) all have well over 25 total illustrations, or more than one per book, whereas three (Umberto Boccioni, Vladimir Tatlin, and Robert Smithson) all have less than 1 illustration per book. The order of these two groups is reversed in table 6.2, however, when the seven sculptors are ranked according to the number of illustrations the same books contain of the single most often reproduced sculpture by each. Thus Boccioni, Smithson, and Tatlin each made one sculpture that is reproduced in well over half the books surveyed, whereas no single work by Rodin, Brancusi, Giacometti, or Smith appears in as many as half the books. Interestingly,

TABLE 6.1
Ranking of Selected Modern Sculptors by Total Illustrations in 25 Textbooks

Artist	Illustrations
Auguste Rodin (1840–1917)	65
Constantin Brancusi (1876–1957)	51
Alberto Giacometti (1901–1966)	39
David Smith (1906–1965)	34
Umberto Boccioni (1882–1916)	21
Vladimir Tatlin (1885–1953)	19
Robert Smithson (1938–1973)	19

Source: See table 4.6.

also, the individual sculptures listed for Boccioni, Smithson, and Tatlin in table 6.2 clearly dominate their careers from the vantage point of the textbooks, as each accounts for more than three-quarters of the total illustrations of those sculptors' works shown in table 6.1.

Taken together, tables 6.1 and 6.2 pose several interesting puzzles. First, why didn't some of the greatest modern sculptors, including Rodin, who is often considered the single most important figure in modern sculpture, produce particular sculptures that are considered indispensable to narratives of art history? Second, why did such relatively minor sculptors as Boccioni, Smithson, and Tatlin produce individual works that are effectively judged more important than any single pieces by much greater sculptors? And third, why does the evidence of the textbooks imply that the careers of Boccioni, Smithson, and Tatlin are dominated by the individual works listed in table 6.2?

These puzzles have not been recognized by art historians, so there has been no discussion of them in the literature. Yet a resolution of all three is suggested by the analysis presented in this book. Specifically, Rodin, Brancusi, Giacometti, and Smith could be experimental innovators, who produced important bodies of work, while Boccioni, Tatlin, and Smithson could be conceptual innovators, whose contributions are dominated by individual masterpieces. Immediate support for this hypothesis is provided by table 6.2, which shows that Boccioni, Tatlin, and Smithson all produced their greatest individual works at considerably younger ages— from 31 to 35—than did Rodin, Brancusi, Giacometti, and Smith, who were from 46 to 58 when they made their most important works. Further evidence in support of the hypothesis is provided by a consideration of these sculptors' goals and achievements.

TABLE 6.2
Single Most Frequently Illustrated Work by Each of the Sculptors in Table 6.1

Artist, Sculpture, Date	Illustrations	Age of Artist at Time of Execution
Boccioni, *Unique Forms of Continuity in Space*, 1913	19	31
Smithson, *Spiral Jetty*, 1970	17	32
Tatlin, *Monument to the Third International*, 1920	15	35
Rodin, *Monument to Balzac*, 1898	12	58
Brancusi, *Bird in Space*, 1928	7	52
Smith, *Cubi XVIII*, 1964	7	58
Giacometti, *Man Pointing*, 1947	4	46
Giacometti, *City Square*, 1948	4	47

Source: See table 4.6.

Rodin is celebrated for the visual sensitivity of his work: George Heard Hamilton described him as "a superb modeller, perhaps the greatest in the history of European sculpture."[3] Yet Rodin's career, and art, developed slowly. The poet Rainer Maria Rilke, who worked for several years as Rodin's secretary, observed that "his work developed through long years. It has grown like a forest." The reason for this was clear to Rilke, for he explained that Rodin's art "depended upon an infallible knowledge of the human body" that he had gained slowly and painstakingly: "His art was not built upon a great idea, but upon a craft."[4] It was not only Rodin's craft that developed slowly, but also his individual sculptures: "I am unfortunately a slow worker, being one of those artists in whose minds the conception of work slowly takes shape and slowly comes to maturity."[5]

Rodin's art was avowedly visual: "I strive to express what I see with as much deliberation as I can."[6] Ideas did not precede form, but followed it: "One must never try to express an idea by form. Make your form, make something, and the idea will come."[7] He did not work from imagination, but always in the presence of a model: "I have no ideas when I don't have something to copy."[8] He was incapable of planning his projects in advance and admitted, "I often begin with one intention and finish with another."[9] He routinely put aside an unfinished work "and for months I may appear to abandon it. Every now and then, however, I return to it and correct or

add a detail here and there. I have not really abandoned it, you see, only I am hard to satisfy."[10]

Rodin in fact became known to many of his contemporaries as a sculptor of unfinished works. In 1889, for example, Edmond de Goncourt criticized Rodin's figures for incomplete execution: "Amidst the present infatuation with Impressionism, when all of painting remains in the sketch stage, he ought to be the first to make his name and *gloire* as a sculptor of unfinished sketches."[11] Although Rodin resented these charges, the historian Albert Elsen concluded, "What now seems heroic and contemporary about Rodin is . . . his passion for the act of *making* rather than *completing* sculpture. During his creative moments, the best of the artist found its outlet through his fingertips. His personal problem was in setting for himself impossible absolutes of perfection toward which he dedicated a lifetime of striving."[12]

Rodin accepted a commission in 1891 for a sculpture to memorialize the great novelist Honoré de Balzac. After failing to meet a series of deadlines for the work, Rodin delivered it in 1898, when he was 58 years old. He considered the sculpture to be his most important achievement, "the sum of my whole life, result of a lifetime of effort, the mainspring of my aesthetic theory."[13] Yet when the sculpture was exhibited at the Salon of 1898 it caused a storm of protest by critics, the literary society that had commissioned it voted to dishonor its contract and refuse the sculpture, and a group of young artists actually plotted to vandalize it.[14] Stung by the criticism, Rodin withdrew *Balzac* from the Salon and moved it to his home outside Paris. It was not cast in bronze until more than two decades after Rodin's death.

The controversy over the *Monument to Balzac* resulted from its innovative synthesis of Rodin's central contributions to sculpture. Rodin was always concerned with animating his figures, and often did this by fixing transitory gestures and poses; doing this with the figure of Balzac, whom he portrayed not in formal dress but in the monk's robe he wore while working, in a dramatic stance, his head thrown back in a moment of creative inspiration, shocked those who expected a more conventional presentation. Rodin also used the surfaces and contours of his works to create atmospheric effects. The jagged profile of *Balzac*, the deep cavities of the face, and the rough surface of the robe all created sharp contrasts of light and shadow that emphasized the place of the figure in its environment, but also made the statue ugly to many viewers.

Rodin's willingness to break with basic conventions of monumental sculpture made *Balzac* a seminal contribution to modern art. He understood that this achievement was a product of his years of work and study. On a trip to Amsterdam in 1899, Rodin saw several of Rembrandt's greatest paintings and asked how old the artist had been when he made them.

When told that they were late works, Rodin remarked, "Of course, this is not the work of youth. . . . [H]ere he was free, he knew what to keep and what to sacrifice." When a friend asked if he saw parallels between the late Rembrandts and his own *Balzac*, Rodin replied that he did: "I, too, was forced to stretch my art in order to reach the kind of simplification in which there is true grandeur."[15]

Early in his career Constantin Brancusi worked briefly in Rodin's studio, but he soon left, explaining that "nothing grows under big trees."[16] Brancusi became an important sculptor by reacting against Rodin's style, but he realized how much he owed to Rodin, as late in his career he wrote, "Without the discoveries of Rodin, my work would have been impossible." Rudolf Wittkower explained that Brancusi's work was based on the fragmentary partial figures pioneered by Rodin: "The discovery that the part can stand for the whole was Rodin's, and Brancusi along with scores of other sculptors accepted the premise."[17] Brancusi's distinctive contribution was to develop an abstract form of sculpture, but he did this visually: the source of his inspiration was always real, and his forms always originated in human and natural biology. Early in his career he also developed the novel approach of working directly in stone. Unlike Rodin, whose plaster sculptures were translated to marble by technicians with the help of mechanical "pointing" devices, Brancusi himself cut directly into the stone.[18] He furthermore did this without advance planning: "I don't work from sketches, I take the chisel and hammer and go right ahead." This direct approach became a philosophy as well as a method: "It must be understood that all those works are conceived directly in the material and made by me from beginning to end, and that the work is hard and long and goes on forever."[19]

Brancusi worked by progressively simplifying a real form; he described his art as a search for "the essence of things."[20] Sidney Geist observed that his approach gave Brancusi's career a distinctive shape, as he worked in series with themes that evolved gradually:

> Brancusi has the curious faculty of continuing old themes while developing new ones, of recapitulating his past in terms that keep pace, as it were, with the evolving present. Thus the motif of *The Kiss* is pursued for a span of over thirty-five years, always recognizably *The Kiss*, always in stone, foursquare, and resting on a flat bottom, but undergoing changes of proportion, degree of stylization, and function. Twenty-seven related *Birds*, made in the course of thirty years, comprise a series that slowly changes in form and meaning and culminates in a version three times as tall as the first. *Mlle. Pogany*, in three marble versions and nine casts in bronze made between 1912

and 1933, maintains the same size while the motif is revised to a state just this side of abstraction.

Geist also noted a consequence of Brancusi's gradual evolution: "Just as there are no unsuccessful Brancusis or grave lapses in quality, so there are no towering peaks whose achievement sets them apart from the rest."[21]

Henry Moore summarized Brancusi's significance in modern sculpture: "Since the Gothic, European sculpture had become overgrown with moss, weeds—all sorts of surface excrescences which completely concealed shape. It has been Brancusi's special mission to get rid of this overgrowth, and to make us more shape-conscious. To do this he has had to concentrate on very simple direct shapes."[22] Brancusi's long experimental career appears as an extended visual process of gradually purifying and simplifying forms in pursuit of more direct shapes.

Umberto Boccioni's career as a sculptor differed radically from those of Rodin and Brancusi. In contrast to the gradual development of their plastic styles over the course of long lives dedicated to work and study, Boccioni sculpted for barely one year and produced a total of just a dozen sculptures. Remarkably, however, table 6.2 shows that one of those sculptures has become one of the most celebrated works of art of the twentieth century.

Boccioni was a young painter in 1909 when he and a few artist friends joined Futurism, which had initially been founded by the Italian poet F. T. Marinetti as a literary movement. One of Marinetti's central themes was the beauty of speed, so a primary concern of the Futurist painters became the visual representation of the experience of movement. One of their goals was to portray motion as a process that occurred over time, while another was to represent the tendency of motion to destroy the concreteness of forms.[23] As a Futurist Boccioni quickly adopted a highly conceptual approach to art, as he wrote to a friend that his new painting was "done completely without models. . . . [T]he emotion will be presented with as little recourse as possible to the objects that have given rise to it."[24]

Late in 1911 Boccioni visited Paris, where he saw new Cubist techniques that he quickly adapted to Futurist ends in his paintings. While in Paris Boccioni also became aware that there was not yet a Cubist school of sculpture, and that sculpture had consequently lagged behind painting in the development of advanced art. A consequence of this was that he might make an immediate impact on the art world by extending the concerns of Futurism to sculpture.[25] Boccioni wasted little time in doing this. Following Marinetti, Futurist artists had used a novel conceptual practice from the start, in which polemical written manifestos accompanied, or even preceded, actual works of art. In keeping with this approach, in April

1912 Boccioni published a manifesto proposing a Futurist sculpture. He then proceeded to learn how to make sculptures.[26]

A year later Boccioni exhibited 11 sculptures at a Paris gallery. His work was praised by the poet Guillaume Apollinaire, who was also perhaps the most respected critic in Paris's advanced art world: "Varied materials, sculptural simultaneity, violent movement—these are the innovations contributed by Boccioni's sculpture." Apollinaire teasingly referred to *Unique Forms of Continuity in Space* as "muscles at full speed," but he described it as a "joyful celebration of energy."[27]

Unique Forms was an imaginative synthesis, as a figure from classical Greek sculpture was transformed, with techniques taken from Cubist painting, to produce a three-dimensional representation of the visual effects of power and speed. The surfaces of the advancing figure are broken into parts, but rather than the straight lines and sharp angles of Cubism they are made into graceful curved planes. Their aerodynamic shapes appear bulky and muscular at the same time they seem to flow in the face of the strong winds created by the figure's rapid forward movement.

Boccioni gave up sculpting after he executed *Unique Forms*; John Golding concluded that "with its completion, Boccioni seems to have realized that he had achieved the definitive masterpiece for which he longed."[28] Boccioni then returned to painting, in a much more conservative style, in the few years that remained before he was killed in 1916 while serving in the Italian army. In spite of the brevity of his career, Boccioni's conceptual approach to art made it possible for him to contribute a seminal work to modern sculpture at the age of 31, after just one year of experience in that art.

Early in his career as a painter in Moscow, Vladimir Tatlin developed the conceptual philosophy that the artist should rely not only on vision, but also on knowledge—of proportion, geometry, and materials. A visit to Paris in 1913, where he saw new reliefs made by Picasso, as well as the work of Boccioni and other sculptors influenced by Cubism, had a profound impact on Tatlin's art, as he returned to Moscow a sculptor.[29] During the next few years, Cubism served as a point of departure for his efforts to organize heterogeneous materials into three-dimensional collages through the systematic use of geometry. Tatlin's reliefs were carefully planned, based on preparatory studies and drawings.

After the 1917 Revolution, Tatlin became a leader of Constructivism, based on his conviction that art should have a social purpose. In 1919, the Soviet government commissioned him to make plans for a monument to the Third International, which Lenin had recently founded to promote global revolution. For this purpose Tatlin designed a tower that, at 1,300 feet, would have been the tallest structure in the world.

Tatlin's *Monument to the Third International* was actually designed as a building that would house the Third International. His conceptual approach to art was reflected in the many layers of symbolism embodied in his plan.[30] Thus, for example, the tower appeared to lean forward, befitting a progressive new form of government. The spiral shapes incorporated into the design were symbols of rising aspirations and triumph; the use of two spirals symbolized the process of dialectical argument and its resolution. Unlike earlier, static governments, which were housed in heavy, immobile structures, the dynamic new communist government should have a mobile and active architecture. The lowest level of the tower, where the congresses of the International would meet, would rotate completely on its axis once in the course of a year; the second level, which would house the International's administrative offices, would revolve once a month; and the highest, third level, which would house the information offices of the International, would revolve daily. The diminishing size of the higher floors reflects the progression of power, up from the large hall of the assembly to smaller and more authoritative bodies at the higher levels.

Tatlin was not an engineer, and his design for the tower was highly impractical. As John Milner observed, "It was the idea and not the mechanistic realities which were his prime concern: as engineering, the tower is utopian."[31] Tatlin's tower, which was to straddle the Neva River in Petrograd, was never built. Yet photographs of its model, and of later models that were made after the original was lost, were widely reproduced in pamphlets and books from an early date, for the design's embodiment of the idea that advanced art could serve the purposes of modern society. The critic Robert Hughes concluded that Tatlin's *Monument* "remains the most influential non-existent object of the twentieth century, and one of the most paradoxical—an unworkable, probably unbuildable metaphor of practicality."[32]

Early in his career Alberto Giacometti was the most prominent Surrealist sculptor and made symbolic works in keeping with the movement's concern with epic subjects. As he grew older, however, he left Surrealism and became increasingly concerned with problems of perception. He became aware that he had been working in a tradition of sculpture, from classical times through Rodin and beyond, that represented not simply what the sculptor sees, but also what he knows about figures, including their volume, substance, and size. Giacometti made it his goal to eliminate the conceptual elements in this traditional approach in favor of a genuinely perceptual method, in which he would model figures as they actually appeared to him—human beings, usually in motion and situated at a specific distance from him, seen from a single viewpoint, and taken in as a unified whole at one glance.[33] As Giacometti stated his intention, "What

is important is to create an object capable of conveying the sensation as close as possible to the one felt at the sight of the subject."[34] Part of the problem was to capture the dynamic nature of perception. Thus Jean-Paul Sartre, who was a friend of Giacometti's, explained in an essay on his art that "for three thousand years, sculpture modelled only corpses. . . . [T]here is a definite goal to be attained, a single problem to be solved: how to mold a man in stone without petrifying him?"[35]

Giacometti became known for constantly revising his sculptures, which he usually did by completely destroying and re-creating them. He did not feel it necessary to preserve most of his efforts because he considered them failures. Thus, for example, in 1964, at the age of 63, he told an interviewer, "If I ever succeed in realizing a single head, I'll probably give up sculpture for good. . . . In fact, since 1935, this is what I've always wanted to do. I've always failed."[36] Sartre contended that the impermanence and contingency of Giacometti's sculptures brought them closer to life: "I like what he said to me one day about some statues he had just destroyed: 'I was satisfied with them but they were made to last only a few hours'. . . . Never was matter less eternal, more fragile, nearer to being human."[37] Giacometti recognized that uncertainty was basic to his enterprise: "I don't know if I work in order to do something or in order to know why I can't do what I want to do."[38]

In 1947 Giacometti produced the first of the tall, thin figures with ravaged surfaces that would characterize his work from then on. Making their first appearance so closely in the wake of World War II, these figures have appeared to invite interpretation as representations of survivors of the Holocaust. Giacometti denied that this was his conscious intent: "I never tried to make thin sculptures. . . . They became thin in spite of me."[39] In part because of Sartre's identification of Giacometti as an existentialist artist, his sculptures were widely taken to represent lonely, isolated, and alienated beings of the postwar era. Yet Sartre himself noted that the appearance of Giacometti's elongated forms is not unrelievedly gloomy, but is more complex, and presents a fundamental ambiguity: "At first glance we are up against the fleshless martyrs of Buchenwald. But a moment later we have a quite different conception; these fine and slender natures rise up to heaven . . . they dance."[40]

As a college student, David Smith spent a summer working on the production line of an automobile factory. Years later, when he settled on welding steel as his favored method of making sculpture, he recalled that his time at Studebaker had prepared him for the aesthetic possibilities of industrial techniques and materials.[41]

Smith developed as an artist in New York in the 1930s and '40s, in close contact with the Abstract Expressionist painters. Although Smith later told an interviewer that they had not directly discussed their work,

"we did spring from the same roots and we had so much in common and our parentage was so much the same that like brothers we didn't need to talk about the art."[42] Like many of the Abstract Expressionists, Smith arrived at his mature style in the early 1950s. This involved a distinct change in his working methods. Whereas he had previously made careful plans for his sculptures, by the mid-1950s he had become committed to discovering forms directly through improvisation. He also began to work explicitly in series. Thus after 1950 he generally titled his sculptures with the name of a series—for example, *Tanktotem*, *Voltri*, *Cubi*—followed by a roman numeral marking the work's place in the sequence.[43]

Smith's experimental approach of the 1950s and '60s closely resembled that of the Abstract Expressionists. His sculptures were not the product of conscious planning: "They can begin with a found object; they can begin with no object; they can begin sometimes even when I'm sweeping the floor and I stumble and kick a few parts that happen to be thrown into an alignment that sets me off on thinking."[44] Once under way, his work was not systematic: "If I try to tell how I make art, it seems difficult. There is no order in it. . . . I have no noble thought process or concept." His works were all connected: "The work is a statement of identity, it comes from a stream, it is related to my past works, the three or four works in process and the work yet to come." No individual work made a complete statement: "In a sense a work of art is never finished."[45] Smith himself could never make a conclusive statement: "The trouble is, every time I make one sculpture, it breeds ten more, and the time is too short to make them all."[46] Making art was at best a process of incremental improvement: "I do not look for total success. If a part is successful . . . I can still call it finished, if I've said anything new."[47] Above all, however, Smith's pleasure in his art was visual: "I like outdoor sculpture and the most practical thing for outdoor sculpture is stainless steel, and I made them and I polished them in such a way that on a dull day, they take on the dull blue, or the color of the sky in the late afternoon sun, the glow, golden like the rays, the colors of nature. . . . They are colored by the sky and surroundings, the green or blue of water."[48]

Central elements of Smith's major contribution in sculpture were drawn visually from painting. Smith believed that the shapes of modern sculpture had a single source: "We come out of Cubism."[49] Like paintings, his sculptures generally face the viewer frontally.[50] Their structures often include frames, or variations on rectangular bounds. And like many Abstract Expressionist paintings, his sculptures often have no central focal point, but are based on allover compositions.[51] The swirling patterns Smith wire-brushed onto the surfaces of his great late series, the *Cubis*, echo the gestural brushstrokes of the Abstract Expressionists, and the

large sizes of these imposing works parallel those of the late canvases of many of the painters of that school.

Robert Smithson was a pioneer of the Earth art movement of the 1960s, in which a group of young artists decided not only to place their art in the landscape, but to use the landscape itself to make their art. As a sculptor in New York, Smithson was the first to use the term "earthwork" to refer to the objects he and his friends created in remote areas.[52] In Smithson's practice, Earth art became a highly complex conceptual activity that involved not only constructing large-scale monuments from earth and stone, but also writing theoretical texts that analyzed the origins and meanings of these monuments, and making extensive photographic and other documentation of the monuments. Smithson planned his projects meticulously, by mapping and photographing potential sites, and drawing sketches and blueprints of the works.[53] Smithson's death, at the age of 35, was in fact caused by the preparatory work for *Amarillo Ramp*, a circular form that was to be built in a small lake on a ranch in west Texas. After marking the shape of the planned sculpture, Smithson wanted to photograph the design of the piece from the air, and he was killed, along with the pilot and the owner of the ranch, when the small plane hired for the purpose crashed into a hillside.[54]

Smithson's masterpiece, *Spiral Jetty*, projects into the north arm of Utah's Great Salt Lake in an isolated area called Gunnison Bay. After Smithson staked out its form, the 1,500-foot-long jetty was created in April 1970, when two dump trucks, a tractor, and a front loader were used to move more than 6,500 tons of mud, salt crystals, and rock. The construction of the jetty was filmed by a professional photographer according to detailed plans Smithson made for the treatment.[55] Two years later Smithson published an essay on the jetty that referred to a variety of his interests, including entropy, archaeology, astronomy, geology, modern painting, cartography, philosophy, biology, photography, physics, and paleontology; in the essay he associated the jetty's spiral shape variously with the solar system, the molecular structure of the salt crystals found in the Great Salt Lake, Brancusi's sketch of James Joyce, the reels of movie film used to document the work, the propeller of the helicopter he used to survey the work, a painting by Jackson Pollock titled *Eyes in the Heat*, the ion source of a cyclotron, ripples in the water of the Great Salt Lake, and other images that are presented in rapid-fire prose.[56]

Although Smithson recognized that *Spiral Jetty* would be submerged periodically when the lake's level rose, he may have miscalculated how common this would be, for the jetty was hidden almost continuously between 1972 and the summer of 2002, when a drought occasioned its reappearance. Even after it reemerged, relatively few people visited it, for it is accessible only by 16 miles of gravel road that lie between the Great Salt

Lake and Utah State Route 83. In spite of the fact that few people have actually seen it, however, the intellectual appeal of Smithson's writings and the striking photographs of the jetty have helped to place it firmly in the canon of contemporary art, and *Spiral Jetty* has become the single work by an American artist of any period that is most likely to be reproduced in textbooks of art history.[57]

This survey of the careers and methods of seven important modern sculptors supports the answer suggested earlier to the puzzles noted at the outset of this section. Rodin, Brancusi, Giacometti, and Smith were experimental artists, who worked by trial and error toward imprecise visual goals. Their incremental approach, and their frequent production of series of closely related works, meant that their innovations appeared gradually in large bodies of work. Experimental innovations are generally the product of extended research, and it is therefore not surprising that these great experimental sculptors made their most important works relatively late in their careers. In contrast, Boccioni, Tatlin, and Smithson used their art to express new ideas. The most radical new ideas tend to occur early in conceptual artists' careers, and this is consistent with the early ages at which these important conceptual sculptors produced their masterpieces.

POETS

> Poetry is not a turning loose of emotion, but an escape
> from emotion; it is not the expression of personality,
> but an escape from personality.
> *T. S. Eliot, 1919*[58]

> No tears in the writer, no tears in the reader.
> *Robert Frost, 1939*[59]

Each year since 1988, a different American poet has served as guest editor for a series of books titled *The Best American Poetry*. For the 2000 edition David Lehman, the series editor, asked each of the past guest editors to list what they considered the best 15 American poems of the twentieth century. Ten of the guest editors submitted such lists, and these were published, together with a similar list chosen by the series editor.[60]

If we consider the entries on the lists as votes, *The Waste Land* ranks as the most important single poem, by appearing on 5 of the 11 lists. Overall, however, the total of 9 votes for T. S. Eliot's poems places him below several other poets, including Robert Frost, who received 11 votes, and Wallace Stevens, who received 10. Yet no single poem by either Frost or Stevens appears on more than two lists. Lehman recognized that this

posed a puzzle, as he observed that although the greatness of Frost and Stevens was widely recognized, there was no agreement as to which of their poems was paramount.[61]

Lehman did not consider why a single poem by Eliot accounted for more than half of the total votes he received, or why Frost and Stevens appear to have been masters without masterpieces. The analysis presented in this book, however, suggests the explanation that Eliot was a conceptual innovator, while Frost and Stevens were experimental innovators. A recent quantitative study of the careers of modern American poets supports this explanation for these three poets and more broadly demonstrates the applicability of this analysis to poets. Its results can be surveyed in part here.

The distinction between conceptual and experimental poets is closely related to that for painters. Conceptual poetry typically emphasizes ideas or emotions, and often involves the creation of imaginary figures and settings, whereas experimental poetry generally stresses visual images and observations, based on real experiences. Conceptual poetry often stems directly from a study of earlier poetry, while experimental poetry is more often motivated by perception of the external world. Conceptual poetry is more often abstract, and aimed at universality, while experimental poetry is generally concrete, and concerned with specifics. Conceptual poets are more likely to compose deductively, effectively working backward from a preconceived conclusion, whereas experimental poets often wish to find the conclusion of a poem during the process of composition. Conceptual poets may privilege technique and use formal or artificial language, whereas experimental poets are more likely to emphasize subject matter, and to use vernacular language.

The quantitative analysis of poets' careers that will be presented here is based on examination of 47 anthologies of poetry, published since 1980, that survey at least the entire modern era.[62] Eight modern American poets will be considered here, and table 6.3 demonstrates that they are all clearly considered important by the editors of the anthologies. Thus each has an average of more than three poems reprinted in the 47 anthologies, four of the eight have an average of more than five poems reprinted, and Frost remarkably has an average of more than ten poems reprinted.

Before examining the quantitative evidence, a consideration of the nature of the work of these eight poets can serve to categorize them as conceptual or experimental. Chronologically, the first of the eight is Robert Frost. Frost made the people of New England his subject, as his metered rhythms transformed their conversational language and diction into poetry. Although he was never entirely dedicated to farming, Frost did run a chicken farm in New Hampshire early in his career. Robert Lowell believed that this experience allowed Frost to find his true subject: "These

TABLE 6.3
Total Anthology Entries for Selected American Poets

Poet	N	% of Entries Written	
		Before 40	After 50
Experimental			
Robert Frost (1874–1963)	503	8	42
William Carlos Williams (1883–1963)	371	23	44
Wallace Stevens (1879–1955)	361	22	49
Robert Lowell (1917–1977)	221	19	25
Conceptual			
Ezra Pound (1885–1972)	237	85	13
E. E. Cummings (1894–1962)	209	59	16
Sylvia Plath (1932–1963)	205	100	—
T. S. Eliot (1888–1965)	166	73	10

Source: Galenson, "Literary Life Cycles," tables 4, 6.

fifteen years or so of farming were as valuable to him as Melville's whaling or Faulkner's Mississippi." After Frost's death, Lowell recalled that "what I liked about Frost's poems when I read them thirty years ago was their description of the New England country. . . . I used to wonder if I knew anything about the country that wasn't in Frost."[63]

Randall Jarrell wrote of Frost in 1963, "No other living poet has written so well about the actions of ordinary men," and commented on his "many, many poems in which there are real people with their real speech and real thought and real emotions."[64] Frost himself declared that his poetry was inspired by real speech: "I was under twenty when I deliberately put it to myself one night after good conversation that there are moments when we actually touch in talk what the best writing can only come near." Frost based his poetry on what he called "sentence-sounds," by which he meant the impact of the rhythms and stress patterns within sentences on the meanings of the words they contained. Capturing sentence-sounds was not a process of imagining, but of listening: "They are gathered by the ear from the vernacular and brought into books. . . . I think no writer invents them. The most original writer only catches them fresh from talk, where they grow spontaneously."[65] The language of Frost's poems equally came from listening: "I would never use a word or combination of words that I hadn't *heard* used in running speech."[66]

Frost believed that poems should not be planned or rehearsed, but that their composition should be a process of discovery: "When I begin a poem I don't know—I don't want a poem that was written toward a good ending. . . . You've got to be the happy discoverer of your ends."[67] A poem would retain its impact on the reader only if the poet himself had not anticipated the poem's development: "No surprise for the writer, no surprise for the reader. . . . It can never lose its sense of a meaning that once unfolded by surprise as it went."[68]

Frost's poetry matured slowly. Lowell attributed this to his experimental method: "Step by step, he had tested his observation of places and people until his best poems had the human and seen richness of great novels."[69] Frost believed strongly that the wisdom that came from experience was more valuable than the more intense but less sustained brilliance of youth. Thus at the age of 63 he wrote, "Young people have insight. They have a flash here and a flash there. . . . It is later in the dark of life that you see forms, constellations. And it is the constellations that are philosophy."[70]

Wallace Stevens's elegant and complex poetry drew heavily on his imagination, but he emphasized that his poems grew out of real experiences. He once wrote to a friend, "While, of course, my imagination is a most important factor, nevertheless I wonder whether, if you were to suggest any particular poem, I could not find an actual background for you. . . . The real world seen by an imaginative man may very well seem like an imaginative construction."[71] Stevens in fact considered it essential for poems to have a basis in reality, as he wrote in one essay that "the imagination loses vitality as it ceases to adhere to what is real," and declared elsewhere that "poetry has to be something more than a conception of the mind. It has to be a revelation of nature."[72]

Stevens did not make plans or outlines for his poems, but improvised as he wrote.[73] Glen MacLeod has compared Stevens's method of finding a poetic subject to the automatism practiced by such experimental painters as Joan Miró and Robert Motherwell: "The artistic process is the same in both cases: The artist manipulates the medium—colors and forms in the case of Motherwell, sounds and images in the case of Stevens—intensely scrutinizing his own emotional responses, until suddenly, automatically, the desired subject manifests itself. . . . Like Motherwell's method of painting, Stevens' poetic process is close in spirit to the automatism of the absolute surrealist Miró."[74] Stevens's poems developed gradually; he once explained, "I start with a concrete thing, and it tends to become so generalized that it isn't any longer a local place."[75] After examining manuscript variations of two of Stevens's poems, George Lensing observed, "Stevens here struggles with the problem of concluding both poems. . . . But the movement from the obvious mediocrity of the alter-

nates to the final versions reveals the sure hand of the artist advancing through trial and error to the most forceful result."[76]

A number of critics have observed that Stevens's poetry matured slowly and continued to develop throughout his career. On the occasion of Stevens's 75th birthday, William Carlos Williams described the strengths of Stevens's work, then noted:

> This power did not come to Stevens at once. Looking at the poems he wrote thirty years ago . . . Stevens reveals himself not the man he has become in such a book as *The Auroras of Autumn* [published at age 71] where his stature as a major poet has reached the full. It is a mark of genius when an accomplished man can go on continually developing, continually improving his techniques as Stevens shows by his recent work. Many long hours of application to the page have gone into this. . . . Patiently the artist has evolved until we feel that should he live to be a hundred it would be as with Hokusai a perspective of always increasing power over his materials until the last breath.[77]

Randall Jarrell similarly observed that "Stevens did what no other American poet has ever done, what few poets have ever done: wrote some of his best and newest and strangest poems during the last year or two of a very long life."[78] Stevens himself revealed an experimentalist's understanding of the process of development when, at the age of 63, he observed that "the poems in my last book are no doubt more important than those in my first book, more important because, as one grows older, one's objectives become clearer."[79]

William Carlos Williams's lifelong goal was to invent a new poetry "rooted in the locality," which would "embody the whole knowable world about me."[80] He wanted to use everyday American speech to portray the essence of everyday American experience. Williams strongly objected to the abstraction of the poetry of his contemporaries Ezra Pound and T. S. Eliot, declaring instead, "That is the poet's business. Not to talk in vague categories but to write particularly, as a physician works upon a patient, upon the thing before him, in the particular to discover the universal."[81]

The metaphor was not casually chosen, for Williams spent nearly his entire adult life as a doctor in a small town in New Jersey. Rather than believing that his medical practice detracted from his poetry, he considered the two complementary: "As a writer I have never felt that medicine interfered with me but rather that it was my very food and drink, the very thing which made it possible for me to write. Was I not interested in man? There the thing was, right in front of me. I could touch it, smell it."[82] Randall Jarrell recognized this as a virtue of his poetry: "Williams has the

knowledge of people one expects, and often does not get, from doctors; a knowledge one does not expect, and almost never gets, from contemporary poets."[83]

Williams was not precocious or facile as a poet. His college friend Ezra Pound praised an early work of Williams for its seriousness, but poked fun at its form, commenting, "I do not pretend to follow all of his volts, jerks, sulks, balks, outbursts and jump-overs."[84] But many poets would later find the strength of Williams's poetry in concreteness and observation. Jarrell observed, "The first thing one notices about Williams's poetry is how radically sensational and perceptual it is: 'Say it! No ideas but in things.' "[85] Even more simply, James Dickey wrote that "if a man will attend Williams closely he will be taught to see."[86] Wallace Stevens stressed the connection between vision and Williams's incremental method: "Williams is a writer to whom writing is the grinding of a glass, the polishing of a lens by which he hopes to be able to see clearly. His delineations are trials. They are rubbings of reality."[87] The primacy of perception marks Williams clearly as an experimental poet. Thus Jarrell grouped him with two other experimentalists: "Williams shares with Marianne Moore and Wallace Stevens a feeling that nothing is more important, more of a true delight, than the way things look."[88] Robert Lowell placed Williams with yet another experimental poet, as he concluded a review of the first section of *Paterson*, published when Williams was 63, by remarking that "for experience and observation, it has, along with a few poems of Frost's, a richness that makes almost all other contemporary poetry look a little secondhand."[89]

Ezra Pound published five volumes of poems by the age of 30, and this early output was marked by "an astonishing display of variety and versatility," with "poems in a wide range of styles and modes."[90] His achievement was primarily in technique: "Pound is more interested in the technical elements of the poem than its subject. His poetry of this period is a learned poetry rather than one that grows from personal experience."[91] Pound famously edited *The Waste Land*, cutting more than half of Eliot's original version to create a sharper and more forceful poem. In gratitude, Eliot later dedicated the poem to Pound with the tribute "il miglior fabbro"—the better craftsman—explaining that he wished "to honor the technical mastery and critical ability in [Pound's] own work."[92] Yet even Eliot admitted that his interest in Pound's work was almost exclusively in its form: thus Eliot wrote, "I confess that I am seldom interested in what Pound . . . is saying, but only in the way he says it."[93]

At the age of 28 Pound conceived a new type of poetry he named Imagism. In keeping with Pound's conceptual approach, he published a set of formal rules for this new poetry. The motivation for the movement lay in thought rather than observation: as the critic Hugh Kenner explained,

"The imagist . . . is not concerned with getting down the general look of the thing. . . . The imagist's fulcrum . . . is the process of cognition itself."[94]

Pound's erudition helped make him extremely influential as a critic as well as a poet early in his career. But the use he made of his erudition was sometimes faulted. As early as 1922, Edmund Wilson remarked on Pound's "peculiar deficiencies of experience and feeling," and his tendency always to return to literary history: "Everything in life only serves to remind him of something in literature."[95] A few years later Conrad Aiken made a similar criticism, noting that Pound's work was "curiously without a center": "He has nothing to say of his own day and age; he prefers to try on, one after another, the styles of the ancients . . . can one not—he says in effect—make a poetry of poetry, a literature of literature?"[96] Experimental poets deplored Pound's influence, as, for example, William Carlos Williams described Pound, and Eliot, as little more than scholarly plagiarists: "Eliot's more exquisite work is rehash, repetition in another way of Verlaine, Baudelaire, Maeterlinck—conscious or unconscious—just as there were Pound's early paraphrases from Yeats and his constant later cribbing from the Renaissance, Provence and the modern French: Men content with the connotations of their masters."[97] Interestingly, late in his life Pound may have come to agree with the critics who complained of a lack of content in his poetry. Thus a friend reported that in 1966, when Pound was 81, the poet declared that the *Cantos*, which had occupied him for much of his life, were a failure, explaining, "I knew too little about so many things. . . . I picked out this and that thing that interested me, and then jumbled them into a bag. But that's not the way to make a work of art."[98]

T. S. Eliot wrote "The Love Song of J. Alfred Prufrock"—"a poem that has become perhaps the most famous ever written by an American"—at the age of 23, while he was a graduate student in philosophy at Harvard.[99] The breakthrough that allowed Eliot to produce this early masterpiece was the result of his discovery two years earlier of the work of the nineteenth-century French Symbolist poet Jules Laforgue. Eliot later recalled that his first reading of Laforgue "was a personal enlightenment such as I can hardly communicate," as he had "changed, metamorphosed almost, within a few weeks even, from a bundle of second-hand sentiments into a person."[100] Noting the technical mastery and sophisticated tone of Eliot's early work, one scholar commented that he "seems never to have been a young man."[101]

At the age of 34 Eliot published *The Waste Land*. Soon after its completion he wrote to a friend, "I think it is the best I have ever done."[102] It quickly established Eliot as the leading modern poet, "the counterpart in poetry to Joyce, Picasso, Stravinski, and to other major creators of the

Modernist revolution in their respective arts." It baffled many readers with its novel methods and forms. David Perkins recently surveyed some of its innovative dimensions: "The technique resembled cinematic montage. . . . It had no plot. There was no poet speaker to be identified with. . . . My point is not simply that the poem couldn't be fitted into any known genre but that there seemed to be nothing—no narrative, meditation, flow of lyric emotion, characterization—which one could follow, thus 'understanding' the poem."[103] Edmund Wilson remarked on the scholarly range of *The Waste Land*: "In a poem of only four hundred and three lines . . . [Eliot] manages to include quotations from, allusions to, or imitations of, at least thirty-five different writers . . . as well as several popular songs; and to introduce passages in six foreign languages, including Sanskrit." Wilson then added: "One would be inclined *a priori* to assume that all this load of erudition and literature would be enough to sink any writer."[104] Conrad Aiken complained that Eliot had made poetry, and its past, his real subject: "In *The Waste Land*, Mr. Eliot's sense of the literary past has become so overmastering as almost to constitute the motive of the work. It is as if, in conjunction with the Mr. Pound of the *Cantos*, he wanted to make a 'literature of literature'—a poetry actuated not more by life itself than by poetry. . . . This involves a kind of idolatry of literature with which it is a little difficult to sympathize."[105]

The impact of *The Waste Land* on American poetry was immediate. William Carlos Williams later recalled that when it was published "it wiped out our world as if an atom bomb had been dropped upon it."[106] Malcom Cowley, a decade younger than Eliot, confirmed his influence: "To American writers of my own age . . . the author who seemed nearest to themselves was T. S. Eliot. . . . His achievement was the writing of perfect poems, poems in which we could not find a line that betrayed immaturity, awkwardness, provincialism, or platitude."[107] To Williams, this elegance and sophistication came at the cost of content: "We can admire Eliot's distinguished use of sentences and words and the tenor of his mind but as for substance—he is for us a cipher." Looking back late in his life, Williams regretted the conceptual influence of Eliot on younger poets, for with *The Waste Land*, "critically Eliot returned us to the classroom just when we were on the point of an escape to matters much closer to the essence of a new art form itself—rooted in the locality which should give it fruit."[108]

E. E. Cummings wrote many lyric poems in a variety of styles drawn from medieval, Renaissance, and Victorian poetry. Thus, as David Perkins noted of one late sonnet, "The irregularities of meter, punctuation, typography, and word order would not be found in a nineteenth-century poet, but in diction, sentiment, and conception the stanza is traditional." Perkins explained that Cummings's innovations were in form:

He experimented with the ellipsis, distortion, fragmentation, and agrammatical juxtaposition that made some of his poetry difficult. He dismembered words into syllables and syllables into letters, and though this fragmentation activated rhymes and puns, the reasons for it were also typographical—the look of the poem on the page. Manipulating letters, syllables, punctuation, capitals, columns of print, indentation, line length, and white space as visual or spatial forms, Cummings arranged them in order to enact feeling and carry meaning.[109]

A persistent criticism of Cummings's poems concerned the substance that lay behind his technique. So, for example, in 1924 Edmund Wilson remarked that Cummings's "emotions are familiar and simple. They occasionally even verge on the banal." Two decades later, F. O. Matthiessen noted that Cummings's work represented "probably the first time on record that complicated technique has been devised to say anything so basically simple. The payoff is, unfortunately, monotony." And another decade later, Randall Jarrell commented, "Some of his sentimentality, his easy lyric sweetness I enjoy in the way one enjoys a rather commonplace composer's half-sweet, half-cloying melodies, but much of it is straight ham, straight corn."[110] In view of his preoccupation with form, it is not surprising that Cummings's trademark contributions were conceptual and appeared early in his career: by the time he finished college he had "armed himself with a whole battery of technical effects" that would recur in his poetry thereafter.[111] As David Perkins observed, "Critics complained that Cummings' poetry did not develop, and he was infuriated. Yet, on the whole, the critics were right. . . . [A]ll his volumes contained the same types of poems and expressed similar attitudes."[112] When Cummings was 50, a reviewer of his latest book remarked, "The fascinating thing about Cummings is that he is always talking about growth, and always remains the same."[113] Nor was this perception restricted to Cummings's detractors. Reviewing a book published by Cummings near the end of his life, James Dickey declared, "I think that Cummings is a daringly original poet, with more virility and more sheer, uncompromising talent than any other living American writer." Yet Dickey opened the review by observing, "When you review one of E. E. Cummings's books, you have to review them all. . . . His books are all exactly alike, and one is faced with evaluating Cummings as a poet, using the current text simply as a hitherto unavailable source of quotations."[114] In a recent survey, David Perkins observed that from the vantage point of William Carlos Williams and his followers, T. S. Eliot "had disseminated . . . a formalism, a cosmopolitanism, and an academicism from which

American poetry recovered only in the 1950s and 1960s."[115] A key figure in that later shift was Robert Lowell. *Life Studies*, published in 1959 when Lowell was 42, was recognized as an important achievement for its introduction of what became known as confessional poetry. *Life Studies* involved a loosening of Lowell's earlier rigorously formal structure, as well as a move to more personal subject matter, as Lowell worked to give priority to substance rather than form. Its achievement was the product of a long struggle that resulted from Lowell's dissatisfaction with the restrictions and constraints of existing poetic forms: for 18 months before writing *Life Studies*, Lowell wrote exclusively in prose, to allow himself to concentrate on "*what* is being said" rather than how it was expressed.[116]

The form of *Life Studies* reinforced its message, for as one scholar recently observed, its improvisational quality was "indicative of an individual seeking coherence in a disordered, troubled life." Lowell's persistent irresolution contributed to the achievement, for "one of the real triumphs of *Life Studies* is exactly in its creative inscription of doubt and uncertainty."[117] Lowell later explained that "in *Life Studies*, I wanted to see how much of my personal stories and memories I could get into poetry. To a large extent it was a technical problem. . . . But it was also something of a cause: to extend the poem to include, without compromise, what I felt and knew."[118] Yet although *Life Studies* won the National Book Award, true to his experimental nature Lowell remained uncertain of his accomplishment: "When I finished *Life Studies* I was left hanging on a question mark. . . . I don't know whether it is a death-rope or a life-line."[119]

Lowell's methods readily identify him as an experimental seeker. In his mature work, he avoided beginning his poems with a predetermined structure, for his goal was to discover a structure in the course of composition, as he sought to articulate his memories and observations. Lowell told an interviewer that even composing new poems invariably involved changes: "I don't believe I've ever written a poem in meter where I've kept a single one of the original lines."[120] Lowell continually revised his old poems, for "what he was after was not so much a poem as a poetic process—something that denied coherence, in the traditional sense, and closure."[121] Lowell's friend and fellow poet Frank Bidart explained that Lowell's constant rethinking, reimagining, and rewriting of his poems was fundamental to him throughout his career: "It proceeded very deeply from the nature of what he was doing as a writer." For Lowell the process of changing his work was not necessarily one of improving it: "He often said that something is lost in revision even if something is gained. Each version is a journey: each occasion that he inhabited the material, slightly different."[122] As Lowell told the poet Stanley Kunitz, "In a way a poem is never finished. It simply reaches a point where it isn't worth any more alteration, where any further tampering is liable to do more harm than

good."[123] Yet Lowell always worked with the goal of discovery. He told an interviewer of his excitement when a successful struggle with form allowed him to arrive at a new statement in the process of composing a poem: "The great moment comes when there's enough resolution of your technical equipment, your way of constructing things, and what you can make a poem out of, to hit something you really want to say. You may not know you have it to say."[124]

Lowell's poetry continued to evolve throughout his life. In 1963, when Lowell was 46, Randall Jarrell observed that Lowell was "a poet of great originality and power who has, extraordinarily, developed instead of repeating himself."[125] At the end of Lowell's life, Donald Hall remarked that "Lowell was not the first poet to undertake great change in mid-career, but he was the *best* poet to change so *much*."[126]

Lowell's introspective writing about his own troubled life inspired many younger poets to create autobiographical works. Sylvia Plath was prominent among these, as she declared that *Life Studies* excited her with "this intense breakthrough into very serious, very personal emotional experience, which I feel has been partly taboo."[127] She followed Lowell in writing vividly and painfully about her own life. Her innovations, however, lay not in subject matter but in language, with "her use of metaphors so strong that they displace what they set out to define and qualify."[128] The power of her work lay in imagination: "Plath was strikingly original and fertile in imaginative invention, in metaphors and fables, and her lyrics, brief though they are, set many metaphors going at once."[129] Plath's writing dealt openly with her mental illness and her attempts at suicide. Stephen Spender observed that Plath's poems presented the reader with a "dark and ominous landscape. The landscape is an entirely interior, mental one in which external objects have become converted into symbols of hysterical vision."[130] Several reviewers of Plath's late work explicitly contrasted it with Lowell's. One commented on "her narrower range of technical resource and objective awareness than Lowell's, and . . . her absolute, almost demonically intense commitment by the end to the confessional mode," while another less delicately declared that "Nothing could be healthier than Lowell's poetry . . . and likewise it is no good pretending that Sylvia Plath's is not sick verse."[131] The poet A. Alvarez, a friend of Plath's, recalled that when she first read him her new poems "Daddy" and "Lady Lazarus" he was shocked: "At first hearing, the things seemed to be not so much poetry as assault and battery."[132] In a foreword to *Ariel*, a posthumous collection of Plath's late poems, Lowell himself commented, "Everything in these poems is personal, confessional, felt, but the manner of feeling is controlled hallucination, the autobiography of a fever."[133]

A. Alvarez remarked that late in her life Plath's poetry became increasingly extreme in transforming the events of her life: "Her poetry acted as a strong, powerful lens through which her ordinary life was filtered and refigured with extraordinary intensity."[134] Similarly, a critic observed that unlike Lowell, whose poetry was intended to describe his life, and whose express intention was to make the reader "believe that he was getting the real Robert Lowell," Plath used her life merely as a point of departure for her poems: "Unlike Lowell, Sylvia Plath was not writing a poetic autobiography but using personal experiences as a way into the poem. . . . The real Sylvia Plath is far from present in the poetry."[135]

Plath's poetry was conceptual, based on extreme emotion rather than careful observation. Her most celebrated poems date from the final two years of her life, before her suicide at the age of 30. Her arrival at her greatest work occurred abruptly: her husband, the poet Ted Hughes, later recalled that in these final two years "she underwent a poetic development that has hardly any equal on record, for suddenness and completeness." She was not hesitant to finish her poems, as Hughes noted that the poems in *Ariel* were "written for the most part at great speed, as she might take dictation," and she frequently began and completed a poem in a single day.[136] Nor did she suffer from doubt about her achievement: four months before her death, she wrote to her mother, "I am a genius of a writer; I have it in me. I am writing the best poems of my life; they will make my name."[137] Plath's prediction proved correct. Two poems written during her final months, "Daddy" and "Lady Lazarus," are among the most frequently anthologized American poems of the twentieth century.[138] It is unlikely, however, that even Plath would have predicted how widely her late poems would make her name, for *Ariel* would eventually sell more than a half million copies, a rare level of popular success for poetry.[139]

As shown in table 6.3, the evidence of the anthologies points to a sharp difference in the life cycles of the conceptual and experimental poets considered here. For the experimental poets—Frost, Lowell, Stevens, and Williams—less than a quarter of their total anthology entries represent poems they wrote before the age of 40, whereas for the conceptual Cummings, Eliot, Plath, and Pound, well over half of the total entries are for poems written before age 40. At least a quarter of the anthology entries for the four experimental poets are of poems they wrote past the age of 50—for Stevens the share is nearly one-half—whereas for Cummings, Eliot, and Pound the comparable share was less than one-sixth. Plath's suicide at 30 obviously makes it impossible to know the path of her career if she had lived into her 70s or 80s, as did Frost and Stevens. Yet no matter what additional greatness Plath might have achieved had she survived, her early achievement was such that her career would not have resembled those of Frost and Stevens. The earliest of Frost's poems reprinted in the antholo-

gies was written at age 38, and the earliest of Stevens's at 36. Had Frost or Stevens died as young as Plath, not only would we today not recognize them as great poets, we would probably not know them at all. Plath's ability to make such a remarkable achievement in a life span of only 30 years is a direct consequence of the conceptual nature of her poetry, and her dramatic early arrival at artistic maturity.

NOVELISTS

It is an epic of two races (Israelite-Irish) and at the same time the cycle of the human body as well as a little story of a day (life). . . . It is also a sort of encyclopedia. My intention is to transpose the myth *sub specie temporis nostri.*
James Joyce on Ulysses, *1920*[140]

The novel is the only form of art which seeks to make us believe that it is giving a full and truthful record of the life of a real person.
Virginia Woolf, 1929[141]

Conceptual novelists often begin from general ideas or principles. They are more likely to produce symbolic works, while experimental writers more often deal with particularized cases in a documentary fashion. The characters in conceptual novels may seem oversimplified or one-dimensional compared with those in experimental novels, who are more likely to be lifelike people seen in realistic situations. The language of conceptual authors is often formal or artificial, that of experimental authors informal or vernacular. The books of conceptual authors will more often be resolved, with clear messages or lessons, whereas experimental authors often leave their plots unresolved, their conclusions open or ambiguous.

Conceptual writers are more likely to base their works on library research and to strive for precise factual accuracy, whereas experimental writers typically rely on their own perceptions and intuitions. Conceptual authors may construct complex plots, carefully planned in advance, whereas experimental authors generally invent their plots as they write, often introducing major changes in their developing plots throughout the process of composition. For experimental writers, plots are often developed to serve the purposes of characterization and creation of atmospheric effects, whereas for conceptual writers characters and settings are more often used to achieve an overarching structure or concept. Experimental authors often believe that the essence of creativity lies in the pro-

cess of writing, and that their most important discoveries are made while their books are being composed, whereas conceptual authors more often value ideas they formulated before beginning to draft their books. The clarity of conceptual authors' goals generally allows them to be satisfied that a book is complete and has achieved a specific purpose, but experimental authors' lack of precise goals often leaves them dissatisfied with their work. Many experimental writers consequently have trouble considering their books finished, they revise their manuscripts repeatedly, and they sometimes even return to published works to revise them further.

This section will apply this analytical scheme to eight British and American novelists of the past two centuries. Although this sample is not intended to represent all the most important writers of the modern period, the writers considered here were all among the most important novelists of their time.[142] This discussion will examine aspects of these writers' work that allows us to categorize them as experimental or conceptual, then will present a quantitative measure of when they produced their greatest contributions in order to examine their careers in light of the nature of their work.

Charles Dickens's strengths and weaknesses are those of an experimental author. Virginia Woolf remarked on the visual quality of his characterizations: "As a creator of character his peculiarity is that he creates wherever his eyes rest—he has the visualizing power in the extreme. His people are branded upon our eyeballs before we hear them speak, by what he sees them doing, and it seems as if it were the sight that sets his thoughts in action."[143] Earlier Anthony Trollope had emphasized Dickens's success in characterization: "No other writer of English language has left so many types of character as Dickens has done—characters which are known by their names familiarly as household words."[144]

Henry James remarked disapprovingly that "Mr. Dickens is a great observer and a great humorist, but he is nothing of a philosopher." Later George Santayana agreed that Dickens did not deal in abstractions but in particularities: "Properly speaking, he had no *ideas* on any subject; what he had was a vast sympathetic participation in the daily life of mankind."[145] Generations of critics have praised Dickens's powers of description. In 1840 William Makepeace Thackeray observed that the *Pickwick Papers* "gives us a better idea of the state and ways of the people than one could gather from any more pompous or authentic histories." In 1856 George Eliot declared, "We have one great novelist who is gifted with the utmost power of rendering the external traits of a town population."[146] A century later Angus Wilson, reflecting on "the intense haunting of my imagination by scenes and characters from Dickens' novels," explained that "their obsessive power does not derive from their total statements;

it seems to come impressionistically from atmosphere and scene which are always determinedly fragmentary."[147]

As Wilson implied, Dickens's plots are not considered a strength. Virginia Woolf commented that "Dickens made his books blaze up, not by tightening the plot . . . but by throwing another handful of people upon the fire," which made his novels "apt to become a bunch of separate characters loosely held together."[148] More bluntly, Arnold Kettle noted, "It is generally agreed that the plots of Dickens' novels are their weakest feature." G. K. Chesterton contended that most of Dickens's books were in fact not novels, because they lacked a key requirement for that form, namely, an ending. Thus Chesterton observed of *Pickwick*, "The point at which, as a fact, we find the printed matter terminates is not an end in any artistic sense of the word. Even as a boy I believed that there were some more pages that were torn out of my copy, and I am looking for them still."[149]

Dickens's craft developed in a number of ways over the course of his career. He worked at improving his organization and plotting, and a number of critics have remarked on his improvement. Thus Daniel Burt recently observed that "readers interested in marking Dickens' remarkable progression as a novelist can do no better than to compare the joyful, seemingly spontaneous generation of *Pickwick* [completed when Dickens was 25], in which Dickens claimed that, given his desultory mode of installment publication, no artful plot could even be attempted, with the intricate, brooding design of *Bleak House* [completed at 41], published in the same monthly installment form."[150] Dickens also refined his strengths over time. He excelled in capturing the speech of his characters, and particularly the colorful vernacular of the working class: "From the beginning Dickens was . . . greatly assisted by his knowledge of the speech forms of lower-class Londoners." A linguistic analysis has shown that his use of this knowledge grew more sophisticated over the course of his career, as over time he gave larger numbers of characters personalized habits and patterns of speech, or idiolects. This produced a greater richness in the later works. Whereas in the early novels the relatively small number of characters with distinct idiolects "dominate the stage as if they were performing a solo act, . . . in the works of the final period it was no longer a question of a group of leading figures with pronounced idiolects being supported by a cast of typified 'also-rans,' but one of a world in which each separate character is the possessor of a sharply-delineated speech idiom which cannot be ignored." Robert Golding consequently perceived "a stylistic development which took in Dickens' fictional writing as a whole, one which finally succeeded in merging all the elements involved— including the idiolects—into a finely balanced whole."[151]

In the summer of 1850, Herman Melville was well along on a draft of a new book on whaling when his move from New York to western Massachusetts occasioned a meeting with the distinguished older novelist Nathaniel Hawthorne. Meeting Hawthorne electrified Melville: in an essay written almost immediately thereafter, he declared, "Hawthorne has dropped germinous seeds into my soul." In his excitement Melville predicted that "if Shakespeare has not been equalled, he is sure to be surpassed, and surpassed by an American born now or yet to be born."[152]

The reference to Shakespeare was not by chance, for Melville had recently bought a complete edition of Shakespeare's works and had reproved himself as a "dolt & ass" for not having made acquaintance earlier with "the divine William."[153] The inspiration of his new friendship with Hawthorne prompted Melville to begin a complete revision of his manuscript on whaling, using the language and tragic grandeur he found in Shakespeare. F. O. Matthiessen observed that Shakespeare's language gave Melville "a range of vocabulary for expressing passion far beyond any that he had previously possessed."[154] The revised version of *Moby-Dick* consequently had an emotional intensity that was new to Melville's work: as D. H. Lawrence later wrote, "There is something really overwhelming in these whale-hunts, almost superhuman or inhuman, bigger than life, more terrific than human activity."[155]

In writing *Moby-Dick*, Melville continued his earlier practice of borrowing extensively from other scholarly and narrative books. Scholars have concluded that Melville relied heavily on five books for information on whaling.[156] A biographer commented on Melville's "extraordinary dependence on the writings of other men," not only for literary means, but for the substance of his books, but noted that in his prose the bare facts of earlier authorities were transformed into metaphors and symbols: "One can never predict when some piece of pedestrian exposition will furnish him with the germ of a great dramatic scene."[157]

When *Moby-Dick* was published in 1851, a reviewer described it as an unlikely but successful allegory: "Who would have looked for philosophy in whales, or for poetry in blubber. Yet few books which professedly deal in metaphysics, or claim the parentage of the muses, contain as much true philosophy and as much genuine poetry as the tale of the Pequod's whaling expedition."[158] Seventy years later, D. H. Lawrence called it "one of the strangest and most wonderful books in the world . . . an epic of the sea such as no man has equalled. . . . It moves awe in the soul."[159] Alfred Kazin explained that "*Moby-Dick* is the most memorable confrontation we have had in America between Nature—as it was in the beginning, without man, God's world alone—and man, forever and uselessly dashing himself against it."[160]

In spite of generations of reappraisals of Melville's later fiction and poetry, there remains widespread agreement with the observation of an admirer of Melville's who wrote even during the latter's lifetime that "it may seem strange that so vigorous a genius, from which stronger and stronger work might reasonably have been expected, should have reached its limit at so early a date."[161] Melville's sudden maturation as a writer, his production at just 32 of a masterpiece that stands as a peak not only in his career, but in American literature, and his subsequent decline as a writer are all consequences of his conceptual approach to his art, as is the allegorical nature of his greatest work.

Bernard De Voto observed that "there is a type of mind, and the lovers of *Huckleberry Finn* belong to it, which prefers experience to metaphysical abstractions and the thing to its symbol. Such minds think of *Huckleberry Finn* as the greatest work of nineteenth century fiction in America precisely because it is not a voyage in pursuit of a white whale but . . . because Huck never encounters a symbol but always some actual human being working out an actual destiny."[162] Alfred Kazin agreed that Mark Twain's "genius was always . . . for the circumstantial, never the abstract formula. . . . Mark Twain's world was all personal, disjointed, accidental."[163]

Twain is celebrated for his use of language. Lionel Trilling declared that "out of his knowledge of the actual speech of America Mark Twain forged a classic prose."[164] Kazin compared Twain's instinct for the rhythm and emphasis of speech to that of a great experimental poet: "A sentence in Mark Twain, as in Frost, is above all a right sound."[165] The prefatory note Twain inserted in *Huckleberry Finn* gently alerted the reader to Twain's craftsmanship: "In this book a number of dialects are used. . . . The shadings have not been done in a hap-hazard fashion, or by guess-work; but pains-takingly, and with the trustworthy guidance and support of personal familiarity with these several forms of speech."[166]

Studies of Twain's methods of composition clearly reveal the procedures of an experimental author. In a memoir of his friend of forty years, the novelist William Dean Howells remarked, "So far as I know, Mr. Clemens is the first writer to use in extended writing the fashion we all use in thinking, and to set down the thing that comes into his mind without fear or favor of the thing that went before or the thing that may be about to follow."[167] Many scholars have agreed with Howell's analysis. Franklin Rogers concluded that "Twain was aware of implicit form and sought to discover it by a sort of trial-and-error method. His routine procedure seems to have been to start a novel with some structural plan which ordinarily soon proved defective, whereupon he would cast about for a new plot which would overcome the difficulty, rewrite what he had already written, and then push on until some new defect forced him to

repeat the process once again." Sydney Krause determined that "Twain learned to consider his subject, not before, but *as*, he wrote."[168] Victor Doyno examined the composition of *Huckleberry Finn*: "Twain discovered his pliable plot as he went along, writing without a definite resolution or plan in mind. His real interests were elsewhere—in writing memorable episodes and frequently in doubling the incidents or repeating the basic situation in varied forms. It is, accordingly, a supreme misreading of the novel to read for plot as plot."[169] Twain himself explained that his focus often changed as a novel progressed: "As the short tale grows into the long tale, the original intention (or motif) is apt to get abolished and find itself superseded by a quite different one."[170]

Twain's difficulties with plots often resulted in substantial discontinuities in the process of writing his novels. Scholars have long been aware, for example, that Twain worked on *Huckleberry Finn* over an elapsed time of nine years, and have now determined that it was written in at least three separate periods of work. The interruptions appear to have occurred when Twain reached an impasse in the story and temporarily lost interest in it.[171] Twain claimed that not only was he not dismayed by having to put aside an unfinished novel, but that he actually came to expect that he would have to: "It was by accident that I found out that a book is pretty sure to get tired along about the middle and refuse to go on with its work until its powers and its interest should have been refreshed by a rest. . . . Ever since then, when I have been writing a book I have pigeon-holed it without misgivings when its tank ran dry, well knowing that it would fill up again without any of my help within the next two or three years, and that then the work of completing it would be simple and easy."[172]

Yet in fact Twain did not always find it either simple or easy to finish his books, and his endings were not always strong. Thus a biographer observed, "His method of composition rested heavily on the unpredictable nature of inspiration. . . . As a consequence, many novels and stories remained unfinished, and some that were finished, such as *Tom Sawyer*, *Huckleberry Finn*, and *A Connecticut Yankee in King Arthur's Court*, have endings that are unsatisfactory to many readers."[173] Twain's endings were often not final even in his own mind, since he routinely wrote sequels to his novels. Even his greatest book ended on an uncertain note. Thus Philip Young pointed out that "*Adventures of Huckleberry Finn* has no definite article in its title, though one is usually put there. . . . Huck ends his book with anticipations (never fulfilled) of further goings-on in the West. For this reason, very likely, Twain hesitated to call the job he had done definitive."[174]

Lionel Trilling considered *Huckleberry Finn* "one of the world's great books and one of the central documents of American culture," both for holding "the truth of moral passion" and for establishing "for written

prose the virtues of American colloquial speech."[175] In *The Adventures of Tom Sawyer*, Twain had avoided the subject of slavery, but in Ralph Ellison's words *"Huckleberry Finn* projected the truth about slavery."[176] Bernard De Voto explained that Twain's maturation was responsible for his masterpiece: "The prime difference between *Huckleberry Finn* and *Tom Sawyer* [published nine years earlier] is that in the later book he brings mature judgment to this society. Society is passed through the mind of a boy, as before, but this time there is a man of fifty speaking."[177]

For Henry James, the process of making art was central: "The execution of a work of art is a part of its very essence." He described the aims of the novelist in visual terms—"try and catch the color of life itself"— and he believed that the real purpose of fiction and painting were the same: "The only reason for the existence of a novel is that it does attempt to represent life . . . the same attempt that we see on the canvas of the painter." The portrayal of real life was the novel's highest calling: "The air of reality (solidity of specification) seems to me to be the supreme virtue of a novel."[178]

In 1906, when a publisher proposed to issue a collection of James's novels, the 63-year-old author not only wrote a new preface for each volume, but also made significant revisions in texts that had originally been published as much as three decades earlier. James's behavior has attracted considerable attention, much of it aimed at understanding his unwillingness to consider his works finished. Thus one scholar observed that "James seems less concerned with closing in on a formal, definitive analysis of a completed text than with opening up new readings," while another commented that James's revisions for the New York Edition were "signs of what his further 'experience' has revealed to him about the meaning of his original writing."[179] As early as 1882, a reviewer noted that "Mr. James' reluctance, or rather his positive refusal, to complete a book in the ordinary sense of the word is a curious trait. . . . In the matter of detail his books are finished to the last degree but, he cannot bring himself to the vulgarity of a regular *dénouement*."[180] In 1905 Joseph Conrad defended James's rejection of finality, arguing that lack of closure mirrored reality: "One is never set at rest by Mr. Henry James's novels. His books end as an episode of life ends . . . with the sense of the life still going on. . . . It is eminently satisfying, but it is not final."[181]

James's experimental art developed gradually. Even before James had reached the age of 40, a reviewer noted that "Mr. James is not a writer who advances by bounds or strides. His literary career has been throughout a steadily progressive one, but it has been a quiet progression, consisting in refinement and selection."[182] Surveying James's career after his death, Virginia Woolf agreed that his extended experimentation was the source of his growth: "A spectator, alert, aloof, endlessly interested, end-

lessly observant, Henry James undoubtedly was; but as obviously, though not so simply, the long-drawn process of adjustment and preparation was from first to last controlled and manipulated by a purpose which, as the years went by, only dealt more powerfully and completely with the treasures of a more complex sensibility."[183]

In 1941, an obituarist described James Joyce as "the great research scientist of letters, handling words with the same freedom and originality that Einstein handles mathematical symbols. The sound, patterns, roots and connotations of words interested him much more than their definite meanings. One might say that he invented a non-Euclidean geometry of language; and that he worked over it with doggedness and devotion as if in a laboratory far removed from the noises of the street. . . . [E]ven the strongest of his characters seem dwarfed by the great apparatus of learning that he brings to bear on them."[184] Joyce was a conceptual innovator who worked at his art methodically and systematically. His landmark contribution, *Ulysses*, was the product, by his own estimate, of 20,000 hours of work over a period of eight years; he told a friend that the preparatory and research notes for the book "filled a small valise."[185] *Ulysses* constituted a dramatic conceptual innovation: T. S. Eliot declared that it "destroyed the whole of the nineteenth century."[186] As Lionel Trilling explained, Eliot meant that "Joyce by his radical innovations of style had made obsolete the styles of the earlier time, and also that . . . the concerns and sentiments to which the old styles were appropriate had lost their interest and authority."[187]

Edmund Wilson observed that "*Ulysses* has been logically thought out and accurately documented to the last detail. . . . Yet when we are admitted to the mind of any [character], we are in a world as complex and special, a world sometimes as fantastic or obscure, as that of a Symbolist poet—and a world rendered by similar devices of language."[188] Joyce's attention to detail was extreme, as one biographer observed that he was "obsessed with the need for his 'encyclopedia' to be accurate, even in the most mundane details."[189] Joyce declared that he wanted *Ulysses* "to give a picture of Dublin so complete that if the city one day suddenly disappeared from the earth it could be reconstructed out of my book." He traced the routes of his characters on maps of the city, and calculated precisely the time they needed to arrive at their destinations.[190]

Joyce outlined *Ulysses* as a whole before he began to write the book, and consequently did not have to draft the episodes in the order in which they were published. A. Walton Litz concluded that "he attempted to visualize the general design of the work before completing individual episodes and the process of composition did not correspond with the final order of the chapters; instead, he programmed his writing as his interests or the need for clarification dictated. . . . Many of the later episodes were

planned and drafted early in the course of composition. . . . Joyce labored
to a predetermined pattern; each fragment of material he gathered was
marked for a specific place in the novel's general design." Litz noted that
"the mechanical nature of this process emphasizes the mechanical nature
of those ordering principles which give *Ulysses* its superficial unity."[191]
Joyce described *Ulysses* as "a modern *Odyssey*. Every episode in it corre-
sponds to an adventure of Ulysses."[192] Joyce constructed the book by
using a system of what he called correspondences: "To each chapter he
gave a title, a scene, an hour, an organ [of the human body], an art, a color,
and a technique." Edna O'Brien remarked that the styles Joyce assigned to
the chapters of *Ulysses* are "so variable that the eighteen episodes could
really be described as eighteen novels between the one cover."[193] The great
diversity and surprising juxtapositions of styles in *Ulysses* in fact led the
French critic Pierre Courthion to compare Joyce to the most protean of
conceptual innovators in modern painting, Pablo Picasso.[194]

A. Walton Litz observed that the form of *Ulysses* "is not organic, but
constructed."[195] Frank Budgen, a friend of Joyce's who wrote a book abut
the making of *Ulysses*, used a metaphor that recurs frequently in the criti-
cal literature on Joyce: "If there is a correspondence for Joyce's writing
in the pictorial arts it is the mosaic artists of Rome and Ravenna who
would supply it. No nervous impulses created for them or disturbed their
handiwork. They built up with inexhaustible patience their figures of
saints and angels out of tiny pieces of colored stone."[196] Joyce does not
appear to have been concerned that no reader could ever recognize or
appreciate all the book's allusions, for he was "aware that his was a mind
which needed more patterns and frames of reference than his readers
could ever utilize."[197]

In 1926, at the age of 44, Virginia Woolf reflected in a diary entry that
although she enjoyed her life and her work, she always felt somewhat
unsettled: "I have some restless searcher in me. Why is there not a discov-
ery in life? Something one can lay hands on & say 'This is it?' "[198] John
Mepham argued that Woolf never settled on a single form that she could
use consistently in her novels because she "never settled on one statement
about the way life is. I think she constantly held in mind different ways
of thinking about what life is, and needed ever new techniques in order
to give voice to them all."[199] Woolf recognized this, as in 1928 she re-
corded her suspicion that she would never cease to vary her styles and
subjects: "For after all, that is my temperament, I think: to be very little
persuaded of the truth of anything—what I say, what people say."[200] After
her death, Stephen Spender observed that for Woolf life had no fixed van-
tage points: "She held life like a crystal which she turned over in her hands
and looked at from another point of view. But a crystal is too static an
image; for, of course, she knew that the crystal flowed."[201]

Woolf's experimental art was based on perception, and a succession of her contemporaries admired the visual nature of her prose. Thus, for example, in 1922 Rebecca West observed, "She can write supremely well only of what can be painted"; in 1924 Clive Bell judged that "this pure, this almost painterlike vision is Virginia Woolf's peculiarity"; in 1926 E. M. Forster declared that "visual sensitiveness . . . becomes in her a productive force. How beautifully she sees!"; and in 1927 the French painter and writer Jacques-Émile Blanche remarked of her prose, "The touches of color here and there . . . construct the picture, delineate it within an invisible contour. The Impressionist painters proceeded in just this manner."[202]

A biographer observed of Woolf that "even more than other novelists who have recorded the birth and growth of their works, she appears to begin without any detailed knowledge of how she will proceed. . . . Each book seems to evolve rather than to be planned and then made."[203] Woolf testified this was true, as she wrote in the introduction to *Mrs. Dalloway* that:

> the idea started as the oyster starts or the snail to secrete a house for itself. And this it did without any conscious direction. The little note book in which an attempt was made to forecast a plan was soon abandoned, and the book grew day by day, week by week, without any plan at all, except that which was dictated each morning in the act of writing. The other way, to make a house and then inhabit it, to develop a theory and then apply it, as Wordsworth did and Coleridge, is, it need not be said, equally good and much more philosophic. But in the present case it was necessary to write the book first and invent a theory afterwards.[204]

Woolf's diary contains illustrations of this process. So, for example, she began to write *To the Lighthouse* early in 1926. On September 5, she recorded that "at this moment I'm casting about for an end. . . . I am feathering about with various ideas. . . . [W]hat becomes [of] Lily & her picture?"[205] She finished the novel just 11 days later; in the end, Lily completed her painting.

Woolf allowed her plots to grow organically because of her belief that writing should be a process of discovery. In a memoir written late in her life, she explained that she derived her greatest satisfaction from the process of composing her novels: "Perhaps this is the strongest pleasure known to me. It is the rapture I get when I seem to be discovering what belongs to what; making a scene come right; making a character come together. From this I reach what I might call a philosophy; at any rate it is a constant idea of mine; that behind the cotton wool is hidden a pattern." When Woolf caught a glimpse of "some real thing behind appear-

ances," she could capture it only by writing: "I make it real by putting it into words. It is only by putting it into words that I make it whole."[206]

In her diary Woolf often pondered the course of her development as an artist. In 1922, the completion of *Jacob's Room* convinced her that she had made progress: "There's no doubt in my mind that I have found out how to begin (at 40) to say something in my own voice." Yet later its publication prompted her to note that her feelings were "as usual— mixed. I shall never write a book that is an entire success." Three years later, after the publication of *Mrs. Dalloway*, her confidence had grown, as she asked, "I wonder if this time I have achieved something?" but she immediately responded, "Well, nothing anyhow compared with Proust." In 1927, however, at the age of 45 Woolf recorded a judgment about her latest novel that many later critics would share: "With The Lighthouse I may just have climbed to the top of my hill."[207] Woolf was clearly aware of the progression in her art that her friend Raymond Mortimer de- scribed in an essay in 1929: "Evidently [Woolf's] style is the result of years of experience. We can see it developing as we follow the chronologi- cal order of her works. But this long apprenticeship has left her a com- plete mistress of her medium. Her line, like a great painter's, is now spon- taneously artful."[208]

In 1922, publication of *The Waste Land* prompted Edmund Wilson to voice his objection to what he considered the excessively introspective focus not only of Eliot, but also of other young writers. After quoting from *The Waste Land*, Wilson observed that "a quotation from a more conventional author who has yet caught something of the spirit of the time puts it even more clearly and briefly. 'I know myself but that is all,' cries one of Scott Fitzgerald's heroes. . . . And that is precisely the point of view of the modern novelist or poet: 'I know myself but that is all.' "[209] After Fitzgerald's death, Lionel Trilling reflected that the significance of his landmark work, *The Great Gatsby*, was a consequence of its "intellec- tual intensity." Trilling explained that the book's characters and settings were subordinated to the story's central idea: "The characters are not 'developed' . . . [but] are treated, we might say, as if they were ideographs, a method of economy that is reinforced by the ideographic use that is made of the Washington Heights flat, the terrible 'valley of ashes' seen from the Long Island Railroad, Gatsby's incoherent parties, and the huge sordid eyes of the oculist's advertising sign." Trilling added parentheti- cally: "It is a technique which gives the novel an affinity with *The Waste Land*."[210] T. S. Eliot apparently noticed the parallels between his own poetry and Fitzgerald's prose, for soon after the publication of *The Great Gatsby* he wrote to tell Fitzgerald that it "excited me more than any new novel I have seen, either English or American, for a number of years,"

and that he considered it "the first step that American fiction has taken since Henry James."[211]

Wilson and Trilling both recognized the conceptual basis of Fitzgerald's fiction, which used lyrical prose, simplified figures, and symbolic stage props and settings in the service of allegorical plots. Thus a recent survey described *Gatsby* as "a symbolist tragedy" told with "a symbolist mode of writing that informs everything—Gatsby's dreams, parties, even his shirts—with an enchanted glow."[212] Harold Bloom observed that "the American Dream tended to be our characteristic myth in the twentieth century, and Scott Fitzgerald was both the prime celebrant and the great satirist of the dream-turned-nightmare."[213]

Fitzgerald was famously precocious, at just 24 publishing *This Side of Paradise*, a best-selling novel that was reviewed by the influential critic H. L. Mencken as "a truly amazing first novel—original in structure, extremely sophisticated in manner, and adorned with a brilliancy that is . . . rare in American writing."[214] Yet his real arrival at artistic maturity came at the age of 29, with the publication of *The Great Gatsby*. Fitzgerald recognized this, for when he completed the novel he wrote to his editor, "I think my novel is about the best American novel ever written. . . . I am grown at last."[215] Over time, as recognition of the magnitude of Fitzgerald's achievement in *Gatsby* increased, the discontinuity it represented in his career became clear. Thus in 1966 a scholar observed, "One of the most difficult problems in Fitzgerald scholarship in the nineteen-fifties and sixties has been the attempt to explain the sudden maturing of Fitzgerald in 1925, with the publication of *The Great Gatsby*. Nothing in Fitzgerald's earlier writing prepares for the authority and the aesthetic control over material that is so impressive in his third novel." Perhaps equally puzzling was Fitzgerald's subsequent failure to match the quality of *Gatsby*. Thus John Berryman observed, "Suddenly he was able, not yet thirty, to lay out and execute a masterpiece. He was happily married, widely admired, and had made money. One might have expected such a career of production as American artists rarely have achieved. What happened then?" Berryman believed that during Fitzgerald's remaining years "he could not use his gift because he no longer had it."[216] Fitzgerald had earlier expressed the same belief. In 1929 he wrote to his friend Ernest Hemingway of his fear that the great amount of writing he had done during 1919–24 had "taken all I had to say too early."[217] Fitzgerald was often praised for the poetic quality of his prose, and like many conceptual poets he spent the last years of his life wondering where his gift had gone. His awareness of the nature of his talent, and of its loss, appear to be reflected in a statement he wrote in 1934, at the age of 38, in the introduction to a new edition of *The Great Gatsby*: "The present writer has always been a 'natural' for his profession in so much that he can think of

nothing he could have done as efficiently as to have lived deeply in the world of imagination."[218]

One of Ernest Hemingway's most distinctive innovations was in his writing of dialogue. In 1926, Conrad Aiken declared in a review of *The Sun Also Rises* that "the dialogue is brilliant," and described it as "alive with the rhythms and idioms, the pauses and suspensions and innuendoes and shorthands, of living speech."[219] In fact, however, Philip Young later explained that "for all the impression of authenticity Hemingway's dialogue gives, it was no simple reproduction of actual human talking. . . . Hemingway's dialogue strips speech down to the essentials which are typical of the speaker. He built a pattern of mannerisms and responses which give an illusion of reality that, in its completeness, reality itself does not give."[220]

Hemingway's dialogue was one of several conceptual devices that he developed early in his career and that became celebrated as his trademark stylistic techniques. Another was the use of organizing symbols, dating from his third novel, *A Farewell to Arms*, in which rain serves as a consistent signal of disaster. Hemingway arrived at these devices not gradually, through years of trial and error, but rapidly, through the study of other writers, principally Mark Twain, Sherwood Anderson, and Gertrude Stein.[221] Together these devices allowed Hemingway, in his early work, to create "a world of his own more brilliant than life, but he was not writing about people living in a real world."[222]

Hemingway's early practices reveal a conceptual writer at work. His first novel was a satire, titled *The Torrents of Spring*. Jeffrey Meyers observed that "Hemingway's ability to parody [Sherwood] Anderson reveals how well he had learned and then rejected the lesson of the master." Hemingway's clarity of purpose was also evident to Allen Tate, who noted in a review of *Torrents* that "he knows what he wishes to do; he usually does it."[223] William Balassi's study of the composition of Hemingway's second novel, *The Sun Also Rises*, revealed that he had worked on it methodically: "Each day he chose a method or a theme. . . . For instance, on four successive days . . . he based each day's composition on a metaphor associated with one of the main characters: *afición* for Jake, bankruptcy for Mike, the gored and segregated steer for Gerald, and the Circe myth for Duff." The reference to mythology was not by chance, for Hemingway's composition paid tribute to James Joyce and the *Odyssey*, in turn, on the two following days. Balassi noted that this effective division of the text into a series of short stories "resulted in a rich inner text, easily overlooked in the printed novel but readily apparent when the novel is divided into the daily stories."[224] Hemingway's third novel, *A Farewell to Arms*, published when he was 30 years old, was tightly plotted, and in Michael Reynolds's words "carefully planned in an orderly, logical

method that is exceptional in the American novel."[225] In that book the two themes of love and war parallel each other, as Frederic Henry's attitude toward World War I goes through six distinct stages while his relationship with Catherine Barkley undergoes six clearly corresponding stages. Philip Young observed that by the end of the novel, "the two stories are as one, in the point that is made very clear . . . that life, both social and personal, is a struggle in which the Loser Takes Nothing."[226]

Late in his life, Hemingway denied that a writer's work had to deteriorate as he grew old: "People who know what they are doing should last as long as their heads last."[227] Many critics, however, believed that his work had declined from an early age. In 1943, with Hemingway just 44 years old, James Farrell called *The Sun Also Rises* Hemingway's best novel, and declared that his contribution was essentially complete by the age of 30: "He said pretty much what he had to say with his first stories and his first two novels." Even earlier, in 1939, Edmund Wilson observed that Hemingway's famed prose had deteriorated from self-indulgence by the time he wrote *Death in the Afternoon*, at the age of 33: "The master of that precise and clean style now indulges in purple patches which go on spreading for pages on end." The judgments of Farrell and Wilson became a consensus over time. Irving Howe wrote in an obituary that Hemingway "was always a young writer," and that he had done his best work early in his career: "Most of his late work was bad, Papa gone soft." Alberto Moravia declared bluntly that throughout his life Hemingway had remained in an "infantile and precocious state of arrested development." Noting that Hemingway's important work was done during the 1920s, when Hemingway himself was in his 20s, Moravia concluded that "he was incapable of developing or adding anything of value to his early, naïve nihilism."[228] In more moderate terms Philip Young agreed, observing that "nowhere in this writer can you find the mature, brooding intelligence, the sense of the past, the grown-up relationships of adult people, and many of the other things we normally ask of a first-rate novelist."[229]

The preceding discussion has suggested that Dickens, James, Twain, and Woolf were experimental innovators, and that Fitzgerald, Hemingway, Joyce, and Melville were conceptual writers. Did the four conceptual authors generally make their greatest contributions at younger ages than did the four experimental authors?

To answer this question, measurements of the relative importance of each author's novels were based on the analysis of critical studies of the author's career. For each author, at least ten critical monographs were selected, each of which examined the author's entire career. For each monograph, a count was made of the number of pages devoted to each of the author's novels. These counts were converted into percentage distributions summarizing the relative amount of space devoted to each novel

TABLE 6.4
Most Important Novels by Selected Authors

Author	Book 1	Book 2	Book 3
Experimental			
Charles Dickens (1812–70)	*Bleak House*, 1853	*David Copperfield*, 1850	*Little Dorrit*, 1857
Henry James (1843–1916)	*The Portrait of a Lady*, 1881	*The Golden Bowl*, 1904	*The Wings of the Dove*, 1902
Mark Twain (1835–1910)	*Adventures of Huckleberry Finn*, 1885	*The Adventures of Tom Sawyer*, 1876	*Pudd'nhead Wilson*, 1894
Virginia Woolf (1882–1941)	*To the Lighthouse*, 1927	*Mrs. Dalloway*, 1925	*The Waves*, 1931
Conceptual			
F. Scott Fitzgerald (1896–1940)	*The Great Gatsby*, 1925	*Tender Is the Night*, 1934	*This Side of Paradise*, 1920
Ernest Hemingway (1899–1961)	*A Farewell to Arms*, 1929	*The Sun Also Rises*, 1926	*For Whom the Bell Tolls*, 1940
James Joyce (1882–1941)	*Ulysses*, 1922	*A Portrait of the Artist as a Young Man*, 1916	*Finnegan's Wake*, 1939
Herman Melville (1819–91)	*Moby-Dick*, 1851	*Mardi*, 1849	*Pierre*, 1852

Source: Galenson, "Portrait of the Artist as a Young or Old Innovator," table 4.

in each critical monograph. Averaging these percentage distributions over all the monographs yielded a single percentage distribution for each author, which reveals the average share of space devoted to each of the author's novels in the monographs analyzed.[230]

Under the assumption that the space devoted to a novel reflects a scholar's judgment of its importance, table 6.4 lists the three most important novels written by each of the eight authors considered here, and table 6.5 displays the authors' ages when these novels were published. There is considerable variation in the ages at which the authors published their single most important novels, as Fitzgerald was just 29 when he published *The Great Gatsby*, whereas Twain was more than two decades older, at age 50, when he published *Adventures of Huckleberry Finn*. The median age at which the four conceptual writers published their single most important novel was 31, or 12 years below the corresponding median age of 43 for the four experimental writers. Considering table 6.5 as whole, the median age for all the entries of the conceptual writers was 33, again 12 years

TABLE 6.5
Ages at Which Authors Published Most Important Novels

Author	Book 1	Book 2	Book 3
Experimental			
Dickens	41	38	45
James	38	61	59
Twain	50	41	59
Woolf	45	43	49
Conceptual			
Fitzgerald	29	38	24
Hemingway	30	27	41
Joyce	40	34	57
Melville	32	30	33

Source: Galenson, "Portrait of the Author as a Young or Old Innovator," table 5.

below the corresponding median age of 45 for the experimental writers. Table 6.5 also shows that 9 of the 12 books listed by conceptual novelists were published when the writers were below the age of 40 (and a tenth, *Ulysses*, was published on the day the author turned 40), whereas in contrast 10 of the 12 books by experimental authors were published when the writers had passed the age of 40. This quantitative evidence clearly supports the prediction that conceptual novelists produce their most important contributions earlier in their lives than their experimental counterparts.

MOVIE DIRECTORS

It is no use telling people; they have got to SEE. We are
making pictures, moving pictures, and though sound
helps and is the most valuable advance the films have
ever made they still remain primarily a visual art.
Alfred Hitchcock, 1937[231]

I know that in theory the word is secondary in cinema
but the secret of my work is that everything is based
on the word. I do not make silent films.
Orson Welles, 1964[232]

Experimental movie directors typically stress the importance of telling a story, with a clear narrative. They generally consider visual images the

most important element of a movie, with the script and sound track used to support the images. Many experimental directors specifically state that their primary goal is to entertain the audience, and they often take commercial success to be a sign of their achievement of that goal. Experimental directors typically aim to make the technical aspects of their movies unobtrusive, for they usually believe that the purpose of technique is to create an illusion of reality. Perhaps the most common criticism of even the best experimental directors is that their movies are merely entertainments, with insufficient artistic or intellectual content.

Conceptual directors often avoid linear narrative and conventional story lines. Many consider a film's script more important than visual images. Rather than seeking to provide entertainment, many conceptual directors aim to educate or influence their audience; they typically want their movies to communicate specific ideas, and their plots are often allegorical. Because many conceptual directors do not attempt to reach a mass audience, they are less likely to consider commercial success an important goal. Their work is often self-consciously innovative, with explicit emphasis on technique that calls attention to itself. Their films are often motivated by an interest in earlier films, or other forms of art, rather than a pursuit of realism. Detractors of conceptual directors commonly criticize their movies for privileging technique over substance, and for achieving artistic virtuosity at the price of superficiality.

This section will consider the work and careers of eight important movie directors.[233] Their best movies will be identified by using data collected by *Sight and Sound*, the journal of the British Film Institute. Once each decade, *Sight and Sound* surveys a large number of prominent critics and directors from around the world, asking each to list what they consider the ten best movies ever made. Using the most recent poll, taken in 2002, the present study counts each listing of a movie by a critic or a director as one vote for that movie.[234] Table 6.6 lists the two movies made by each of the eight directors considered here that received the most votes from all the critics and directors polled. This evidence will be examined after the directors are categorized as experimental or conceptual, based on a consideration of the nature of their work. The order in which they are discussed will be determined by the chronological order of appearance of their single best films.

Sergei Eisenstein's conception of art was largely a product of the Russian Revolution, as during the 1920s he and a group of colleagues set out to create a revolutionary Soviet cinema. His theories and technical innovations were all based on the principle that art must accomplish political tasks.[235] Thus in an early theoretical statement, Eisenstein expressed his belief that film was "a factor for exercising emotional influence over the masses," and declared that "there is, or rather should be, no cinema

TABLE 6.6
Best Movies of Selected Directors

Director	Movie 1	Movie 2
Conceptual		
Sergei Eisenstein (1898–1948)	*Battleship Potemkin*, 1925	*Ivan the Terrible*, 1945
Federico Fellini (1920–93)	*8 ½*, 1963	*La Dolce Vita*, 1960
Jean-Luc Godard (1930–)	*Breathless*, 1960	*Le Mépris*, 1963
Orson Welles (1915–85)	*Citizen Kane*, 1941	*Touch of Evil*, 1958
Experimental		
John Ford (1894–1973)	*The Searchers*, 1956	*The Man Who Shot Liberty Valance*, 1962
Howard Hawks (1896–1977)	*Rio Bravo*, 1959	*His Girl Friday*, 1940
Alfred Hitchcock (1899–1980)	*Vertigo*, 1958	*Psycho*, 1960
Jean Renoir (1894–1979)	*The Rules of the Game*, 1939	*Grand Illusion*, 1937

Source: See text.

other than agit-cinema"; even more vividly, he explained that in his conception a work of art "is first and foremost a tractor ploughing over the audience's psyche in a particular class context."[236]

Eisenstein's early academic training in engineering may have contributed to his desire to develop a scientific approach to the creation of films. In an interview shortly after he directed his landmark work, *Battleship Potemkin*, he explained that art should be made systematically, like industrial machinery: "My artistic principle . . . is: not intuitive creativity but the rational constructive composition of effective elements. . . . That is, I believe, a purely mathematical affair and it has nothing whatsoever to do with the 'manifestation of creative genius.' You need not a jot more wit for this than you need to design a utilitarian steel works."[237]

Eisenstein is known for a number of radical technical innovations. Gerald Mast explained that his films "break all the rules of narrative construction. They lack a protagonist and focal characters; they lack a linear plot." The most celebrated demonstration of Eisenstein's innovations was in

Potemkin. It was meticulously constructed: "The film's five parts, mirroring the five-part structure of classical drama, form a taut structural whole." Its most famous technical device was Eisentein's use of montage. Rapid juxtaposition of inanimate objects was used to make symbolic statements, for example, as Mast noted that "the famous montage of the stone lions (three sequential shots of three statues—a lion sleeping, waking, and rising—so edited as to produce the impression of a single, natural, connected action) . . . is a rather explicit metaphor . . . for the rising of the people in power and anger, outraged by the slaughter on the Odessa Steps."[238] Eisenstein's desire to shock his audience further led him radically to accelerate his film's pace: the average shot length of *Potemkin* was about two seconds, well below the average of five to six seconds in Hollywood films of the era.[239]

Eisenstein's political motivation and scientific approach to technical innovation mark him clearly as a conceptual director. His work has been of interest not only to those in the film industry, but also to scholars of early Soviet politics. Thus Richard Taylor, a political scientist who edited a recent edition of Eisenstein's writings, observed that "for Eisenstein the end was always *ultimately* ideological (in the broadest sense of conveying an idea)."[240]

In a tribute written in 1967, the French director François Truffaut declared that "Jean Renoir is the greatest filmmaker in the world." For Truffaut, Renoir portrayed reality: "Renoir's films draw their animation from real life. . . . Renoir does not film ideas, but men and women who have ideas." Truffaut considered Renoir's *Rules of the Game* "the film of films," and remarked that "along with *Citizen Kane*, *La Règle du Jeu* is certainly the film that sparked the careers of the greatest number of directors."[241] The critic Peter Wollen agreed that *Rules of the Game* "strives to capture life in the raw," describing it as "an ethnographic film in the sense that, despite its intricate plot, it truly tries to capture an impression of life as it is lived."[242]

On a number of occasions Renoir expressed his belief that his understanding of a film came only in the process of making it: "I absolutely believe that the true meaning of a film is revealed only during the shooting, and sometimes after the shooting. . . . I'm not always able to understand the meaning of a scene before I've actually seen it. I find the true meaning of the acting, a scene, even a word, only after the words have materialized, once they exist. As Sartre would say, I believe that the essence comes after the existence."[243] As Truffaut noted, a consequence was that Renoir's films did not have neatly resolved endings, but that instead each was "a deliberately unfinished 'open' work that each viewer can complete for himself."[244]

Like many experimental painters, Renoir considered all his works variations on a single theme: "I've basically shot one film, I've continued to shoot one film, ever since I began, and it's always the same film. I add things, I see things that I haven't said before. . . . I don't know whether it gets better or not, but I know it continues."[245] Pauline Kael recognized Renoir's experimental method in contrasting his unobtrusive technique with the more assertive styles of two conceptual directors, as she reflected that "in cinema there is the artistry that brings the medium alive with self-conscious excitement (Eisenstein's *Potemkin*, Orson Welles' *Citizen Kane*) and there is the artistry that makes the medium disappear (*La Grande Illusion*). . . . *La Grande Illusion* is a triumph of clarity and lucidity. . . . The result is the greatest achievement in narrative film."[246] For David Thomson, Renoir's experimental nature was a central element in making him the greatest of directors: "Renoir asks us to see the variety and muddle of life without settling for one interpretation. . . . [H]e shrugs off the weight of 'masterpieces' or 'definitive statements.' The impossibility of grasping final solutions or perfect works is his 'rule.' "[247]

There is remarkably widespread agreement that *Citizen Kane* is the most important movie ever made: to cite just one of many possible indicators, it has placed first in all five international decennial polls *Sight and Sound* has conducted of movie critics since 1962. Among the most celebrated facts about *Citizen Kane* is that it was directed and coauthored by Orson Welles, who also played the title role, when he was just 26 years old. It was Welles's first film.

The importance of *Citizen Kane* derived in large part from its technical innovations. This was not accidental, but was a result of extensive planning. Both the film's composer and its photographer emphasized that they were given exceptional amounts of time and freedom to plan and achieve the novel aims they and Welles had formulated. Thus Bernard Herrmann wrote that contrary to the normal Hollywood procedure, in which musical scores were not written until filming was completed, he and Welles agreed that "the dynamics of all music in the picture should be planned ahead of time." In a number of scenes, film sequences were actually tailored to match the music.[248] Similarly, Gregg Toland explained that "the photographic approach to *Citizen Kane* was planned and considered long before the first camera turned." This allowed Toland time not only to formulate innovative plans, but to make extensive experiments with equipment and sets to make the plans possible.[249]

The meticulous planning of Welles and his collaborators produced a movie that contained many novel techniques involving both sound and sight. A number of the sound innovations reflected Welles's experience in radio. These included musical bridges that foreshadowed transitions from one scene to the next, series of short bursts of speech that revealed the

reactions of several characters in quick succession, and overlapping dialogue tracks that mimicked real conversation, with varying sound levels that allowed one to be heard at a time. *Kane*'s visual innovations have become even more famous. Several of these created what Toland called "human-eye focus," with much greater depth of field than movies normally afforded. Contributing to this was the construction of unusually deep sets, so action could occur simultaneously at different distances from the camera, the use of extremely wide-angle lenses, which allowed sharp focus throughout the sets' deep space and made possible the startling effect of having important action in the background, and long camera takes that allowed the actors greater freedom of movement and extended ensemble acting. The novel device of building ceilings over the sets also permitted the dramatic low-angle shots that became one of the movie's visual trademarks.[250]

In spite of the influence of the movie's many technical innovations, Welles's single greatest achievement in *Citizen Kane* may have been synthetic, as he created symbolic linkages between the new technical devices and the film's story. At a broad level, the variety of striking technical means used to punctuate the narrative of the story reinforces the varied views of Kane presented by different characters. Jorge Luis Borges recognized this, as he observed that *Citizen Kane*'s subject is "the discovery of the secret soul of a man," which was accomplished through "the rhythmic integration of disparate scenes without chronological order. In astonishing and endlessly varied ways, Orson Welles exhibits the fragments of the life of the man, Charles Foster Kane, and invites us to combine and reconstruct them."[251]

Citizen Kane is an acknowledged conceptual masterpiece. Peter Wollen noted that "in formal terms, it is plainly an Aristotelian tragedy, with its pyramidal rise, its climax or peripeteia, its downfall and its tragic end."[252] *Kane* also dominates Welles's career. When Welles was presented the American Film Institute's Life Achievement Award in 1975, at the age of 60, the published tribute to him mentioned by name only one film, *Citizen Kane*, which it described as "a benchmark in world cinema, an achievement against which other films are still measured."[253]

Orson Welles's Life Achievement Award was the third given by the American Film Institute. When the institute established the award two years earlier, to honor individuals "whose talent has, in a fundamental way, advanced the film art, and whose accomplishments have been acknowledged by scholars, critics, professional peers, and the general public," its first honoree was John Ford. The citation for Ford declared that "no individual has more fully explored on film the American experience."[254] Interestingly, the institute's citation for Ford's Life Achievement Award did not mention any specific movie, but referred collectively to his

films as "a creative tapestry representing over 50 years of work." Ford
directed more than 100 movies and won six Oscars, but no one of his
films has emerged clearly as a masterpiece, and there is no strong consen-
sus even among his admirers over what constitute his best one or two
films.[255] Table 6.6 shows that *Sight and Sound*'s poll ranks *The Searchers*
and *The Man Who Shot Liberty Valance* as his best two movies; Ford
directed these at the ages of 62 and 68, respectively.

That Ford was a master without a dominant masterpiece and that he
created important films late in his career both appear to be consequences
of the fact that his approach to movies was experimental. Ford's movies
have been consistently praised for their visual qualities. Alfred Hitchcock
stated that "a John Ford film is a visual gratification," and Andrew Sarris
declared that "*The Searchers* is rich in all the colors and textures of the
seasons and the elements."[256] Elia Kazan acknowledged that Ford "taught
me to tell it in pictures," and Orson Welles made a similar statement:
"I've only been influenced by somebody once: prior to making *Citizen
Kane* I saw [Ford's] *Stagecoach* forty times. I didn't need to learn from
somebody who had something to say, but from somebody who would
show me how to say what I had in mind; and John Ford is perfect for
that."[257] Federico Fellini stressed Ford's appeal to another one of the
senses: "When I think of Ford, I sense the smell of barracks, of horses, or
gun powder."[258]

Unlike Welles, who believed that a good script was necessary for a good
film, Ford did not consider the script to be a crucial determinant of the
quality of a movie. He explained, "After all, you've got to tell your story
through the people who portray it. You can have a weak, utterly bad
script—and a good cast will turn it into a good picture."[259] Gerald Mast
observed that "Ford's methods emphasized visual images rather than
talk," and Ford agreed, stating that "pictures, not words, should tell the
story."[260] On another occasion Ford elaborated on his philosophy: "When
a motion picture is at its best, it is long on action and short on dialogue.
When it tells its story and reveals its characters in a series of simple, beau-
tiful, active pictures, and does it with as little talk as possible, then the
motion picture medium is being used to its fullest advantage."[261]

Ford wanted his movies to achieve immediacy and realism: "I try to
make people forget they're in a theatre. I don't want them to be conscious
of a camera or a screen. I want them to feel what they're seeing is real."[262]
François Truffaut remarked on Ford's success in achieving this goal:
"John Ford might be awarded (the same goes for Howard Hawks) the
prize for 'invisible direction.' The camera work of these two great story-
tellers is never apparent to the eye."[263] Ford believed that simple tech-
niques were the best means to his desired end, and he distrusted complex-
ity of all kinds: "I like, as a director and spectator, simple, direct, frank

films. Nothing disgusts me more than snobbism, mannerism, technical gratuity . . . and, most of all, intellectualism."[264]

Like those of other experimental artists, Ford's methods developed gradually, with considerable continuity from film to film. Peter Bogdanovich remarked, "Every Ford movie is filled with reverberations from another—which makes his use of the same players from year to year, decade to decade, so much more than just building 'a stock company'—and one film of his cannot really be looked at as separate from the rest." Ford is widely considered to have refined his art throughout his long career. Thus Bogdanovich rated Ford's late films as his best, "not only in execution but in depth of expression," and Andrew Sarris judged that "the last two decades of his career were his richest and most rewarding."[265]

Alfred Hitchcock's philosophy of film was straightforward: "I try to make it a rule that nothing should be permitted to interfere with the story. The making of a movie is nothing but the telling of a story."[266] In an essay on Hitchcock, François Truffaut categorized him with other great experimental directors: "There are two kinds of directors: those who have the public in mind when they conceive and make their films and those who don't consider the public at all. . . . Renoir, [Henri-Georges] Clouzot, Hitchcock and Hawks make movies for the public, and ask themselves all the questions they think will interest their audience."[267]

Hitchcock often stressed the importance of visual images in film: "I've always believed that you can tell as much visually as you can with words."[268] He told an interviewer that he thought in pictures, and he explained that this is what animated his movies: "This is what gives the effect of life to a picture—the feeling that when you see it on the screen you are watching something that has been conceived and brought to birth directly in visual terms."[269] He wanted his viewers to be caught up in the reality of his films: "Watching a well-made film, we don't sit by as spectators; we participate." Technique should be used solely to serve this end: "Technique that calls itself to the audience's attention is poor technique. The mark of good technique is that it is unnoticed."[270] James Agee remarked on Hitchcock's realization of these goals, observing that "he has a strong sense of the importance of the real place and the real atmosphere."[271] Truffaut considered Hitchcock's films to be a textbook for directors on the use of visual images, noting that "in Hitchcock's work a film-maker is bound to find the answer to many of his own problems, including the most fundamental question of all: how to express oneself by purely visual means."[272]

Hitchcock wanted his films to reach the largest possible audience. This stemmed from his conception of the discipline: "I've always believed in film as the newest art of the twentieth century because of its ability to communicate with the mass audiences of the world."[273] Andrew Sarris

believed that Hitchcock's commercial success caused many critics and scholars to ignore his importance, noting that "Hitchcock's reputation has suffered from the fact that he has given audiences more pleasure than is permissible for serious cinema. No one who is so entertaining could possibly seem profound to the intellectual puritans."[274]

As he approached the age of 50, Hitchcock recorded his belief that "style in directing develops slowly and naturally as it does in everything else."[275] In a monograph published when Hitchcock had passed the age of 65, Robin Wood stressed the growth of his art in a number of dimensions, declaring, "Not only in theme—in style, method, moral attitude, assumptions about the nature of life—Hitchcock's mature films reveal, on inspection, a consistent development, deepening and clarification. . . . There is discernible throughout Hitchcock's career an acceleration of the process of development right up to the present day."[276] François Truffaut agreed, as he wrote in 1963 that "Hitchcock's mastery of the art grows greater with each film."[277]

Howard Hawks told an interviewer that John Ford had been his model at the beginning of his career: "He was a good director when I started, and I copied him every time I could." Like Ford, Hawks described his goals in simple terms, explaining, "All I'm doing is telling a story. I don't analyze or do a lot of thinking about it. . . . I think our job is to make entertainment."[278] Like Ford, Hawks wanted to tell his stories visually: "Tell it from your eyes. Let the audience see exactly as they would if they were there."[279] And, like Ford, Hawks considered simplicity a virtue: "I try to tell my story as simply as possible."[280]

Robin Wood echoed Truffaut's observation that Hawks's directing, like Ford's, was invisible: "Nowhere in Hawks is one aware of 'direction' as something distinct from the presentation of the action."[281] Andrew Sarris considered Hawks's work a model of economy, declaring that "this is good, clean, direct, functional cinema, perhaps the most distinctively American cinema of all."[282] The French critic Henri Langlois agreed that the power of Hawks's work lay in its clarity and directness: "The essential. The truth of the dialogue, the truth of the situations, the truth of the subjects, of the milieux, of the characters. . . . There is nothing superfluous: no stopping, no meandering, no fleshing out."[283]

When Sarris placed Hawks among the pantheon directors in his book on the American cinema in 1968, he began his profile of him by observing that "Howard Hawks was until recently the least known and least appreciated Hollywood director of any stature."[284] For Gerald Mast, the longtime critical neglect of Hawks was a direct consequence of the director's skill, as he argued that Hawks was "so perfect at convincing the audience of the artlessness of his art that the artist literally disappeared for every contemporary commentator."[285] Yet as with Hitchcock, the atti-

tudes of many critics were undoubtedly affected by Hawks's commercial success, and by his open pursuit of it, for as a biographer observed, "He wanted to make good films with big stars and bring in a lot of money. . . . For Hawks, there was something wrong with a picture if it didn't go over with the public.[286]

Like a number of young French directors in the late 1950s, Jean-Luc Godard began making movies only after working for several years as a film critic. Claude Chabrol, Eric Rohmer, François Truffaut, Godard, and the others who made up what came to be called the New Wave devised a variety of new conceptual approaches to film. As Godard later recalled, "Our first films were all *films de cinéphile*—the work of film enthusiasts."[287] Godard also recognized that his early work was based entirely on earlier films: "I knew nothing of life except through the cinema. . . . I didn't see things in relation to the world, to life or history, but in relation to the cinema."[288] Like most of his colleagues in the New Wave, Godard's conception of film was highly literary: "I consider myself an essayist; . . . simply, I film them instead of writing them. If the cinema were to disappear, I'd go back to pencil and paper."[289]

Godard has directed scores of movies in a career that continues today in its fifth decade, but there is a strong critical consensus that his most important single work is his first full-length movie, *Breathless*, which he made in 1960 at the age of 30. In language that stresses the extremity of the film's radical conceptual innovativeness, Peter Wollen observed that in *Breathless* "all the conventional rules of editing, lighting, screenwriting and direction were trashed, all the time-honored conventions ignored."[290] *Breathless* was a gangster film, but it was based on earlier American gangster movies rather than any direct observation of the real underworld.[291] And, even then, Godard's conceptual approach transformed it into something very different from traditional gangster films. Later Godard acknowledged this, as he told an interviewer that although he had set out to make *Breathless* a realistic film, he had in fact created "a completely unreal, surrealistic world" that in the end had more in common with *Alice in Wonderland* than with *Scarface*.[292] Godard made *Breathless* on a low budget, with a very small crew, no artificial lighting, no constructed sets, and often a handheld camera. Its most celebrated innovations involved Godard's intentional and jarring violations of narrative continuity: "*Breathless* was notorious for its 'faux raccords' (false matching shots) before it had even played in the cinema. . . . But much more radical were the jump cuts, where Godard simply advanced the action without any regard to narrative logic or to a motivated look."[293]

Susan Sontag described Godard as "a deliberate 'destroyer' of cinema," and compared his innovations to the radical conceptual departures of Cubism: "His approach to established rules of film technique like the

unobtrusive cut, consistency of point of view, and clear story line is comparable . . . to the challenge of the Cubists to such hallowed rules of painting as realistic figuration and three-dimensional pictorial space." She also recognized the conceptual intent of his art: "That Godard has boldly addressed the task of representing or embodying abstract ideas as no other film-maker has done before him is undeniable."[294] Manny Farber called attention to another aspect of Godard's conceptual approach, by contrasting the diversity of his works with the consistency of the approach of a great experimental painter: "Unlike Cézanne, who used a three-eighths-inch square stroke and a nervously exacting line around every apple he painted, the form and manner of [Godard's] execution changes totally with each film. . . . Each of his pictures presents a puzzle of parts, a unique combination of elements to prove a preconceived theory."[295]

Godard created a new and distinctively conceptual approach to movies, "more self-aware and proudly artificial than classical stylists find acceptable." This approach involved a clear break with linear narrative: "Asked by a bewildered colleague whether his movies have any kind of structure—even a beginning, middle, and end—Godard famously replied, 'Yes, but not necessarily in that order.' "[296] But equally conceptual is the content of Godard's work, as he has consistently created art that refers to other art. The critic Royal Brown summarized the vast extent of Godard's borrowings:

> All of Godard's movies contain countless allusions, direct or otherwise, to any number of artistic and/or intellectual endeavors—poetry, philosophy, painting, political theory, music, and, of course, the cinema itself, to name the major areas from which Godard draws—whose choice seems to have been dictated solely on the basis of the director's own personal tastes and predilections. Every Godard film is a chapter in an amazingly broad intellectual and aesthetic autobiography. Indeed, it is doubtful that anybody will ever manage to discover all the scattered references that abound in Godard's cinema, so frequent is their use and so thoroughly are they integrated into the director's art.[297]

The scholar Peter Bondanella described Federico Fellini as "the archetypal case of the 'art film' director." Bondanella characterized Fellini as a great showman: "He was a believer in the value of illusion and prestidigitation, an artist who preferred artifice to reality, and a man who believed that dreams were the most honest expression possible for a human being."[298] Fellini himself clearly stated that his own conceptions of things interested him more than the things themselves: "Real life isn't what interests me. I like to observe life, but to leave my imagination unfettered. Even as a child, I drew pictures not of a person, but of the picture in my

mind of the person." His art was avowedly personal: "My fantasies and obsessions are not only my reality, but the stuff of which my films are made."[299] His goal was to express his own thoughts: "I make films because I like to tell lies, to imagine fairy-tales. . . . I mostly like to tell about myself."[300]

Like other conceptual directors, Fellini avoided traditional narrative forms: "I am trying to free my work from certain constructions—a story with a beginning, a development, an ending. It should be more like a poem with meter and cadence."[301] Interestingly, the scholar Robert Richardson compared Fellini's films to the conceptual poem *The Waste Land*: "Both Fellini and Eliot have made highly sophisticated, perfectly deliberate attempts to work out a modern narrative form that does not emphasize narrative smoothness or continuity."[302] Fellini himself compared the structure of his films to the work of another great conceptual artist: "So I said: let's invent episodes, let's not worry for now about the logic or the narrative. We have to make a statue, break it, and recompose the pieces. Or better yet, try a decomposition in the manner of Picasso. The cinema is narrative in the nineteenth-century sense: now let's try to do something different."[303]

The conceptual nature of *8 ½*, which the *Sight and Sound* voters considered Fellini's best film, is reflected in both its form and its substance. Dream and fantasy sequences alternate with realistic episodes, and the boundaries between them are often blurred, so that "everything in the work avoids the traditional seamless storyline of the classic Hollywood film."[304] And in telling the story of a director trying to make a movie, *8 ½* is obviously a movie about the cinema itself. In fact, since *8 ½* is about the movie the director is trying to make, Christian Metz observed that the situation is actually more complicated: "It is not only a film about the cinema, it is a film about a film that is presumably itself about the cinema; it is not only a film about a director, but a film about a director who is reflecting himself onto his film."[305] Peter Bondanella concluded that *8 ½* was "primarily a manifesto about the nature of the intellectual experience that goes into the creation of art."[306]

The evidence of tables 6.6 and 6.7 clearly supports the prediction that conceptual directors make their best movies earlier in their careers than their experimental counterparts. Thus the median age at which the four conceptual directors made the eight movies listed in the table is 37, fully 23 years below the corresponding median age of 60 for the four experimental directors. The difference is even greater if we consider only the single best movie of each director, for the median age at which the four conceptual directors made their single best film was just 29, a remarkable 32 years below the median age of 61 of the four experimental directors. The striking contrast presented in table 6.7, with Ford, Hawks, and Hitchcock making their greatest movies at ages 30 years and more beyond those at which

TABLE 6.7
Ages at Which Directors Made Best Movies

Director	Movie 1	Movie 2
Conceptual		
Eisenstein	27	47
Fellini	43	40
Godard	30	33
Welles	26	43
Experimental		
Ford	62	68
Hawks	63	44
Hitchcock	59	61
Renoir	45	43

Source: See table 6.6.

Eisenstein, Goddard, and Welles made their greatest films, constitutes strong support for the analysis offered by this study. For the difference is clearly understandable as a consequence of the differing styles and contributions of the two types of director, with the visual and storytelling skills of the experimental directors developing over long years of experience, in contrast to the radical new technical devices the conceptual directors invented in the enthusiasm and energy of their youthful iconoclasm.

In extending my analysis of the life cycles of creativity from painting to four other arts, this chapter has considered a limited number of sculptors, poets, novelists, and movie directors, consisting not of samples of hundreds but only dozens. Yet the results are impressive, for this investigation is sufficient to show that some of the very most important figures in the modern history of these arts clearly fit the two categories described by the analysis, and that their careers clearly fit the life cycles predicted for their respective categories. In each of these arts, the major figures considered here can readily be divided into those whose work is conceptual, and others whose work is based on perception: in each of the arts, members of the first group execute works that express their ideas or emotions, whereas those of the second group proceed by trial and error in an attempt to express what they see. And as is the case in painting, important conceptual sculptors, poets, novelists, and movie directors tend to make their greatest contributions suddenly and early in their careers, whereas their experimental counterparts innovate gradually, and arrive at their greatest achievements late in their careers.

CHAPTER SEVEN

perspectives

The preceding chapters of this book have been concerned with defining, elaborating, and applying the analysis of the two types of artistic creativity and their associated life cycles. This chapter will conclude the book by placing this analysis in perspective from several different vantage points. The first of these will consider instances in which important modern artists recognized the distinction between experimental and conceptual practitioners. The second section will then examine the views of a number of other artists on the relationship between age and artistic creativity. The third section will compare my analysis with that of psychologists who have studied the life cycle of human creativity. Finally, a fourth section will consider the implications of my research for understanding creativity more generally.

PORTRAITS OF THE ARTIST AS AN EXPERIMENTAL OR CONCEPTUAL INNOVATOR

Years ago Michael Longley wrote an essay on poets from Northern Ireland in which he made a distinction between igneous and sedimentary modes of poetic composition. In geology, igneous rocks are derived from magma or lava solidified below the earth's surface, whereas sedimentary ones are formed by the deposit and accumulation of mineral and organic materials worked on, broken down, and reconstituted by the action of water, ice, wind. The very sound of the words is suggestive of what is entailed in each case. Igneous is irruptive, unlooked-for and peremptory; sedimentary is steady-keeled, dwelt-upon, graduated.
Seamus Heaney[1]

The distinction between experimental and conceptual innovators is not a new one in the study of the arts. Although it has never been the primary subject of any significant investigation, it has been noted in passing by a number of critics and scholars. Some of these observations have been quoted in the course of earlier discussions in this book.

Yet perhaps more interesting is that aspects of this distinction have also been considered by a number of artists. One instance occurred in an essay by the poet Stephen Spender published in 1946. Spender described differences among poets in methods of composition:

> Different poets concentrate in different ways. In my own mind I make a sharp distinction between two types of concentration: one is immediate and complete, the other is plodding and only completed by stages. Some poets write immediately works which, when they are written, scarcely need revision. Others write their poems by stages, feeling their way from rough draft to rough draft, until finally, after many revisions, they have produced a result which may seem to have very little connection with their early sketches.

Spender noted that the first of these types was "the more brilliant and dazzling," but he was careful to insist that the difference between the two types did not have any implications for the quality of the final product: "Genius, unlike virtuosity, is judged by greatness of results, not by brilliance of performance." The difference instead involved the artistic process: "One type . . . is able to plunge the greatest depths of his own experience by the tremendous effort of a moment, the other . . . must dig deeper and deeper into his consciousness, layer by layer."

Spender did not pursue the implications of his distinction, for this analysis merely served as a preamble to a discussion of his own—experimental—process of composition; its real purpose was clearly to preempt potential criticisms of his own plodding procedures. Thus he embarked on a detailed illustration of his struggles with several poems after stressing that although a poet "may be clumsy and slow; that does not matter, what matters is integrity of purpose."[2]

On several occasions, William Faulkner used the distinction between experimental and conceptual art in the course of explaining why he considered his own work superior to that of his contemporary and fellow Nobel laureate Ernest Hemingway. In interviews, Faulkner noted that "there were sculptors, there were few painters, there were few musicians, like Mozart, that knew exactly what they were doing, that used their music like the mathematician uses his formula." Having identified Mozart as the prototype of the artist who worked with deductive certainty, Faulkner then coupled Hemingway with the composer, pointing out that not all artists have "whatever the quality that Mozart, Hemingway had." Faulkner explained that whereas Hemingway had early learned a style that he had consistently used thereafter, other authors, including Thomas Wolfe and Faulkner himself, had not, because "we didn't have the instinct, or the preceptors, or whatever it was, anyway. We tried to crowd and cram everything, all experience, into each paragraph. . . . That's why

it's clumsy and hard to read. It's not that we deliberately tried to make it clumsy, we just couldn't help it." Faulkner acknowledged that Hemingway had "done consistently probably the most solid work of all of us," because of his early discovery of a method that satisfied him. Yet Faulkner considered Thomas Wolfe the greatest writer of his generation, because of the ambition of his attempt: "He failed the best because he had tried the hardest, he had taken the longest gambles, taken the longest shots." In contrast, Faulkner ranked Hemingway not only below Wolfe, but also below Erskine Caldwell, John Dos Passos, and Faulkner himself, because Hemingway had stuck to his early method "without splashing around to try to experiment."

Faulkner wasn't troubled by failure, since he considered it inevitable: "None of it is perfection . . . and anything less than perfection is failure." The measure of a writer was consequently not success, but how hard "he tried . . . to do what he knew he couldn't do." In simple terms, he stated the experimental author's creed: "I think that the writer must want primarily perfection. . . . He can't do it in this life because he can't be as brave as he wishes he might, he can't always be as honest as he wishes he might, but here's the chance to hope that when he has pencil and paper he can make something as perfect as he dreamed it to be." Appropriately for a great experimental writer whose favorite book was *Don Quixote*, Faulkner judged artists by the nobility of their quest for the impossible dream: "It was simply on the degree of the attempt to reach the unattainable dream, to accomplish more than any flesh and blood man could accomplish, could touch."[3]

In a lecture given in 1951 at New York's Museum of Modern Art, Wallace Stevens remarked that there was a division between two classes of modern poetry that also existed between the factions in modern painting:

> Let me divide modern poetry into two classes, one that is modern in respect to what it says, the other that is modern in respect to form. The first kind is not interested primarily in form. The second is. The first kind is interested in form but it accepts a banality of form as incidental to its language. Its justification is that in expressing thought or feeling in poetry the purpose of the poet must be to subordinate the mode of expression, that while the value of the poem as a poem depends on expression, it depends primarily on what is expressed.

Stevens left little doubt of his identification with this first type when he proceeded to treat the concerns of poets of the second type: "One sees a good deal of poetry . . . in which the exploitation of form involves nothing more than the use of small letters for capitals, eccentric line-endings, too little or too much punctuation and similar aberrations. These have nothing to do with being alive."[4] Stevens's emphasis on the primacy of subject

matter over form was consistent with the experimental nature of his po-
etry. His message also appealed to the Abstract Expressionist painters as
they struggled against the rise of conceptual art later in the 1950s.[5]

In a lecture given in 1965, the Italian poet and movie director Pier Paolo
Pasolini distinguished between two cinematic traditions from the vantage
point of semiology. Pasolini explained that the older of the two traditions
in film, which he called the language of prose, was concerned with ratio-
nal, illustrative, logical methods of narrative, and had initially emerged
to profit from the availability of an audience of consumers vastly larger
than existed for other kinds of art. In contrast, Pasolini observed that the
trend of recent cinema had been toward the use of instruments drawn
from the irrational world of memory and dreams, which he called the
language of poetry: "The principal characteristic of these [recent] indica-
tions of a tradition of the cinema of poetry consists in a phenomenon
which technicians define normally and tritely as 'making the camera felt.'
In sum, the maxim of wise filmmakers in force up till the '60s—'Never
let the camera's presence be felt'—has been replaced by the opposite."
That Pasolini's distinction is in fact the same as that between experimental
and conceptual films is made clear by his subsequent relation of these two
different technical approaches to an underlying philosophical difference
of intention. Thus in his view filmmakers who used the language of prose
were interested in making statements of truth, while those who used the
language of poetry were interested in the process of cognition: "These
two opposite points, gnosiological and gnomic, indiscussibly define the
existence of two different ways of making films: of two different cinematic
languages."[6]

What is almost certainly the most influential description of an experi-
mental artist appeared in a work of fiction that has fascinated generations
of modern painters. This is the characterization of the aged master Fren-
hofer created by Honoré de Balzac in his novella *The Unknown Master-
piece*, published in 1837. Frenhofer has spent years pursuing an aesthetic
ideal of beauty: "Form's a Proteus much more elusive and resourceful
than the one in the myth—only after a long struggle can you compel it to
reveal its true aspect." He is tormented by the inadequacy of artistic meth-
ods for the goal of capturing reality: "Line is the means by which man
accounts for the effect of light on objects, but in nature there are no
lines—in nature everything is continuous and whole." He recognizes that
his extended research has had a chilling effect on his achievement:
"There's no escaping it; too much knowledge, like too much ignorance,
leads to a negation. My work is . . . my doubt!" Yet he persists in his
decade-long effort to produce a single perfect painting: "It's ten years
now, young man, that I've been struggling with this problem. But what
are ten short years when you're contending with nature?"

Another painter, Porbus, respectfully offers an analysis of Frenhofer that has since been applied to a number of great experimental painters: "Frenhofer's a man in love with our art, a man who sees higher and farther than other painters. He's meditated on the nature of color, on the absolute truth of line, but by dint of so much research, he has come to doubt the very subject of his investigations." The pragmatic Porbus sympathizes with Frenhofer's uncertainty, but refuses to be paralyzed by its extremity, and offers more practical advice to a student: "Practice and observation are everything to a painter; so that if reasoning and poetry argue with our brushes, we wind up in doubt, like our old man here, who's as much a lunatic as he is a painter. . . . Don't do that to yourself! Work while you can! A painter should philosophize only with a brush in his hand."[7] But Frenhofer himself is beyond help. His uncompromising pursuit of the impossible can have only one outcome, and the final sentence of the novella reveals that he has died after burning all his canvases.

Many modern artists have identified with Frenhofer. The most famous recorded instance of this is contained in Émile Bernard's account of his visit to Cézanne in Aix in 1904: "One evening I spoke to him of *Le chef d'oeuvre inconnu* and of Frenhofer, the hero of Balzac's tragedy. He got up from the table, stood before me, and striking his chest with his index finger, he admitted wordlessly by this repeated gesture that he was the very character in the novel. He was so moved by this feeling that tears filled his eyes."[8]

Other examples of artists' awareness of the distinction between experimental and conceptual approaches to art might be added, but those discussed here are sufficient to demonstrate that the difference has been understood by modern painters, poets, novelists, and movie directors. This is not surprising, for the difference between the two types of artist lies not simply in how they paint, or write, but even more basically in why they make paintings or write texts. In view of the importance of the distinction, and the richness of its implications for our understanding of the history of the arts, it is unfortunate that scholars of art have not followed the leads given to them by Balzac, Stevens, Faulkner, and other important modern artists.

PORTRAITS OF THE ARTIST AS A YOUNG OR OLD INNOVATOR

The talent that matures early is usually of the poetic,
which mine was in large part. The prose talent depends
on other factors—assimilation of material and careful se-
lection of it, or more bluntly: having something to say
and an interesting, highly developed way of saying it.
F. Scott Fitzgerald, 1940[9]

A few modern artists have also devoted more than casual attention to the question of how and why artists' work changes over the course of their lives. It is perhaps not surprising that the subtlest and most extensive consideration of the life cycles of both experimental and conceptual artists was given by Henry James. At the age of 50, James published a story, "The Middle Years," which gives a detailed portrayal of an experimental novelist in old age, as he faces his impending death. Having just received in the mail the published text of what he now knows will be his final novel, Dencombe soon takes a pencil and begins to make changes, for he is "a passionate corrector, a fingerer of style; the last thing he ever arrived at was a form final for himself." In rereading his last book, Dencombe recognizes, with all the qualifications and ambivalence of an experimental artist, that it is his best work: "Never probably had that talent, such as it was, been so fine. His difficulties were still there, but what was also there, to his perception, though probably, alas! to nobody's else, was the art that in most cases had surmounted them." With this recognition, however, comes the painful perception of how slowly his talent had grown: "His development had been abnormally slow, almost grotesquely gradual. He had been hindered and retarded by experience, he had for long periods only groped his way. It had taken too much of his life to produce too little of his art." Dencombe is overwhelmed by regret that he is dying just when he might have begun to use the skills he had acquired so slowly and painstakingly: "Only today at last had he begun to *see*, so that all he had hitherto shown was a movement without a direction. He had ripened too late and was so clumsily constituted that he had had to teach himself by mistakes." But his health is such that he will not have time even to transform his last book into a satisfactory demonstration of his ability: "What he dreaded was the idea that his reputation should stand on the unfinished." James allows Dencombe some relief only on his deathbed, when the insistence of a young admirer prompts him to admit that he had in fact accomplished "something or other," and to accept that uncertainty was inevitable: "We work in the dark—we do what we can—we give what we have. Our doubt is our passion and our passion is our task. The rest is the madness of art."[10]

In the same year James wrote a review of an exhibition of paintings by John Singer Sargent, who was then 37 years old, in which he gave a penetrating analysis of the career of a conceptual artist. James praised Sargent for his clarity of purpose and confident execution: "It is difficult to imagine a young painter less in the dark about his own ideal, more lucid and more responsible from the first about what he desires. In an altogether exceptional degree does he give us the sense that the intention and the art of carrying it out are for him one and the same thing." James noted, however, that Sargent's recent work did not demonstrate develop-

ment: "As he saw and 'rendered' ten years ago, so he sees and renders today; and I may add that there is no present symptom of his passing into another manner." James was disturbed by Sargent's precocity, for "it offers the slightly 'uncanny' spectacle of a talent which on the very threshold of its career has nothing more to learn"; James found himself "murmuring, 'Yes, but what is left?' and even wondering whether it be an advantage to an artist to obtain early in life such possession of his means that the struggle with them, discipline, *tâtonnement*, cease to exist for him. May not this breed an irresponsibility of cleverness, a wantonness, an irreverence—what is vulgarly termed a 'larkiness'—on the part of the youthful genius who has, as it were, all his fortune in his pocket?" In conclusion, James praised Sargent's technical skills: "The gift that he possesses he possesses completely—the immediate perception of the end and of the means." Yet his final words raised his fear that Sargent would never achieve what James called "the highest result," which "is achieved when to this element of quick perception a certain faculty of brooding reflection is added. . . . I mean the quality in the light of which the artist sees deep into his subject, undergoes it, absorbs it, discovers in it new things that were not on the surface, becomes patient with it, and almost reverent, and, in short, enlarges and humanizes the technical problem."[11]

The validity of James's fear that Sargent's best work was already a decade behind him even at the early age of 37 is confirmed by a survey of textbooks of art history published since 1960. The 37 texts examined contained a total of 39 illustrations of paintings by Sargent, 24 of which (62 percent) were executed before the age of 30, and 33 of which (85 percent) had been painted by the time of the exhibition that occasioned James's review. Sargent would work for more than 30 years beyond that date, but his two most often reproduced paintings—both discussed in James's review—were executed at the ages of 26 and 28. In view of this quantitative evidence, it is not surprising that Sargent worked conceptually, with careful preparation for his paintings, sketching his patrons before painting their portraits, and making preparatory drawings for his outdoor subjects before executing them in his studio.[12]

Although both of James's portraits are remarkable descriptions of the type of artist they treat, his analysis of the dangers of the conceptual approach is perhaps the more impressive of the two. James's awareness not only of the slow growth of an experimental artist's skills, but also of the pervasive uncertainty that accompanies that growth, could be attributed to introspection about his own career, but his recognition that the precocity of a gifted conceptual artist would be associated with the danger that the artist would not develop the depth of feeling that we often attribute to great experimental painters could only come from careful observation of artists other than himself.

Most often, it appears that artists who examine the life cycle are aware primarily of only one of the two patterns, specifically that which characterizes their own career. Joan Miró was an important experimental painter, who believed strongly in the value of working by trial and error. So, for example, early in his career he reported to a friend, "I have studied a lot this summer. My two paintings have been changed a thousand times. . . . Perhaps this summer's paintings will be a *struggle* more than a *result*—so much the better." When Miró was 24, in a letter to another young painter he described the kind of artist he admired, who "sees a different problem in every tree and in every bit of sky: this is the man who suffers, the man who is always moving and can never sit still, the man who will never do what people call a 'definitive' work. He is the man who always stumbles and gets to his feet again. . . . [H]e is always saying *not yet, it is still not ready*, and when he is satisfied with his last canvas and starts another one, he destroys the earlier one." The next year Miró declared that no artist of this type "will begin to know how to paint until he is 45." Consistent with this characterization, two decades later Miró told an interviewer of his admiration for two experimental artists, the painter Pierre Bonnard and the sculptor Aristide Maillol: "These two will continue to struggle until their last breath. Each year of their old age marks a new birth. The great ones develop and grow as they get older."[13]

Virginia Woolf was probably also thinking about her own development in 1923 when, at the age of 41, she reflected on the life of a great English novelist who had died at that age more than a century earlier. In an essay originally titled "Jane Austen at Sixty," Woolf declared, "She died at the height of her powers. She was still subject to those changes which often make the final period of a writer's career the most interesting of all," and went on to speculate about how Austen's art might have changed had she lived longer: "She would have known more. . . . She would have trusted less . . . to dialogue and more to reflection to give us a knowledge of her characters. . . . She would have devised a method, clear and composed as ever, but deeper and more suggestive, for conveying not only what people say, but what they leave unsaid; not only what they are, but what life is." Woolf concluded that in this development Austen "would have been the forerunner of Henry James and of Proust."[14] It would appear that only modesty caused Woolf to omit herself from this group, since her analysis of Austen's hypothetical later work points to Woolf's understanding of how a great experimental writer gains in knowledge and depth of understanding as she ages, and in turn becomes an influence on the great experimental writers of later generations.

Poetry is one of the intellectual activities most commonly assumed to be dominated by young geniuses. So, for example, the poet Josephine Jacobsen observed that "in our general conception, old age is a period

alien, if not fatal, to poetry. The Shelley-Keats image, the youthful figure
of the runner fame never outran, lingers."[15] Interestingly, two great con-
ceptual poets of the early twentieth century offered somewhat more com-
plex general thoughts on how poets' work changes with age. In a lecture
given in 1940, T. S. Eliot observed, "It is my experience that towards
middle age a man has three choices: to stop writing altogether, to repeat
himself with perhaps an increasing skill of virtuosity, or by taking thought
to adapt himself to middle age and find a different way of working." Eliot
argued that the third option was a real one: "In theory, there is no reason
why a poet's inspiration or material should fail, in middle age or at any
time before senility. For a man who is capable of experience finds himself
in a different world in every decade of his life; as he sees it with different
eyes, the material of his art is continually renewed." Yet Eliot's empirical
judgment was that this was unlikely: "In fact, very few poets have shown
this capacity of adaptation to the years. It requires, indeed, an exceptional
honesty and courage to face the change. Most men either cling to the
experiences of youth, so that their writing becomes an insincere mimicry
of their earlier work, or they leave their passion behind, and write only
from the head, with a hollow and wasted virtuosity."[16]

When Eliot delivered this lecture he was 52 years old. Two years later
he completed the *Four Quartets* and told a friend, "I have reached the end
of something." He had little interest in writing poetry in the more than
two decades that remained to him, and a biographer observed that it was
"as though the Eliot of the great poems was no longer there."[17] When he
gave his lecture in 1940 Eliot may have been unaware of the recent progress
of his contemporaries Robert Frost, Marianne Moore, Wallace Stevens,
and William Carlos Williams, or perhaps the conceptual Eliot was simply
unable to appreciate the great achievements in middle age of these experi-
mental poets who lacked his precocity and brilliance. Whichever the case,
Eliot's judgment clearly applies to conceptual poets like himself, who rise
quickly to a high level of achievement, are typically unable later to surpass
or even match that early peak, and are often mystified by the loss of their
creative powers. It is difficult not to hear a personal sense of loss in a
statement Eliot made in that 1940 lecture: "That a poet should develop at
all, that he should find something new to say, and say it equally well, in
middle age, has always something miraculous about it."[18]

Several decades earlier, Eliot's friend and fellow conceptual poet Ezra
Pound had offered a somewhat more skeptical view of the association
between youth and poetic achievement. Pound began by rejecting the say-
ing that "a lyric poet might as well die at thirty," noting that although
many people are drawn to producing poetry in early adulthood, the re-
sults are not necessarily excellent: "The emotions are new, and, to their
possessor, interesting, and there is not much mind or personality to be

moved." As the poet ages, the mind "becomes a heavier and heavier machine" requiring "a constantly greater voltage of emotional energy," but, since "the emotions increase in vigor as a vigorous man matures," the result is that "most important poetry has been written by men over thirty."[19] Although this is clearly stated as an empirical conclusion, Pound gave only one example in support, and he may not have expected readers to be greatly impressed by his contention that Guido Cavalcanti produced his best work at 50. Rather than constituting the end product of extensive study, this discussion in an essay written when Pound was 28 might be taken as a theoretical argument that his own best work could still be ahead of him.

A number of modern artists have understood that there is a connection between the nature of an artist's work and the path of that artist's creativity over the life cycle. Indeed, Henry James and T. S. Eliot both clearly recognized that there are two distinct life cycles of creativity, and that each can be traced in the careers of specific artists.[20] In spite of these major artists' analyses, however, scholars in the humanities have not used the distinction between experimental and conceptual artists to explain differences in the life cycles of individuals, or as a tool in understanding the development of specific arts—painting, fiction, or poetry—over time. This neglect is unfortunate, but the failure of humanists to carry out systematic comparative analysis is not a new development. In his inaugural lecture as professor of art history at Cambridge University in 1933, Roger Fry declared that "we have such a crying need for systematic study in which scientific methods will be followed wherever possible, where at all events the scientific attitude may be fostered and the sentimental attitude discouraged."[21] Fry's appeal to his discipline fell on deaf ears at the time, but it is to be hoped that humanists will recognize the gains to their disciplines of heeding it now.

Although humanists have not studied the life cycles of innovators, however, there is a discipline that has done this. The next section of this chapter will examine how psychologists have approached this subject, and how my analysis differs from theirs.

PSYCHOLOGISTS ON THE LIFE CYCLES OF CREATIVITY

Possibly every human behavior has its period of prime.
Harvey Lehman, 1953[22]

Poets peak young.
James Kaufman, director, Learning Research Institute,
California State University, San Bernardino, 2004[23]

In 1953, the psychologist Harvey Lehman published *Age and Achievement*, which has since become recognized as a landmark work in the quantitative study of creative life cycles. Lehman's single goal was "to set forth the relationship between chronological age and outstanding performances," and through the collection and analysis of vast amounts of data, he did just that for practitioners of a wide range of academic disciplines, arts, sports, and politics.[24]

Lehman's methods and results can be illustrated through reference to his treatment of several of the arts considered by the present study. In analyzing oil painting, for example, Lehman used 60 lists of great paintings published by European and American critics to identify the most important painters of the past, which he defined as those artists who had at least one picture on 5 or more of the lists. For each of these 67 artists, Lehman identified the artist's single best painting as that with the largest number of appearances on the 60 lists. He then distributed these 67 paintings by the ages of the artists when the paintings were executed. Inspection of this distribution "revealed rather conclusively that . . . the great oil paintings were executed most frequently at [ages] 32 to 36."[25]

With considerable energy and ingenuity, Lehman carried out similar analyses for scores of other activities. In a summary discussion, he presented the age ranges that represented "the maximum average rate of highly superior production" for 80 fields. Among these were oil painting, ages 32 to 36 (as noted earlier); lyric poetry, ages 26 to 31; and novels, ages 40 to 44.[26]

A number of psychologists have echoed Lehman's findings in a variety of contexts. A few recent examples can be cited. In 1989, Colin Martindale commented that "in general, a person's most creative work is done at a fairly early age, and this age of peak productivity varies from field to field. It is fairly early in lyric poetry . . . (ages 25–35). . . . Only a few specialties, such as architecture and novel writing, show peak performance at later ages (40–45)."[27] In 1993, Howard Gardner observed, "While other kinds of writing seem relatively resistant to the processes of aging, lyric poetry is a domain where talent is discovered early, burns brightly, and then peters out at an early age. There are few exceptions to this meteoric pattern."[28] In 1994, Dean Simonton explained that "in some fields creative productivity comes and goes like a meteor shower; the peak arrives early, and the decline is unkind. In other creative domains the ascent is more gradual, the optimum point is later, and the descent is more leisurely and merciful. . . . In the arts, for example, the curve for writing novels peaks much later than that for poetry writing."[29] In 1996, Mihaly Csikszentmihalyi noted, "The most creative lyric verse is believed to be that written by the young."[30] And in 1998, Carolyn Adams-Price remarked that "lyric poetry tends to be produced early in life."[31]

As these statements indicate, Martindale, Gardner, Simonton, Csiks-zentmihalyi, and Adams-Price follow Lehman in focusing on a single age period in which practitioners of a particular activity tend to produce their most creative work.[32] In general, there must be such a period: if we consider any given intellectual activity, and specify an era of interest, a plurality of the most important innovations in that activity will have been made by people who were in some particular range of ages at the time they made their contributions. It is extremely important to remember, however, that this does not mean that all, or even most, of the major contributions were made by people in that age-group; in fact, that age-group may not account for even a majority of those works. Thus, for example, Lehman's finding that "the maximum average rate of highly superior production" of lyric poems occurred at ages 26 to 31 does not imply that all poets peak young, nor does it imply that most do; it means only that in his sample, more poets peaked in that age span than in any other. The danger of concentrating on a single prime period for poetry, or any other activity, is that this may cause us to lose sight of the variation in the ages at which great innovators can peak, and that we will consequently fail to discover that different kinds of innovations may be associated with different peak ages. And it appears that in fact this may have occurred in psychologists' analyses of creativity, as generalizations about the single age period when poets, novelists, or other innovators peak appear to have interfered with their ability to understand creativity at the individual level. For the theory and evidence presented in this book suggest that for the arts considered here—painting, sculpture, poetry, novels, and movies—there is no single phase of the life cycle that dominates the production of important contributions, but instead there are two very different distributions of quality of work by age, with very different peaks, within each art.

The danger of referring to a single peak age period for an activity can be illustrated with a simple example. Table 7.1 lists the ten poems written by the American poets discussed in chapter 6 that are most often reprinted in the 47 anthologies analyzed for that study. In summarizing table 7.1, we could note that only one age is represented by more than a single entry, and thus conclude that age 30 was the age of maximum production of superior poems by these poets. This is obviously consistent with the results Lehman obtained from a much larger sample, since 30 falls within the range of ages he identified as the best for lyric poets. If we were simply to report that table 7.1 reveals that 30 is the prime age for lyric poets, the psychologists quoted in this section could nod in agreement, secure in their belief that lyric poetry is a young person's domain.

Yet taking age 30 to represent the evidence in table 7.1 would neglect several important facts. One is that the decade of the 40s has four entries, or more than any other; the 30s have only three entries. And a second is

TABLE 7.1
Most Often Anthologized Poems by Poets Listed in Table 6.3

Poet, Poem	Age of Poet at Publication	Number of Anthology Entries
1. (t) Eliot, "The Love Song of J. Alfred Prufrock"	23	31
1. (t) Lowell, "Skunk Hour"	41	31
3. Frost, "Stopping by Woods on a Snowy Evening"	48	29
4. Williams, "The Red Wheelbarrow"	40	28
5. Pound, "The River-Merchant's Wife: A Letter"	30	25
6. Plath, "Daddy"	30	24
7. Pound, "In a Station of the Metro"	28	24
8. (t) Frost, "Mending Wall"	38	23
8. (t) Stevens, "The Snow Man"	42	23
8. (t) Williams, "The Dance"	59	23

Source: Galenson, "Literary Life Cycles," table 5.

that six of the table's ten poems were written by poets aged 38 or older, whereas four were written by poets at age 30 or younger. Only if we worried about the significance of these facts would we be prompted to ask why there is such a considerable difference in the ages at which great lyric poets do their best work. Studying this question could then lead us to the conclusion, presented in chapter 6, that Eliot, Plath, and Pound were conceptual innovators, who peaked early, whereas Frost, Lowell, Stevens, and Williams were experimental innovators, who matured more gradually. We would then learn that writing lyric poetry is a more varied and complex activity than Lehman and the other psychologists might believe.

Recognition of this complexity has been a casualty of the psychologists' assumption that each activity has a single period of peak creativity. Thus, for example, Dean Simonton offered an explanation for the supposed fact that poets peak at earlier ages than novelists: "Fast ideation and elaboration are characteristic of lyric poetry, whereas writing novels requires more time both for isolating an original chance configuration and for transforming it into a polished communication configuration."[33] Simonton's concentration on the time required to produce a single poem or

novel is misguided, for this simply does not explain the age-creativity profiles of authors. It is true that Sylvia Plath could write a major poem in one day, whereas Mark Twain took almost a decade to complete *Huckleberry Finn*, but it is also true that Scott Fitzgerald could publish what many critics consider the greatest American novel when he was just 29, and that Robert Frost did not write "Stopping by Woods on a Snowy Evening," his most frequently anthologized poem, until he was 48. What shapes the age-creativity profiles of writers is not the time required to produce a particular work, but rather the time needed to develop their art. The conceptual approaches of Plath and Fitzgerald, with sudden innovation based on radical departures from existing practices, allowed them to produce great works at early ages, while in contrast the experimental approaches of Twain and Frost, with powers of observation and craftsmanship developed gradually through painstaking trial and error, meant that they reached their greatest heights later in their lives.

Determining whether more poets have been young geniuses or old masters would require extensive quantitative research. Lehman began this process, but his measurements did not allow for possible variation over time in the relative numbers of important practitioners of the two types—not only over long periods, as from one century to the next, but also over shorter ones, from decade to decade. A precise determination would necessarily involve careful time-series analysis, for it is possible that poetry, like painting, has had periods when conceptual approaches dominated, and others when experimental approaches were preeminent; if so, young geniuses may have made the greatest contributions in some periods, and old masters in others.[34] Quantitative analysis of this kind has not been done, by Lehman or others. Nor would such studies appear to be a high priority for our understanding of creativity. For what is critically important is not simply to know what single pattern of creativity over the life cycle has been most common in a particular activity, but rather what different patterns have characterized the experience of the greatest innovators, and why. Even if it proved to be the case that young geniuses have been more numerous in poetry than old masters, our understanding of creative genius in modern American poetry would be incomplete if we studied the contributions and careers of Cummings, Eliot, Plath, and Pound and ignored those of Frost, Lowell, Stevens, and Williams. An awareness that both types of poet have made major contributions can lead us to study the differences in the kinds of poetry they produced, yielding a richer understanding not only of modern poetry, but of creativity in general.

At the very least, the identification of a single age period of prime creativity for an activity may cause us to miss the drama of individual variation—the difference, for example, between the 23-year-old Eliot writing

"The Love Song of J. Alfred Prufrock" while studying philosophy as a graduate student at Harvard, and the 48-year-old Frost writing "Stopping by Woods on a Snowy Evening" at the kitchen table of his farm in Vermont. More seriously, however, the assumption that each activity has a single typical life cycle of maximum creativity can lead to a basic misunderstanding of how creativity occurs. Thus, for example, a scholar who works under this belief, and accepts Lehman's empirical findings for poets, may consider cases like that of Frost as aberrant or, even worse, may not bother to study them at all as a result of the mistaken assumption that they must conform to the general rule that lyric poets peak at early ages. The generalizations of the psychologists quoted here may stem from uncritical acceptance of the findings of Lehman, buttressed by the dramatic examples of Byron, Keats, Shelley, and the other famous young geniuses who died prematurely. Whatever the cause, a mistaken belief that a question has been conclusively studied and answered appears to have led to a failure to notice that the true answer is more complex.

The significance of the difference between the present study and the research of psychologists on creative life cycles concerns the implications of the two approaches for the causal basis of the relationship between the nature, and timing, of the contributions of creative individuals and the activities they pursue. For Lehman and those psychologists who have followed him, the single pattern of creativity over the life cycle that characterizes each activity is effectively assumed to be determined by the activity: poets peak early, novelists later. In contrast, for the present investigation, the pattern of creativity by age is not determined by the activity, but by the approach of the creative individual. It is possible that it is more common for great poems to be written by the young, and great novels by their elders, but it is important to recognize that Frost, Stevens, Williams, and other great experimental innovators have found ways to write great poetry late in their lives, just as Fitzgerald, Hemingway, Melville, and other great conceptual innovators have found ways to write great novels early in theirs.

The difference between my approach and that of the psychologists may have a considerable impact on our ability to understand creativity. The psychologists' belief that the nature of an intellectual activity determines the pattern of the life cycle of contributors to it appears to be founded on the proposition that some activities are more complex than others. Before a scholar or artist can make a significant innovation, he or she must have a firm knowledge of the most advanced current practice in the relevant field. This knowledge can be gained relatively quickly in activities that deal with more abstract concepts, and requires a longer period in activities in which the central ideas are more concrete. Potential innovators can consequently reach the frontier of creativity more quickly in more abstract, theoretical activities than in more concrete, empirical ones, and they can simi-

larly formulate and develop new ideas that go beyond the frontier more rapidly in more theoretical activities than in more empirical ones.[35]

It is clear that some activities are more complex than others at any moment. Yet what we learn from studying the careers of great innovators is that the complexity of an activity can be changed, sometimes dramatically, by innovations. The psychologists quoted here implicitly assume that the complexity of a field is exogenous to practitioners of that activity, and that it is effectively immutable. On the contrary, I believe that the complexity of a field is endogenous to important innovators, because major innovations often radically change the complexity of an activity. The artists discussed in this book provide many examples. So, for instance, the Abstract Expressionists dominated the advanced art world of the late 1940s and early '50s with visual works that were highly complex, and generally required long periods of apprenticeship from important contributors. Within a brief span of time, however, in the late 1950s Jasper Johns and Robert Rauschenberg created new conceptual forms of art that were much less complex, and could be assimilated much more quickly, with very brief required apprenticeships. Thus the contributions of Frank Stella, Andy Warhol, Roy Lichtenstein, and many others who followed Johns and Rauschenberg were highly conceptual, and were generally made much earlier in their careers than those of Jackson Pollock, Willem de Kooning, Mark Rothko, and the other important Abstract Expressionists. The nature of an activity isn't given to important innovators; it is determined by them.

I believe that recognizing the mutability of activities is crucial for understanding the role of innovators. The psychologists' view of innovators is that they advance their disciplines or arts. In contrast, my analysis recognizes that innovators not only advance their disciplines, but that they often change them. Great experimental innovators may add substantive content to a previously abstract discipline, while great conceptual innovators may discover ways to simplify previously complex domains.

UNDERSTANDING AND INCREASING CREATIVITY

There is a line among the fragments of the Greek poet Archilochus which says: "The fox knows many things, but the hedgehog knows one big thing". . . . [T]aken figuratively, the words can be made to yield a sense in which they mark one of the deepest differences which divide writers and thinkers, and, it may be, human beings in general. For there exists a great chasm between those, on one side, who relate

> everything to a single central vision . . . and, on the
> other side, those who pursue many ends. . . . The first
> kind of intellectual and artistic personality belongs
> to the hedgehogs, the second to the foxes.
> *Isaiah Berlin, 1953*[36]

> Some of the reasons for attention to the creative
> process are practical. . . . [I]nsight into the processes
> of invention can increase the efficiency of almost any
> developed and active intelligence.
> *Brewster Ghiselin, 1952*[37]

The significance of the analysis presented in this book may be considerable, for I believe it is likely that the distinction between experimental and conceptual innovators exists not only in the arts, but in virtually all intellectual activities. The work involved in testing this hypothesis for academic disciplines may be substantial, but a start has been made in recent research. Thus a study of the life cycles of the Nobel laureates in economics who were born in or before 1926 has found that scholars categorized as conceptual were most likely to publish their most frequently cited work at the age of 43, whereas those categorized as experimental were most likely to publish their most cited work at 61. The study furthermore found that when the conceptual laureates were divided according to the degree of abstraction of their major contributions, those classed as extreme conceptual innovators—that is, those who worked at very high levels of abstraction—published their best work at a mean age of 36, compared with a mean age of 45 for their moderate conceptual counterparts.[38] For some very important innovators in economics, this research therefore supports the prediction that scholars who work deductively generally do their most important research considerably earlier in their careers than those who work inductively; it also indicates that among the deductive scholars, those who work at higher levels of abstraction generally produce their major contributions significantly earlier than their counterparts who typically work at lower levels of abstraction.

The possibility that the present analysis is applicable to all intellectual activities obviously increases the importance of pursuing our examination of the implications of the analysis. To conclude this book, this section will summarize some basic characteristics of each of the types that appear to be general to all the activities considered in this study, then examine some ways in which an artist or scholar of either type might increase his or her creativity.

The consideration in this book of the work and careers of experimental and conceptual innovators in a number of arts demonstrates not only

that there are clear differences in basic characteristics of the work of the two types of artists, but also that there are significant similarities within each of the categories across the arts. These provide the basis for general descriptions.

Conceptual innovators historically have been those artists most likely to be described as geniuses, as their early manifestations of brilliance and virtuosity have been taken to indicate that these individuals were born with extraordinary talents. Conceptual innovators normally make their most important contributions to a discipline not long after their first exposure to it. These precocious innovators are often perceived as irreverent and iconoclastic: in many cases their lack of respect for earlier work in their disciplines has figured prominently in their ability to make bold departures from existing practices. Many extreme conceptual innovators do not spend long periods acquiring the complex skills common to many practitioners of their disciplines, in some cases because the extreme simplifications they make in their work can allow them to avoid the need for those skills. The central elements of conceptual innovators' major contributions often arrive in brief moments of inspiration, and they can often be recorded and communicated very quickly. Their innovations often involve radical leaps, producing work that has no relation to their own earlier output. Detractors often consider their work to be naive and simplistic, but admirers perceive that its power lies in its simplicity and generality. A fundamental characteristic of conceptual innovators is certainty; most have great confidence in the validity and significance of their contributions, and this allows them to put forward dramatic new works early in their careers in spite of their knowledge that most practitioners of their disciplines will be hostile to their new ideas.

Experimental innovators are most often praised for their wisdom and judgment. Their major contributions typically involve superb craftsmanship, the result of painstaking effort and experience acquired over the course of long careers. Experimental innovators are celebrated for the depth of their understanding and respect for the traditions of their disciplines. Even their major works are not generally intended as definitive statements, but are provisional, subject to later modification or further development, reflecting their author's lack of certainty in their accomplishment. Uncertainty is perhaps the most common characteristic of great experimental innovators; if conceptual innovators typically live in a world of black and white, experimentalists instead see only a highly nuanced range of shades of gray. Because of this, detractors often consider their work indecisive and unresolved, while admirers see in it subtlety and realism. Their uncertainty is the basic cause of the gradual nature of the progression normally seen in their work over time, as their styles evolve slowly through cautious and extended experimentation. Their uncer-

tainty is also often directly reflected in their work, for their art often contains explicit or implicit statements of ambiguity and irresolution.

A few examples can make these generalizations more concrete. Robert Frost was an experimental artist who believed in following the traditional rules of his art strictly. He famously denounced a deviation from those rules that was becoming increasingly popular among modern poets by declaring, "I had as soon write free verse as play tennis with the net down."[39] When another poet objected that you could play a better game with the net down, Frost replied that that might be so, "but it ain't tennis."[40] For Frost, the essence of poetry lay in the craftsmanship that allowed the poet to express himself within the constraints created by traditional meters, and he worked within their discipline throughout his life; as Robert Lowell observed, "He became the best strictly metered poet in our history."[41]

Ezra Pound was Frost's antithesis, a conceptual artist who had no qualms about breaking traditional rules. In a characteristically brash and definite early statement of his credo, Pound declared, "I believe . . . in the trampling down of every convention that impedes or obscures . . . the precise rendering of the impulse."[42] One such convention was traditional meter. Many years later he looked back with satisfaction on the revolution he had promoted in modern poetry in his youth, and remarked, "To break the pentameter, that was the first heave."[43] Pound understood the problem of communication that existed when the brilliant young conceptual artist faced the older and wiser experimentalist: "A very young man can be quite 'right' without carrying conviction to an older man who is wrong and who may quite well be wrong and still know a good deal that the younger man doesn't know."[44]

Frost and Pound highlight the contrasting attitudes of the experimental and conceptual artist. To the experimentalist, a conceptual innovation may simply be perceived as cheating; so for Frost free verse was illegitimate, and could have no possible justification. In contrast, to the conceptual innovator, breaking the rules of an art may have a positive value if it achieves a desired end; so for Pound discarding the convention of traditional meter was to be looked on with approval, as the creation of a new and better form. A basic difference underlying this disagreement involves whether the artist believes in the existence of a definite goal that can actually be achieved. For a conceptual artist there is a specific goal that is within reach, and the end of achieving it can justify the means used to do so. In contrast, for the experimentalist the goal is imprecise and probably unachievable, and since the end cannot be reached there can be no justification for attempting to do so with illegitimate means.

Another illustration of the differing vantage points of experimental and conceptual artists is afforded by Virginia Woolf's account of her differ-

ence of opinion with T. S. Eliot over James Joyce's *Ulysses*. When Woolf began reading *Ulysses* shortly after it was published, she reported in her diary that her initial enjoyment of the first few chapters soon evaporated, and that she became "puzzled, bored, irritated & disillusioned as by a queasy undergraduate scratching his pimples." She puzzled over Eliot's high opinion of it: "Tom, great Tom, thinks this on a par with War & Peace." Several weeks later Woolf finished *Ulysses* and judged it "a misfire. Genius it has I think; but of the inferior water." She found the book pretentious and questioned Joyce's judgment: "A first rate writer, I mean, respects writing too much to be tricky; startling; doing stunts. . . . [O]ne hopes he'll grow out of it; but as Joyce is 40 this scarcely seems likely." She clearly recognized that Joyce was a fox, and Tolstoy a hedgehog, as she described the experience of reading *Ulysses*: "I feel that myriads of tiny bullets pepper one & spatter one; but one does not get one deadly wound straight in the face—as from Tolstoy, for instance; but it is entirely absurd to compare him with Tolstoy."

Eliot, who had completed *The Waste Land*, his own conceptual masterpiece, just a few months earlier, understood that *Ulysses* was a conceptual landmark that would have a profound impact on the modern novel. The experimental Woolf could not accept that it was important, however, because she found in it no "new insight into human nature." For Woolf, a great novelist was one, like Tolstoy, "who sees what we see," and portrays a real world, "in which the postman's knock is heard at eight o'clock, and people go to bed between ten and eleven." Although Eliot defended Joyce as "a purely literary writer," to Woolf he was little more than a precocious schoolboy who did tricks to attract notice.[45]

With the understanding that has now been built up of the two types of innovator, it might be useful to turn to what Brewster Ghiselin called the practical reasons for examining the creative process. What implications does the analysis developed here have for increasing the creativity of artistic or scholarly innovators? This discussion must necessarily be speculative, but it does seem possible to use our knowledge of the advantages and disadvantages of the two types of innovator to suggest both the dangers and the opportunities they face in general.

There is a traditional and romantic belief that brilliant young conceptual innovators lose their powers as they age because they have simply used up some natural endowment of ideas or insight that was initially fixed in quantity: when that stock is exhausted, their genius is gone. Late in his life, F. Scott Fitzgerald eloquently expressed this view: "I have asked a lot of my emotions—one hundred and twenty stories. The price was high, right up with Kipling, because there was one little drop of something—not blood, not a tear, not my seed, but me more intimately than these, in every story, it was the extra I had. Now it has gone and I am just

like you now."[46] From the vantage point of the present study, however, the inability of Fitzgerald and other aging conceptual innovators to match the brilliant achievements of their youth is not a product of their depletion of a stock of some magical elixir of artistry. Instead, it is caused by the impact of accumulating experience. My analysis implies that the real enemies of conceptual innovators are the establishment of fixed habits of thought and the growing awareness of the complexity of their disciplines. The power of the most extreme conceptual innovations lies in looking at old problems in radically new ways, and in greatly simplifying those problems in the process. Working on a problem long enough to become committed to a single way of approaching it may therefore inhibit new conceptual innovation, and the same may be true for studying a problem long enough to become enmeshed in its details and complications. Conceptual innovators thus face the danger that they will become stuck in a rut, and that they will be able to see no simple way out of it. Even important conceptual innovators may become the captives of an important early achievement and fall into a comfortable but relatively unproductive practice of repeating the same analysis, or effectively continually producing the same product, while adding little new of value.

Picasso and a number of other important conceptual innovators both in art and in scholarship have avoided the danger of this repetition by selecting or posing new problems that differ from their earlier work sufficiently that they are unable to draw on their earlier innovations in tackling them. Conceptual innovators have an advantage in being able to change styles, or problems, quickly, and knowing when to do this can be a key to increasing the number of creative contributions they make over the course of their careers. The more radically they change problems, the greater the potential for large new innovations.

Many successful conceptual innovators have also recognized that their advantage lies in producing simple solutions for old problems. Because the ability to perceive simple generalizations may be progressively reduced in the face of the growing perception of the complexity of a problem, some of these innovators have recognized that it is valuable for them to avoid becoming too thoroughly immersed in detailed empirical evidence or complex methods of analysis. Much of the genius of conceptual innovation lies in being able to absorb enough evidence to allow the formulation of a new solution to a problem, without taking in so much evidence that a simple generalization appears inadequate.

If conceptual innovators are sprinters, important experimental innovators are marathoners. Their greatest successes are the result of long periods of gradual improvement of their skills and accumulation of expertise. Late in his life, Cézanne told Émile Bernard of the benefits and costs of

his decades of study: "I believe I have in fact made some more progress, rather slow, in the last studies which you have seen at my house. It is, however, very painful to have to state that the improvement produced in the comprehension of nature from the point of view of the picture and the development of the means of expression is accompanied by old age and a weakening of the body."[47] Old age and illness are not the only obstacles that face experimental innovators, for loss of interest in their work and distractions from it are also common hazards for those whose achievements often come only painfully and slowly. In the face of frustration at this slow pace, it is important to recognize, as Cézanne did, that slow progress is nonetheless progress. Persistence in following a line of research is a virtue for experimental innovators, even when this may be perceived as stubbornness by others.

It is crucial for experimental artists and scholars to recognize what their skills are, so they can select new problems that are sufficiently similar in structure or substance to use to advantage the techniques they have developed and the knowledge they have acquired in the past. Unfortunately, appreciation of their work by others usually comes more slowly, and later in their lives, for experimentalists than for their conceptual peers, but experimentalists have to resist the temptation to try to compete with conceptual practitioners of their own disciplines by changing problems frequently. If they persist, they may find that their reward is a growing mastery of their work as they grow older.

A problem that plagued Cézanne and a number of other great experimental innovators involves deciding when to present their work to the public, by selling or publishing. Many experimentalists have been excessively cautious to show their work. There is a danger that this can slow their progress even further, by effectively limiting the critical reactions to their work that might help them improve it or by reducing the resources they can devote to their work due to lack of professional success. Cézanne was slower than his experimental friend Monet to recognize that it could be valuable to let a piece of his work go when he had achieved something new in it, even though he was not fully satisfied with it, and planned to develop the relevant approach further. Experimentalists tend to be perfectionists, and their enemy is often the belief that each of their works must be definitive. It is important for them to develop the ability to use their uncertainty as a spur to further research, without allowing it to paralyze them. Experimental innovators must learn that unresolved works are not necessarily unfinished, and that even unfinished works can contribute new ideas or approaches to a discipline.

An additional issue of importance for experimental artists and scholars concerns how to react constructively to the advance of age, including the

problems caused by what Cézanne called the weakening of the body. As seen in this study, advanced age does not have to reduce creativity: Cézanne was at his greatest after the age of 65, Henry James wrote one of his best novels at 61, and Frans Hals produced his most important painting at 80. More examples could be generated by expanding the study to other great experimental artists. Thus among painters, Pierre Bonnard made his greatest contribution after the age of 65, and Hans Hofmann made his after 80; Elizabeth Bishop wrote "One Art," one of her greatest poems, at 65; Henrik Ibsen wrote *Hedda Gabler* and other major plays after the age of 60; and Fyodor Dostoevsky completed his greatest novel, *The Brothers Karamazov*, at 59, just months before his death.[48] Yet these cases appear exceptional, as in all these arts great achievements appear to be relatively rare from the late 50s on. An interesting possibility, however, is suggested by the movie directors examined here, for it is striking that John Ford, Howard Hawks, and Alfred Hitchcock were all at their best during their late 50s and their 60s. Making movies under the Hollywood studio system was obviously a more highly collaborative activity than the other kinds of artistic work considered in this study, and this may have allowed these great directors to use their skills to best advantage without being constrained as severely by their advancing age as they might have been in more solitary activities.

Suggestive evidence in support of this hypothesis comes from another highly collaborative form of art. Thus the great experimental architect Frank Lloyd Wright designed several of his greatest buildings, including Fallingwater and New York's Guggenheim Museum, after he had passed the age of 65.[49] Nor was Wright unique in this respect, for other great modern architects have produced important work at advanced ages: thus Walter Gropius's Graduate Center at Harvard University was erected when he was 67; Le Corbusier's Notre Dame du Haut at Ronchamp was erected when he was 63; Ludwig Mies van der Rohe's 860–880 North Lake Shore Drive Apartments in Chicago were erected when was 65; Louis Kahn's Kimbell Art Museum in Forth Worth was erected when he was 65; I. M. Pei's glass pyramid at the Louvre was commissioned when he was 64; Frank Gehry's Guggenheim Museum at Bilbao was erected when he was 68; and Cesar Pelli's Petronas Towers in Kuala Lumpur were erected when he was 72.[50] A possible lesson for experimental artists and scholars from these great movie directors and architects may involve the benefits of collaboration, for working with younger colleagues or assistants may permit experimentalists to continue to use their valuable skills and expertise to best advantage later in their lives than would otherwise be the case.

SEEKERS AND FINDERS

I am going on with my research and shall inform you
of the results achieved as soon as I have obtained
some satisfaction from my efforts.
Paul Cézanne to Ambroise Vollard, 1902[51]

The idea of research has often made painting go
astray. . . . The spirit of research has poisoned those
who have not fully understood all the positive and
conclusive elements in modern art.
Pablo Picasso, 1923[52]

Creativity is not the exclusive domain of either theorists or empiricists, nor are major innovations made exclusively by the young or old. In a wide range of intellectual activities, important contributions have been made both by conceptual innovators, who work deductively, and by experimental innovators, who work inductively. The conceptual innovators are most often the young geniuses, who revolutionize their disciplines early in their careers, whereas the experimental innovators are the old masters, whose greatest achievements usually arrive late in their lives.

There is a tension between these two types of innovators, because they differ not only in the methods by which they make their work, but in their conceptions of their disciplines. Conceptual innovators state their ideas or emotions, often summarily and without hesitation, while in contrast experimental innovators think of their careers as an extended process of searching for the elusive means of understanding and expressing their perceptions. The tension between the approaches often causes conflict that is disruptive, but in the long run it can be productive, for conceptual artists and scholars may be forced to take account of new perceptions or evidence generated experimentally, and experimentalists may be forced to increase the scope of their investigations by conceptual discoveries.

This book has shown how the two approaches can be identified in a number of artistic disciplines. It has also demonstrated some of the gains that follow from the recognition of the differences between the approaches. One of the central benefits is a deeper understanding of the role of the life cycle in human creativity.

A basic result that has emerged from this research is the recognition that both conceptual and experimental innovations have played an enormous role in the modern history of each of the artistic activities that have been studied here. The significance of this fact is great, for it implies that aptitude and ambition are more important factors in allowing people to make contributions to a chosen discipline than the ability to think and

work in any particular way, either deductively or inductively. And the type of aptitude in question is not necessarily that which has played the greatest role in the discipline in the past, for the results of this analysis demonstrate that innovators do not simply follow, but often change, the approaches that are used productively in their disciplines.

Experimental innovators seek, and conceptual innovators find. Increasing our understanding of the difference can help us gain a better understanding of the development of the disciplines we study, and it may also help us increase our own creativity. For recognizing the difference between experimental and conceptual creativity can serve to give us a better understanding not only of how we think, but also of how we learn.

NOTES

INTRODUCTION

1. Gauguin, *Writings of a Savage*, pp. 212, 267.
2. Stein, *Autobiography of Alice B. Toklas*, p. 120.
3. Sickert, *Complete Writings on Art*, p. 253.
4. Whistler, *Gentle Art of Making Enemies*, p. 30.
5. Rosenberg, *Discovering the Present*, pp. 112, 118.

CHAPTER ONE
THEORY

1. Bowness, *Modern European Art*, p. 73.
2. Doran, *Conversations with Cézanne*, p. 163.
3. Barr, *Picasso*, p. 270.
4. Cézanne, *Paul Cézanne, Letters*, pp. 329–30.
5. Fry, *Cézanne*, p. 3.
6. Bowness, *Modern European Art*, p. 37.
7. Doran, *Conversations with Cézanne*, pp. 59, 78.
8. Bell, "Debt to Cézanne," p. 77.
9. Cézanne, *Paul Cézanne, Letters*, pp. 302–3.
10. Gasquet, *Joachim Gasquet's Cézanne*, p. 148.
11. Sylvester, *Looking at Giacometti*, pp. 35–36.
12. Schapiro, *Paul Cézanne*, pp. 18–19.
13. Doran, *Conversations with Cézanne*, p. 38.
14. Cézanne, *Paul Cézanne, Letters*, pp. 316–17.
15. Merleau-Ponty, *Sense and Non-Sense*, pp. 14–15.
16. Fry, *Cézanne*, pp. 47–48.
17. Schapiro, *Paul Cézanne*, p. 18.
18. Schapiro, *Paul Cézanne*, p. 19.
19. Barr, *Picasso*, pp. 270–71.
20. McCully, *Picasso Anthology*, p. 145.
21. Berger, *Success and Failure of Picasso*, pp. 35–36.
22. Cabanne, *Pablo Picasso*, p. 272.
23. Galenson, "Quantifying Artistic Success," table 3; Galenson, "Measuring Masters and Masterpieces," table 3.
24. Rubin, Seckel, and Cousins, *Les Demoiselles d'Avignon*, pp. 14, 119.
25. Richardson, *Life of Picasso*, 2:45–83.
26. Golding, *Cubism*, p. 60.
27. Gilot and Lake, *Life with Picasso*, pp. 123–34.
28. Cabanne, *Pablo Picasso*, p. 511.

29. Schapiro, *Unity of Picasso's Art*, pp. 5, 29.
30. Schlemmer, *Letters and Diaries of Oskar Schlemmer*, p. 102.
31. McCully, *Picasso Anthology*, pp. 146–48.
32. Valéry, *Degas, Manet, Morisot*, p. 51.
33. This is an extension of the scheme presented by Richard Wollheim, "Minimal Art," p. 396.
34. Rewald, *Post-Impressionism*, p. 86.
35. Gauguin, *Writings of a Savage*, p. 5.
36. Van Gogh, *Complete Letters of Vincent van Gogh*, 2:606–7.
37. Duchamp, *Writings of Marcel Duchamp*, p. 125.
38. Friedman, *Charles Sheeler*, p. 72.
39. Stiles and Selz, *Theories and Documents of Contemporary Art*, p. 89.
40. Madoff, *Pop Art*, p. 104.
41. Zevi, *Sol LeWitt*, p. 78.
42. Lyons and Storr, *Chuck Close*, p. 29.
43. Smithson, *Robert Smithson*, p. 192.
44. Mangold, *Robert Mangold*, p. 163.
45. Richter, *Daily Practice of Painting*, pp. 23, 30.
46. Gouma-Peterson, *Breaking the Rules*, p. 60.
47. Benezra and Brougher, *Ed Ruscha*, p. 146.
48. Kimmelman, "Modern Op," p. 48.
49. Kendall, *Monet by Himself*, p. 178.
50. Renoir, *Renoir, My Father*, p. 188.
51. Lindsay and Vergo, *Kandinsky*, p. 370.
52. Klee, *Diaries of Paul Klee, 1898–1918*, pp. 236–37.
53. Holty, "Mondrian in New York," p. 21.
54. Miró, *Joan Miró*, p. 211.
55. Sylvester, *Looking at Giacometti*, pp. 76–77.
56. Shapiro and Shapiro, *Abstract Expressionism*, p. 397.
57. Friedman, *Jackson Pollock*, p. 100.
58. De Kooning, *Spirit of Abstract Expressionism*, p. 69.
59. Gibson, *Issues in Abstract Expressionism*, p. 241.
60. Terenzio, *Collected Writings of Robert Motherwell*, p. 227.
61. Graham-Dixon, *Howard Hodgkin*, p. 214.
62. Balthus, *Vanished Splendors*, p. 55.
63. Gruen, *Artist Observed*, p. 302.
64. Kimmelman, *Portraits*, p. 43.
65. Kuthy, *Pierre Soulages*, p. 23.
66. Livingston, *Art of Richard Diebenkorn*, p. 72.
67. Rose, *Frankenthaler*, p. 36.
68. Bernstock, *Joan Mitchell*, p. 57.
69. Simon, *Susan Rothenberg*, p. 137.
70. Vollard, *Cézanne*, p. 86.
71. Rewald, *Paintings of Paul Cézanne*.
72. O'Brian, *Pablo Ruiz Picasso*, p. 288.
73. Gilot and Lake, *Life with Picasso*, p. 123.

74. Lehman, *Age and Achievement*, pp. 330–31.
75. Joyce, *Hockney on "Art,"* p. 214.
76. Rubin, *Cézanne*, p. 37.
77. Golding, *Cubism*, p. 15.
78. Sickert, *Complete Writings on Art*, p. 216.
79. Ghiselin, *Creative Process*, p. 14.
80. Kubler, *Shape of Time*, p. 10.
81. Warhol, *Philosophy of Andy Warhol*, p. 178.
82. Bourdieu, *Field of Cultural Production*, p. 116.
83. Tuchman and Barron, *David Hockney*, p. 87.
84. Baxandall, *Patterns of Intention*, chaps. 1–2.
85. Schapiro, *Worldview in Painting*, pp. 142–43.
86. Kubler, *Shape of Time*, p. 10.
87. Referring to art and literature, the sociologist Pierre Bourdieu observed, "There are in fact very few other areas in which the glorification of 'great individuals,' unique creators irreducible to any condition or conditioning is more common or uncontroversial"; *Field of Cultural Production*, p. 29.
88. As is the case for scholars, the initial recognition of important artists is typically by their fellow artists. See the interesting comments by Alan Bowness, *Conditions of Success*.
89. Tomkins, *Off the Wall*, p. 118.
90. Richter, *Daily Practice of Painting*, pp. 24, 256.
91. Bowness, *Modern European Art*, p. 73.
92. Sylvester, *About Modern Art*, pp. 229–30.
93. Fry, *Last Lectures*, pp. 3, 14–15.

CHAPTER TWO
MEASUREMENT

1. Kubler, *Shape of Time*, p. 83.
2. Rosenberg, *Art on the Edge*, p. 80.
3. For a full description of the regression analysis, see Galenson, *Painting outside the Lines*, pp. 195–96.
4. A regression in which the binary dependent variable was equal to 1 for paintings owned by museums, and 0 otherwise, produced the following estimate (t-statistics are given in parentheses):

Probability of museum ownership = .249 + .0041 age at execution
$$(4.04) \quad (3.08)$$
$$n = 945, R^2 = .01$$

5. Thus, for example, eight paintings by Cézanne appeared in four or more of the textbooks surveyed for Galenson, "Quantifying Artistic Success," 17n1. The mean size of these eight paintings was 2,151 sq. in. This is more than three times as large as the overall mean, of 657 sq. in., of all Cézanne's paintings in Rewald's catalogue raisonné.

6. A regression with the natural logarithm of a painting's surface area in square inches as the dependent variable yields the following estimate:

$$\text{Ln(size)} = 4.86 + .22 \text{ age at execution} + .337 \text{ museum ownership}$$
$$(43.7) \ (9.33) \qquad\qquad (5.80)$$

$$n = 945, \ R^2 = .124$$

Thus controlling the age at which the painting was made, paintings by Cézanne owned by museums at the time of publication of Rewald's catalogue were on average one-third larger than those privately owned.

7. These results for Cézanne are likely to extend to other artists as well. It will be demonstrated later that art scholars' judgments of when artists have done their best work generally agree with market valuations. As a result, because these best works are most sought after by museums, the auction market will generally understate the true value of work from the artist's best period relative to that of the rest of his career. This effect typically serves to strengthen the usefulness of using auction data to date the timing of the artist's best work.

8. Greenberg, *Collected Essays and Criticism*, 4:118.

9. De Chirico, *Memoirs of Giorgio de Chirico*, pp. 70, 225.

10. Duret, *Manet and the French Impressionists*, p. 72.

11. Pissarro, *Letters to His Son Lucien*, p. 49.

12. Pissarro, *Letters to His Son Lucien*, p. 277.

13. Guérin, *Lettres de Degas*, p. 107.

14. Vollard, *Degas*, p. 102.

15. Valéry, *Degas, Manet, Morisot*, p. 50.

16. Moore, *Impressions and Opinions*, p. 229. A survey of 33 textbooks found that 20 different paintings of dancers by Degas were illustrated a total of 29 times, but that no one of them appeared in more than four of the books; Galenson, "Quantifying Artistic Success," p. 13.

17. Kandinsky, *Kandinsky, Complete Writings on Art*, pp. 369–70.

18. Golding, *Paths to the Absolute*, p. 67.

19. Kuh, *Artist's Voice*, p. 191.

20. Goodrich and Bry, *Georgia O'Keeffe*, p. 19.

21. Kuh, *Artist's Voice*, p. 190.

22. Lynes, *O'Keeffe, Stieglitz and the Critics, 1916–1929*, p. 288.

23. Selz, *Work of Jean Dubuffet*, p. 105.

24. Russell, *Matisse: Father and Son*, p. 286. For evidence from textbooks that demonstrates the absence of notable individual works or peak years for Dubuffet, see Galenson, "New York School versus the School of Paris," p. 149.

25. Heller, *Edvard Munch*, pp. 70–80, 107.

26. Giry, *Fauvism*, p. 250.

27. Hamilton, *Painting and Sculpture in Europe*, p. 166.

28. Cooper, *Cubist Epoch*, p. 42.

29. Richardson, *Life of Picasso*, 2:105.

30. Green, *Juan Gris*, pp. 41, 55; Golding, *Cubism*, pp. 130–31.

31. Green, *Juan Gris*, pp. 18–19; Golding, *Visions of the Modern*, p. 92.

32. Green, *Juan Gris*, p. 51.

33. Soby, *Giorgio de Chirico*, pp. 42, 161.
34. Soby, *Giorgio de Chirico*, p. 157.
35. Soby, *Giorgio de Chirico*, p. 161.
36. Varnedoe, *Jasper Johns*, p. 7.
37. Battcock, *Minimal Art*, p. 161.
38. Friedman, *Jackson Pollock*, p. 100.
39. Shapiro and Shapiro, *Abstract Expressionism*, p. 397.
40. Newman, *Barnett Newman*, p. 248.
41. Spender, *From a High Place*, p. 275.
42. Sylvester, *Interviews with American Artists*, p. 57.
43. Breslin, *Mark Rothko*, p. 232.
44. De Kooning, *Spirit of Abstract Expressionism*, p. 226.
45. Newman, *Barnett Newman*, p. 254.
46. Breslin, *Mark Rothko*, pp. 317, 469.
47. Breslin, *Mark Rothko*, p. 526.
48. Breslin, *Mark Rothko*, p. 211.
49. Karmel, *Jackson Pollock*, pp. 20–21.
50. Newman, *Barnett Newman*, p. 251.
51. Newman, *Barnett Newman*, p. 240.
52. Hess, *Willem de Kooning*, p. 149.
53. Friedman, *Jackson Pollock*, p. 183.
54. Jones, *Machine in the Studio*, p. 90.
55. Sylvester, *Interviews with American Artists*, p. 224.
56. Madoff, *Pop Art*, p. 104.
57. Battcock, *Minimal Art*, p. 158.
58. Johns, *Writings, Sketchbook Notes, Interviews*, p. 113.
59. Jones, *Machine in the Studio*, pp. 197–98.
60. Gruen, *Artist Observed*, p. 225.
61. Battcock, *Minimal Art*, pp. 157–58.
62. Madoff, *Pop Art*, pp. 107–8.
63. On the selection of these ten artists, see Galenson, "Was Jackson Pollock the Greatest Modern American Painter?" table 2, p. 119.
64. Bowness, *Conditions of Success*, pp. 9–11.
65. Franc, *Invitation to See*. For a list of individuals consulted in the selection of the works, see p. 185.
66. E.g., see Wood et al., *Modernism in Dispute*, pp. 77–81.
67. Solomon, "Frank Stella's Expressionist Phase," p. 47.
68. Graczyk, "MOMA Hiatus Gives Houston Rare Art."
69. Graczyk, "MOMA Hiatus Gives Houston Rare Art."
70. Elderfield, *Visions of Modern Art*, p. 19.
71. Graczyk, "MOMA Hiatus Gives Houston Rare Art."
72. Bowness, *Conditions of Success*, p. 51.
73. Duff, "In Payscales, Life Sometimes Imitates Art," p. B1.
74. Galenson, "Quantifying Artistic Success," table 5, p. 14; Galenson, "Measuring Masters and Masterpieces," table 5, p. 63.
75. Franc, *Invitation to See*, pp. 58, 170.

CHAPTER THREE
EXTENSIONS

1. Zevi, *Sol LeWitt*, p. 80.
2. Crone, "Form and Ideology," pp. 87–88; Livingstone, "Do It Yourself," pp. 69–72.
3. Bockris, *Warhol*, pp. 164, 170.
4. Zevi, *Sol Le Witt*, p. 95.
5. Russell, *Seurat*, pp. 135–65; Herbert, *Seurat*, pp. 83–84.
6. Rich, *Seurat and the Evolution of "La Grande Jatte,"* p. 10.
7. Rich, *Seurat and the Evolution of "La Grande Jatte,"* p. 58.
8. Rewald, *Georges Seurat*, p. 26.
9. Spurling, *Unknown Matisse*, p. 293.
10. Rubin and Lanchner, *André Masson*, p. 21.
11. Friedman, *Jackson Pollock*, p. 100.
12. Carmean and Rathbone, *American Art at Mid-Century*, pp. 133–39.
13. De Leiris, *Drawings of Edouard Manet*, pp. 30–31.
14. Reff, *Manet: Olympia*, pp. 69–77; de Leiris, *Drawings of Edouard Manet*, pp. 13, 61, 109.
15. Duret, *Manet and the French Impressionists*, p. 90
16. House, *Monet*, pp. 45, 230.
17. House, *Monet*, p. 183.
18. House, *Monet*, pp. 145–46, 188.
19. Bomford et al., *Art in the Making*, pp. 122–23; also see House, *Monet*, chap. 11.
20. House, *Monet*, p. 191.
21. Jirat-Wasiutynski and Newton, *Technique and Meaning*, p. 44.
22. Bomford et al., *Art in the Making*, p. 165.
23. Jirat-Wasiutynski and Newton, *Technique and Meaning*, p. 76. On the timing of Gauguin's major work, see Galenson, "Quantifying Artistic Success," p. 15.
24. Brettell and Lloyd, *Catalogue of the Drawings by Camille Pissarro*, pp. 42–49; also see House, "Camille Pissarro's Idea of Unity," p. 20.
25. Gauguin, *Writings of a Savage*, p. 22.
26. Rewald, *Georges Seurat*, p. 68.
27. Foster, *Thomas Eakins Rediscovered*, pp. 128–29, 142–43.
28. Tucker and Gutman, "Photographs and the Making of Paintings," pp. 225–38.
29. Tucker and Gutman, "Pursuit of 'True Tones,' " pp. 353–66.
30. Pissarro, *Letters to His Son Lucien*, p. 73.
31. Pissarro, *Letters to His Son Lucien*, pp. 273–74.
32. Rewald, *Paul Cézanne*, p. 203.
33. Cachin, et al., *Cézanne*, pp. 100–102, 104–8, 116–20.
34. Cachin, *Signac*, pp. 8–18.
35. Bomford et al., *Art in the Making*, pp. 114–15; Wilson, *Manet at Work*, pp. 22–27; de Leiris, *Drawings of Edouard Manet*, pp. 54–63; Reff, *Manet: Olympia*, p. 78.

36. De Leiris, *Drawings of Edouard Manet*, pp. 33, 170–71.

37. De Leiris, *Drawings of Edouard Manet*, p. 33.

38. Collins, *12 Views of Manet's Bar*, pp. 13, 177, 240.

39. De Leiris, *Drawings of Edouard Manet*, p. 33.

40. Pissarro, *Letters to His Son Lucien*, p. 30.

41. Brettell and Lloyd, *Catalogue of the Drawings by Camille Pissarro*, p. 23.

42. Pissarro, *Letters to His Son Lucien*, p. 64.

43. Pissarro, *Letters to His Son Lucien*, p. 132.

44. Rewald, *Post-Impressionism*, p. 130.

45. Pissarro, *Letters to His Son Lucien*, p. 158.

46. Rewald, *Georges Seurat*, p. 68.

47. Broude, *Seurat in Perspective*, pp. 28–29.

48. Pissarro, *Letters to His Son Lucien*, p. 135.

49. E.g., see Daix, *Picasso*, p. 336.

50. Gilot and Lake, *Life with Picasso*, pp. 115–16.

51. Brassaï, *Conversations with Picasso*, p. 347.

52. Kubler, *Shape of Time*, p. 6.

53. Kendall, *Monet by Himself*, p. 172.

54. Clark, *Landscape into Art*, pp. 170–76.

55. For a detailed analysis of the specific elements of Monet's early innovation, see House, *Monet*, pp. 51–53, 77, 115.

56. Stuckey, *Monet*, pp. 206, 217; Kendall, *Monet by Himself*, p. 255.

57. Stuckey, *Monet*, p. 217.

58. Kubler, *Shape of Time*, p. 6.

59. House, *Monet*, p. 201. For later examples of this attitude, see Newman, *Barnett Newman*, p. 198; Sylvester, *Interviews with America Artists*, p. 187.

60. E.g., Greenberg, *Collected Essays and Criticism*, 3:228; 4:3–11; Agee, *Sam Francis*, p. 20.

61. House, *Monet*, p. 217.

62. Kendall, *Monet by Himself*, p. 265.

63. Rewald, *Post-Impressionism*, p. 368.

64. Van Gogh, *Complete Letters of Vincent van Gogh*, 2:515.

65. Van Gogh, *Complete Letters of Vincent van Gogh*, 3:6, 28–31.

66. Greenberg, *Homemade Esthetics*, p. 117.

67. Gruen, *Artist Observed*, p. 222.

68. Madoff, *Pop Art*, p. 198.

69. Galenson, "Was Jackson Pollock the Greatest Modern American Painter?" table 3, p. 119.

CHAPTER FOUR
IMPLICATIONS

1. Rewald, *History of Impressionism*, p. 140.

2. Hamilton, *Manet and His Critics*, p. 15.

3. Courbet, *Letters of Gustave Courbet*, p. 129. The painting was of course *L'Atelier*, which is included in table 4.1.

4. Courbet, *Letters of Gustave Courbet*, p. 230.

5. For discussion see Galenson and Jensen, "Careers and Canvases."

6. Daix, *Picasso*, p. 56; Cottington, "What the Papers Say," p. 353.

7. Rewald, *History of Impressionism*, p. 172.

8. Sickert, *Complete Writings on Art*, p. 254.

9. Isaacson, *Monet: Le Déjeuner sur l'herbe*, chaps. 1–5; Stuckey, *Monet*, p. 334.

10. Rewald, *History of Impressionism*, pp. 166–68.

11. Hanson, *Manet and the Modern Tradition*, p. 44.

12. Hamilton, *Collected Words, 1953–1982*, p. 266.

13. Chipp, *Theories of Modern Art*, p. 101.

14. Chipp, *Theories of Modern Art*, p. 101.

15. E.g., see Drucker, *Theorizing Modernism*, pp. 67–69.

16. Curiger, *Meret Oppenheim*, pp. 20–21.

17. Curiger, *Meret Oppenheim* , p. 39.

18. Elderfield, *Visions of Modern Art*, p. 158; Hughes, *Shock of the New*, pp. 33–36.

19. Barr, *Fantastic Art, Dada, Surrealism*, pp. 49–50.

20. Elderfield, *Visions of Modern Art*, p. 158; Hughes, *Shock of the New*, p. 243.

21. Livingstone, *Pop Art*, pp. 33–36.

22. Morphet, *Richard Hamilton*, p. 149; Hamilton, *Collected Words*, pp. 22–24.

23. Morphet, *Richard Hamilton*, p. 7; Livingstone, *Pop Art*, p. 33.

24. Livingstone, *Pop Art*, p. 34.

25. Livingstone, *Pop Art*, p. 36.

26. Galenson, "Reappearing Masterpiece."

27. Lin, *Boundaries*, pp. 4:8–10.

28. Lin, *Boundaries*, p. 4:11.

29. Goldberger, "Memories," p. 50.

30. Munro, *Originals*, pp. 285–86.

31. Stokstad and Grayson, *Art History*, p. 1162.

32. Rosenberg, *De-definition of Art*, p. 130.

33. Rosenberg, *De-definition of Art* , pp. 130–31.

34. Galenson and Weinberg, "Age and the Quality of Work," pp. 761–77.

35. Breslin, *Mark Rothko*, p. 427.

36. Johns, *Writings, Sketchbook Notes, Interviews*, p. 136.

37. Sanouillet and Peterson, *Writings of Marcel Duchamp*, p. 125.

38. Tomkins, *Bride and the Bachelors*, p. 24.

39. Tomkins, *Duchamp*, p. 58.

40. Rubin, *Frank Stella*, p. 32.

41. Pissarro, *Letters to His Son Lucien*, pp. 96–97, 174, 221.

42. Galenson and Weinberg, "Creating Modern Art," pp. 1063–71.

43. De Duve, *Kant after Duchamp*, p. 216.

44. Terenzio, *Collected Writings of Robert Motherwell*, pp. 137–38.

45. Danto, *Embodied Meanings*, p. 85.

46. Cézanne, *Paul Cézanne, Letters*, p. 231.

47. Sandler, *Art of the Postmodern Era*, p. 443.

48. Brassaï, *Conversations with Picasso*, p. 180.

49. E.g., see Tomkins, *Duchamp*, pp. 240–50; Golding, *Paths to the Absolute*, pp. 78–79.

50. Spurling, *Unknown Matisse*, p. 297.

51. Rewald, *Post-Impressionism*, pp. 37–38; Spurling, *Unknown Matisse*, pp. 134–35, 178.

52. Mathews, *Mary Cassatt*, pp. 125–26, 140–42, 146–50.

53. Golding, *Paths to the Absolute*, pp. 48–53; Golding, *Visions of the Modern*, pp. 172–76.

54. Golding, *Paths to the Absolute*, pp. 47–58; Golding, *Visions of the Modern*, pp. 171–77.

55. Terenzio, *Collected Writings of Robert Motherwell*, pp. 155–67.

56. Friedman, *Jackson Pollock*, pp. 37–38; Ashton, *New York School*, p. 67.

57. Breslin, *Mark Rothko*, pp. 93–96.

58. Rubin, *Frank Stella*, p. 12.

59. Galenson, "Was Jackson Pollock the Greatest Modern American Painter?" table 5, p. 122; Rubin, *Frank Stella*, p. 171.

60. Sandler, *Art of the Postmodern Era*, pp. 301–5; Hopkins, *After Modern Art*, pp. 126–27.

61. Richter, *Daily Practice of Painting*, p. 16.

62. E.g., see Sandler, *Art of the Postmodern Era*, p. xxvi; Hopkins, *After Modern Art*, p. 2.

63. Haftmann, *Painting in the Twentieth Century*, 1:377.

64. Alberro and Norvell, *Recording Conceptual Art*, p. 53.

65. Tamplin, *Arts*; Lucie-Smith, *Movements in Art since 1945*.

66. Archer, *Art since 1960*, p. 213.

CHAPTER FIVE

BEFORE MODERN ART

1. Wittkower, *Sculpture*, p. 144.

2. Vasari, *Vasari's Lives of the Artists*, p. 285.

3. Van de Wetering, *Rembrandt*, pp. 75–81.

4. Van de Wetering, *Rembrandt*, p. 168; Ainsworth, *Art and Autoradiography*, pp. 25–96.

5. Alpers, *Rembrandt's Enterprise*, pp. 59–60, 70–71, 144.

6. Adams, *Rembrandt's "Bathsheba Reading King David's Letter,"* pp. 36–38.

7. Alpers, *Rembrandt's Enterprise*, pp. 7–16.

8. Van de Wetering, *Rembrandt*, pp. 160–65.

9. Alpers, *Rembrandt's Enterprise*, pp. 16, 99.

10. Van de Wetering, *Rembrandt*, p. 164.

11. Schwartz, *Rembrandt*, pp. 227–31; Alpers, *Rembrandt's Enterprise*, p. 59.

12. Alpers, *Rembrandt's Enterprise*, pp. 5, 101–2.

13. Alpers, *Rembrandt's Enterprise*, pp. 88–99.

14. Schwartz, *Rembrandt*, p. 289.

15. Alpers, *Rembrandt's Enterprise*, pp. 72–77; Adams, *Rembrandt's "Bathsheba Reading King David's Letter,"* p. 154.

16. Hinterding, Luijten, and Royalton-Kisch, *Rembrandt the Printmaker*, p. 64.

17. Alpers, *Rembrandt's Enterprise*, p. 100.

18. Curiously, van de Wetering offers an interpretation that is at odds with the hypothesis that Rembrandt was an experimental painter. Thus in discussing a painting by Rembrandt that depicts a painter in his studio, standing at a distance from his painting (which is turned away from the viewer), van de Wetering suggests that the painter is shown developing a mental conception of the painting before beginning to paint it, and he further suggests that this was Rembrandt's own method; *Rembrandt*, pp. 88–89. This would imply that Rembrandt worked conceptually. Yet Gary Schwartz has challenged van de Wetering's interpretation of *Painter in His Studio*: "The young painter in the studio is holding a handful of brushes, so he must be working up his panel in color, rather than creating the composition, which was done in monochrome. At that stage . . . all of its major elements must already have been blocked in. The moment when the artist transferred the conception in his mind's eye to the panel has already passed"; *Rembrandt*, p. 55. Although it is not known whether *Painter in His Studio* was intended to represent Rembrandt, Schwartz's interpretation of the painting would be consistent with the practice of an experimental painter, who has stepped back from his work in progress to examine its appearance and judge how he should proceed.

19. Rosenberg, Slive, and ter Kuile, *Dutch Art and Architecture*, p. 80.

20. Jensen, "Anticipating Artistic Behavior." Except where other sources are specifically cited, the following discussion of old masters' techniques is based on this paper. Also see Galenson and Jensen, "Young Geniuses and Old Masters."

21. Goffen, *Masaccio's "Trinity,"* pp. 53, 92.

22. Ames-Lewis, *Drawing in Early Renaissance Italy*, pp. 24–26.

23. Vasari, *Vasari's Lives of the Artists*, p. 67; Kemp, *Leonardo da Vinci*, p. 24.

24. Honour and Fleming, *Visual Arts*, p. 475.

25. Rosand, *Meaning of the Mark*, p. 32.

26. Gombrich, *Gombrich on the Renaissance*, 1:58.

27. Kemp, *Leonardo da Vinci*, pp. 54–56, 68.

28. Gombrich, *Gombrich on the Renaissance*, 1:58.

29. Kemp, *Leonardo da Vinci*, pp. 198–99.

30. Kemp, *Leonardo da Vinci*, pp. 264–70.

31. Gombrich, *Gombrich on the Renaissance*, 1:62.

32. Hibbard, *Michelangelo*, p. 99.

33. Freedberg, *Painting in Italy*, pp. 21–25.

34. E.g., see Hibbard, *Michelangelo*, pp. 118, 152, 209.

35. Ackerman, *Architecture of Michelangelo*, p. 7.

36. Wittkower, *Sculpture*, pp. 143–44.

37. Vasari, *Vasari's Lives of the Artists*, p. 219.

38. Ames-Lewis, *Draftsman Raphael*, p. 151.

39. Ames-Lewis, *Draftsman Raphael*, pp. 3, 8.

40. Rosand, *Meaning of the Mark*, p. 69.

41. Cartwright, *Early Work of Raphael*, p. 42.

42. Gombrich, *Gombrich on the Renaissance*, 1:68.

43. Belting, *Invisible Masterpiece*, p. 53.

44. Vasari, *Vasari's Lives of the Artists*, p. 231. Even if the statement does not reflect Raphael's own opinion, it demonstrates that Vasari clearly defined Raphael's conceptual strengths in clear expression and orderly composition.

45. Clark, *What Is a Masterpiece?* p. 44.

46. Pope-Hennessy, *Raphael*, p. 104.

47. Ames-Lewis, *Draftsman Raphael*, p. 99.

48. Vasari, *Vasari's Lives of the Artists*, pp. 267–68.

49. Vasari, *Vasari's Lives of the Artists*, p. 232.

50. Pope-Hennessy, *Raphael*, pp. 217–21.

51. Cole, *Titian and Venetian Painting*, pp. 170–71.

52. Manca, *Titian 500*, pp. 205–7.

53. Biadene, *Titian*, p. 97.

54. Rosand, *Meaning of the Mark*, pp. 60–61.

55. Meilman, *Cambridge Companion to Titian*, pp. 29–30.

56. Van de Wetering, *Rembrandt*, pp. 162–69.

57. Fry, *Last Lectures*, pp. 14–15.

58. Rosenberg, Slive, and ter Kuile, *Dutch Art and Architecture*, p. 62.

59. Rosenberg, Slive, and ter Kuile, *Dutch Art and Architecture*, pp. 62, 66.

60. Rosenberg, Slive, and ter Kuile, *Dutch Art and Architecture*, pp. 67, 73.

61. McKim-Smith, Anderson-Bergdoll, and Newman, *Examining Velázquez*, p. 40.

62. Brown and Garrido, *Velázquez*, p. 18.

63. McKim-Smith, Anderson-Bergdoll, and Newman, *Examining Velázquez*, p. 94.

64. Brown and Garrido, *Velázquez*, p. 19.

65. Ortega y Gasset, *Velázquez, Goya and the Dehumanization of Art*, pp. 99–100.

66. McKim-Smith, Anderson-Bergdoll, and Newman, *Examining Velázquez*, p. 95.

67. Brown and Garrido, *Velázquez*, p. 191.

68. Gaskell and Jonker, *Vermeer Studies*, pp. 145–52.

69. Gaskell and Jonker, *Vermeer Studies*, p. 187.

70. Rosenberg, Slive, and ter Kuile, *Dutch Art and Architecture*, pp. 47–48.

71. Richardson, "Picasso: A Retrospective View," p. 294.

CHAPTER SIX
BEYOND PAINTING

1. Rodin, *Rodin on Art and Artists*, p. 11.

2. Smithson, *Robert Smithson*, p. 192.

3. Hamilton, *Painting and Sculpture in Europe*, p. 62.

4. Elsen, *Auguste Rodin*, p. 115.

5. Lampert, *Rodin*, p. 135.
6. Elsen, *Auguste Rodin*, p. 154.
7. Elsen, *Rodin*, p. 141.
8. Elsen, *Auguste Rodin*, p. 164.
9. Elsen, *Rodin*, p. 141.
10. Lampert, *Rodin*, p. 135.
11. Grunfeld, *Rodin*, p. 289.
12. Elsen, *Rodin*, p. 145.
13. Elsen, *Rodin*, p. 89.
14. Grunfeld, *Rodin*, pp. 374–77.
15. Butler, *Shape of Genius*, p. 340.
16. Grunfeld, *Rodin*, p. 577.
17. Wittkower, *Sculpture*, pp. 253–55.
18. Geist, *Brancusi*, pp. 28, 142.
19. Geist, *Brancusi/The Kiss*, p. 99.
20. Hamilton, *Painting and Sculpture in Europe*, p. 462.
21. Geist, *Constantin Brancusi*, pp. 21–23.
22. Moore, *Henry Moore*, p. 145.
23. Apollonio, *Futurist Manifestos*, pp. 21–47.
24. Coen, *Umberto Boccioni*, p. 94.
25. Golding, *Boccioni's "Unique Forms of Continuity in Space,"* pp. 12–14; Coen, *Umberto Boccioni*, p. 205.
26. Perloff, *Futurist Moment*, chap. 3; Coen, *Umberto Boccioni*, p. 203.
27. Apollinaire, *Apollinaire on Art*, pp. 320–21.
28. Golding, *Boccioni's "Unique Forms of Continuity in Space,"* p. 28.
29. Milner, *Vladimir Tatlin and the Russian Avant-Garde*, chap. 3.
30. For a more detailed discussion see Milner, *Vladimir Tatlin and the Russian Avant-Garde*, chap. 8.
31. Milner, *Vladimir Tatlin and the Russian Avant-Garde*, p. 170.
32. Hughes, *Shock of the New*, p. 92.
33. Hohl, *Alberto Giacometti*, pp. 19–27.
34. Wilson, *Alberto Giacometti*, pp. 227–37.
35. Sartre, "Search for the Absolute," p. 4.
36. Hohl, *Alberto Giacometti*, p. 19.
37. Sartre, "Search for the Absolute," p. 6.
38. Sylvester, *Looking at Giacometti*, pp. 76–77.
39. Wilson, *Alberto Giacometti*, pp. 227–37.
40. Sartre, "Search for the Absolute," p. 16.
41. McCoy, *David Smith*, p. 18.
42. Sylvester, *Interviews with American Artists*, p. 3.
43. Marcus, *David Smith*, pp. 89, 118–19.
44. Sylvester, *Interviews with American Artists*, p. 7.
45. McCoy, *David Smith*, pp. 78, 84, 155.
46. Kuh, *Artist's Voice*, p. 233.
47. McCoy, *David Smith*, p. 148.
48. McCoy, *David Smith*, p. 184.
49. McCoy, *David Smith*, p. 182.

50. Krauss, *Terminal Iron Works*, pp. 181–85.
51. Marcus, *David Smith*, p. 96.
52. Smithson, *Robert Smithson*, p. 68.
53. For a number of examples, see Hobbs, *Robert Smithson*.
54. Robins, *Pluralist Era*, p. 85.
55. Hobbs, *Robert Smithson*, pp. 194–95.
56. Smithson, *Robert Smithson*, pp. 143–53.
57. Galenson, "Reappearing Masterpiece," p. 6.
58. Eliot, *Selected Prose of T. S. Eliot*, p. 43.
59. Barry, *Robert Frost on Writing*, p. 126.
60. Dove, *Best American Poetry 2000*, pp. 269–84.
61. Lehman, "All-Century Team," p. 43.
62. For a listing of the anthologies used, see Galenson, "Literary Life Cycles," appendix.
63. Lowell, *Collected Prose*, p. 9.
64. Jarrell, *No Other Book*, p. 233.
65. Poirier, *Robert Frost*, pp. 72–73.
66. Perkins, *History of Modern Poetry: From the 1890s . . .*, p. 235.
67. Barry, *Robert Frost on Writing*, p. 160.
68. Barry, *Robert Frost on Writing*, pp. 126–28.
69. Lowell, *Collected Prose*, p. 10.
70. Thompson, *Fire and Ice*, p. 133.
71. Stevens, *Letters of Wallace Stevens*, p. 289.
72. Stevens, *Necessary Angel*, p. 6; Stevens, *Opus Posthumous*, p. 164.
73. Lensing, *Wallace Stevens*, pp. 125, 140.
74. MacLeod, *Wallace Stevens and Modern Art*, p. 131.
75. Lensing, *Wallace Stevens*, p. 146.
76. Lensing, *Wallace Stevens*, p. 138.
77. Doyle, *Wallace Stevens*, p. 393.
78. Jarrell, *No Other Book*, p. 237.
79. Stevens, *Collected Poetry and Prose*, pp. 807–8.
80. Williams, *Autobiography of William Carlos Williams*, pp. 174, 391.
81. Williams, *Autobiography of William Carlos Williams*, p. 391.
82. Williams, *Autobiography of William Carlos Williams*, p. 357.
83. Jarrell, *No Other Book*, p. 79.
84. Axelrod and Deese, *Critical Essays on William Carlos Williams*, p. 51.
85. Jarrell, *No Other Book*, p. 77.
86. Dickey, *Babel to Byzantium*, p. 192.
87. Stevens, *Collected Poetry and Prose*, p. 815.
88. Jarrell, *No Other Book*, p. 77.
89. Lowell, *Collected Prose*, p. 33.
90. Stauffer, *Short History of American Poetry*, p. 259.
91. Shucard, Moramarco, and Sullivan, *Modern American Poetry*, p. 124.
92. Carpenter, *Serious Character*, pp. 405–16.
93. Gordon, *T. S. Eliot*, p. 101.
94. Perkins, *History of Modern Poetry: From the 1890s . . .*, p. 333; Kenner, *Poetry of Ezra Pound*, p. 73.

95. Wilson, *Shores of Light*, pp. 46–47.
96. Aiken, *Reviewer's ABC*, p. 324.
97. Williams, *Selected Essays of William Carlos Williams*, p. 21.
98. Cory, "Ezra Pound," p. 38.
99. Shucard, Moramarco, and Sullivan, *Modern American Poetry*, p. 99.
100. Gordon, *T. S. Eliot*, p. 42.
101. Stauffer, *Short History of American Poetry*, p. 266.
102. Eliot, *Letters of T. S. Eliot*, 1:530.
103. Perkins, *History of Modern Poetry: From the 1890s . . .* , pp. 499, 502.
104. Wilson, *Axel's Castle*, p. 110.
105. Aiken, *Reviewer's ABC*, p. 177.
106. Williams, *Autobiography of William Carlos Williams*, p. 174.
107. Cowley, *Exile's Return*, pp. 110–11.
108. Williams, *Selected Essays of William Carlos Williams*, p. 103; Williams, *Autobiography of William Carlos Williams*, p. 174.
109. Perkins, *History of Modern Poetry: Modernism and After*, pp. 41–42.
110. Baum, *E. E. Cummings and the Critics*, pp. 27, 118, 191–92.
111. Perkins, *History of Modern Poetry: Modernism and After*, pp. 4–5; Gray, *American Poetry of the Twentieth Century*, p. 195.
112. Perkins, *History of Modern Poetry: Modernism and After*, p. 45.
113. Baum, *E. E. Cummings and the Critics*, p. 117.
114. Dickey, *Babel to Byzantium*, p. 100.
115. Perkins, *History of Modern Poetry: Modernism and After*, pp. 4–5.
116. Hamilton, *Robert Lowell*, p. 232.
117. Roberts, *Companion to Twentieth-Century Poetry*, p. 489.
118. Kunitz, *A Kind of Order, A Kind of Folly*, p. 154.
119. Hamilton, *Robert Lowell*, p. 277.
120. Plimpton, *Poets at Work*, p. 116.
121. Gray, *American Poetry of the Twentieth Century*, pp. 253–55.
122. Lowell, *Collected Poems*, pp. vii, xii.
123. Kunitz, *A Kind of Order, A Kind of Folly*, p. 159.
124. Plimpton, *Poets at Work*, p. 133.
125. Jarrell, *No Other Book*, p. 253.
126. Hall, *Weather for Poetry*, p. 195.
127. Alexander, *Ariel Ascending*, p. 199.
128. Schmidt, *Lives of the Poets*, p. 829.
129. Perkins, *History of Modern Poetry: Modernism and After*, p. 593.
130. Wagner, *Sylvia Plath*, p. 71.
131. Wagner, *Sylvia Plath*, pp. 60, 73.
132. Alexander, *Ariel Ascending*, p. 195.
133. Plath, *Ariel*, p. xiii.
134. Alexander, *Ariel Ascending*, p. 202.
135. Wagner, *Sylvia Plath*, p. 196.
136. Hughes, *Winter Pollen*, p. 161; Alexander, *Ariel Ascending*, p. 94.
137. Plath, *Letters Home*, p. 468.
138. Galenson, "Literary Life Cycles," table 5.
139. Alexander, *Rough Magic*, p. 344.

140. Joyce, *Letters of James Joyce*, 1:37–38.

141. Woolf, *Collected Essays*, 2:99.

142. For discussion see Galenson, "Portrait of the Artist as a Young or Old Innovator," p. 4.

143. Woolf, *Collected Essays*, 1:194.

144. Collins, *Dickens*, p. 324.

145. Ford and Lane, *Dickens Critics*, pp. 53, 137.

146. Collins, *Dickens*, pp. 38, 343.

147. Ford and Lane, *Dickens Critics*, p. 376.

148. Woolf, *Collected Essays*, 1:194.

149. Ford and Lane, *Dickens Critics*, pp. 109, 259.

150. Burt, *Novel 100*, pp. 52–53; also see Engel, *Maturity of Dickens*, pp. 3–4; Jordan, *Cambridge Companion to Charles Dickens*, p. 157.

151. Golding, *Idiolects in Dickens*, pp. 214, 219, 228.

152. Melville, *Tales, Poems, and Other Writings*, pp. 55, 59.

153. Parker, *Herman Melville*, 1:616.

154. Matthiessen, *American Renaissance*, p. 425.

155. Lawrence, *Selected Literary Criticism*, p. 387.

156. Vincent, *Trying-Out of Moby-Dick*, pp. 126–35; Sealts, *Melville's Reading*, pp. 68–69.

157. Arvin, *Herman Melville*, pp. 144–45, 148–49.

158. Branch, *Melville*, p. 255.

159. Lawrence, *Selected Literary Criticism*, p. 390.

160. Kazin, *American Procession*, p. 144.

161. Branch, *Melville*, pp. 415–16.

162. De Voto, *Mark Twain at Work*, p. 100.

163. Kazin, *American Procession*, pp. 183, 189.

164. Trilling, *Liberal Imagination*, p. 117.

165. Kazin, *American Procession*, p. 191.

166. Hearn, *Annotated Huckleberry Finn*, p. 5.

167. Howells, *My Mark Twain*, pp. 166–67.

168. Rogers, *Mark Twain's Satires and Burlesques*, pp. 5–6.

169. Doyno, *Writing Huck Finn*, p. 102.

170. Rogers, *Mark Twain's Satires and Burlesques*, pp. 5–6.

171. Emerson, *Mark Twain*, pp. 142–48; De Voto, *Mark Twain at Work*, pp. 53–55.

172. Neider, *Autobiography of Mark Twain*, p. 265.

173. Emerson, *Mark Twain*, p. 128.

174. Young, *Ernest Hemingway*, p. 212.

175. Trilling, *Liberal Imagination*, pp. 106, 116.

176. Ellison, *Going to the Territory*, p. 316.

177. De Voto, *Mark Twain at Work*, p. 89.

178. Miller, *Theory of Fiction*, pp. 30, 35, 44, 171.

179. McWhirter, *Henry James's New York Edition*, pp. 9, 109.

180. Gard, *Henry James*, pp. 118–19.

181. Edel, *Henry James*, p. 17.

182. Gard, *Henry James*, p. 118.

183. Woolf, *Collected Essays*, 1:280.
184. Deming, *James Joyce*, 2:747.
185. Kenner, *Dublin's Joyce*, p. 45; Litz, *Art of James Joyce*, p. 10.
186. Woolf, *Writer's Diary*, p. 49.
187. Trilling, *Last Decade*, p. 27.
188. Wilson, *Axel's Castle*, p. 205.
189. Beja, *James Joyce*, p. 64.
190. Budgen, *James Joyce and the Making of Ulysses*, pp. 67–68, 122–23.
191. Litz, *Art of James Joyce*, pp. 4, 7, 9, 27.
192. Budgen, *James Joyce and the Making of Ulysses*, p. 20.
193. O'Brien, *James Joyce*, p. 97.
194. Courthion, *Le Visage de Matisse*, pp. 92–93.
195. Litz, *James Joyce*, p. 116.
196. Budgen, *James Joyce and the Making of Ulysses*, p. 174; also see Gilbert, *Letters of James Joyce*, 1:172; Litz, *Art of James Joyce*, p. 12.
197. Litz, *James Joyce*, p. 96.
198. Woolf, *Diary of Virginia Woolf*, 3:62.
199. Mepham, *Virginia Woolf*, p. xiv.
200. Woolf, *Diary of Virginia Woolf*, 3:203.
201. Majumdar and McLaurin, *Virginia Woolf*, p. 427.
202. Majumdar and McLaurin, *Virginia Woolf*, pp. 101, 144, 175, 213.
203. Bennett, *Virginia Woolf*, pp. 142, 148.
204. Woolf, *Mrs. Dalloway*, pp. vii-viii.
205. Woolf, *Diary of Virginia Woolf*, 3:106.
206. Woolf, *Moments of Being*, p. 72.
207. Woolf, *Diary of Virginia Woolf*, 2:186, 209; 3:7, 152.
208. Majumdar and McLaurin, *Virginia Woolf*, p. 243.
209. Sklar, *F. Scott Fitzgerald*, p. 157.
210. Trilling, *Liberal Imagination*, p. 252.
211. Fitzgerald, *Crack-Up*, p. 310.
212. Ruland and Bradbury, *From Puritanism to Postmodernism*, pp. 299–300.
213. Bloom, *Genius*, p. 41.
214. Claridge, *F. Scott Fitzgerald*, 2:48.
215. Bruccoli, *F. Scott Fitzgerald*, p. 80.
216. Claridge, *F. Scott Fitzgerald*, 2:456; 4:46.
217. Bruccoli, *F. Scott Fitzgerald*, p. 169.
218. Claridge, *F. Scott Fitzgerald*, 2:149.
219. Meyers, *Hemingway*, p. 91.
220. Young, *Ernest Hemingway*, p. 205.
221. Young, *Ernest Hemingway*, pp. 92, 177–91.
222. Kazin, *On Native Grounds*, pp. 334–35.
223. Meyers, *Hemingway*, pp. 14, 78.
224. Barbour and Quirk, *Writing the American Classics*, pp. 141–42.
225. Reynolds, *Hemingway's First War*, p. 238.
226. Young, *Ernest Hemingway*, p. 93.
227. Baker, *Hemingway and His Critics*, p. 33.
228. Meyers, *Hemingway*, pp. 17, 303, 430–31, 441.

229. Young, *Ernest Hemingway*, pp. 245–46.

230. For a more detailed discussion of the construction of the quantitative measure and full citations to the critical monographs considered, see Galenson, "Portrait of the Artist as a Young or Old Innovator."

231. Hitchcock, *Hitchcock on Hitchcock*, p. 48.

232. Welles, *Interviews*, p. 102.

233. Seven of the eight directors considered here directed at least one movie that received a combined total of more than 15 votes from the directors and critics in *Sight and Sound*'s 2002 poll (described later). The eighth—Hawks—was placed among the Pantheon Directors by Andrew Sarris in his classic book, *The American Cinema* (as were also Ford, Hitchcock, Renoir, and Welles among the directors considered here).

234. The 2002 *Sight and Sound* poll was based on rankings submitted by 108 directors and 144 critics. The rankings of each of these individuals are available on the Web at www.bfi.org.uk/sightandsound/topten.

235. Bordwell, *Cinema of Eisenstein*, pp. 9–12.

236. Taylor, *Eisenstein Reader*, pp. 35, 40, 56.

237. Taylor, *Eisenstein Reader*, p. 65.

238. Mast, *Short History of the Movies*, pp. 159, 161, 165.

239. Bordwell, *Cinema of Eisenstein*, p. 46.

240. Taylor, *Eisenstein Reader*, p. 4.

241. Truffaut, *Films in My Life*, pp. 36, 42, 46–47.

242. Wollen, *Paris Hollywood*, p. 161.

243. Renoir, *Renoir on Renoir*, pp. 112–13, 179.

244. Truffaut, *Films in My Life*, pp. 36–37.

245. Renoir, *Renoir on Renoir*, pp. 250–51.

246. Leprohon, *Jean Renoir*, p. 193.

247. Thomson, *Biographical Dictionary of the Cinema*, p. 508.

248. Gottesman, *Focus on Citizen Kane*, pp. 69–72.

249. Gottesman, *Focus on Citizen Kane*, pp. 73–76.

250. For discussion see Kael, *Raising Kane*; Carringer, *Making of Citizen Kane*.

251. Gottesman, *Focus on Citizen Kane*, p. 127.

252. Wollen, *Paris Hollywood*, p. 12.

253. American Film Institute, "Orson Welles."

254. American Film Institute, "John Ford."

255. An indication of both of these phenomena is given by the AFI ranking of the 100 greatest American movies of all time, based on a survey conducted in 1998. In spite of the fact that Ford had been the first recipient of the AFI's Life Achievement Award, no film of his ranked among the top 20 movies, and only three ranked in the top 100: *The Grapes of Wrath* ranked 21st, *Stagecoach* ranked 63rd, and *The Searchers* ranked just 96th. In contrast, the voters in the 2002 *Sight and Sound* poll placed *The Searchers* first among Ford's films, *The Man Who Shot Liberty Valance* second, and *The Grapes of Wrath* and *Stagecoach* tied for third, together with *My Darling Clementine*. (Unlike this difference in the ranking of Ford's films, *Citizen Kane* ranked first in both the 1998 AFI ranking and *Sight and Sound*'s 2002 poll.)

256. Ford, *Interviews*, p. ix; Sarris, *John Ford Movie Mystery*, p. 174.

257. Ford, *Interviews*, p. ix; Welles, *Interviews*, p. 76.

258. Ford, *Interviews*, p. ix.

259. Welles, *Interviews*, p. 46; Ford, *Interviews*, p. 16.

260. Mast, *Short History of the Movies*, p. 252; Ford, *Interviews*, p. 64.

261. Ford, *Interviews*, p. 47.

262. Ford, *Interviews*, p. 85.

263. Truffaut, *Films in My Life*, p. 63.

264. Ford, *Interviews*, p. 71.

265. Bogdanovich, *John Ford*, pp. 24, 31; Sarris, *John Ford Movie Mystery*, p. 124.

266. Hitchcock, *Hitchcock on Hitchcock*, p. 205.

267. Truffaut, *Films in My Life*, p. 77.

268. Hitchcock, *Interviews*, p. 158.

269. Hitchcock, *Interviews*, p. 80; Hitchcock, *Hitchcock on Hitchcock*, pp. 255–56.

270. Hitchcock, *Hitchcock on Hitchcock*, pp. 109, 208.

271. LaValley, *Focus on Hitchcock*, p. 98.

272. Truffaut, *Hitchcock*, p. 8.

273. Hitchcock, *Interviews*, p. 130.

274. Sarris, *American Cinema*, p. 58.

275. Hitchcock, *Hitchcock on Hitchcock*, p. 115.

276. Wood, *Hitchcock's Films*, p. 17.

277. Truffaut, *Films in My Life*, p. 87.

278. McBride, *Hawks on Hawks*, pp. 8, 109.

279. Bogdanovich, *Who the Devil Made It*, p. 262.

280. McBride, *Hawks on Hawks*, p. 82.

281. Wood, *Howard Hawks*, p. 11.

282. Sarris, *American Cinema*, p. 55.

283. Hillier and Wollen, *Howard Hawks, American Artist*, p. 74.

284. Sarris, *The American Cinema*, p. 53.

285. Mast, *Howard Hawks, Storyteller*, p. 367.

286. McCarthy, *Howard Hawks*, p. 7.

287. Godard, *Godard on Godard*, p. 173.

288. Godard, *Interviews*, p. 4.

289. Andrew, *Breathless*, p. 171.

290. Wollen, *Paris Hollywood*, p. 92.

291. Roud, *Jean-Luc Godard*, p. 36.

292. Godard, *Interviews*, p. 5; Godard, *Godard on Godard*, p. 175.

293. McCabe, *Godard*, p. 121.

294. Sontag, *Styles of Radical Will*, pp. 150–53.

295. Farber, *Negative Space*, p. 259.

296. Sterritt, *Films of Jean-Luc Godard*, p. 20.

297. Brown, *Focus on Godard*, p. 112.

298. Bondanella, *Films of Federico Fellini*, pp. 1–4.

299. Chandler, *I, Fellini*, pp. 11, 58.

300. Bondanella, *Federico Fellini*, p. 8.

301. Bondanella, *Films of Federico Fellini*, p. 71.

302. Bondanella, *Federico Fellini*, p. 111.

303. Bondanella, *Films of Federico Fellini*, p. 72.

304. Bondanella, *Films of Federico Fellini*, p. 98.

305. Bondanella, *Federico Fellini*, pp. 131–32.

306. Bondanella, *Films of Federico Fellini*, p. 146.

CHAPTER SEVEN
PERSPECTIVES

1. Heaney, *Finders Keepers*, p. 220.

2. Spender, *Making of a Poem*, pp. 48–49.

3. Jelliffe, *Faulkner at Nagano*, pp. 36–37, 42, 53, 90, 161; Gwynn and Blotner, *Faulkner in the University*, pp. 143–44, 206–7. On Faulkner as an experimental writer, see Galenson, "Portrait of the Artist as a Young or Old Innovator."

4. Stevens, *Necessary Angel*, pp. 167–69.

5. Ashton, *American Art since 1945*, p. 132.

6. Nichols, *Movies and Methods*, p. 556

7. Balzac, *Unknown Masterpiece*, pp. 14, 23–24, 27.

8. Doran, *Conversations with Cézanne*, p. 65.

9. Bruccoli, *F. Scott Fitzgerald*, p. 455.

10. James, *Novels and Tales of Henry James*, 16:81–82, 90, 93, 95, 105.

11. James, *Painter's Eye*, pp. 216–18, 223, 227–28.

12. For a full presentation of the evidence and documentation of this discussion, see Galenson, "Methods and Careers of Leading American Painters in the Late Nineteenth Century."

13. Miró, *Joan Miró*, pp. 51, 55, 63, 150.

14. Guiguet, *Virginia Woolf and Her Works*, p. 356; Woolf, *Collected Essays*, 1:151–53.

15. Jacobsen, *Instant of Knowing*, p. 75.

16. Eliot, *Selected Prose of T. S. Eliot*, pp. 249, 252–53.

17. Gordon, *T. S. Eliot*, pp. 519–20.

18. Eliot, *Selected Prose of T. S. Eliot*, p. 250.

19. Eliot, *Literary Essays of Ezra Pound*, p. 52.

20. As noted earlier in the text, Eliot concluded that it was rare for writers' work to gain in quality as they aged, but he did allow that there were exceptional poets who had managed to overcome the obstacles: thus, "With Shakespeare, one sees a slow, continuous development of mastery of his craft of verse," and "Yeats is pre-eminently the poet of middle age;" *Selected Prose of T. S. Eliot*, pp. 250, 252. Both Shakespeare and Yeats appear to have been experimental innovators. Eliot also commented on the experimental Dickens's ability to produce a masterpiece, *Bleak House*, in middle age; ibid., p. 249.

21. Fry, *Last Lectures*, p. 3.

22. Lehman, *Age and Achievement*, p. 331.

23. Lee, "Going Early into That Good Night," p. A15.

24. Lehman, *Age and Achievement*, p. vii.

25. Lehman, *Age and Achievement*, pp. 77–78.

26. Lehman, *Age and Achievement*, pp. 325–26.

27. Martindale, "Personality, Situation, and Creativity," p. 221.

28. Gardner, *Creating Minds*, p. 376; also see p. 248.

29. Simonton, *Greatness*, p. 185.

30. Csikszentmihalyi, *Creativity*, p. 39.

31. Adams-Price, *Creativity and Successful Aging*, p. 272

32. An anonymous referee of this book called my attention to an exception to this practice. A quantitative study of the performance of 73 film directors over the course of their careers found that some directors' work deteriorated over time, but that other directors' performance improved with age. Although they did not report individual results for most of the directors, the authors did mention that John Ford was among those whose work improved over time; Zickar and Slaughter, "Examining Creative Performance over Time Using Hierarchical Linear Modeling."

33. Simonton, *Scientific Genius*, p. 72.

34. For evidence of changes over time in the predominance of experimental and conceptual approaches to modern painting, see Galenson and Weinberg, "Age and the Quality of Work," and Galenson and Weinberg, "Creating Modern Art."

35. E.g., see Simonton, *Creative Genius*, p. 73.

36. Berlin, *Hedgehog and the Fox*, p. 3

37. Ghiselin, *Creative Process*, p. 1.

38. Galenson and Weinberg, "Creative Careers."

39. Gray, *American Poetry of the Twentieth Century*, p. 130.

40. Meyers, *Robert Frost*, p. 81.

41. Lowell, *Collected Prose*, p. 10.

42. Eliot, *Literary Essays of Ezra Pound*, p. 9

43. Pound, *Pisan Cantos*, p. 96.

44. Pound, *ABC of Reading*, p. 26.

45. Woolf, *Diary of Virginia Woolf*, 2:188–89, 199–200, 202–3; Woolf, *Collected Essays*, 1:244.

46. Fitzgerald, *Crack-Up*, p. 165. Surprisingly, this hypothesis is also given by Simonton, *Scientific Genius*, p. 69.

47. Cézanne, *Paul Cézanne, Letters*, p. 315.

48. Galenson, *Painting outside the Lines*, pp. 178, 188; Galenson, "Literary Life Cycles," table 5; Galenson, "Portrait of the Artist as a Very Young or Very Old Innovator."

49. Galenson, "Portrait of the Artist as a Very Young or Very Old Innovator"; Doordan, *Twentieth-Century Architecture*, pp. 187–88.

50. Doordan, *Twentieth-Century Architecture*, pp. 181, 193, 160, 206, 233, 282, 255.

51. Cézanne, *Paul Cézanne, Letters*, p. 288.

52. Barr, *Picasso*, p. 270.

BIBLIOGRAPHY

Ackerman, James. *The Architecture of Michelangelo*. New York: Viking Press, 1961.

Adams, Ann Jensen, ed. *Rembrandt's "Bathsheba Reading King David's Letter."* Cambridge: Cambridge University Press, 1998.

Adams, Laurie. *A History of Western Art*. New York: Harry N. Abrams, 1994.

Adams-Price, Carolyn. *Creativity and Successful Aging*. New York: Springer, 1993.

Agee, William C. *Sam Francis*. Los Angeles: Los Angeles Museum of Contemporary Art, 1999.

Aiken, Conrad. *A Reviewer's ABC*. New York: Meridian Books, 1958.

Ainsworth, Morgan Wynn. *Art and Autoradiography*. New York: Metropolitan Museum of Art, 1982.

Alberro, Alexander, and Patricia Norvell, eds. *Recording Conceptual Art*. Berkeley: University of California Press, 2001.

Alexander, Paul, ed. *Ariel Ascending: Writings about Sylvia Plath*. New York: Harper and Row, 1985.

———. *Rough Magic*. New York: Viking Press, 1991.

Alpers, Svetlana. *Rembrandt's Enterprise*. Chicago: University of Chicago Press, 1988.

American Film Institute. "John Ford: Life Achievement Award 1973 Tribute Address." Online at www.AFI.com.

———. "Orson Welles: Life Achievement Award 1975 Tribute Address." Online at www.AFI.com.

Ames-Lewis, Francis. *Drawing in Early Renaissance Italy*. New Haven, CT: Yale University Press, 1981.

———. *The Draftsman Raphael*. New Haven, CT: Yale University Press, 1986.

Andrew, Dudley, ed. *Breathless*. New Brunswick, NJ: Rutgers University Press, 1987.

Apollinaire, Guillaume. *Apollinaire on Art*. Boston: MFA Publications, 2001.

Apollonio, Umbro, ed. *Futurist Manifestos*. New York: Viking Press, 1973.

Archer, Michael. *Art since 1960*. New ed. London: Thames and Hudson, 2002.

Arnason, H. H., and Daniel Wheeler. *History of Modern Art*. 3rd ed. New York: Harry N. Abrams, 1986.

Arvin, Newton. *Herman Melville*. Westport: Greenwood Press, 1972.

Ashton, Dore. *American Art since 1945*. New York: Oxford University Press, 1982.

———. *The New York School*. Berkeley: University of California Press, 1992.

Axelrod, Steven Gould, and Helen Deese, eds. *Critical Essays on William Carlos Williams*. New York: G. K. Hall, 1995.

Baker, Carlos, ed. *Hemingway and His Critics*. New York: Hill and Wang, 1961.

Balthus. *Vanished Splendors*. New York: HarperCollins, 2001.

Balzac, Honoré de. *The Unknown Masterpiece*. New York: New York Review of Books, 2001.

Barbour, James, and Tom Quirk, eds. *Writing the American Classics*. Chapel Hill: University of North Carolina Press, 1990.

Barr, Alfred H., Jr. *Fantastic Art, Dada, Surrealism*. New York: Museum of Modern Art, 1946.

———. *Picasso*. New York: Museum of Modern Art, 1946.

Barry, Elaine. *Robert Frost on Writing*. New Brunswick, NJ: Rutgers University Press, 1973.

Battcock, Gregory, ed. *Minimal Art*. Berkeley: University of California Press, 1995.

Baum, S. V., ed. *E. E. Cummings and the Critics*. East Lansing: Michigan State University Press, 1962.

Baxandall, Michael. *Patterns of Intention*. New Haven, CT: Yale University Press, 1985.

Beja, Morris. *James Joyce*. Columbus: Ohio State University Press, 1992.

Bell, Clive. "The Debt to Cézanne." In Frascina and Harrison, eds. *Modern Art and Modernism*, pp. 75–78.

Bell, Cory. *Modern Art*. New York: Watson-Guptill, 2000.

Belting, Hans. *The Invisible Masterpiece*. Chicago: University of Chicago Press, 2001.

Benezra, Neal, and Kerry Brougher. *Ed Ruscha*. Washington, DC: Smithsonian Institution, 2000.

Bennett, Joan. *Virginia Woolf*. 2nd ed. Cambridge: Cambridge University Press, 1964.

Berger, John. *The Success and Failure of Picasso*. New York: Random House, 1993.

Berlin, Isaiah. *The Hedgehog and the Fox*. Chicago: Ivan Dee, 1993.

Bernstock, Judith E. *Joan Mitchell*. New York: Hudson Hills Press, 1988.

Biadene, Susanna, ed. *Titian*. Munich: Prestel, 1990.

Bloom, Harold. *Genius*. New York: Warner Books, 2002.

Bockris, Victor. *Warhol*. New York: Da Capo Press, 1997.

Bocola, Sandro. *The Art of Modernism*. Munich: Prestel Verlag, 1999.

Bogdanovich, Peter. *John Ford*. Berkeley: University of California Press, 1978.

———. *Who the Devil Made It*. New York: Alfred A. Knopf, 1997.

Bomford, David, Jo Kirby, John Leighton, and Ashok Roy. *Art in the Making: Impressionism*. London: National Gallery, 1990.

Bondanella, Peter, ed. *Federico Fellini*. Oxford: Oxford University Press, 1978.

———. *The Films of Federico Fellini*. Cambridge: Cambridge University Press, 2002.

Bordwell, David. *The Cinema of Eisenstein*. Cambridge, MA: Harvard University Press, 1993.

Bourdieu, Pierre. *The Field of Cultural Production*. New York: Columbia University Press, 1993.

Bowness, Alan. *Modern European Art*. London: Thames and Hudson, 1972.

———. *The Conditions of Success: How the Modern Artist Rises to Fame*. New York: Thames and Hudson, 1989.

Branch, Watson, ed. *Melville: The Critical Heritage*. London: Routledge and Kegan Paul, 1974.

Brassaï. *Conversations with Picasso*. Chicago: University of Chicago Press, 1999.

Breslin, James E. B. *Mark Rothko*. Chicago: University of Chicago Press, 1993.

Brettell, Richard, and Christopher Lloyd. *A Catalogue of the Drawings by Camille Pissarro in the Ashmolean Museum, Oxford*. Oxford: Clarendon Press, 1980.

British Film Institute. "The *Sight and Sound* Top Ten Poll 2002." Online at http://www.bfi.org.uk/sightandsound/topten/.

Britsch, Ralph, and Todd Britsch. *The Arts in Western Culture*. Englewood Cliffs, NJ: Prentice-Hall, 1984.

Britt, David, ed. *Modern Art*. New York: Thames and Hudson, 1999.

Broude, Norma, ed. *Seurat in Perspective*. Englewood Cliffs, NJ: Prentice-Hall, 1978.

Brown, Jonathan, and Carmen Garrido. *Velázquez*. New Haven, CT: Yale University Press, 1998.

Brown, Royal, ed. *Focus on Godard*. Englewood Cliffs, NJ: Prentice-Hall, 1972.

Bruccoli, Matthew, ed. *F. Scott Fitzgerald: A Life in Letters*. New York: Charles Scribner's Sons, 1994.

Budgen, Frank. *James Joyce and the Making of Ulysses*. Bloomington: Indiana University Press, 1960.

Burt, Daniel S. *The Novel 100*. New York: Checkmark Books, 2004.

Butler, Ruth. *The Shape of Genius*. New Haven, CT: Yale University Press, 1993.

Cabanne, Pierre. *Pablo Picasso*. New York: William Morrow, 1977.

Cachin, Françoise. *Signac*. Paris: Gallimard, 2000.

Cachin, Françoise, Isabelle Cahn, Walter Feilchenfeldt, Henri Loyrette, and Joseph Rishel. *Cézanne*. New York: Harry N. Abrams, 1996.

Carmean, E. A., Jr., and Eliza E. Rathbone. *American Art at Mid-Century*. Washington, DC: National Gallery of Art, 1978.

Carpenter, Humphrey. *A Serious Character: The Life of Ezra Pound*. Boston: Houghton Mifflin, 1988.

Carringer, Robert. *The Making of Citizen Kane*. Berkeley: University of California Press, 1985.

Cartwright, Julia. *The Early Work of Raphael*. London: Seeley, 1900.

Cézanne, Paul. *Paul Cézanne, Letters*. New York: Da Capo Press, 1995.

Chandler, Charlotte. *I, Fellini*. New York: Random House, 1995.

Chipp, Herschel B. *Theories of Modern Art*. Berkeley: University of California Press, 1968.

Claridge, Henry, ed. *F. Scott Fitzgerald: Critical Assessments*. Vol. 2. Sussex: Helm Information, 1991.

Clark, Kenneth. *Landscape into Art*. 2nd ed. New York: Harper and Row, 1976.

———. *What Is a Masterpiece?* New York: Thames and Hudson, 1981.

Coen, Ester. *Umberto Boccioni*. New York: Metropolitan Museum of Art, 1988.

Cole, Bruce. *Titian and Venetian Painting, 1450–1590*. Boulder, CO: Westview Press, 1999.

Collins, Bradford R., ed. *12 Views of Manet's Bar*. Princeton, NJ: Princeton University Press, 1996.

Collins, Philip, ed. *Dickens: The Critical Heritage*. London: Routledge and Kegan Paul, 1971.

Cooper, Douglas. *The Cubist Epoch*. London: Phaidon, 1970.

Cornell, Sara. *Art*. Englewood Cliffs, NJ: Prentice-Hall, 1983.

Cory, Daniel. "Ezra Pound." *Encounter* 30, no. 5 (May 1968):30–39.

Cottington, David. "What the Papers Say: Politics and Ideology in Picasso's Collages of 1912." *Art Journal* 47, no. 4 (Winter 1988): 350–59.

Courbet, Gustave. *Letters of Gustave Courbet*. Chicago: University of Chicago Press, 1992.

Courthion, Pierre. *Le Visage de Matisse*. Lausanne: Jean Marguerat, 1942.

Cowley, Malcolm. *Exile's Return*. New York: Viking Press, 1951.

Crone, Rainer. "Form and Ideology: Warhol's Techniques from Blotted Line to Film." In Garrels, *The Work of Andy Warhol*, pp. 70–92.

Csikszentmihalyi, Mihaly. *Creativity*. New York: HarperCollins, 1996.

Curiger, Bice. *Meret Oppenheim*. Zurich: Parkett, 1989.

Daix, Pierre. *Picasso*. New York: HarperCollins, 1994.

Danto, Arthur. *Embodied Meanings*. New York: Farrar, Straus and Giroux, 1994.

de Chirico, Giorgio. *The Memoirs of Giorgio de Chirico*. New York: Da Capo Press, 1994.

de Duve, Thierry. *Kant after Duchamp*. Cambridge, MA: MIT Press, 1996.

de Kooning, Elaine. *The Spirit of Abstract Expressionism*. New York: George Braziller, 1994.

de la Croix, Horst, Richard Tansey, and Diane Kirkpatrick. *Gardner's Art Through the Ages*. 9th ed. San Diego: Harcourt Brace Jovanovich, 1991.

de Leiris, Alain. *The Drawings of Edouard Manet*. Berkeley: University of California Press, 1969.

De Voto, Bernard. *Mark Twain at Work*. Cambridge, MA: Harvard University Press, 1942.

Deming, Robert, ed. *James Joyce: The Critical Heritage*. Vol. 2. New York: Barnes and Noble, 1970.

Dempsey, Amy. *Art in the Modern Era*. New York: Harry N. Abrams, 2002.

Dickey, James. *Babel to Byzantium: Poets and Poetry Now*. New York: Farrar, Straus and Giroux, 1968.

Doordan, Dennis P. *Twentieth-Century Architecture*. New York: Harry N. Abrams, 2002.

Doran, Michael, ed. *Conversations with Cézanne*. Berkeley: University of California Press, 2001.

Dove, Rita, ed. *The Best American Poetry 2000*. New York: Scribner, 2000.

Doyle, Charles, ed. *Wallace Stevens*. London: Routledge and Kegan Paul, 1985.

Doyno, Victor. *Writing Huck Finn: Mark Twain's Creative Process*. Philadelphia: University of Pennsylvania Press, 1991.

Drucker, Johanna. *Theorizing Modernism*. New York: Columbia University Press, 1994.

Duchamp, Marcel. *The Writings of Marcel Duchamp*. New York: Da Capo Press, 1989.

Duff, Christina. "In Payscales, Life Sometimes Imitates Art." *Wall Street Journal*, May 22, 1998, p. B1.

Duret, Théodore. *Manet and the French Impressionists*. Philadelphia: J. B. Lippincott, 1910.

Edel, Leon, ed. *Henry James*. Englewood Cliffs, NJ: Prentice-Hall, 1963.

Elderfield, John, ed. *Visions of Modern Art*. New York: Museum of Modern Art, 2003.

Eliot, T. S., ed. *Literary Essays of Ezra Pound*. New York: New Directions, 1935.

———. *Selected Prose of T. S. Eliot*. New York: Harcourt Brace Jovanovich, 1975.

Eliot, Valerie, ed. *The Letters of T. S. Eliot*. Vol. 1. London: Faber and Faber, 1988.

Ellison, Ralph. *Going to the Territory*. New York: Random House, 1986.

Elsen, Albert. *Rodin*. New York: Museum of Modern Art, 1963.

———. *Auguste Rodin: Readings on His Life and Work*. Englewood Cliffs, NJ: Prentice-Hall, 1965.

Emerson, Victor. *Mark Twain*. Philadelphia: University of Pennsylvania Press, 2000.

Engel, Monroe. *The Maturity of Dickens*. Cambridge, MA: Harvard University Press, 1959.

Farber, Manny. *Negative Space*. New York: Da Capo Press, 1998.

Feldman, Edward. *Thinking about Art*. Englewood Cliffs, NJ: Prentice-Hall, 1985.

Fitzgerald, F. Scott. *The Crack-Up*. New York: New Directions, 1945.

Fleming, William. *Arts and Ideas*. 9th ed. Fort Worth, TX: Harcourt Brace, 1995.

Ford, George, and Lauriat Lane, eds. *The Dickens Critics*. Westport, CT: Greenwood Press, 1972.

Ford, John. *Interviews*. Jackson: University Press of Mississippi, 2001.

Foster, Kathleen A. *Thomas Eakins Rediscovered*. New Haven, CT: Yale University Press, 1997.

Franc, Helen M. *An Invitation to See: 150 Works from the Museum of Modern Art*. New York: Museum of Modern Art, 1992.

Frascina, Francis, and Charles Harrison, eds. *Modern Art and Modernism*. New York: Harper and Row, 1982.

Freedberg, S. J. *Painting in Italy, 1500 to 1600*. Harmondsworth: Penguin Books, 1971.

Freeman, Julian. *Art*. New York: Watson-Guptill, 1998.

Friedman, B. H. *Jackson Pollock*. New York: Da Capo Press, 1995.

Friedman, Martin. *Charles Sheeler*. New York: Watson-Guptill, 1975.

Fry, Roger. *Last Lectures*. Boston: Beacon Press, 1962.

———. *Cézanne*. Chicago: University of Chicago Press, 1989.

Galenson, David W. *Painting outside the Lines: Patterns of Creativity in Modern Art*. Cambridge, MA: Harvard University Press, 2001.

———. "Measuring Masters and Masterpieces: French Rankings of French Painters and Paintings from Realism to Surrealism." *Histoire et Mesure* 17, nos. 1–2 (2002): 47–85.

———. "Quantifying Artistic Success: Ranking French Painters—and Paintings—from Impressionism to Cubism." *Historical Methods* 35, no. 1 (Winter 2002): 5–20.

———. "Was Jackson Pollock the Greatest Modern American Painter? A Quantitative Investigation." *Historical Methods* 35, no. 3 (Summer 2002): 117–28.

Galenson, David W. "The New York School versus the School of Paris: Who Really Made the Most Important Art after World War II?" *Historical Methods* 35, no. 4 (Fall 2002): 141–53.

———. "The Reappearing Masterpiece: Ranking American Artists and Art Works of the Late Twentieth Century." NBER Working Paper 9935 (August 2003).

———. "A Portrait of the Artist as a Young or Old Innovator: Measuring the Careers of Modern Novelists." NBER Working Paper 10213 (January 2004).

———. "A Portrait of the Artist as a Very Young or Very Old Innovator: Creativity at the Extremes of the Life Cycle." NBER Working Paper 10515 (May 2004).

———. "Before Abstract Expressionism: Ranking American Painters and Paintings of the Early Twentieth Century." Unpublished paper, University of Chicago, 2005.

———. "The Methods and Careers of Leading American Painters in the Late Nineteenth Century." Unpublished paper, University of Chicago, 2005.

———. "Toward Abstraction: Ranking European Printers and Paintings of the Early Twentieth Century." Unpublished paper, University of Chicago, 2005.

———. "Literary Life Cycles: The Careers of Modern American Poets." *Historical Methods*, 38, no. 2 (Spring 2005): 45–60.

———. "One-Hit Wonders: Why Some of the Most Important Works of Modern Art Are Not by Important Artists." Historical Methods, forthcoming.

Galenson, David W., and Robert Jensen. "Young Geniuses and Old Masters: The Life Cycles of Great Artists from Masaccio to Jasper Johns." NBER Working Paper 8368 (July 2001).

———. "Careers and Canvases: The Rise of the Market for Modern Art in the Nineteenth Century." NBER Working Paper 9123 (September 2002).

Galenson, David W., and Bruce A. Weinberg. "Age and the Quality of Work: The Case of Modern American Painters." *Journal of Political Economy* 108, no. 4 (August 2000): 761–77.

———. "Creating Modern Art: The Changing Careers of Painters in France from Impressionism to Cubism." *American Economic Review* 91, no. 4 (September 2001): 1063–71.

———. "Creative Careers: The Life Cycles of Nobel Laureates in Economics." Unpublished paper, 2004.

Gard, Roger, ed. *Henry James: The Critical Heritage*. London: Routledge and Kegan Paul, 1968.

Gardner, Howard. *Creating Minds*. New York: Basic Books, 1993.

Garrels, Gary, ed. *The Work of Andy Warhol*. Seattle, WA: Bay Press, 1989.

Gaskell, Ivan, and Michiel Jonker. *Vermeer Studies*. Washington, DC: National Gallery of Art, 1998.

Gasquet, Joachim. *Joachim Gasquet's Cézanne*. London: Thames and Hudson, 1991.

Gauguin, Paul. *The Writings of a Savage*. New York: Da Capo Press, 1996.

Geist, Sidney. *Brancusi*. New York: Grossman, 1968.

————. *Constantin Brancusi, 1876–1957*. New York: Solomon R. Guggenheim Museum, 1969.

————. *Brancusi/The Kiss*. New York: Harper and Row, 1978.

Ghiselin, Brewster, ed. *The Creative Process*. Berkeley: University of California Press, 1985.

Giacometti, Alberto. *Exhibition of Sculpture, Paintings, Drawings*. New York: Pierre Matisse Gallery, 1948.

Gibson, Ann Eden. *Issues in Abstract Expressionism*. Ann Arbor, MI: UMI Research Press, 1990.

Gilbert, Rita. *Living with Art*. 5th ed. Boston: McGraw Hill, 1998.

Gilbert, Stuart, ed. *Letters of James Joyce*. Vol. 1. New York: Viking Press, 1966.

Gilot, Françoise, and Carlton Lake. *Life with Picasso*. New York: Doubleday, 1989.

Giry, Marcel. *Fauvism*. New York: Alpine Fine Arts, 1982.

Glover, John, Royce Ronning, and Cecil Reynolds, eds. *Handbook of Creativity*. New York: Plenum Press, 1989.

Godard, Jean-Luc. *Godard on Godard*. New York: Da Capo Press, 1986.

————. *Interviews*. Jackson: University Press of Mississippi, 1998.

Goffen, Rona, ed. *Masaccio's "Trinity."* Cambridge: Cambridge University Press, 1998.

Goldberger, Paul. "Memories." *New Yorker*, December 8, 2003, 50.

Golding, John. *Cubism*. London: Faber and Faber, 1959.

————. *Boccioni's "Unique Forms of Continuity in Space."* Newcastle: University of Newcastle upon Tyne, 1972.

————. *Visions of the Modern*. Berkeley: University of California Press, 1994.

————. *Paths to the Absolute*. Princeton, NJ: Princeton University Press, 2000.

Golding, Robert. *Idiolects in Dickens*. New York: Saint Martin's Press, 1985.

Gombrich, E. H. *Gombrich on the Renaissance*. Vol. 1. London: Phaidon Press, 1966.

Goodrich, Lloyd, and Doris Bry. *Georgia O'Keeffe*. New York: Whitney Museum, 1970.

Gordon, Lyndall. *T. S. Eliot*. New York: Norton, 1998.

Gottesman, Ronald, ed. *Focus on Citizen Kane*. Englewood Cliffs, NJ: Prentice-Hall, 1971.

Gouma-Peterson, Thalia. *Breaking the Rules: Audrey Flack*. New York: Harry N. Abrams, 1992.

Graczyk, Michael. "MOMA Hiatus Gives Houston Rare Art." *Chicago Tribune*, December 29, 2003.

Graham-Dixon, Andrew. *Howard Hodgkin*. London: Thames and Hudson, 2001.

Gray, Richard. *American Poetry of the Twentieth Century*. London: Longman, 1990.

Green, Christopher. *Juan Gris*. New Haven, CT: Yale University Press, 1992.

Greenberg, Clement. *The Collected Essays and Criticism*. Vol. 3. Chicago: University of Chicago Press, 1993.

Greenberg, Clement. *The Collected Essays and Criticism*. Vol. 4. Chicago: University of Chicago Press, 1993.

————. *Homemade Esthetics*. New York: Oxford University Press, 1999.

Gruen, John. *The Artist Observed*. Chicago: a cappella Books, 1991.

Grunfeld, Frederic. *Rodin*. New York: Henry Holt, 1987.

Guérin, Marcel, ed. *Lettres de Degas*. Paris: Bernard Grasset, 1931.

Guiguet, Jean. *Virginia Woolf and Her Works*. New York: Harcourt, Brace and World, 1965.

Gwynn, Frederick, and Joseph Blotner, eds. *Faulkner in the University*. Charlottesville: University Press of Virginia, 1995.

Haftmann, Werner. *Painting in the Twentieth Century*. Vol. 1. New York: Frederick A. Praeger, 1965.

Hall, Donald. *The Weather for Poetry*. Ann Arbor: University of Michigan Press, 1982.

Hamilton, George Heard. *Manet and His Critics*. New Haven, CT: Yale University Press, 1954.

———. *Painting and Sculpture in Europe, 1880–1940*. Harmondsworth: Penguin Books, 1967.

Hamilton, Ian. *Robert Lowell*. New York: Random House, 1982.

Hamilton, Richard. *Collected Words, 1953–1982*. London: Thames and Hudson, 1982.

Hanson, Anne Coffin. *Manet and the Modern Tradition*. New Haven, CT: Yale University Press, 1977.

Hartt, Frederick. *A History of Painting, Sculpture, Architecture*. 3rd ed. New York: Harry N. Abrams, 1989.

Heaney, Seamus. *Finders Keepers*. New York: Farrar, Straus and Giroux, 2002.

Hearn, Michael, ed. *The Annotated Huckleberry Finn*. New York: W. W. Norton, 2001.

Heller, Reinhold. *Edvard Munch: The Scream*. New York: Viking Press, 1973.

Herbert, Robert L. *Seurat*. New Haven, CT: Yale University Press, 2001.

Hess, Thomas B. *Willem de Kooning*. New York: Museum of Modern Art, 1968.

Hibbard, Howard. *Michelangelo*. 2nd ed. Boulder, CO: Westview Press, 1998.

Hillier, Jim, and Peter Wollen, eds. *Howard Hawks, American Artist*. London: British Film Institute, 1996.

Hinterding, Erik, Ger Luijten, and Martin Royalton-Kisch. *Rembrandt the Printmaker*. Chicago: Fitzroy Dearborn, 2003.

Hitchcock, Alfred. *Hitchcock on Hitchcock*. Berkeley: University of California Press, 1995.

———. *Interviews*. Jackson: University Press of Mississippi, 2003.

Hobbs, Robert. *Robert Smithson: Sculpture*. Ithaca, NY: Cornell University Press, 1981.

Hohl, Reinhold. *Alberto Giacometti*. New York: Praeger, 1974.

Holty, Carl. "Mondrian in New York: A Memoir." *Arts* 31, no. 10 (September 1957): 17–21.

Honour, Hugh, and John Fleming. *The Visual Arts*. 5th ed. New York: Harry N. Abrams, 1999.

Hopkins, David. *After Modern Art, 1945–2000*. Oxford: Oxford University Press, 2000.

House, John. "Camille Pissarro's Idea of Unity." In Lloyd, *Studies on Camille Pissarro,* pp. 15–34.

House, John. *Monet: Nature into Art*. New Haven, CT: Yale University Press, 1986.

Howells, William Dean. *My Mark Twain*. Mineola, NY: Dover, 1997.

Hughes, Robert. *The Shock of the New*. New York: Harry N. Abrams, 1990.

Hughes, Ted. *Winter Pollen*. New York: Picador, 1994.

Hunter, Sam, and John Jacobus. *Modern Art*. 3rd ed. Englewood Cliffs, NJ: Prentice-Hall, 1992.

Isaacson, Joel. *Monet: Le Déjeuner sur l'herbe*. New York: Viking Press, 1972.

Jacobsen, Josephine. *The Instant of Knowing*. Ann Arbor: University of Michigan Press, 2002.

James, Henry. *The Novels and Tales of Henry James: New York Edition*. Vol. 16. New York: Charles Scribner's Sons, 1937.

———. *The Painter's Eye*. Madison: University of Wisconsin Press, 1989.

Jarrell, Randall. *No Other Book*. New York: HarperCollins, 1999.

Jelliffe, Robert. *Faulkner at Nagano*. Tokyo: Kenkyusha, 1966.

Jensen, Robert. "Anticipating Artistic Behavior: New Research Tools for Art Historians." *Historical Methods* 37, no. 3 (Summer 2004): 137–53.

Jirat-Wasiutynski, Vojtech, and H. Travers Newton Jr. *Technique and Meaning in the Paintings of Paul Gauguin*. Cambridge: Cambridge University Press, 2000.

Johns, Jasper. *Writings, Sketchbook Notes, Interviews*. New York: Museum of Modern Art, 1996.

Jones, Caroline A. *Machine in the Studio*. Chicago: University of Chicago Press, 1996.

Jordan, John, ed. *The Cambridge Companion to Charles Dickens*. Cambridge: Cambridge University Press, 2001.

Joyce, James. *Letters of James Joyce*. Vol. 1. New York: Viking Press, 1966.

Joyce, Paul. *Hockney on "Art."* London: Little, Brown, 2000.

Kael, Pauline. *Raising Kane*. London: Martin Secker and Warburg, 1971.

Kandinsky, Wassily. *Kandinsky, Complete Writings on Art*. New York: Da Capo Press, 1994.

Karmel, Pepe, ed. *Jackson Pollock*. New York: Museum of Modern Art, 1999.

Kazin, Alfred. *On Native Grounds*. New York: Harcourt, Brace and World, 1942.

———. *An American Procession*. New York: Alfred A. Knopf, 1984.

Kemp, Martin. *Leonardo da Vinci*. London: J. M. Dent and Sons, 1981.

———, ed. *The Oxford History of Western Art*. Oxford: Oxford University Press, 2000.

Kendall, Richard, ed. *Monet by Himself*. New York: Knickerbocker Press, 1999.

Kenner, Hugh. *Dublin's Joyce*. Boston: Beacon Press 1962.

———. *The Poetry of Ezra Pound*. Lincoln: University of Nebraska Press, 1985.

Kimmelman, Michael. *Portraits*. New York: Modern Library, 1999.

———. "Modern Op." *New York Times Magazine*, August 27, 2000, 44–48.

Klee, Felix, ed. *The Diaries of Paul Klee, 1898–1918*. Berkeley: University of California Press, 1964.

Krauss, Rosalind. *Terminal Iron Works*. Cambridge, MA: MIT Press, 1971.

Kubler, George. *The Shape of Time*. New Haven, CT: Yale University Press, 1962.

Kuh, Katharine. *The Artist's Voice*. New York: Harper and Row, 1962.

Kunitz, Stanley. *A Kind of Order, A Kind of Folly*. Boston: Little, Brown, 1975.

Kuthy, Sandor, ed. *Pierre Soulages*. Geneva: Skira, 1999.

Lampert, Catherine. *Rodin*. London: Arts Council of Great Britain, 1986.

LaValley, Albert. *Focus on Hitchcock*. Englewood Cliffs, NJ: Prentice-Hall, 1972.

Lawrence, D. H. *Selected Literary Criticism*. New York: Viking, 1956.

Lee, Felicia. "Going Early into That Good Night." *New York Times*, April 24, 2004, A15.

Lehman, David. "All-Century Team." *New York Times Book Review*, September 17, 2000, 43.

Lehman, Harvey C. *Age and Achievement*. Princeton, NJ: Princeton University Press, 1953.

Lensing, George. *Wallace Stevens*. Baton Rouge: Louisiana State University Press, 1986.

Leprohon, Pierre. *Jean Renoir*. New York: Crown, 1971.

Lin, Maya. *Boundaries*. New York: Simon and Schuster, 2000.

Lindsay, Kenneth C., and Peter Vergo, eds. *Kandinsky*. New York: Da Capo Press, 1994.

Livingston, Jane. *The Art of Richard Diebenkorn*. New York: Whitney Museum of Art, 1997.

Livingstone, Marco. "Do It Yourself: Notes on Warhol's Techniques." In McShine, *Andy Warhol: A Retrospective*, pp. 63–80.

———. *Pop Art*. New York: Harry N. Abrams, 1990.

Litz, A. Walton. *The Art of James Joyce*. London: Oxford University Press, 1961.

———. *James Joyce*. Rev. ed. New York: Hippocrene Books, 1972.

Lloyd, Christopher, ed. *Studies on Camille Pissarro*. London: Routledge and Kegan Paul, 1986.

Lowell, Robert. *Collected Prose*. New York: Noonday Press, 1990.

———. *Collected Poems*. New York: Farrar, Straus and Giroux, 2003.

Lucie-Smith, Edward. *Movements in Art since 1945*. New ed. London: Thames and Hudson, 2001.

Lynes, Barbara Buhler. *O'Keeffe, Stieglitz and the Critics, 1916–1929*. Chicago: University of Chicago Press, 1989.

Lyons, Lisa, and Robert Storr. *Chuck Close*. New York: Rizzoli, 1987.

MacLeod, Glenn. *Wallace Stevens and Modern Art*. New Haven, CT: Yale University Press, 1993.

Madoff, Steven Henry, ed. *Pop Art*. Berkeley: University of California Press, 1997.

Majumdar, Robin, and Allen McLaurin, eds. *Virginia Woolf: The Critical Heritage*. London: Routledge and Kegan Paul, 1975.

Manca, Joseph, ed. *Titian 500*. Washington, DC: National Gallery of Art, 1993.

Marcus, Stanley. *David Smith*. Ithaca, NY: Cornell University Press, 1983.

Mangold, Robert. *Robert Mangold*. London: Phaidon Press, 2000.

Martindale, Colin. "Personality, Situation, and Creativity." In Glover, Ronning, and Reynolds, *Handbook of Creativity*, pp. 211–32.

Mast, Gerald. *Howard Hawks, Storyteller*. New York: Oxford University Press, 1982.

———. *A Short History of the Movies*. 4th ed. New York: Macmillan, 1986.

Mathews, Nancy Mowll. *Mary Cassatt*. New York: Villard Books, 1994.

Matthiessen, F. O. *American Renaissance*. London: Oxford University Press, 1941.

McBride, Joseph. *Hawks on Hawks*. Berkeley: University of California Press, 1982.

McCabe, Colin. *Godard*. New York: Farrar, Straus and Giroux, 2004.

McCarthy, Todd. *Howard Hawks*. New York: Grove Press, 1997.

McCoy, Garnett, ed. *David Smith*. New York: Frederick A. Praeger, 1973.

McCully, Marilyn, ed. *A Picasso Anthology*. Princeton, NJ: Princeton University Press, 1982.

McKim-Smith, Gridley, Greta Anderson-Bergdoll, and Richard Newman. *Examining Velázquez*. New Haven, CT: Yale University Press, 1988.

McShine, Kynaston, ed. *Andy Warhol: A Retrospective*. New York: Museum of Modern Art, 1989.

McWhirter, David, ed. *Henry James's New York Edition*. Stanford, CA: Stanford University Press, 1995.

Meilman, Patricia, ed. *The Cambridge Companion to Titian*. Cambridge: Cambridge University Press, 2004.

Melville, Herman. *Tales, Poems, and Other Writings*. New York: Modern Library, 2002.

Mepham, John. *Virginia Woolf*. London: Macmillan, 1991.

Merleau-Ponty, Maurice. *Sense and Non-Sense*. Evanston, IL: Northwestern University Press, 1969.

Meyers, Jeffrey, ed. *Hemingway: The Critical Heritage*. London: Routledge and Kegan Paul, 1982.

———. *Robert Frost*. Boston: Houghton Mifflin, 1996.

Miller, James, ed. *Theory of Fiction: Henry James*. Lincoln: University of Nebraska Press, 1972.

Milner, John. *Vladimir Tatlin and the Russian Avant-Garde*. New Haven, CT: Yale University Press, 1983.

Miró, Joan. *Joan Miró: Selected Writings and Interviews*. New York: Da Capo Press, 1992.

Moffett, Charles. *The New Painting: Impressionism 1874–1886*. San Francisco: Fine Arts Museums of San Francisco, 1986.

Moore, George. *Impressions and Opinions*. New York: Brentano, 1913.

Moore, Henry. *Henry Moore: Writings and Conversations*. Berkeley: University of California Press, 2002.

Morphet, Richard. *Richard Hamilton*. London: Tate Gallery, 1992.

Munro, Eleanor. *Originals*. New ed. New York: Da Capo Press, 2000.

Neider, Charles, ed. *The Autobiography of Mark Twain*. New York: Harper and Row, 1959.

Newman, Barnett. *Barnett Newman: Selected Writings and Interviews*. Berkeley: University of California Press, 1992.

Nichols, Bill, ed. *Movies and Methods: An Anthology*. Berkeley: University of California Press, 1976.

O'Brian, Patrick. *Pablo Ruiz Picasso*. New York: W. W. Norton, 1976.

O'Brien, Edna. *James Joyce*. New York: Penguin, 1999.

Ortega y Gasset, José. *Velázquez, Goya and the Dehumanization of Art.* New York: W. W. Norton, 1972.

Parker, Hershel. *Herman Melville.* Vol. 1. Baltimore: Johns Hopkins University Press, 1996.

Perkins, David. *A History of Modern Poetry: From the 1890s to the High Modernist Mode.* Cambridge, MA: Harvard University Press, 1976.

———. *A History of Modern Poetry: Modernism and After.* Cambridge, MA: Harvard University Press, 1987.

Perloff, Marjorie. *The Futurist Moment.* Chicago: University of Chicago Press, 1986.

Pissarro, Camille. *Letters to His Son Lucien.* New York: Da Capo Press, 1995.

Plath, Sylvia. *Ariel.* New York: HarperCollins, 1975.

———. *Letters Home.* New York: Harper and Row, 1975.

Plimpton, George, ed. *Poets at Work.* New York: Penguin Books, 1989.

Poirier, Richard. *Robert Frost.* Stanford, CA: Stanford University Press, 1990.

Pope-Hennessy, John. *Raphael.* New York: Harper and Row, 1970.

Pound, Ezra. *The ABC of Reading.* New York: New Directions, 1960.

———. *The Pisan Cantos.* New York: New Directions, 2003.

Reff, Theodore. *Manet: Olympia.* New York: Viking Press, 1977.

Renoir, Jean. *Renoir on Renoir.* Cambridge: Cambridge University Press, 1989.

———. *Renoir, My Father.* New York: New York Review of Books, 2001.

Rewald, John. *Georges Seurat.* New York: Wittenborn, 1943.

———. *Paul Cézanne.* New York: Simon and Schuster, 1948.

———. *Post-Impressionism.* New York: Museum of Modern Art, 1956.

———. *The History of Impressionism.* Rev. ed. New York: Museum of Modern Art, 1961.

———. *The Paintings of Paul Cézanne: A Catalogue Raisonné.* 2 vols. New York: Harry N. Abrams, 1996.

Reynolds, Michael. *Hemingway's First War.* Princeton, NJ: Princeton University Press, 1976.

Rich, Daniel Catton. *Seurat and the Evolution of "La Grande Jatte."* Chicago: University of Chicago Press, 1935.

Richardson, John. "Picasso: A Retrospective View." In McCully, *A Picasso Anthology,* p. 284.

———. *A Life of Picasso.* Vol. 2, *1907–1917.* New York: Random House, 1996.

Richter, Gerhard. *The Daily Practice of Painting.* Cambridge, MA: MIT Press, 1995.

Roberts, Neil, ed. *A Companion to Twentieth-Century Poetry.* Oxford: Blackwell, 2001.

Robins, Corinne. *The Pluralist Era: American Art, 1968–1981.* New York: Harper and Row, 1984.

Rodin, Auguste. *Rodin on Art and Artists.* New York: Dover, 1983.

Rogers, Franklin, ed. *Mark Twain's Satires and Burlesques.* Berkeley: University of California Press, 1968.

Rosand, David. *The Meaning of the Mark.* Lawrence: Spencer Museum of Art, University of Kansas, 1988.

Rose, Barbara. *Frankenthaler.* New York: Harry N. Abrams, 1971.

Rosenberg, Harold. *Discovering the Present*. Chicago: University of Chicago Press, 1973.

———. *Art on the Edge*. Chicago: University of Chicago Press, 1983.

———. *The De-definition of Art*. Chicago: University of Chicago Press, 1983.

Rosenberg, Jakob, Seymour Slive, and E. H. ter Kuile. *Dutch Art and Architecture, 1600 to 1800*. Baltimore: Penguin, 1966.

Roud, Richard. *Jean-Luc Godard*. Garden City, NY: Doubleday, 1968.

Rubin, William. *Frank Stella*. New York: Museum of Modern Art, 1970.

———, ed. *Cézanne: The Late Work*. New York: Museum of Modern Art, 1977.

———, ed. *Pablo Picasso: A Retrospective*. New York: Museum of Modern Art, 1980.

Rubin, William, and Carolyn Lanchner. *André Masson*. New York: Museum of Modern Art, 1976.

Rubin, William, Hélène Seckel, and Judith Cousins. *Les Demoiselles d'Avignon*. New York: Museum of Modern Art, 1994.

Ruland, Richard, and Malcolm Bradbury. *From Puritanism to Postmodernism*. New York: Viking, 1991.

Russell, John. *Seurat*. London: Thames and Hudson, 1965.

———. *Matisse: Father and Son*. New York: Harry N. Abrams, 1999.

Sandler, Irving. *Art of the Postmodern Era*. New York: HarperCollins, 1996.

Sanouillet, Michel, and Elmer Peterson. *The Writings of Marcel Duchamp*. New York: Da Capo Press, 1989.

Sarris, Andrew. *The American Cinema*. Chicago: University of Chicago Press, 1985.

———. *The John Ford Movie Mystery*. London: British Film Institute, 1998.

Sartre, Jean-Paul. "The Search for the Absolute." In Giacometti, *Exhibition of Sculpture, Paintings, Drawings*, pp. 2–22.

Schapiro, Meyer. *Paul Cézanne*. New York: Harry N. Abrams, 1952.

———. *Worldview in Painting: Art and Society*. New York: George Braziller, 1999.

———. *The Unity of Picasso's Art*. New York: George Braziller, 2000.

Schlemmer, Tut, ed. *The Letters and Diaries of Oskar Schlemmer*. Middletown, CT: Wesleyan University Press, 1972.

Schmidt, Michael. *Lives of the Poets*. New York: Alfred A. Knopf, 1999.

Schwartz, Gary. *Rembrandt*. New York: Viking, 1985.

Sealts, Merton. *Melville's Reading*. Columbia: University of South Carolina Press, 1988.

Selz, Peter. *The Work of Jean Dubuffet*. New York: Museum of Modern Art, 1962.

Sewell, Darrel, ed. *Thomas Eakins*. New Haven, CT: Yale University Press, 2001.

Shapiro, David, and Cecile Shapiro, eds. *Abstract Expressionism*. Cambridge: Cambridge University Press, 1990.

Shucard, Alan, Fred Moramarco, and William Sullivan. *Modern American Poetry*. Boston: Twayne, 1989.

Sickert, Walter. *The Complete Writings on Art*. Oxford: Oxford University Press, 2000.

Simon, Joan. *Susan Rothenberg*. New York: Harry N. Abrams, 1991.

Simonton, Dean Keith. *Scientific Genius*. Cambridge: Cambridge University Press, 1988.

————. *Greatness*. New York: Guilford Press, 1994.

Sklar, Robert. *F. Scott Fitzgerald*. New York: Oxford University Press, 1967.

Smithson, Robert. *Robert Smithson: The Collected Writings*. Berkeley: University of California Press, 1996.

Soby, James Thrall. *Giorgio de Chirico*. New York: Museum of Modern Art, 1955.

Solomon, Deborah. "Frank Stella's Expressionist Phase." *New York Times Magazine*, May 4, 2003, 44–47.

Sontag, Susan. *Styles of Radical Will*. New York: Farrar, Straus and Giroux, 1969.

Spender, Matthew. *From a High Place: A Life of Arshile Gorky*. New York: Alfred A. Knopf, 1999.

Spender, Stephen. *The Making of a Poem*. London: Hamish Hamilton, 1955.

Sporre, Dennis. *The Arts*. Englewood Cliffs, NJ: Prentice-Hall, 1984.

Sproccati, Sandro. *A Guide to Art*. New York: Harry N. Abrams, 1992.

Spurling, Hilary. *The Unknown Matisse*. New York: Alfred A. Knopf, 1998.

Stauffer, Donald. *A Short History of American Poetry*. New York: E. P. Dutton, 1974.

Stein, Gertrude. *The Autobiography of Alice B. Toklas*. New York: Harcourt, Brace, 1933.

Sterritt, David. *The Films of Jean-Luc Godard*. Cambridge: Cambridge University Press, 1999.

Stevens, Holly, ed. *Letters of Wallace Stevens*. New York: Alfred A. Knopf, 1972.

Stevens, Wallace. *The Necessary Angel: Essays on Reality and the Imagination*. New York: Vintage Books, 1965.

————. *Opus Posthumous*. New York: Knopf, 1966.

————. *Collected Poetry and Prose*. New York: Library of America, 1997.

Stiles, Kristine, and Peter Selz, eds. *Theories and Documents of Contemporary Art*. Berkeley: University of California Press, 1996.

Stokstad, Marilyn, and Marion Spears Grayson. *Art History*. New York: Abrams, 1995.

Strickland, Carol, and John Boswell. *The Annotated Mona Lisa*. Kansas City, MO: Andrews and McMeel, 1992.

Stuckey, Charles F., ed. *Monet*. New York: Park Lane, 1986.

Sylvester, David. *Looking at Giacometti*. New York: Henry Holt, 1994.

————. *About Modern Art*. New York: Henry Holt, 1997.

————. *Interviews with American Artists*. New Haven, CT: Yale University Press, 2001.

Tamplin, Ronald, ed. *The Arts*. Oxford: Oxford University Press, 1991.

Taylor, Richard, ed. *The Eisenstein Reader*. London: British Film Institute, 1998.

Terenzio, Stephanie, ed. *The Collected Writings of Robert Motherwell*. New York: Oxford University Press, 1992.

Thomson, David. *A Biographical Dictionary of the Cinema*. London: Secker and Warburg, 1980.

Thompson, Lawrance. *Fire and Ice*. New York: Russell and Russell, 1961.

Tomkins, Calvin. *The Bride and the Bachelors*. New York: Viking, 1965.

————. *Off the Wall*. Garden City, NY: Doubleday, 1980.

————. *Duchamp*. New York: Henry Holt, 1996.

Trilling, Lionel. *The Liberal Imagination*. New York: Viking, 1951.

————. *The Last Decade*. New York: Harcourt Brace Jovanovich, 1979.

Truffaut, François. *Hitchcock*. New York: Simon and Schuster, 1967.

————. *The Films in My Life*. New York: Da Capo Press, 1994.

Tuchman, Maurice, and Stephanie Barron. *David Hockney: A Retrospective*. Los Angeles: Los Angeles County Museum of Art, 1988.

Tucker, Mark, and Nica Gutman. "Photographs and the Making of Paintings." In Sewell, *Thomas Eakins*, pp. 225–38.

————. "The Pursuit of 'True Tones.'" In Sewell, *Thomas Eakins*, pp. 353–66.

Valéry, Paul. *Degas, Manet, Morisot*. Princeton, NJ: Princeton University Press, 1989.

van de Wetering, Ernst. *Rembrandt: The Painter at Work*. Berkeley: University of California Press, 2000.

van Gogh, Vincent. *The Complete Letters of Vincent van Gogh*. Vol. 2. London: Thames and Hudson, 1958.

————. *The Complete Letters of Vincent van Gogh*. Vol. 3. London: Thames and Hudson, 1958.

Varnedoe, Kirk. *A Fine Disregard*. New York: Harry N. Abrams, 1990.

————. *Jasper Johns: A Retrospective*. New York: Museum of Modern Art, 1996.

Vasari, Giorgio. *Vasari's Lives of the Artists*. New York: Simon and Schuster, 1946.

Vincent, Howard. *The Trying-Out of Moby-Dick*. Boston: Houghton Mifflin, 1949.

Vollard, Ambroise. *Degas*. London: George Allen and Unwin, 1928.

————. *Cézanne*. New York: Dover, 1984.

Wagner, Linda, ed. *Sylvia Plath*. London: Routledge, 1988.

Warhol, Andy. *The Philosophy of Andy Warhol*. San Diego: Harcourt Brace, 1975.

Welles, Orson. *Interviews*. Jackson: University of Mississippi Press, 2002.

Whistler, James Abbott McNeill. *The Gentle Art of Making Enemies*. New York: G. P. Putnam's Sons, 1922.

Wilkins, David, Bernard Schultz, and Katheryn Linduff. *Art Past, Art Present*. 3rd ed. New York: Harry N. Abrams, 1997.

Williams, William Carlos. *The Autobiography of William Carlos Williams*. New York: Random House, 1951.

————. *Selected Essays of William Carlos Williams*. New York: Random House, 1954.

Wilson, Edmund. *The Shores of Light*. New York: Farrar, Straus, and Young, 1952.

Wilson, Edmund. *Axel's Castle*. New York: W. W. Norton, 1984.

Wilson, Laurie. *Alberto Giacometti*. New Haven, CT: Yale University Press, 2003.

Wilson, Michael. *Manet at Work*. London: National Gallery, 1983.

Wittkower, Rudolf. *Sculpture: Processes and Principles*. New York: Harper and Row, 1977.

Wollen, Peter. *Paris Hollywood*. London: Verso, 2002.

Wollheim, Richard. "Minimal Art." In Battcock, *Minimal Art,* pp. 387–99.

Wood, Michael, Bruce Cole, and Adelheid Gealt. *Art of the Western World.* New York: Simon and Schuster, 1989.

Wood, Paul, Frances Frascina, Jonathan Harris, and Charles Harrison. *Modernism in Dispute.* New Haven, CT: Yale University Press, 1993.

Wood, Robin. *Howard Hawks.* Garden City, NY: Doubleday, 1968.

———. *Hitchcock's Films.* London: A. Zwemmer, 1969.

Woolf, Leonard, ed. *A Writer's Diary.* San Diego: Harcourt Brace, 1982.

Woolf, Virginia. *Collected Essays.* 4 vols. New York: Harcourt, Brace and World, 1925.

———. *Mrs. Dalloway.* New York: Modern Library, 1928.

———. *Moments of Being.* New York: Harcourt Brace Jovanovich, 1976.

———. *The Diary of Virginia Woolf.* 3 vols. Edited by Anne Bell. New York: Harcourt Brace Jovanovich, 1980.

Young, Philip. *Ernest Hemingway: A Reconsideration.* University Park: Pennsylvania State University Press, 1966.

Zevi, Adachiara, ed. *Sol LeWitt: Critical Texts.* Rome: Inonia, 1994.

Zickar, Michael, and Jerel Slaughter. "Examining Creative Performance over Time Using Hierarchial Linear Modeling: An Illustration Using Film Directors." *Human Performance* 12, no. 3/4 (1999): 211–30.

INDEX

Abduction, The (Cézanne), 56
L'Absinthe (Degas), 75
abstract art, pioneers of, 29–30, 88–89
Abstract Expressionism, 36–38; and age at
 which leading artists had their first exhi-
 bition, 81–82; and art history, place in,
 85; automatism in, 50; benefit to from
 European artists escaping Fascism, 89;
 complexity of art within, 177; and con-
 ceptual successors, reaction to, 84;
 Monet as a forerunner of, 64; Smith
 and, 119–20
Ackerman, James, 101
Adams-Price, Carolyn, 172–73
aesthetically motivated experimentation.
 See experimental innovation/artists
age: artistic achievement and (*see* life cycle
 theory of creativity); illustrations in text-
 books and the artist's, 26–27; inclusion
 in *An Invitation to See* and, 40–42; inclu-
 sion in "The Heroic Century" exhibition
 and, 43–45; innovation/quality of work
 and, 1, 14–15, 166–71; of novelists
 when writing their most important
 works, 148–49; premodern masters and,
 109–10; prices at auction and the art-
 ist's, 22–24; the problem of reacting con-
 structively to advancing, 183–84; psy-
 chologists on creativity and, 171–77;
 quantitative measures of an artist's best
 work and, 28–33; retrospective exhibi-
 tions and, 33–35; the young master, rise
 of, 80–82
Age and Achievement (Lehman), 172
Agee, James, 156
Aiken, Conrad, 128, 129, 146
Alechinsky, Pierre, 14
Alpers, Svetlana, 95–96
Alvarez, A., 132–33
American Film Institute, 154–55
Ames-Lewis, Francis, 102
Anatomy Lesson of Dr. Tulp (Rembrandt),
 109
Anderson, Sherwood, 146
Apollinaire, Guillaume, 32, 117

Archer, Michael, 91–93
Archilochus, 177
architects, 184
Ariel (Plath), 133
art/artists: conspiracy theories in, 3; experi-
 mental and conceptual, characteristics
 of, 177–84; experimental and concep-
 tual, consideration of the distinction be-
 tween, 162–66; globalization of, 86–93;
 implications of the theory for (*see* impli-
 cations of the theory); innovation as
 source of importance/lasting reputation
 in, 2–3; innovation in and age of the art-
 ist (*see* age; life cycle theory of creativ-
 ity); measurement of quality of (*see* mea-
 surement); motivations, comparison of
 artists and scholars regarding, 15–20;
 quality of, age and, 1, 14–15, 166–71;
 quality of, determinants of, 2–3; quality
 of, size of paintings and, 23; textbook il-
 lustrations as evidence regarding quality
 of, 25–27. *See also names of artists;
 names of movements*
art historians: and artists and scientists, ig-
 noring of parallels between, 17; global-
 ization of art and, 90–91; and master-
 pieces without masters, awareness of,
 73; measurement of the quality of work
 and, 44; and textbooks, publishing of
 and illustrations in, 25–26; and types of
 artistic innovators and creative life cy-
 cles, recognition of, 19–20
Art since 1960 (Archer), 91–93
Aurier, Albert, 64
Austen, Jane, 169
Avery, Milton, 89

Bacon, Francis, 14
Balassi, William, 146
Balthus (Balthasar Klossowski de Rola),
 13–14
Balzac, Honoré de, 114, 165–66
Bar at the Folies-Bergère, A (Manet), 57
Basquiat, Jean-Michel, 86
Bathers at La Grenouillère (Monet), 52–53